The Art Institute of Chicago Centennial Lectures

Museum Studies 10

Contemporary Books, Inc.
Chicago

Copyright © 1983 by The Art Institute of Chicago
All rights reserved
Published by Contemporary Books, Inc.
180 North Michigan Avenue, Chicago, Illinois 60601
Manufactured in the United States of America

Published simultaneously in Canada by Beaverbooks, Ltd.
195 Allstate Parkway, Valleywood Business Park, Markham, Ontario L3R 4T8, Canada

Designed by Lynn Martin, Chicago
Typeset by Automated Office Systems, Chicago

Library of Congress Cataloging in Publication Data
Main entry under title:

The Art Institute of Chicago centennial lectures.

(Museum studies; 10)
1. Art—Addresses, essays, lectures. I. Art
Institute of Chicago. II. Series: Museum studies
(Chicago, Ill.); 10.
N81.C45 vol. 10 [N7443.2] 700s [700] 83-1892
ISBN 0-8092-5978-8

Contents

Preface and Acknowledgments

On May 24, 1979, the Art Institute of Chicago celebrated its 100th anniversary. In the course of that year, the Institute received many gifts and tributes in honor of its extraordinary achievements, which have enhanced the cultural life of this country. Among several centennial projects sponsored by the museum's Auxiliary Board was a series of lectures that brought a number of eminent scholars from Europe and America to Chicago to speak on their various specialities and interests. So that these talks would constitute a permanent contribution to art scholarship, the board determined to underwrite not only the lectures themselves but also their publication. It is therefore with particular pleasure and pride that we introduce *The Art Institute of Chicago Centennial Lectures,* a special, commemorative volume of the Art Institute's journal, *Museum Studies.*

As is true of any undertaking as ambitious as this one, many individuals are responsible for its success. We would like to express the Art Institute's appreciation first and foremost to the Auxiliary Board for their enthusiastic and sustained support of our lecture and publications programs. *Centennial Lectures* is, in fact, the second centennial publication realized through their sponsorship, the first being *The Art Institute of Chicago: 100 Masterpieces.* Our special gratitude goes to past presidents David C. Hilliard, Mrs. Jeffrey C. Ward, and H. George Mann, during whose terms the project was conceived and carried out; to current president Mrs. George M. Covington; and especially to O. Renard Goltra, who arranged for the publication of the lectures, including financing, and saw the project through to completion. Co-chairmen for the lecture series were Mrs. Jeffrey C. Ward, Mrs. James P. Stirling, Mrs. John A. Bross, and H. George Mann. Implementation of the project would not have been possible without the tireless service of Mrs. Claudia R. Luebbers, Miss Lynne Alsdorf, Mrs. William G. Brown, Mrs. Julian W. Harvey, and Christopher Nielsen. To them and to all of the Auxiliary Board members go our heartfelt thanks.

The painstaking preparation of the lectures for publication was accomplished over a two-year period by Chicago-based art historian Jean Goldman, working closely with authors and with the curatorial staff of the museum. We also wish to thank the authors for their cooperation and patience, as well as the many institutions and individuals for their permission to reproduce their works of art here. Responsible for the book's elegant appearance is Chicago designer Lynn Martin.

Finally, we wish to express our deep appreciation to the publisher of *Centennial Lectures,* Harvey Plotnick of Contemporary Books, Chicago. Without Mr. Plotnick's commitment to the project and his generosity, the book would never have been realized. He and his staff—in particular, Mary Eley—have been most accommodating throughout the production process. We are very grateful to him and to everyone at Contemporary Books for their cooperation.

James N. Wood, *Director*

Introduction

To commemorate the one-hundred-year anniversary of the establishment of the Art Institute of Chicago, its Auxiliary Board sponsored a series of lectures on topics in each of the museum's curatorial specialties. Initially the project was conceived to illuminate aspects of the Art Institute's collections or exhibitions held in its centennial year. Subsequently, however, the scope was expanded to encompass a broad range of subjects.

Each lecturer, an eminent scholar of outstanding reputation, presented original research never before published. The resulting material is both uniquely readable for the layman and of substantial interest to art historians.

The recurring theme that unifies these seemingly disparate essays is the glimpses they offer into the art historical process: how a problem is discovered, analyzed, and resolved by distinguished scholars. The problems are as varied as their solutions. Sometimes the study commences with the discovery of the artwork itself; other times the goal might be the working out of a new meaning for an established masterpiece, or providing a new attribution or a date for an object.

Starting with the discovery of a bronze ring, Susan Vogel spent several years unraveling its mysterious iconography. In the process, she was able to relate this ring to about fifty others, all with similar arresting motifs: gagged heads, multiple human sacrifices, and vultures. Addressing herself to the enigmatic relationship of these motifs, she slowly untwines the rings' symbolism. Armed with the newly acquired understanding of the meaning of these motifs, she goes a step further and determines where the rings were made and what their purpose was, placing them in the more general context of primitive ceremonial art.

Instead of ferreting out the meaning of a new discovery, Wanda Corn analyzes a painting that has been misunderstood to determine a more plausible iconography for it. Rather than exotic lands and people, she chooses a very familiar work—almost a national icon—Grant Wood's *American Gothic*. One of the Art Institute's masterpieces, it has become so famous that we probably no longer really "see" the painting.

These two topics, African rings and *American Gothic,* represent opposite ends of the art historical spectrum, not only in time and place but in types of analytical skills displayed. The archeological and anthropological methodology of the specialist in African art is far different from the techniques and connoisseurship appropriate to the historian studying modern art.

It is with drawings that the authors address themselves particularly to the wide range of methodology useful to the art historian in solving problems of attribution, intent, date, and original location.

Availing himself of the large corpus of drawings by Raphael and his "school," John Shearman reconstructs the creative process of conceiving and executing a Renaissance decorative cycle. His primary concern is the procedure and bureaucracy of a workshop system that

produced a series of masterpieces. While detailing how a large Renaissance workshop functioned (and sometimes failed to function), he simultaneously sharpens our perception of the distinction between drawings that are copies, originals, preparatory sketches, and record-keeping notations.

Beginning with this same group of drawings but continuing on to discuss several more, Sydney Freedberg orchestrates the "fugue of styles," as he puts it, dominating Italian art by punctuating, clarifying, and highlighting the complex artistic developments of a century that witnessed a succession of styles from the High Renaissance through Mannerism to the early Baroque. He uses the drawings of Raphael, Michelangelo, and Annibale Carracci, among many others, to render a concise survey of the period.

Like Shearman, Lorenz Eitner structures his essay around drawings as the foundation for gaining an understanding of the creative process. In discussing some of the sketches in Géricault's *Chicago Album,* Eitner clarifies the evolution and significance of one of Géricault's paintings, the *Farrier's Signboard.* A modest work, it nonetheless marks a turning point in Géricault's stylistic growth. By placing it in relation not only to its sequence of preparatory drawings but also to the paintings immediately preceding and following its execution, Eitner documents this growth: The awareness of the development, in turn, broadens the appreciation of the finished painting.

Reaching beyond the clues provided by drawings, Wendy Hefford employs a different range of investigative procedures. She interprets entries in workshop notebooks to deduce the geographic origins of a seventeenth-century tapestry series. She also relies on technical analysis, comparing warp counts and dyes, to trace the manufacture of tapestries to specific factories in England and Holland. Aided further by a literary analysis of the content of the scenes depicted on the tapestries, she successfully reunites—albeit mentally—a whole series of tapestries now dispersed in collections around the world.

Like Hefford, Evan Turner discusses the problem of original location of an artwork. This problem arises frequently with works that have been removed from the sites for which they were originally intended. Often the site has also been altered. Contemporary accounts and visual records such as prints and paintings of the location are consulted to reconstruct the original setting. Turner and Hefford had to interpret the sequence and arrangement of several works in their original position. Benjamin Buchloh, on the other hand, discusses artists who entirely redefine the concept of original location, attaching to it a philosophical and aesthetic dimension. A central premise of the conceptual art on which he focuses is the jarring of our sensibilities caused by taking artworks out of their original locations, juxtaposing them with related or unrelated objects in sometimes startling relocations.

At the same time that an art historian is analyzing the unique problems inherent in a particular artwork or set of artworks, he must also be aware of the larger context in which the work was created. He must consider where the work fits in the artist's development and where it ultimately fits in the history of style. To do this, he must consider the artwork's resemblance to known works by the artist and by other artists active in that period. He must have a vast knowledge, therefore, of the stylistic characteristics of a particular historical period. Articles in this collection that reflect this concern include Jeffrey Weidman's study of three works by William Rimmer, and Roger Keyes's of the *100 Poems* set by Hokusai. Others have attempted to consider individual works in an even broader historical perspective. John Reps and Carol

Krinsky document Burnham's *Plan of Chicago* as a major achievement in city planning efforts. Still others attempt to clarify the internal history of a single masterpiece by retracing the artistic process from the preparatory stages to its completion, as Eitner and Shearman do for Géricault and Raphael, respectively. Their particular concern is the reconstruction of the preliminary stages in the evolution of an artwork. They study drawings to understand the choices made and the ideas rejected by the artist as he evaluates and refines his ideas on form and content. Every art object has an intimate history of its own development, as Eitner observes. In some cases, we have ready access to this history through extant preliminary drawing material or through letters or account books. In these cases, an art historian can reconstruct the intimate history by a careful reading of such documents. To varying degrees, Corn, Keyes, Turner, and Weidman have also been involved with these concerns. It is not a task that is possible in all periods, nor for all artists, being dependent, as it is, on available evidence.

Although hardly an exact science, art history is governed by certain techniques and methods in its approach to problems. These essays demonstrate the range of tools and procedures useful for solving the mysteries inherent in a field where there are so many missing links—where an artist may be dead or unknown, or where function, symbolic content, original location, and materials are often uncertain. While archival proficiency and technical training in the use of a variety of media are prerequisites for much scholarly investigation, the visual impressions and insightful comparisons of a renowned art historian can be equally instructive. In some of these essays, therefore, the reminiscences and overview of a respected scholar are presented in such a way as to raise provocative new issues or synthesize a diffuse body of information. The remarks of Sir Ellis Waterhouse on the great Chicago collectors of the early twentieth century—some of whom he knew personally—are fascinating sidelights of history to be smilingly savored. Far different in tone and subject matter is the view of the forces behind the development of a specifically American aesthetic in photography outlined in the informal style of John Szarkowski. Karl Schefold provides this same kind of personal—and highly philosophical—interpretation of ancient Roman painting, which has been gleaned from innumerable years of study. Pratapaditya Pal does likewise for Indian art of the Gupta period.

Whether they be investigative art historical procedures or general philosophical viewpoints, the insights afforded into recent art historical scholarship by this collection of essays are far-reaching and always stimulating. This centennial project, moreover, is a model for a significant, forward-looking approach to museum scholarship. By inviting scholars to take a fresh look at objects in their collections, museums can shift their emphasis, encouraging creative, new ways of using their own resources.

<div style="text-align: right">Jean Goldman, Editor</div>

The
Art Institute of Chicago
Centennial Lectures

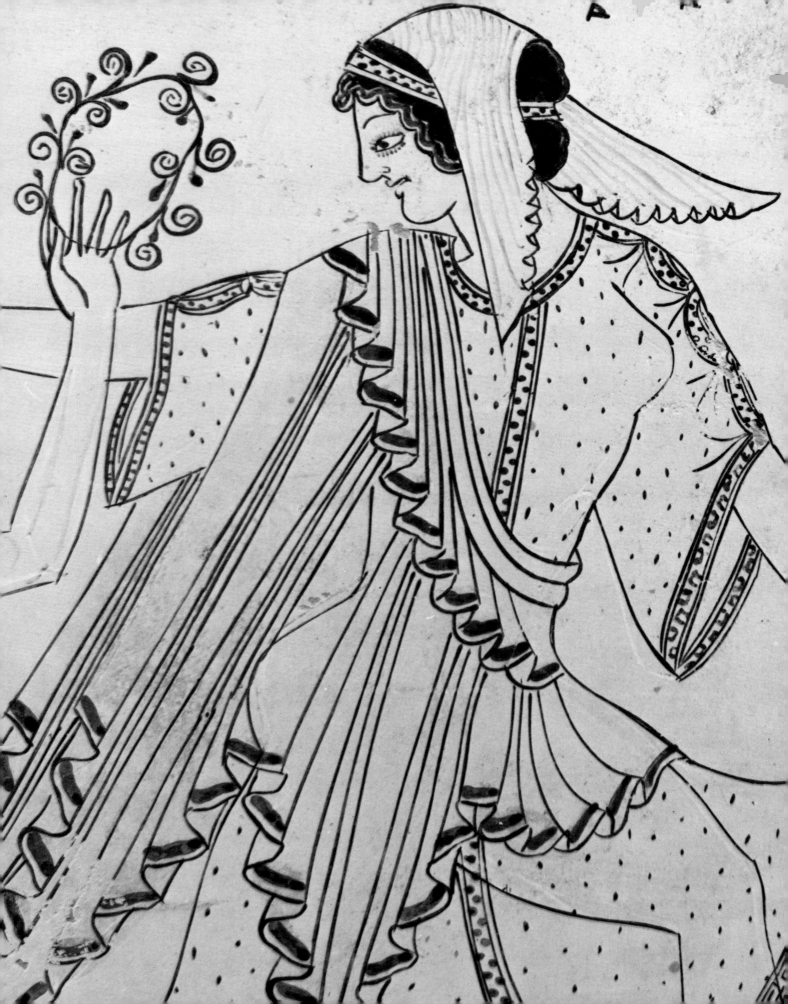

John Boardman

Atalanta

When the hounds of spring are on winter's traces,
 The mother of months in meadow or plain
Fills the shadows and windy places
 With lisp of leaves and ripple of rain.

These are certainly the best-known lines from Swinburne's otherwise unmemorable poetic play *Atalanta in Calydon,* and they set the scene in an appropriately vigorous and open-air manner for our heroine, Atalanta, the huntress and athlete. This is not, however, the image of her that concerns us first and I present her instead in a very different light, and in a manner which poses a question and requires an answer.

A fine white-ground lekythos painted in Athens in the early part of the fifth century B.C. by one of the best of Athenian vase painters, Douris, was acquired by the Cleveland Museum of Art in 1966 and has already been thoroughly published (fig. 1).[1] It is a shape designed to contain perfumed oil and a type of vase often destined for the grave. It is likely that it was found in a grave in Italy, though perhaps not a Greek grave. The outline technique on a white ground differs from the usual red-figure technique of these years in lacking the black back-ground, and for this period it is nowhere better demonstrated than on this vase.

The central figure on the lekythos is of a girl running swiftly. If her name, "Atalante" (the Greek form of the name), had not been written before her we might have wondered who she is. She is well dressed; even overdressed, we might think, for such a show of energy. She wears a finely patterned gown or chiton, whose hem she lifts so that she can run the more freely. Over it is a short cloak which is gathered at her waist and over her right shoulder, with its ends and hem flying in that elegant pattern of zigzags and pleats loved by the late Archaic Athenian artists. She wears a crown and, over her hair, a small kerchief, no less delicately drawn and with neatly crimped ends. The outline of her bare legs shows through the dress; she is a well-built girl. Why, though, when so finely dressed, is she in such a hurry? There is almost an element of "get me to the church on time," and we shall see that the thought is not altogether inapposite. She is looking round, wide-eyed, and extends her right hand in a gesture of surprise or as if to fend off attack.

She is not alone. With her are three Erotes—the naked winged boy is sometimes multi-plied in this way in Greek art. The two outer figures carry flowers, but the third, immediately

behind and pursuing her, is differently equipped. In his left hand he holds a wreath which he raises toward her head and which she is clearly anxious to avoid, and in his right we see now a flower, like those carried by his companions. But this flower has been put there by the modern restorer because the original object he was carrying was too poorly preserved for him to understand. It was, in fact, a whip, traces of which are quite clear on the vase.

For Atalanta the choice seems a desperate one: the whip, and despite her legendary fleetness of foot she would need all her skill to get away from a winged pursuer—or the wreath, which in Eros's hands implies the consummation of at least love, if not marriage.

On Greek vases Eros wields his whip more often in pursuit of boys. On a lekythos of different shape and in the red-figure technique, but by the same painter as of the Cleveland vase, Douris, we find a flying Eros with a whip driving a boy into the arms of a second Eros.[2] And on a rather later vase, by the Oionokles Painter, a single Eros chases a boy with his whip past an altar.[3] We are perhaps to assume that the boy's fault is failure to acquiesce in the demands of a lover. When the quarry is a girl, and a heroine such as Atalanta, the explanation may not be so ready, and we have to consider her career and reputation in antiquity, the stories about her and in particular the way she was treated by Greek artists and their Roman successors.

For a coherent account of any mythological figure such as Atalanta, we have usually to turn to authors of the Roman period or later who have conflated and adjusted the treatments of the stories by earlier authors and poets, mainly lost to us. What seemed important to these late authors may not have seemed important to artists and poets of the Classical Greek period, and some details may even have been added or invented. If we wish to discover details of a story or figure as they were understood in the sixth or fifth century B.C., we have to turn to the evidence of contemporary art, or of contemporary literature, if we are lucky enough to find that a relevant whole poem or play has survived. Art is usually the more prolific source.

The Atalanta of the late mythographers[4] appears to have had a dual personality, or at least a dual persona with important common elements. In the version that seems to have been current in Boetia, in central Greece, she was a princess devoted to the hunt, a virgin and uninterested in men. She was obliged, however, to marry whoever succeeded in defeating her in the footrace. Those who failed she killed, thereby discouraging entrants and eliminating second attempts. Aphrodite, the goddess of love, felt herself slighted by this behavior and counseled one suitor, usually called Hippomenes in antiquity, on a means of outstripping her. She gave him three golden apples which he was to cast before her during the race. This he did; she could not resist stopping to pick them up, and so lost. The sequel to the race is told in different ways; it may be that of the resultant marriage the hero Parthenopaios was born, but another story has the couple make love in a sanctuary and for this sacrilege turned into lions, either by Zeus or the goddess Cybele.

The Atalanta of Arcadia in South Greece was a decidedly similar character. She was said to have been exposed at birth by her disappointed father and suckled by a she-bear. Again, she was a chaste huntress, devoted to the huntress goddess Artemis (Diana) rather than to Aphrodite. Her principal exploit was her part in the famous hunt of the Calydonian boar which had been sent to ravage the land by Artemis. The hunt was graced by the presence of many heroes, but it was the girl Atalanta, it was said, who struck the beast first and to her were awarded the spoils of the boar's head and hide. The leader of the hunt was Meleager, and in Greek literature and art from the time of Euripides on they became more than just hunting companions. This is

4

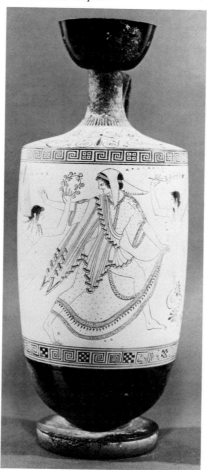

Figure 1. *Atalanta and Erotes,* detail of a leky-thos by Douris, Greek (Athens), c. 500/490 B.C. White ground, clay; h. 32.5 cm. The Cleveland Museum of Art, Purchase, Leonard C. Hanna Bequest.

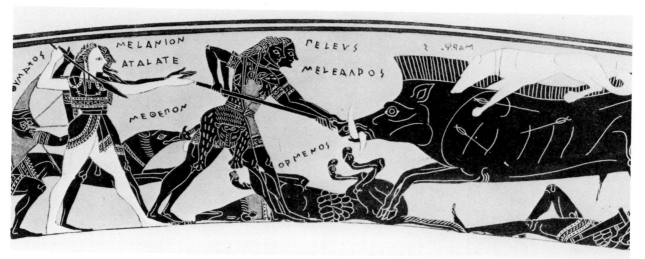

Figure 2. *Calydonian Boar Hunt,* detail from the François Vase, Kleitias, Greek (Athens), c. 570 B.C. Black-figure volute crater, clay. Florence, Museo Nazionale, no. 4209. (Drawing by K. Reichhold from A. Furtwangler and K. Reichhold, *Griechische Vasenmalerei,* Munich, 1904, pl. 3.)

5

Figure 4. *Calydonian Boar Hunt,* Greek (Melos?), c. 470
B.C. Terracotta relief plaque; 14.5 x 23.8 cm. Amster-
dam, Allard Pierson Museum, no. 1758. (From P. Jacobs-
thal, *Die melischen Reliefs,* Berlin, 1931, no. 27, pl. 15.)

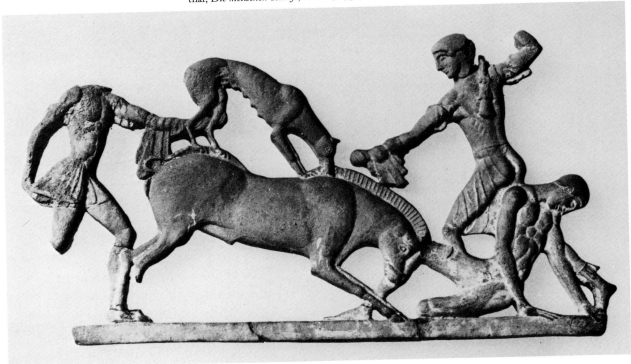

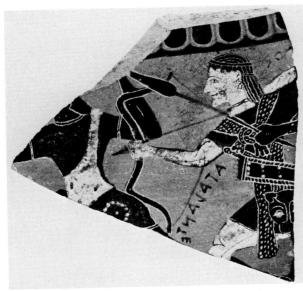

Figure 3. *Calydonian Boar Hunt,* fragment of a dinos,
Greek (Athens), c. 570/560 B.C. Black figure, clay. Os-
termundigen, Switzerland, R. Blatter Collection. (From
R. Blatter, "Dinos Fragmente mit der kalydonischen
Eberjagd," *Antike Kunst* 5 [1962], pl. 16.2.)

Figure 5. *Calydonian Boar Hunt,* detail of a pelike, Greek
(Athens), c. 370 B.C. Red figure, clay. Leningrad, Her-
mitage Museum, no. B. 4528.

an important theme. Meleager's uncles were jealous of the way in which he had assigned the spoils to Atalanta and this led to his death. This, too, was the subject of Swinburne's play.

There are one or two other episodes in her life which are worth mentioning. She had an unpleasant experience with two centaurs who tried to rape her, but she killed them. She wished to join the famous Argonaut expedition to seek the Golden Fleece but was not accepted for enrollment because she was regarded as a possible source of jealousy and discord in an otherwise all-male party. At the famous games for the funeral of King Pelias she wrestled with the hero Peleus, and this story at least became a subject for art too, as we shall see. But on the whole the balance of these stories, as told by the late authors, does not closely match the interest shown in Atalanta by artists in different periods.

The huntress element in her career is clearly an important one and is apparent even in the story of her being suckled by a she-bear. As a local deity, she was readily assimilated to the goddess Artemis, also a protectress and huntress of animals, who had like tastes and a like distaste for men. It is easy to see how regional variations in her story could develop in Boetia and Arcadia; or how local stories of a huntress-heroine attracted the same name and divine associations.

In Greek art we see her first as a huntress, in the episode with the Calydonian boar.[5] The scenes appear first in Athenian art from about 580 B.C. on, and her immediate companion in the hunt is sometimes named Milanion. His name can be cited in both the boar hunt and the footrace story, but this confusion of names and personalities in Greek myth is not uncommon. The famous François Vase, painted in Athens by Kleitias about 570 B.C., offers one of the earliest and most explicit scenes of the hunt.[6] The boar is at the center with pairs of heroes at either side (fig. 2). The beast has already brought down one hunter and one dog and is being worried by another dog. The heroes facing the boar are, first, Peleus and Meleager, and in the second rank Milanion and Atalanta, distinguished from her male companions by her pale flesh, following the usual convention on these vases. All the figures are named. There is no particular indication here, or in any of the other scenes of the hunt on Athenian vases (not all of which show Atalanta), that she will strike the first blow. Nor is there any uniformity in the weapon she uses. On the François Vase she carries a spear, but generally the bow, Artemis's own weapon, was favored. Her dress varies, too, sometimes with a panther skin over her tunic, hunting boots, even a helmet, and elsewhere earrings and necklace to display her femininity (fig. 3).[7] In Boetia, one of her homes, the scheme is the same. On a vase made by an East Greek artist working in Etruria (a "Caeretan hydria") the girl facing a boar must be our heroine but is equipped, rather improbably, with sword and shield.[8]

The scenes are hardly less common later. On a fifth-century clay relief plaque (fig. 4), probably made on the island of Melos, she is attacking the boar from the right and this time her weapon is a club.[9] On later Athenian vases in the red-figure technique, and on South Italian vases that are related to them, the scheme for the hunt changes from the friezelike arrangement of the Archaic vases to a design with the figures disposed up and down the near-rectangular field, resembling the arrangement of wall paintings of the day. Now she is regularly shown with a bow, often at the top right of the composition and so not particularly close to the boar. Her dress is the usual short tunic of a hunter, with boots, and a hunting dog is in attendance. On one Athenian vase her dress has slipped to bare part of her torso (fig. 5), a motif that would reappear.[10]

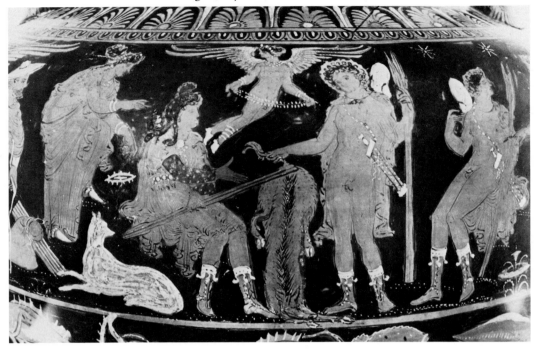

Figure 6. *Meleager Awarding the Boar Hide to Atalanta,* detail of an amphora, South Italian (Tarentum), c. 330 B.C. Red figure, clay. Bari, Museo Civico, no. 872.

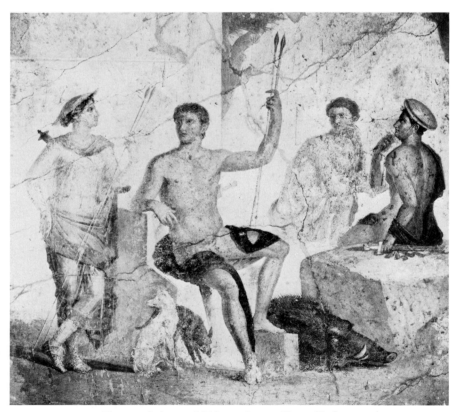

Figure 7. *Atalanta and Meleager,* Roman (Pompeii), fresco from the House of the Centaur, c . 40/50. Naples, Museo Archeologico Nazionale, no. 8980.

The hunt, and her inevitable participation in it, was also a subject for monumental art. The relief decoration of a hero-monument at Trysa in Asia Minor, built about 400 B.C., includes the hunt and shows her as an archer.[11] And on the temple of Athena Alea at Tegea in South Greece the hunt was the subject for one of the pediments. Recent study has identified her in a torso wearing the usual short tunic.[12]

The last important series of representations of the hunt appears on Roman sarcophagi of the second and third centuries A.D.[13] Her dress is as it had been in Classical Greece—short tunic and boots—and her weapon the bow. She may still be set at some distance from the boar but often is shown very close to its head, aiming her bow at it. Meleager driving in his spear, the boar itself, and hunting dogs tend to occupy the foreground. The artists were in some difficulties to demonstrate both Meleager's and her vital roles in the dispatch of the animal—she shot it first, but he delivered the fatal blow—so they both had to occupy prominent positions and, not surprisingly, Meleager got the limelight.

The association with Meleager becomes particularly important after the end of the fifth century B.C. On a vase painted at Tarentum in South Italy (fig. 6) in the later years of the fourth century we see him handing over the boar hide to a seated Atalanta.[14] She is wearing a rather stagey version of hunting dress, holding her hunting spears and with her dog beside her. The love interest between the two principal figures is made quite explicit here by Eros hovering between them and by Aphrodite standing behind them and holding a love charm. Other vases, Athenian of slightly earlier date (especially the work of the Meleager Painter, named for them), show Atalanta at ease with hunter companions, including Meleager.[15] We are also told of a panel painting by the artist Parrhasios which showed them in an act of considerable intimacy and which the Roman emperor Tiberius acquired to hang in his bedroom.[16] So, in Greek art and literature Atalanta seems at last to have acquired a lover through the shared interest and danger of the hunt.

Greek works also probably served as models for the various wall paintings showing Atalanta and Meleager which have been found in Roman buildings. One of the finest, from the House of the Centaur at Pompeii, shows him seated with two spears (fig. 7).[17] She also carries the hunter's weapons but is standing nonchalantly at his side and is naked but for the dress slung loosely round her neck and hips, the sunhat, and her hunting boots. The great boar's head at Meleager's feet reminds us of their joint adventure. In other Pompeian paintings she wears ordinary day dress but still with the quiver at her shoulder. In one, she pampers her hero–lover while an Eros hovers behind him and another leans on her knee.[18] Roman mosaics, too, present the pair in these calm settings, with only the carcass or head of the boar to denote the circumstance of their meeting.

One of the latest of the depictions of them in antiquity is found in a far more unusual medium, a woolen tapestry wall-hanging made in about 400 A.D. (fig. 8).[19] It shows a double arcade, gabled, and beneath each arch is one of the hunters. Meleager stands with his spear while Atalanta is drawing an arrow from the quiver at her shoulder. She is splendidly dressed like a hunting princess, with a fine tiara.

Roman artists did not dwell only on these scenes of inaction, but there are a number of representations of them in the hunt, not always of the Calydonian boar or of any boar, but demonstrating their shared interest in the sport. They can be shown hunting on foot or on horseback, as in the mosaic from Halicarnassus now in London.[20] They figure, too, in late

antique silver plate. A superb dish from Istanbul, now in Leningrad, made in the seventh century A.D.,[21] has them standing with their horses while an attendant is bringing bait for the hunting nets, and the dogs, nets, and a groom are also at hand.

The sequel to their hunting exploits, leading to Meleager's death, was a subject for Classical plays but not for Classical art. Meleager was promised life as long as a magic firebrand remained unconsumed, and it was his mother, moved by her brothers' appeals, who destroyed the brand and his life. The expiring Meleager is shown on a Greek vase[22] but with no Atalanta. This would be a subject for Roman art. We do see her also on a Greek vase, with her son Parthenopaios, in the uncharacteristic role of a concerned mother, while he is being persuaded to join the fateful expedition of the Seven against Thebes.[23] It is on Roman sarcophagi of the second and third centuries A.D. that we observe most fully the final episodes of the drama. A few show rather surprisingly a feast which must be the celebration of the successful outcome of the hunt. Atalanta can be identified in such scenes, taking her place like a man but in her short hunting dress still, wreathed for the feast and tippling freely.[24] The death of Meleager held especial symbolic significance in the funerary art of the Roman world, and the dead hero, laid out and mourned on his bier, is not an uncommon subject. And here again we find Atalanta in some of the most poignant representations of the heroine (fig. 9). She stands or sits, usually at the head of the bier but turning away from it in her grief, often wearing her hunting dress still and with her dog beside her, but with her head buried sorrowfully in her hands.[25] Her presence is not only mythologically appropriate but it offers a singularly moving and human element to a scene commemorating the untimely death of a young hero.

We now leave the story of Meleager and Atalanta, and her career as a huntress, to turn to her role as athlete, runner, and wrestler. It is a role attested to in the very first references to her in Greek literature,[26] yet it is not easy to relate it to her character as devotee of Artemis. We start with her wrestling, an activity almost ignored in extant literature from antiquity but most popular with artists down to the Classical period.

At the games for the funeral of King Pelias at Iolcus in North Greece a great many of the heroes of the Argonaut expedition joined the competition. With them was Atalanta, though she was never a regular member of their party. From a late source we learn that she wrestled with Peleus.[27] On a vase made in a Chalcidian colony in South Italy about 540 B.C. (one of the so-called Chalcidian black-figure vases), we see Atalanta and Peleus grappling, attended by various heroes (fig. 10).[28] In the background hangs the boar skin, and its head is on a table in a position where we might expect to find the prize for the contest. If this is its function here, it is surprising and it is far more likely that it appears as a demonstration of her role in the heroic hunt, a display of status.

On the Chalcidian vase Peleus is naked while Atalanta wears a tunic. Greek athletes normally exercised and competed naked, and it is probably not surprising that the rules had to be adjusted for a heroine athlete. Most male heroic activity in Greek myth was mirrored in Greek life. Girl athletes were not altogether unknown in ancient Greece. In Sparta particularly the girls were said to exercise naked with the boys, and the rest of Greece frowned at the way the Spartan girls showed their thighs. There were even women's games at Olympia, though women were excluded from observing the male events, but we hear little about them. In Classical Athens it is very doubtful whether physical education played any part at all in the life

Figure 8. *Meleager and Atalanta,* detail of a tapestry, Roman, c. 400. Wool; h. of detail about 106 cm. Bern in Riggisberg, Abegg-stiftung. (From E. Simon, *Meleager und Atalanta,* Riggisberg, 1970, pl. 9.)

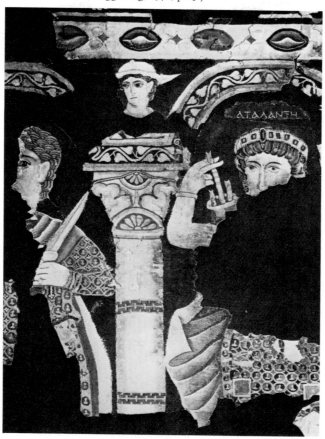

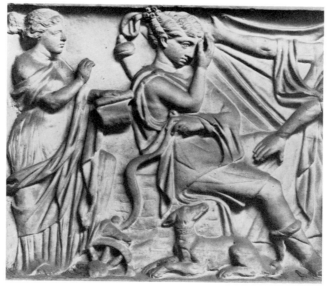

Figure 9. *Atalanta Mourning Beside Meleager's Bier,* detail of a sarcophagus, Roman, c. 170. Marble. Rome, Museo Capitolino, no. 623. (From G. Koch, *Meleager,* Berlin, 1975, no. 120.)

of ladies, and Plato was being somewhat contrary and pro-Spartan in recommending that the sexes might exercise together, bare if need be.

On the Chalcidian vase Atalanta is quite decently clothed, but in most Athenian art she is called upon to wear far less and so approximate more closely to the usual male athletic practice. On a red-figure vase by the Euaion Painter of about 450 to 440 B.C. (fig. 11)[29] she is shown in her full, though minimal, kit: an exercise cap such as wrestlers wear, a brassière, and pants. She holds a pick, with which athletes break up the ground in the landing area for the long jump; and hanging up is the usual male equipment for the after-exercise bath and rubdown—an oil bottle and scraper. In the scenes of the wrestling match with Peleus, however, she goes topless and wears only pants or a loose loincloth. On a red-figure cup by Oltos her exercise cap is elaborated into something a little more feminine (fig. 12).[30] The scheme of the fight remains the same throughout the Archaic period, but there is a later, puzzling scene on a fragment of an Attic vase of about 440 to 430 B.C., where she is shown in exercise cap and with a bra of rather advanced design (exposing the nipples). She is held around the waist by a young man named Hippomenes.[31] We shall meet him in another context and this should really be Peleus and is the last of the Greek scenes of the wrestling match. It had appeared on other objects than painted vases: on another of the Classical clay plaques from Melos, on a scarab intaglio, and on another gem from Cyprus, where, surprisingly, the boar's head is also shown, as it was on the Chalcidian vase, showing that it was no accident there.[32]

Atalanta's other athletic activity was running, and this brings us to the famous footrace, an event alluded to in the very first extant reference to her in Greek literature but one which was almost wholly ignored in Greek art.

The only clear exception to this appears on an Athenian vase of the end of the fifth century B.C. (fig 13).[33] Atalanta occupies the central position, naked but for her sandals and cap, which she is adjusting, ready for the race and for her next victim. To the right there is mischief afoot and Aphrodite is talking earnestly to a young man, who must be Hippomenes (who is generally named in antiquity as the suitor), and she is taking an object, surely one of the golden apples, from Eros, who is holding two more. The plot is laid, the instruments of Atalanta's defeat devised, and she has run her last winning race.

But now, in ancient art, we have to wait for more than 500 years for further news of the footrace. On an incised glass beaker from North Italy, Hippomenes (he is named) is shown in a commanding lead and looking back at Atalanta, who has her sword drawn.[34] On another glass bowl, probably made in Egypt at about the same date (second century A.D.) but found in France, the situation is the same, again with the drawn sword but now also with what are perhaps meant to be the apples in the field (fig. 14). A difference here is that the winner is called Hippomedon, not Hippomenes. So he is once called in literature,[35] and on relief roundels on a Gallo-Roman jug in New York, where he poses with his winner's palm beside Atalanta, after the race. She holds an apple and beside them are her father, Schoeneus, and a personification of the exercise ground, Palaestra.[36]

All this shows remarkably little interest in the one episode in Atalanta's career which we remember most readily. Possibly the male of antiquity was not overanxious to be reminded of a heroine who could beat all men at their own sport, and could eventually be defeated only by cheating. All may be fair in love, but the more thoughtful women of Classical antiquity might have taken a more jaundiced view of the episode and have been in no position to express it as

Figure 10. *Peleus Wrestling with Atalanta,* hydria, South Italian (Chalcidian colony), c. 540 B.C. Black figure, clay. Munich, Antikensammlungen, no. 596.

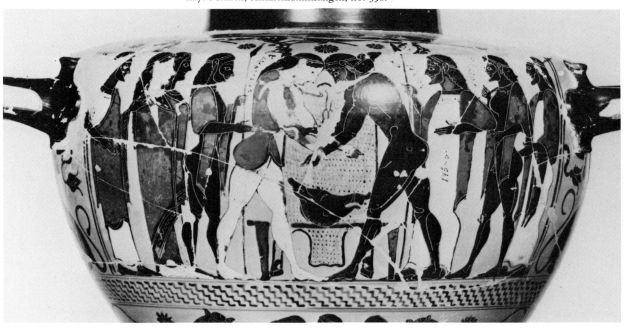

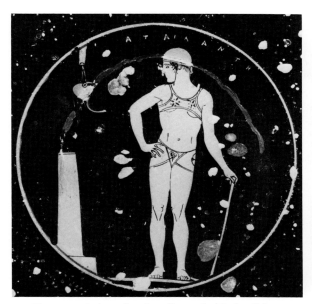

Figure 11. *Atalanta,* interior of a cup by Euaion Painter, Greek (Athens), c. 450/440 B.C. Red figure, clay. Paris, Musée du Louvre, no. CA 2259.

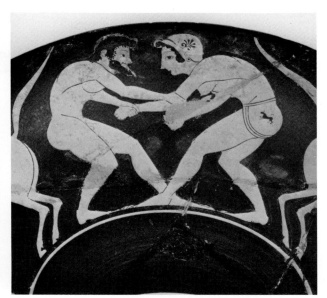

Figure 12. *Peleus Wrestling with Atalanta,* detail of a cup by Oltos, Greek (Athens), c. 510 B.C. Red figure, clay. Bologna, Museo Civico Archeologico, no. 361.

13

Figure 13. *Preparation for the Footrace Between Atalanta and Hippomenes*(?), detail from a calyx crater by Dinos Painter, Greek (Athens), c. 420 B.C. Red figure, clay. Bologna, Museo Civico Archeologico, no. 300.

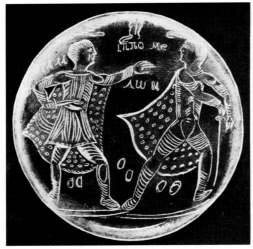

Figure 14. *Footrace Between Atalanta and Hippomenes*, bowl, Roman (Egypt?), second century. Glass. Reims, Musée Archéologique, no. 2281. (From *Catalogue du Musée Archéologique, ville de Reims*, Troyes, 1901, pl. 2.)

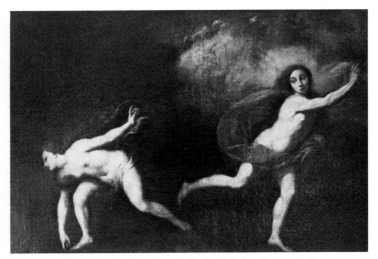

Figure 15. Attributed to Guido Reni, Italian (1575–1647). *Footrace Between Atalanta and Hippomenes*. Oil on canvas. Odessa, Museum.

14

freely as their modern counterparts. (I am told of an adaptation of the story for the modern child in which the result of the race is a dead heat and the two part, just good friends.) Not that all men always mind being beaten by women:

> Love-thirty, love-forty, oh! weakness of joy,
> The speed of a swallow, the grace of a boy,
> With carefullest carelessness, gaily you won,
> I am weak from your loveliness, Joan Hunter Dunn.
>
> Miss Joan Hunter Dunn, Miss Joan Hunter Dunn,
> How mad I am, sad I am, glad that you won.
> The warm-handled racket is back in its press,
> But my shock-headed victor, she loves me no less.[37]

Since antiquity, in the Renaissance, and later, the story of Atalanta or certain episodes of it were not forgotten. In general the choice follows the popularity of the scenes observed on the Roman sarcophagi, a common source for Classical motifs. But there was strong influence from literary sources, too, with the result that the race, which antiquity almost ignored, became of prime importance to later artists, both painters and poets. Of the other episodes it is the hunt itself, Meleager delivering the head of the boar, and the death of Meleager which are favored.

From the world of art I cite only a very few examples. When Rubens painted the hunt,[38] it seems clear that he was rather more interested in the setting than in the tiny figures of Atalanta and Meleager who are in the foreground, with their dogs, hunting the boar. The Italian *cassoni*, the wooden chests made to house the linen and clothes of a bride, favor the subject for the symbolic association, presumably, and the message of love won and lost. They also add something to the story, and we find Atalanta with an entourage of hunting maidens like those who accompanied Artemis/Diana in antiquity. Once a blind Cupid riding a boar accompanies such a band of hunting women.[39] And the race is shown, normally with the victor reaching the goal, sometimes the palace door, just in front of Atalanta, who is bending aside to pick up the last of the apples.[40] The scheme is little altered with time. At its simplest it appears in Guido Reni's versions (see fig. 15), and the strangest, perhaps, is by Richard Dadd,[41] who murdered his father and spent most of his life locked up in Bedlam and Broadmoor, where he produced many visionary masterpieces before his death in 1887.

In literature the race is dominant, and I cite but three examples, from English literature, to add to Swinburne's play, quoted at the beginning of this paper, which deals with the whole story of the hunt, to Meleager's death, but not with the race at all.

John Donne deliberately changed the significance of the image of the apples (he calls them balls) and their purpose.[42] He calls them Atalanta's and implies that she used them to distract men's attention from herself to her possessions, just as women do in the wearing of jewelry:

> Gems which you women use
> Are like Atalanta's balls, cast in men's view,
> That when a fool's eye lighteth on a Gem,
> His earthly soul may covet theirs, not them.

Later than Swinburne, William Morris devoted a long poem[43] of extremely slight merit to the race. Atalanta at the start, beside a victim:

> A maid stood by him like Diana clad
> When in the woods she lists her bow to bend,

> Too fair for one to look on and be glad,
> Who scarcely yet has thirty summers had,
> If he must still behold her from afar;
> Too fair to let the world live free from war.

Milanion, commonly named as the victor in literature, beats her in this version. She has picked up the third apple and is ready for the home stretch but is overcome with dizziness and stops during the sprint:

> She spread her arms abroad some stay to find
> Else must she fall, indeed, and findeth this,
> A strong man's arms about her body twined.
> Nor may she shudder now to feel his kiss,
> So wrapped she is in new unbroken bliss:
> Made happy that the foe the prize hath won,
> She weeps glad tears for all her glory done.

If there are any deeper messages of love rejected and love found in these versions they are neither particularly subtle nor moving and the narrative is uppermost. I suspect, however, that Thomas Hardy used the story with deliberation and sympathy, albeit as an aside, in the closing scenes of his *Tess of the D'Urbervilles*. Tess had been seduced; later married another man but was rejected by him on her wedding night when he discovered her secret (that she had killed her seducer), and was then reconciled with her husband, so that they came to their belated marriage bed overshadowed by the gallows that awaited her. On the bed, Hardy, who chose his classical allusions well, put along the head "carved running figures, apparently Atalanta's race," thinking perhaps of the girl who killed, who found her lover again but was herself doomed, on her wedding night, to suffer with her man that transformation into lions which was Zeus's penalty for the desecration of his sanctuary.

This brings us back to Atalanta and her love life. She had rejected the arts and appeal of Aphrodite in favor of the chase. In some versions her companion in the hunt is Milanion (also named in later literature as her victor in the footrace), who was also alleged to be indifferent to love, a misogynist, but was eventually won over. With Meleager the relationship and shared hunting interests seem to have developed more naturally. And her relationship to Hippomenes/ Milanion, who defeated her in the footrace, is not recorded.

If we look to ancient artists for a record of this aspect of her life in their works the evidence is not always clear, at least in Greece. Her near-nakedness as an athlete could with little difficulty be translated to erotic imagery. On an Athenian vase Peleus watches her, naked, washing her hair, and the setting is one of the boudoir rather than the exercise ground.[44] In Roman art she occasionally appears naked, or nearly so. This is the case in the House of the Centaur painting from Pompeii, but there is another on which she is also shown wearing her sunhat and holding a spear but with her dress deliberately arranged in a totally revealing manner.[45] Even on a sarcophagus, with her hunter companions, she may be shown sharing their heroic nudity and the connotation seems somehow less than heroic.[46]

Although the purely erotic aspects of her story were not ignored by the Greeks—witness the painting by Parrhasios in Tiberius's bedroom—it is in Etruscan art that it is made most explicit. On a fine scarab of about 500 B.C.[47] she is shown completely naked, like a male athlete, and with the usual athletic gear of sponge, oil bottle, and scraper, but this might be

Figure 18. *Adonis, Aphrodite, Athrpa (Atropos), Meleager, and Atalanta,* mirror, Etruscan, c. 320 B.C. Bronze; diam. 20.5 cm. East Berlin, Staatliche Museen, no. Fr. 146. (From E. Gerhard, *Etruskische Spiegel,* Berlin, 1897, pl. 176.)

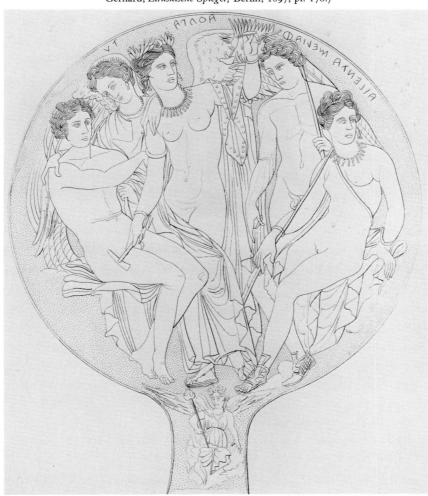

Figure 16. *Judgment of Paris with Atalanta, Helen, and Alsir,* detail of box, Etruscan, fourth/third century B.C. Bronze. East Berlin, Staatliche Museen, no. 3467. (From *Monumenti dell'Instituto* 6 [1861], pl. 55.)

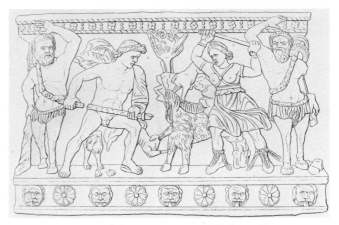

Figure 17. *Calydonian Boar Hunt,* relief urn, Etruscan (Volterra), second century B.C. Alabaster; *l.* 75 cm. Florence, Museo Nazionale, no. 78474. (From H. Brunn and G. Körte, *I rilievi delle urne etruschi* 2, Rome/Berlin, 1890, pl. 59.7.)

17

simply athletic nudity. We are told of an early wall painting in Etruria where she was shown naked beside Helen,[48] and on a third-century B.C. Etruscan bronze box (*cista*) she takes part in an unusual Judgment of Paris (fig. 16), since instead of the three goddesses we have, naked, Atalanta, Helen, and a woman called Alsir.[49] Even in action against the boar she may be shown somewhat lightly dressed, and one or both breasts are bared on an Etruscan mirror and on third- to second-century B.C. relief urns from Volterra (fig. 17).[50] When we see bare-breasted huntresses later, usually bronze figurines, we are perhaps entitled to look for an Atalanta rather than Artemis/Diana.

On both vases and mirrors in Etruria she is shown in the company of Meleager and other hunters, and she is naked, even sometimes still incongruously wearing her hunting boots, holding the hunting spears and with the boar-head trophy prominent.[51] On the finest of the mirrors[52] the erotic is skillfully combined with the poignant, for she is shown beside Meleager with, opposite them, Aphrodite and Adonis (fig. 18). Both youths were hunters; both died prematurely and tragically. At the center of the group the winged figure nailing up the boar-head trophy is Athrpa, the Fate Atropos. It is a sad tale, and the mirror quietly reflects the tragedy. Brave Meleager dies through the favor he showed Atalanta, who had herself once renounced love. From the earliest references in literature her attitude was noted, and it colors both the main stories in which she was involved, that with Meleager, and the conditions of the footrace. It is not, however, one which the artists of antiquity seemed to have wished to stress; or, at least, so it had seemed before the Cleveland vase was known. For here we have the bride Atalanta rejecting, but hopelessly, the wreath of wedlock, running, it might be, from the bridal finery for her better-loved dress for hunt or race. But Eros has wings and Eros has a whip, and where Aphrodite dictates none escape, even though, as it was to prove for Atalanta and her lovers, the escape was ultimately to their deaths.

1. See J. Boardman, "Atalante," in *Lexicon Iconographicum Mythologiae Classicae*, II, Zurich (forthcoming), no. 84. See also C. Boulter, *Corpus Vasorum Antiquorum Cleveland* I, Cleveland Museum of Art, 1971, pls. 32–34, 35.1; and J. D. Beazley, *Paralipomena*, Oxford, 1971: 376, no. 266 bis.

2. Athens, National Museum, no. 15375. See A. Greifenhagen, *Griechische Eroten*, Berlin, 1957: 59; Beazley, *Attic Red-Figure Vase Painters*, Oxford, 1963: 447, no. 274.

3. Charlecote Park (near Stratford-on-Avon), England. See Beazley (note 2): 648, no. 32.

4. See especially Apollodorus, *Bibliotheca*, 3.9.2 (Loeb edition).

5. For representations, see G. Daltrop, *Die kalydonische Jagd in der Antike*, Hamburg/Berlin, 1966.

6. See Boardman, *Athenian Black Figure Vases*, London, 1974, fig. 46.3; E. Simon and M. and A. Hirmer, *Die griechischen Vasen*, Munich, 1976, pl. 55 top; and Boardman (note 1), no. 2.

7. For examples, see Boardman (note 1), nos. 1–8. See also D. von Bothmer, "An Attic Black-figured Dinos," *Bulletin of the Museum of Fine Arts, Boston* 46 (1948): 42–48; and R. Blatter, "Dinos Fragmente mit der kalydonischen Eberjagd," *Antike Kunst* 5 (1962), pl. 16.1–3.

8. Copenhagen, National Museum, no. 13567. See K. Friis Johansen, "Eine neve Caeretaner Hydria," *Opuscula Romana* 4 (1962): 61–81, figs. 2–3, pl. 2; and Boardman (note 1), no. 12.

9. See Boardman (note 1), no. 15.

10. See Daltrop (note 5), pl. 21; and Boardman (note 1), no. 9.

11. Vienna, Kunsthistorisches Museum. See F. S. Kleiner, "The Kalydonian Hunt: A Reconstruction of a Painting from the Circle of Polygnotos," *Antike Kunst* 15 (1972), pl. 3.1; and Boardman (note 1), no. 17.

12. Tegea Museum, no. 2297. See A. F. Stewart, *Skopas of Paros*, Park Ridge, N.J., 1977: 16, no. 8, 61–62.

13. For these, see G. Koch, *Meleager (Die antiken Sarkophagreliefs* XII.6), Berlin, 1975.

14. See A. D. Trendall and T. B. L. Webster, *Illustrations of Greek Drama*, London, 1971, III, 3, 39.

15. See Beazley (note 2): 1408ff., nos. 1, 14, 39–40; and Boardman (note 1), nos. 37–38.

16. Suetonius, *Tiberius*, 44.2.

17. See Daltrop (note 5), pl. 26; and Boardman (note 1), no. 31.

18. See R. Herbig, "Jägerliebe," *Römische Mitteilungen* 66 (1959): 209–11, pl. 58.1; and Boardman (note 1), nos. 41–42.

19. See E. Simon, *Meleager und Atalante*, Riggisberg, 1970, pl. 9; and Boardman (note 1), no. 48.

20. British Museum. See Simon (note 19): 21–24, figs. 5–6; and Boardman (note 1), no. 46.

21. Hermitage Museum, no. ωι. See *Wealth of the Roman World*, ed. by J. P. C. Kent and K. S. Painter, London, British Museum, 1977, no. 160; and Boardman (note 1), no. 50.

22. Naples, Museo Archeologico Nazionale, Stg. 11. See Trendall/Webster (note 14), III, 3, 40.

23. Milan, Museo Civico, St. 6873. See Trendall/Webster (note 14), III, 4, 1; and Boardman (note 1), no. 85.

24. For example, see Koch (note 13), pl. 116a; and Boardman (note 1), no. 52.

25. For example, see Koch (note 13), pls. 101a, 103a, 105b; and Boardman (note 1), nos. 54–55.

26. Hesiod, frs. 72–77, Merkelbach-West, 1970.

27. See note 4 and Tzetzes, *Chiliades*, 12.937.

28. See *Corpus Vasorum Antiquorum München*, Munich, 1968, 6 pls., 280.1, 281.1; Daltrop (note 5), pl. 12; Simon/Hirmer (note 6), pl. 39; and Boardman (note 1), no. 69.

29. See Beazley (note 2): 797, no. 137; and Boardman (note 1), no. 56.

30. See Beazley (note 2): 65, no. 113; Boardman, *Athenian Red Figure Vases*, London, 1975, fig. 62; and idem (note 1), nos. 58–68.

31. Ferrara, Museo Nazionale di Spina, no. T. 404. See Beazley, "Some Inscriptions on Vases," *American Journal of Archaeology* 64 (1960): 221–25, pls. 53.1,3 and 54; Beazley (note 2): 1039, no. 9, Peleus Painter; and Boardman (note 1), no. 68.

32. See P. Jacobsthal, *Die melischen Reliefs,* Berlin, 1931, no. 80, pl. 41; and Boardman (note 1), no. 71. Also, in New York, Metropolitan Museum of Art, Cesnola 4152; see F. Lenormant, in *Gazette Archéologique* 6 (1880): 84; and Boardman (note 1), no. 70.

33. See Beazley (note 2): 1152, no. 7, Dinos Painter; *Corpus Vasorum Antiquorum Bologna* 4, Rome, 1957, pls. 86–87; and Boardman (note 1), no. 75.

34. Corning (N.Y.) Museum of Glass, no. 66.1.238. See A. Minto, "La corsa di Atalante e Hippomenes figurata in alcuni oggetti antichi," *Ausonia* 9 (1919): 82–85, figs. 1–2; and Boardman (note 1), no. 78.

35. Scholiast to Apollonius Rhodius I, 769.

36. See Minto (note 34), figs. 3–4; and Boardman (note 1), nos. 76–77.

37. John Betjeman, "A Subaltern's Love-song," 1945.

38. Madrid, Museo del Prado, no. 1662.

39. C. 1480, Vienna, Weinberger Collection.

40. See P. Schubring, *Cassoni: Truhen und Truhenbilder der italienischen Frührenaissance,* Leipzig, 1915, pls. 126 (572: the race), 141 (658: the race), 142 (660: with Cupid; 659: the hunt), 143 (661: with women attendants).

41. London, Sotheby's, sale, Nov. 17, 1976.

42. Elegie XIX.

43. "Atalanta's Race," in Collins's *Book of Narrative Verse,* Oxford, 1930.

44. Paris, Bibliothèque Nationale, no. 818. See Beazley (note 2): 1512, no. 23, Jena Painter; F. A. Beck, *Album of Greek Education,* Sydney, 1975, fig. 408; and Boardman (note 1), no. 81.

45. House of the Danzatrici; the painting is now destroyed. See K. Schefold, *Vergessenes Pompeji,* Bern, 1962, pl. 169.3; and Boardman (note 1), no. 33.

46. See Koch (note 13), pl. 133b; and Boardman (note 1), no. 83.

47. Lost. See Boardman, *Archaic Greek Gems,* London, 1968, no. 339, pl. 24; and idem (note 1), no. 57.

48. Pliny, *Natural History,* 35.17.

49. See L. B. Ghali-Kahil, *Les Enlèvements et le retour d'Hélène,* Paris, 1955, pl. 96.2; and Boardman (note 1), no. 86.

50. See H. Brunn and G. Körte, *I rilievi delle urne etruschi* 2, Rome/Berlin, 1890, pls. 57–61; E. Gerhard, *Etruskische Spiegel* 5, Berlin, 1897, pl. 94; and Boardman (note 1), nos. 19–20.

51. See Gerhard (note 50), pls. 174–75; and Boardman (note 1), nos. 29–30B.

52. See Beazley, "The World of the Etruscan Mirror," *Journal of Hellenic Studies* 69 (1949): 12–13, fig. 15; and Boardman (note 1), no. 28.

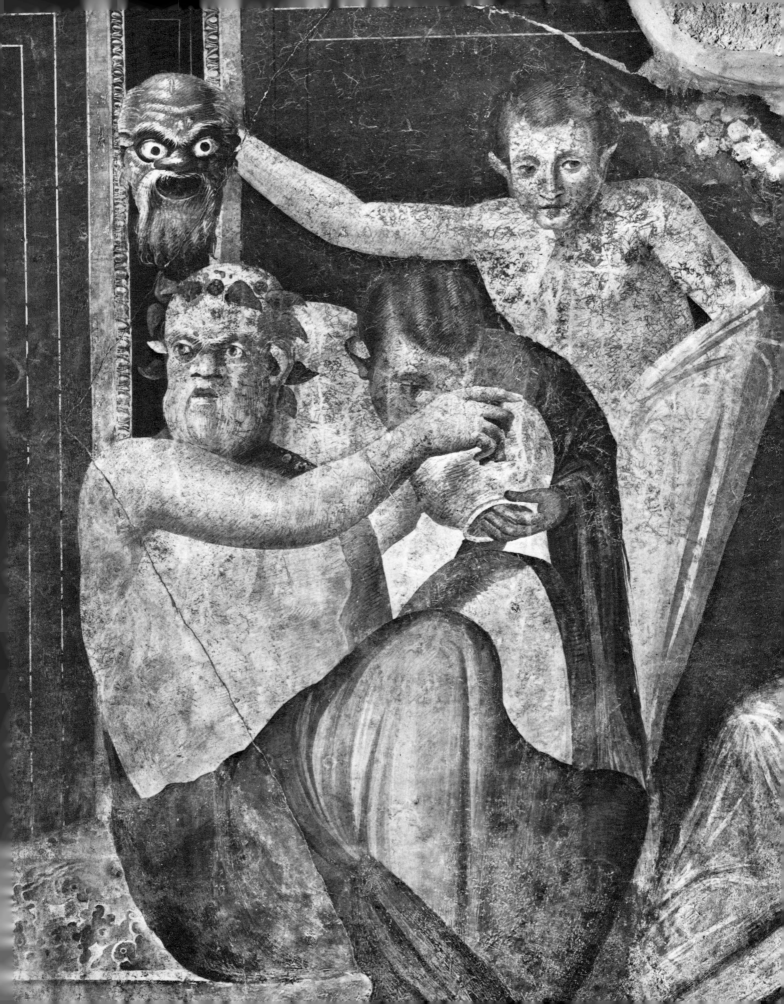

Karl Schefold

Roman Visions and Greek Inventions at the Foot of Mount Vesuvius

Mount Vesuvius brought terrible destruction but also miraculous revival. Thus, it can be viewed as a symbol both of life's splendor and of life's decline. The opulence of Roman wall decoration (figs. 1–2) recalls the prolific gardens surrounding Mount Vesuvius. The descriptions of villas by Pliny the Younger and Statius indicate the importance accorded to paintings of views of the surrounding landscape in the design of these villas.[1] Although all of the elements of this decoration originated in Greek art, the synthesis was created in Rome and in the Campanian villas of the Roman aristocracy.

The Romans' feeling for landscape was different from that of the Greeks. Every Greek creation, be it the organic form of a vase or a landscape painting, reflects the Greeks' profound familiarity with nature. A peasant people, the Romans also were bound to nature. Nevertheless, they saw all values as ideals that were in contrast to reality. Greek artists created symbols of reality; the Romans used these symbols to express their ideals. The unremitting shift from the real to the ideal is one of the decisive traits of Roman art and led to its final stage, that of the early Christian style and iconology.[2]

Because Classical art was an ideal of the Romans, they borrowed Greek conventions, including landscape motifs. The transformation of these into new visions and syntheses was a great accomplishment on the part of the Romans.

The fundamental difference between Greek and Roman comprehension of landscape is still undervalued in research. Thus, an account by Pliny the Elder is often quoted uncritically because it mentions that a painter of the time of Augustus, a certain Spurius Tadius,

first introduced the most attractive fashion of painting walls with pictures of country houses and porticoes and landscape gardens, groves, woods, hills, fish ponds, canals, rivers, coasts, and whatever anybody could desire, together with various sketches of people going for a stroll or sailing a boat or on land going to country houses, riding on asses or in carriages, and also people fishing and fowling or hunting . . . and a number of humorous drawings besides, extremely wittily designed.[3]

In fact, it is possible to trace all of these elements to Hellenistic illuminated scrolls,[4] which resemble Far Eastern ones. Indeed, in the way space is subordinated to the three-dimensional

forms, such as the fountain, cave, and canopy in the *Landscape with Grotto* from the villa at Boscoreale (fig. 2),[5] Roman landscape differs from late European painting and is closer to Byzantine and Far Eastern examples. While Pliny considered it novel that these motifs began to be painted on walls, he did not contend that they were invented at that time. The landscapes in Hellenistic scrolls lack precisely what Drerup identified as the new characteristic of the Roman villa: a sentimental feeling for landscape that connected the villa with the surrounding scenery.[6]

Hellenistic landscapes influenced not only Roman painting but Roman architecture as well. Pliny the Younger mentioned a villa that was as beautiful as a painted one, meaning the buildings in Hellenistic landscape paintings.[7] In Tivoli, temples built above rocky slopes, grottos, and waterfalls (fig. 5) illustrate magnificently how painted prototypes were transposed into the Roman landscape. The elements of the Boscoreale landscape (fig. 2) are copies of such a prototype. They include a sacred canopy above a grotto and a spring. The ramifications of this concept were felt in European art up to eighteenth-century English gardens.[8] And, until recently, in Leukerbad, a spa in the Swiss Valais, a Neo-Gothic chapel stood in place of a Hellenistic sacred building, above waterfalls and a grotto.

The relationship of the Roman villa and landscape is the first of several Roman concepts examined in this article. Closely connected to it is a second concept: the interpretation of the house-garden as a sacred grove with altars and votive offerings to the gods.[9] In Greece, an arid country, the houses had courtyards which also contained altars, but Greek gardens were located outside the city and sacred groves surrounded the temples.

In contrast, within the decoration of the Roman house, manipulation of the motif of the sacred grove was a central concern. From room to room, the bases of the walls were adorned with plants, connecting the interior spaces with the garden. As early as in the Villa of the Mysteries near Pompeii[10] and at Boscoreale, mural decorations incorporated trompe l'oeil views into sacred precincts. Usually such views suggest that one is looking into the actual gardens behind the walls on which the scenes are painted.[11] The emphasis on the grove is one of the factors that led to the creation of the so-called Second Style of Roman decoration and helps to explain how the style was invented.[12]

Even more important in this connection is a third Roman concept: the upper-class citizen imitating the lifestyle of the Hellenistic prince. The eastern Greek megaron house previously had been claimed as an aristocratic form. Subsequently, it was developed in a most stately manner as a palace form in Ai Kanum in Bactria and in Vuni on Cyprus.[13] Furthermore, in Eretria, Greek aristocrats had built palacelike houses around 400 B.C. One of them featured a palestra as a court containing a palestra god whose faintly individualized traits probably portrayed the master of the house. In the court of another house, fragments of a copy of the Hermes by Praxiteles were found.[14]

Some of the walls of these private palaces were adorned with stucco imitations of patterns of ashlar; and some of the floors were covered with mosaics, following the examples of temples and palaces of the rulers. They were furnished with valuable materials, precious stones, and metals. Frescoes such as those from Boscoreale (figs. 1–4) imitate and therefore illustrate beautifully such details of this early Hellenistic architecture.[15]

The new element in Roman art was the extent to which the royal luxury of furnishing was applied to the private home.[16] The traditional Roman love of pomp and splendor (an expression of a transcendental intensification of life) was transferred to the private house.

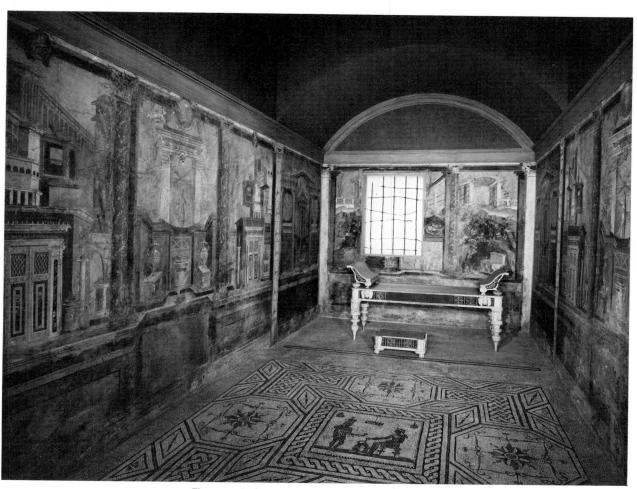

Figure 1. Bedroom (cubiculum) of villa at Boscoreale (with frescoes, other furnishings, and mosaic floor), Roman, first century B.C. New York, The Metropolitan Museum of Art, Rogers Fund, 1903.

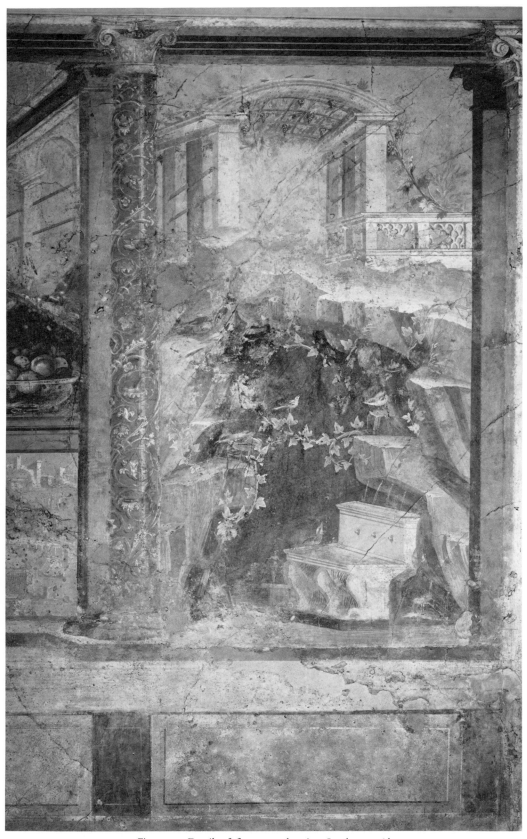

Figure 2. Detail of figure 1, showing *Landscape with Grotto.*

In the First Style of Roman mural decoration, Greek architectural embellishment underwent subtle changes. First, the court became a sacred grove. In addition, the layout became axial, directed toward a focal point. Combined with the Italic form of atrium, alae, and tablinium, an atmosphere of space was evoked that had been avoided in Greek architecture.[17] Further, the structure of the wall was enriched by the insertion of a socle beneath the orthostates, which seems to elevate the wall to a higher sphere. Thus, the Roman did not merely imitate the prince, as in Greece; in playing with the elements of a palace, he behaved like a prince.

Paintings around the garden sometimes represent Oriental animals, because to possess a zoological garden, a "paradeisos," befitted the Hellenistic prince and, therefore, a prominent Roman citizen. Furthermore, portraits of Hellenistic princes were incorporated into the decoration (fig. 3). This royal symbolism corresponds to the imagery best known from Republican coins, where the symbols actually helped pave the way for the monarchy.[18] However, in our context, it is of greater importance that house and garden seemed to form a "little Greece" in Italian surroundings. This imitation of Greek life explains the luxurious style of living the Romans developed in the Vesuvian cities.

We call "Roman" the period after the victory over Macedonia, 168 B.C., when Rome became the predominant power in the eastern Mediterranean and the capital of the civilized world in place of Athens, Alexandria, and Antioch. Prior to these great victories, art in Italy followed Hellenistic models. But, after 168 B.C., one can no longer call the Roman world simply Hellenistic. Pompeii had been Hellenized long before. Its civilization is an important source for understanding the foundation of Roman art, as its monuments are so much better preserved than those in Rome itself.[19]

While Hellenistic historians of art transmitted detailed accounts concerning Greek artists, information about artists and artisans of the Roman period has been acquired accidentally and is almost incoherent. It is also significant that there are no portraits of Roman literary personalities during the first centuries before and after Christ. This can be explained by the fact that this classicistic civilization was so interested in Greek originals that contemporary work was considered mere imitation; what we admire as Roman, the Romans themselves appreciated more for symbolic meaning than for artistic quality.[20]

A fourth Roman concept that can be observed particularly well in Pompeii is a formal vision in which space and axial perspective were directed toward a central, vertical focal point. This principle has already been noted with regard to the house; its increasing importance in Pompeii during the second century B.C. for the layout of the forum and the basilica[21] indicates that prototypes must have existed in Rome. Indeed, such ground plans are to be found in the famous marble city plan of Rome.[22] During the transformation of the Roman forum after 310 B.C., a system that was symmetrical to the axis was purposefully applied in order to heighten the political effect.[23]

In the Greek sanctuary, the temple stood free, like a statue in a grove, visible from all sides; the divinity dwelt among the people. In contrast, the Roman temple confronted the onlooker with its façade. Raised onto a platform, accessible by steps in front, it represented a sublime world. Previously, the Etruscans had developed platforms and accentuated façades, but only after Rome's victory over Macedonia were these Etruscan traditions combined with the Greek practice in which squares were surrounded by porticoes. The new spiritual aim was realized most magnificently in the sanctuary of Praeneste[24] and in the creation of the amphitheater and

basilica.[25] In these forms, the interior space became a symbol of transcendence because it expressed a sense of timeless, solemn peace. In Greek architecture, space was experienced only as the area between sculptured forms. During the Classical period this effect was heightened, and during the Hellenistic period new tensions arose between such gigantic sculpture as the groups of the Gauls and the Nike of Samothrace and the surrounding space. Nonetheless, space never received the independent, superior treatment it did in the Roman period.

Technical innovations, such as mortar masonry and construction of vaults, served the Roman concepts described above. Whereas many of the new types of Roman architecture—the aqueducts, arched bridges, thermae, and multistoried tenement houses—are better preserved in Latium than in Campania, mural decoration is best represented at the foot of Vesuvius. Here colorful buildings with marble paneling, stucco, and painting, and new systems of decoration were created from Greek elements. For this reason, we turn to Campania to learn the meaning and form of Roman art up to the eruption of Vesuvius.

Among the Roman visions to be observed at the foot of Vesuvius, the creation of the Second Style of mural decoration had the most important consequences (figs. 1–4, 6–7). It is a synthesis of all the tendencies examined above—the bonds the Romans felt with nature and its sacred groves and the use of royal imagery to create a princely life. The ashlar composition of the walls was no longer imitated in stucco, as in the First Style, but was painted in perspective instead. This created an effect in which the low base around the room appeared to protrude and the wall above seemed to retreat. Consequently, the illusion of living in a palace found artistic expression for the first time.

In important Classical and Hellenistic buildings, such as the late fourth-century B.C. tomb in Leucadia,[26] the walls were not decorated with imitations of ashlar masonry. Instead, they were divided by pilasters, including ones painted in perspective. This created spaces above the bases and between the pilasters. But such Greek decorations were not forerunners of the Second Style, as is often said, because space there was not represented illusionistically, as it was in the Second Style, where the upper wall was opened up with painted landscape vistas. The illusionistic expansion of space through the combination of pilaster and ashlar decoration was an ingenious invention of the time of Sulla, about 100 B.C. The colorful splendor of Roman mural decoration, enhanced by the plant forms painted on its bases, was part of the Romans' response to their belief in divine nature. The Greek First Style, with its stucco imitations of ashlar walls, never manifested this bond. Despite Macedonia's fertility, the interiors of Macedonian tombs seem urban in character. Thus, the concepts of nature described here are sufficient in themselves to explain the creation of the Second Style; it is not necessary to trace them, as many have (see below), to a stimulus derived from Hellenistic stage-painting. According to a remark by Pliny, the inventor of a Second Style of decoration in Rome was an otherwise unknown artist by the name of Serapion.[27] The ingenuity of Serapion's innovation cannot be overestimated. In fact, it reached its fullest expression in the richly pictorial mural decorations of European artists working in the sixteenth to the eighteenth centuries.[28] But the Roman prototypes preserve the sculptural character of the Greek elements much more than do the Baroque decorations.

A further Roman concept, that of Classical education, was also crucial to the development of the Second Style.[29] The notion that education overcomes mortality was long established in antiquity. Only later, with Christianity, was the concept of immortality focused on the after-

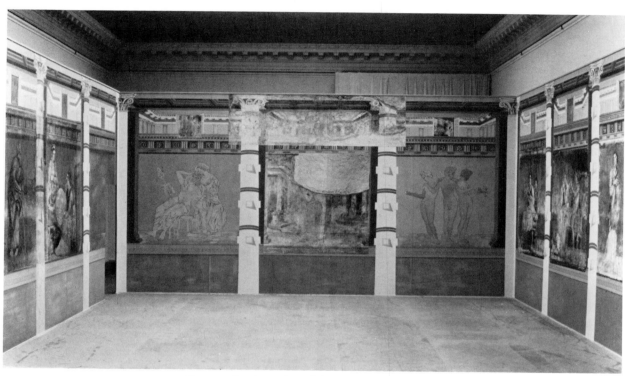

Figure 3. Reconstruction of dining room (triclinium) of
villa at Boscoreale with fragments in the Metropolitan
Museum of Art, New York, and the Museo Nazionale
Archeologico, Naples), Roman, first century B.C. Fresco
showing, left side: philosopher Menedemaos, Antigonos
Gonatas, and his mother, Phila; right side: cither player,
Demetrios Poliorketes, and other princes; back left: Di-
onysus and Ariadne; middle: Isis as Aphrodite in an
Egyptianizing landscape; right: the Three Graces. (From
B. Andreae and H. Kryieleis, *Neue Forschungen in Pompeji,*
Recklinghausen, 1975, fig. 59.)

life. To the Classical Greek, it was natural to hope to survive gloriously in the memory of one's descendants. This outlook is reflected in Roman decoration. Just as the Roman played with the notion of princeliness, he also played with godlike immortality; even so, he was very skeptical about the afterlife. He collected copies of Greek works of art as symbols of his education, which, it was believed, led to immortality. Sharing the same intention, Roman art and poetry created new works out of Classical prototypes.

Reinforcing this Roman vision of Classical education were certain innovations in villa decoration. To begin with, instead of common contemporary motifs, the floor was decorated with copies of famous Greek originals, such as the ones magnificently preserved in the House of the Faun: Examples include the well-known mosaic with the *Battle of Alexander* and the less-understood one with a marine landscape (Naples, Museo Nazionale Archeologico).[30] In the latter, the careful observation of sea animals and their distribution over the surface without any illusion of space is Greek. Copies of this sort still provide the best idea of Greek painting that we possess. During the period of the First Style, little friezes, copied from treasured Greek picture books, began to be inserted into mural decoration. Those from the Homeric House (figs. 8–9) are especially well preserved.[31] Both innovations—copies of mosaics and picture friezes—were also present in Delos. Inhabited by Italic people, Delos is our main source, besides Campania, for early Roman art.

The illusionistic opening up of the wall in the Second Style created new possibilities for the use of Greek prototypes. This permitted figurative motifs to be painted on the walls instead of being copied in the expensive technique of mosaic flooring. This illusionistic mural decoration followed Greek iconography and typology but not the Greek manner of decoration. Greek monumental mural friezes had been painted on wooden panels, many of which were brought to Italy by the Romans; but Greek friezes were not copied literally, because the rather sculptural style of the admired Greek prototypes did not correspond to the Roman sense of space. In the Villa Item, a classicistic frieze, painted about 100 B.C., was copied from its prototype in such a way[32] that the figures seem to be moving on the perspective base and in front of the orthostates. The incongruity of the sculpturesque figures moving in the illusionistic space gives the fresco a charm all its own.

The Hellenistic figures in the *Frieze of the Princes* from the villa at Boscoreale seem better integrated with the painted columns and pillars, which create a magnificent illusion of a canopy (fig. 3).[33] Here the sculptural character of the prototypes received a new spatial interpretation. These copies relate to their lost originals much in the same way as contemporary sculptural groups from Sperlonga relate to the Hellenistic figures of the Gauls.[34]

With the appropriation of elements of Greek painting, the Second Style flourished. Vitruvius's polemics against the late Second Style, together with his accounts of Hellenistic stage scenery, have led some scholars to the conclusion that complete walls of the Second Style depict stage scenery.[35] While the principle of Greek stage sets was of great importance to the development of the Second Style,[36] only certain aspects of this type of decoration were copied exactly: for example, the grotto landscape on the rear wall of the bedroom of the villa at Boscoreale, as well as the room's city views (figs. 1–2).

To relate the landscape and architectural scenes of the Second Style to contemporary sources is a mistake, because a main tenet of classicistic Roman art was that Greek elements, not contemporary ones, be used. The similarities of Roman fine arts, architecture, and poetry

Figure 4. Detail of figure 1, showing Artemis.

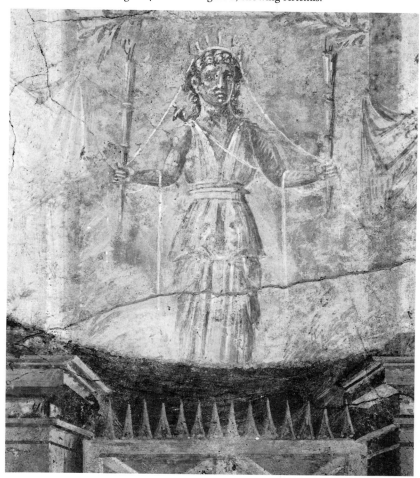

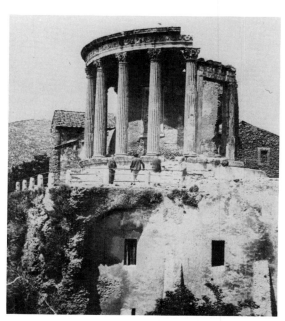

Figure 5. Round Temple at Tivoli, Roman, early first century B.C.

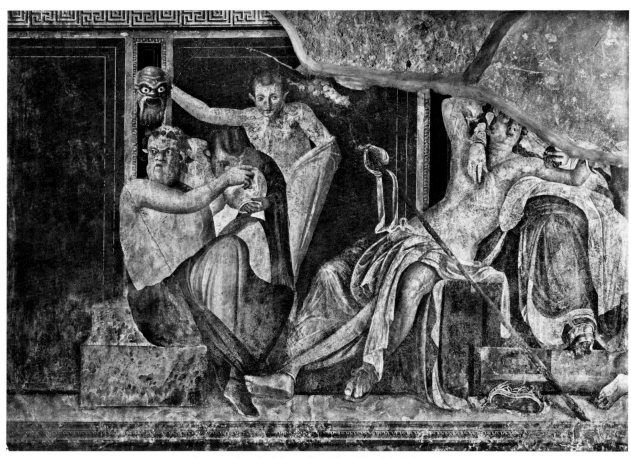

Figure 6. Detail of fresco from the Villa of the Mysteries
at Pompeii, showing followers of Dionysus and the god
himself reclining on the lap of Aphrodite, Roman, c. 60
B.C.

may be explained by analogous Roman combinations of Greek prototypes. Unfortunately, this is still not well understood, because insufficient attention has been paid to the history of style.

Since stage decorations were painted on wooden panels, they were transportable, as were the wooden panels with mural paintings. The importation of these Greek panels to Italy explains the pure Greek character of the partial copies described above. But the synthesis of these copies is purely Roman.

Like the room with the *Frieze of the Princes,* the bedroom at Boscoreale was also conceived as a canopy supported by pillars and columns (fig. 1). The fascinating contrast between the Roman spaciousness of the canopy architecture and the one-dimensionality of the Greek elements was consciously accentuated. This is especially so in the views of ancient cities, with their Attic motifs, and the Erechtheum-like differentiation of entablature.[37] The city views serve as a foil to the two symmetrical long walls on which are displayed the spacious sanctuaries of Aphrodite/Artemis/Isis (fig. 4). Similarly, the grotto landscape of the rear wall (fig. 2)—the most faithful copy of a Greek landscape we possess—contrasts with the illusionistic interior of the room. In its peaceful charm and quiet magic, it is unequaled. The juxtaposition of the landscape with the illusionistic decoration gives it, in fact, a stronger three-dimensional impact than the original could have had.

In addition to the grotto landscape and the city views, a third painted motif at Boscoreale is the sanctuary with a circular temple of Aphrodite Pelagia, another manifestation of Isis. While the surrounding colonnades are Greek in inspiration, the Roman painter removed their sculptural character. However, the motifs that might have provided Serapion with the basis for the creation of the Second Style remain: One had only to give a three-dimensional meaning to the perspective elements of this prospect and apply it to the whole room to obtain the system of the Second Style.

The use of motifs from Greek stage design also made it possible to transform the ashlar wall, which had been pushed back illusionistically in early Second Style painting, into the wall of a sacred grove, even equipped with a portal (fig. 1, middle left side). Copies of Greek masks and small painted panels showing still lifes, ritual scenes, and portraits of celebrated Greeks were placed on this wall as votive offerings. It even became possible to create a view into the sanctuary over this temenos wall. In some paintings, these prospects were replaced by mythological friezes, such as those illustrations of the *Iliad* cycle in the Homeric House (figs. 8–9), or the famous landscapes with scenes from the *Odyssey* in the Vatican Museum, Rome.[38] Not only were Greek picture books copied in little friezes, but they were rendered at the same time in monumental dimensions in the sculpture cycles of Sperlonga.[39] This was more than the result of education: The idea was to praise the Greek and Trojan origins of Rome.

It is astonishing how all these Roman visions depend on Greek prototypes; contemporary art was excluded from the home and reserved for public monuments. The state was Roman, the education Greek. This principle would change only in the time of Vespasian. Therefore, one can err in associating the architectural elements of the Second Style with contemporary Roman architecture.[40] In fact, Roman architecture was influenced in many ways by Hellenistic examples, which were transmitted through illuminated manuscripts.

The use of stage design is connected to another, even more far-reaching concept, that of the consecration of life through the mysteries (figs. 6–7). Motifs belonging to the religion of Isis were incorporated into mural designs as early as 100 B.C. in a view of the Nile in the

House of the Faun and in landscapes evoking Egypt that form part of the oldest decorations of the Villa of the Mysteries.[41] Similar iconography can be found in the bedroom at Boscoreale, where Artemis is crowned with Isis's royal snakes (fig. 4). Greek followers of Isis could worship her as Aphrodite and as Artemis (fig. 3, middle), as well. Here we find the roots of the later Alexandrine Christian concept of the Holy Trinity. During the period of illusionism, from 100 B.C. to 70 A.D., scholars avoided specific doctrines, but they utilized the symbols of education and the mysteries to express the consecration of life. Rostovtzeff clarified the significance of the Dionysiac mystery motifs in Roman decoration.[42] Subsequently, Alföldi identified, in addition to the iconography on coins that helped pave the way for the monarchy, symbols of the Isis cult. He demonstrated their role during the struggle for power in the first century B.C.[43] Sects for the worship of Isis also existed,[44] but in mural decoration, the use of mystery motifs extended far beyond the context of the faithful.[45] While Petronius, in his famous novel *Satyricon,* derided the trivial use of these motifs, his jokes indicate a deep concern for them.

From the time of Caesar and Augustus, the center of the wall became accentuated, confronting the viewer with a rigorous order.[46] Illusionistic elements were increasingly subordinated to an emphasis on surface. These tendencies reached a climax around 15 B.C. with the so-called Third Style (figs. 10–11). In this new, one-dimensional approach to decoration, illusionistic elements appear to be mysteriously irrational. The princely symbolism receded. The motifs of education and the mysteries were no longer understood as enhancements of life, as dream and consecration. Instead, they became symbols of the new religious behavior that Augustus demanded. Copies of Classical and classicistic prototypes were integrated more successfully into the Third Style than they had been in the Second Style.[47] In the Third Style, these panels became the main focus of decoration. The concept projected was that of the landlord as owner of a picture gallery.

Following Rostovtzeff and Karl Lehmann,[48] I have tried to prove that the combination of themes makes sense. Leading scholars have agreed that the cycles do have meaning.[49] However, the intrinsic value of such artistic synthesis is only rarely perceived, because scholars frequently lack the understanding to place all the elements in their religious Roman context. The Roman visions I am concerned with here express a religious searching. To understand this, we have to comprehend Roman art not in the restricted sense of a doctrine but as a reflection of the most sublime values of life.

Augustus and his poets wished to teach the Romans a new gravity. Thus, in the murals of the Third Style, such as those from the villa at Boscotrecase, heroes face evildoers (fig. 11).[50] The patterns for the murals were derived from Greek picture books, which were illustrated in continuous narration. The painters extracted significant parts and re-created them in monumental size.[51] This explains why Roman paintings depict not only the actual deed but also its consequence in the same picture. For example, in a fresco from the villa at Boscotrecase, Polyphemus's courtship of Galatea is followed by the murder of Akis, while Ulysses's ship approaches in order to punish the murderer (fig. 11). In the companion picture, the rescue of Andromeda is followed by Perseus being rewarded with Andromeda's hand. Earlier, Hellenistic poets had combined illustrations of fatal love and punished wrongdoers.[52] The new element in the Third Style, then, is the combination of motifs that are monumental in size and ethical in meaning with aspects of nature to express emotional

Figure 7. Detail of fresco from the Villa of the Mysteries,
showing ritual ceremony with three female figures and
Silenus.

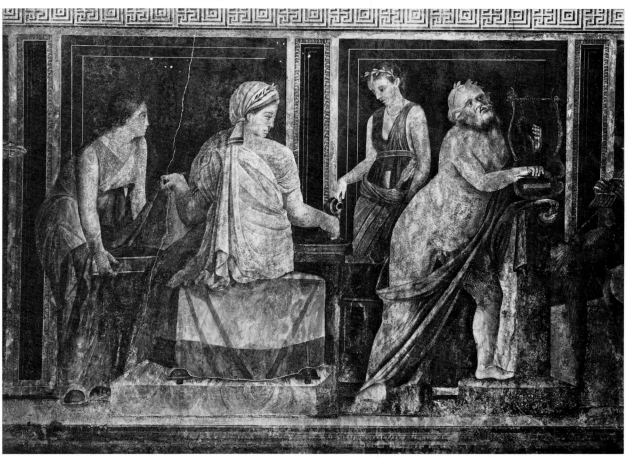

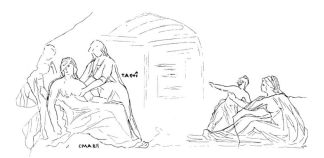

Figure 8. Scene from the *Iliad,* showing Andromache at
the Tomb of Hector, fresco in the Homeric House at
Pompeii, Roman, c. 30 B.C. (From V. Spinazzola, *Pompei alla luce degli scavi nuovi di Via Abbondanza,* Rome,
1953, fig. 955.)

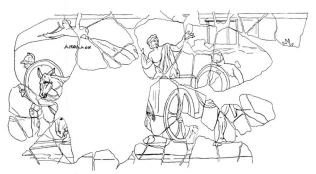

Figure 9. Scene from the *Iliad,* showing the Achaeans
punished by Apollo, fresco from the Homeric House.
(From V. Spinazzola, *Pompei alla luce degli scavi nuovi di
Via Abbondanza,* Rome, 1953, fig. 904.)

33

values. Scenes from illuminated scrolls depicting the holy land of Isis were re-created monumentally as well.[53] Such idyllic landscapes, with their irrational, floating atmosphere, were admired by the Romans as something bold and new.[54]

More popular than the moralizing iconography were symbols of fortune. The combination of heroes and lovers was developed to celebrate immortal life; pictures of a lover's death frequently allude to immortality. Examples include Pyramus and Thisbe and, more often, Adonis and Narcissus. In Ovid's *Metamorphoses* the transformation into generic beings such as plants and animals implies a sort of immortality. In the third century, Christianity transposed this sense of transcending life into the martyr's readiness to die.

The celebration of immortal life found its artistic expression in a new vision, the creation of the Fourth Style. The development of this style is related to the enthusiastic spirit reflected in Nero's Domus Transitoria and Golden House.[55] The brilliant gleam of colors and forms corresponds to the "Neronianism" described by Picard as the conception of life of great affluence.[56] In the Fourth Style the system of wall decoration of the Third Style was extended and perspective elements were once again used more logically. Consequently, a more rational illusion of space replaced the irrational one of the preceding style. However, this kind of architecture could no longer be constructed like that of the Second Style. The ecstatic splendor of the decoration actually was developed at the expense of the comprehension of architectural form. The prototypes were not contemporary buildings, as some have thought,[57] but Hellenistic ones, of which the bedroom at Boscoreale gives us such a splendid idea. Figures from Greek paintings and victorious champions were incorporated into these fantastic architectural settings in a manner that suggests the representation of heavenly Jerusalem in late antiquity.[58]

A final Roman concept that can be observed prior to the eruption of Vesuvius is the new classicism that began to develop during the reign of Vespasian.[59] Most Pompeian wall paintings belong to the period of Vespasian, because the earthquake of A.D. 62 nearly destroyed the whole town and extensive repairs had to be made. The new classicism made it possible to insert veritable copies of Greek paintings into the mural decorations. As we have seen, in the First Style, copies were incorporated only as mosaics on the floor.[60] In the Second Style, Greek prototypes had to be inserted into the illusionistic designs of the walls, thereby sacrificing the composition of the originals (fig. 3). In the Third Style, the sculptural character of the prototypes yielded to a taste for Classical one-dimensionality. The threefold arrangement of the wall was meant to reappear within the representations; the wall colors were coordinated with those of the mural decoration (figs. 10–11). The Neronic Fourth Style continued in this tradition, but with a further refinement: Compositions had to adapt to the illusion of space, with crossed axes leading into the distance.[61]

During the reign of Vespasian, copies of Greek paintings were meant to seem like originals.[62] The fact that the color and composition of the originals were no longer harmonized with the overall concept of the decoration is a result of the diminishing sensualism that may be observed from Vespasian on in all genera of Roman art. A more intellectual attitude, which we have named "transparent,"[63] replaced illusionism. It developed in the second and third centuries. During the reign of Vespasian the task of copying was handled with great exactitude. Pattern books from the earlier systems of decoration were probably still in use. However, during this period—the time of Pliny the Elder and Quintilian[64]—the principal goal was to adhere faithfully to the Classical style. Pliny strictly rejected the previous fashions. He praised

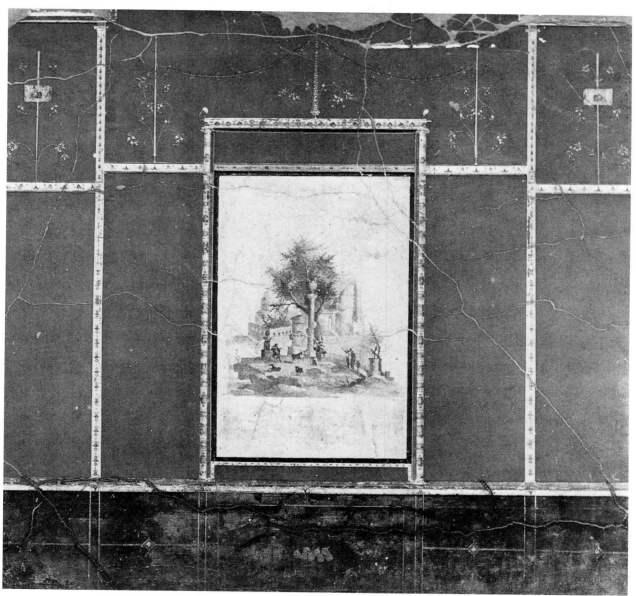

Figure 10. *Sacred Landscape,* fresco from villa at Boscotre-
case, Roman, c. 4/7 A.D. Naples, Museo Nazionale
Archeologico.

Figure 11. *Story of Polyphemus,* fresco from villa at Bos-
cotrecase, Roman, c. 4/7 A.D. New York, The Metro-
politan Museum of Art, Rogers Fund, 1920.

Classical prototypes as well as contemporary painters, to whom he credited a rebirth of art after a long decline. Moreover, his sources for the history of Greek art were evidently much better than his sources for Roman art, for which he had to rely upon a few anecdotes. Since the classicistic theory of art concentrated only on Greece, hardly any signatures of painters of the Roman period or of the excellent silversmiths have survived.[65] Only the Classical masters were held in great esteem.

We have gleaned an impressive idea of Greek sculptors from some originals and from Roman marble copies. The situation is much different regarding the masterworks of Greek painting. We read of many hundreds of famous works in Pliny's book on painting, works of which, at best, we might know the artist and subject but not the appearance. Without the discoveries made near Vesuvius, we would not know any of the principal works of Greek painting. Thanks to Pompeii, we know at least three paintings by famous Greek artists: *The Battle of Alexander,* by Philoxenos; *Medea,* by Timomachos; and *The Dismissal of Briseis,* which seems to be based upon a painting by Athenion.[66] Since we do not have any clearly documented idea of the work of Athenion's most important contemporaries, Apelles and Protogenes, we have to rely upon *The Dismissal of Briseis* as the most faithful example of painting during the time of Alexander the Great. Although the Andromeda and the Io of Nikias have been justly identified in Pompeian paintings,[67] they were copied so freely that they rather distort the notion gained of this golden age of painting from *The Dismissal of Briseis* and the masterpieces among the late Classical vases.[68] The same is true of the charming little picture based upon Apelles's *Alexander Holding a Lightning Flash,* which must have in common with the celebrated masterpiece of Apelles only its motifs.[69] Nevertheless, as Roman products, these works are most precious.

The Roman visions preserved in the Vesuvian cities complement the literary notions about the age of the Scipiones, Sulla, and Caesar. Only the combination of literary and archeological sources provides adequate knowledge of late Republican and early Imperial civilization. The task before us now is to apply archeological concepts to historical investigation, following the methods of Rostovtzeff, Alföldi, and Grimal.

In conclusion, it must be stressed that it is impossible to understand Roman art without making a clear distinction between Roman visions and Greek inventions. The Greek tendency to understand form as the essential element of life was rediscovered in the Neoclassical period of the late eighteenth century, especially by Goethe. He found form—*Gestalt*—in the metamorphosis of nature as well as in poetry, art, and spiritual life.[70] In our time, in referring to painting and art, Hofmannsthal has stated several times that when you succeed in creating the form, or *Gestalt,* the shadows disappear.[71] The Roman visions constitute a glorious part of our heritage, but the Greek understanding of the forms of nature can give us hope for the future. It is, perhaps, our greatest task to subordinate modern life to the laws of creation once again.

1. H. Drerup, "Die römische Villa," *Marburger Winckelmannsprogramm,* Marburg, 1959; W. J. Peters, *Landscape in Romano-Campanian Mural Painting,* Essen, 1963; P. Zanker, "Die Villa als Vorbild des späteren pompejanischen Wohngeschmacks," *Jahrbuch des Deutschen archäologischen Instituts* 94 (1979): 46off.

2. K. Schefold, *Römische Kunst als religiöses Phänomen,* Reinbek bei Hamburg, 1964.

3. Pliny the Elder, *Natural History,* 35.16.

4. Schefold, *Vergessenes Pompeji,* Bern, 1962: 72. See also idem, "Origins of Roman Landscape Painting," *Art Bulletin* 42 (1960): 93. But, see R. Ling, "Studies on the Beginning of Roman Landscape Painting," *Journal of Roman Studies* (1977): 1ff.

5. P. W. Lehmann, *Roman Wall Paintings from Boscoreale in the Metropolitan Museum of Art* (Monographs on Archaeology and Fine Arts 5), Cambridge, Ma., 1953, pl. 20.

6. Drerup (note 1): 9f.

7. Pliny the Younger, *Epistles*, 5.6.13; see Schefold, "Origins" (note 4): 93.

8. Compare I. Bergström, *The Revival of Antique Illusionistic Wall-Painting in Renaissance Art*, Stockholm, 1957; and E. Simon (review of P. H. von Blanckenhagen and C. Alexander [note 50]), *Gnomon* (1972): 198ff.

9. P. Grimal, "Les Jardins romains," *Bibliothèque de l'Ecole Française d'Athènes et de Rome* (1943): 155. This critical observation seems not to have been taken seriously enough, even by F. Rakob in "Ein Grottentriklinium in Pompeji," *Römische Mitteilungen* 71 (1964): 182ff.; and by Zanker (note 1): 492ff. But, see E. J. Dwyer, "On the Meaning of the Griffin Pelta," *Studies in Classical Art and Archaeology, A Tribute to P. H. von Blanckenhagen*, ed. by G. Kopcke and M. B. Moore, New York, 1979: 235ff. (cited subsequently as *Festschrift Blanckenhagen*); and D. Michel, "Pompejanische Gartenmalereien," *Tainia, Roland Hampe zum 70. Geburtstag am 2. Dezember 1978 dargebracht*, Mainz am Rhein, 1980: 373–404.

10. A. Maiuri, *La Villa dei Misteri*, Rome, 1947: 71ff., figs. 80ff; Schefold, *Vergessenes Pompeji* (note 4), pl. 2,1.

11. Schefold, *Die Wände Pompejis*, Berlin, 1957: 296 no. 16.

12. See G. C. Picard, "Origine et signification des fresques architectoniques romano-campaniennes dites de second style," *Revue archéologique* (1977): 231ff.; and note 26 below.

13. J. Böhlau and K. Schefold, *Larisa am Hermos* I, Berlin, 1940: 33; Schefold, "Residenz von Larisa am Hermos . . .," *Proceedings of the Tenth International Congress of Classical Archaeology*, Ankara, 1978: 549ff.; P. Bernard, *Ai Khanoum*, Paris, 1971.

14. J. M. Gard, "L'Hermès juvénile du Palais II d'Erétrie," *Antike Kunst* 17 (1974): 50–59.

15. Drerup, *Zum Ausstattungsluxus in der römischen Architektur*, Münster, 1957: 11f.

16. Ibid.: 7f.; Zanker (note 1).

17. Drerup (note 15): 33, 56.

18. A. Alföldi, "Die Geburt der kaiserlichen Bildsymbolik," *Museum Helveticum* 7 (1950): 1ff.; 8 (1951): 190ff.; 9 (1952): 204ff.; 10 (1953): 103ff.; 11 (1954): 133ff. Reprinted in idem, *Der Vater des Vaterlandes im römischen Denken*, Darmstadt, 1978: 2ff. See also O. Brendel, *Prolegomena to a Book on Roman Art*, New York, 1979: 161.

19. Schefold, "Pompejis Tuffzeit als Zeugnis für die Begründung römischer Kunst," *Neue Beiträge, Festschrift B. Schweitzer*, Stuttgart, 1954: 297ff. These observations are ignored in the latest analysis of the phenomenon: H. Lauter, "Ptolemais in Libyen," *Jahrbuch des Deutschen archäologischen Instituts* 94 (1979): 149ff.

20. Drerup, "Architektur als Symbol," *Gymnasium* 73 (1966): 181ff. Compare E. Künzl, "Quod sine te factum est hoc magis archetypum est?" *Archaeolog. Korrespondenzblatt* 8 (1978): 311ff.

21. For references, compare note 2.

22. W. Technau, *Kunst der Römer*, Berlin, 1940: 47.

23. T. Hölscher, "Zu den Anfängen Römischer Repräsentationskunst," *Römische Mitteilungen* 85 (1978): 321.

24. G. Gullini, "La datazione et l'inquadramento stilistico del sanctuario della Fortuna Primigenia a Palestrina," in H. Temporini, *Aufstieg und Niedergang der römischen Welt* I, 4, Berlin, 1973: 746ff.

25. K. F. Ohr, "Die Basilika in Pompeji," *Cronache Pompeiane* 3 (1977): 17ff.

26. P. M. Petsas, *Ho taphos ton Leukadion*, Athens, 1966, pls. 20–24. The Hellenistic elements of the Second Style have been defined more recently by V. J. Bruno, K. Fittschen, S. K. Miller, P. M. Petsas, and others (most recently, by P. W. Lehmann in *Festschrift Blanckenhagen* [note 9]: 225ff.). But one should not forget the high level of synthesis achieved in the Second Style. It may be by chance preservation that we know the Hellenistic elements best from sites in northern Greece: The two-storied façade of the Leukadia tomb recalls those near Alexandria, Petra, and Ptolemais; see Lauter (note 19).

27. Pliny the Elder (note 3), 35.113.

28. Bergström (note 8).

29. H. I. Marrou, *Mousikos Aner*, Paris, 1964.

30. B. Andreae, *Das Alexandermosaik*, Recklinghausen, 1977. Compare F. Winter and E. Pernice, *Die hellenistische Kunst in Pompeji* 6, Berlin, 1938: 149ff., pls. 52–53; Gullini, *I mosaici di Palestrina*, Rome, 1956, pl. 7.1; and A. de Franciscis (review of Andreae [above]), *Cronache Pompeiane* 3 (1977): 232ff.

31. Schefold, "Die Trojasage in Pompeji," *Wort und Bild*, Basel, 1975: 12. Compare Pappalardo (note 32).

32. Maiuri (note 10). The most recent study of the subject is U. Pappalardo, "Il fregio con eroti fra girali nella 'sala dei Misteri' a Pompei," *Jahrbuch des Deutschen archäologischen Instituts* 97 (1982): 251ff. (with bib.); idem, "Beobachtungen am Fries der Mysterien-Villa in Pompeji," *Antike Welt* 13 (1982): 3, 10ff.

33. Andreae and H. Kyrieleis, *Neue Forschungen in Pompeji*, Recklinghausen, 1975, figs. 59–71; and Picard (note 12): 241.

34. Schefold, "Das neue Museum im Vatikan," *Antike Kunst* 9 (1973): 87.

35. Vitruvius, *De architectura*, 7,5 and 5,6,8; Drerup (note 15): 32, 49; and Picard (note 12).

36. Schefold, "Der zweite Stil als Ausdruck alexandrinischer Architektur," in Andreae/Kyrieleis (note 33): 53ff.

37. W. B. Dinsmoor, *The Architecture of Ancient Greece*, London, 1950: 193.

38. Schefold, *La Peinture Pompéienne* (Collection Latomus 108), Brussels, 1972: 110ff. (I am very grateful to J. M. Croisille for the French-language edition of my *Pompejanische Malerei*, Basel, 1952, and to G. C. Picard for his introduction.)

39. Schefold (note 34).

40. J. Engemann, "Architekturdarstellungen des frühen zweiten Stils und ihre Vorbilder in der realen Architektur," *Römische Mitteilungen* 12 (1967) and Picard (note 12): 234f.

41. House of the Faun (Pompeii VI 12): Schefold (note 11): 128 no. 30.37. Villa of the Mysteries: idem (note 11): 296 no 16; idem (note 38): 110ff.

42. M. Rostovtzeff, *Mystic Italy*, New York, 1927.

43. Alföldi, "The Main Aspects of Political Propaganda," *Essays on Roman Coinage Presented to Harold Mattingly*, ed. by R. A. G. Carson and C. H. V. Sutherland, Oxford, 1957: 63ff.; and idem, "Die alexandrinischen Götter und die Vota Publica am Jahresbeginn," *Jahrbuch für Antike und Christentum* 8–9 (1965–66): 53ff.

44. V. Tran Tam Tinh, *Essai sur le culte d'Isis à Pompéi d'après les représentations murales*, Paris, 1964; idem, *Le Culte des divinités orientales à Herculaneum*, Leiden, 1971; M. Malaise, *Inventaire préliminaire des documents égyptiens découverts en Italie*, Paris, 1972; Schefold (review of Tran Tam Tinh [above]), *Gnomon* (1979): 171ff.

45. Schefold, "Probleme des pompeianischen Malerei," *Römische Mitteilungen* 72 (1965): 117f.; and J. Leclant, "Recherches sur la diffusion des cultes isiaques," *Ecole practique des hautes études, Annuaire* 86 (1977–78): 173.

46. Picard (note 12): 234 n. 4.

47. Simon, "Ungedeutete Wandbilder der Casa del Citarista zu Pompeji," *Mélanges Mansel*, Ankara, 1974: 31ff.; Schefold, "Zur Silbernen Periode der Malerei Pompejis," in *Archaiognosia*, Athens, 1980: 191ff.

48. See K. Lehmann, "The *Imagines* of the Elder Philostratus," *Art Bulletin* 23 (1941): 16ff.; idem, "A Roman Poet Visits a

Museum," *Hesperia* 14 (1945): 259f.; Schefold (note 44): 116 n. 1.

49. On this controversy, see Schefold (note 11): VI,1; idem, (note 38): 10,1.

50. C. Alexander and P. H. von Blanckenhagen, "The Paintings from Boscotrecase," *Römische Mitteilungen* suppl. 6 (1962), pls. 40–46. On Augustan social policy, see D. E. E. Kleiner, "The Great Friezes of the Ara Pacis Augustae," *Mélanges d'archéologie et d'histoire de l'Ecole Française de Rome* 90 (1978): 753ff.

51. Schefold, "Origins" (note 4): 95; IDEM, "Bilderbücher als Vorlagen römischer Sarkophage," *Mélanges d'archéologie et d'histoire de l'Ecole Française de Rome* 88 (1976): 51. Oppositely, see Blanckenhagen, "Daedalus and Icarus on Pompeian Walls," *Römische Mitteilungen* 75 (1968): 106ff.

52. Schefold, "Die frühhellenistische Bilderzählung der griechischen Heldensage," in H. Brunner, R. Kannicht, and K. Schwager, *Wort und Bild,* Vienna, 1979: 304f.

53. See Schefold, "Origins" (note 4): 90ff.

54. K. Woermann, *Die Landschaft in der Kunst der alten Völker,* Munich, 1876, passim; and Blanckenhagen (note 50): 58–61.

55. Schefold, *Vergessenes Pompeji* (note 4): 99ff., pls. 12–14, 62ff. De Franciscis's discovery and excavation of the Oplontis villa confirms my thesis that the decoration of the alae in the House of the Vetii dates from the Vespasian period and that the walling up of the left ala is to be explained by an earthquake that occurred shortly before the eruption of Vesuvius in 79 A.D. See Franciscis, "La villa romano di Oplontis," in Andreae/Kyrieleis (note 33); idem, *Festschrift Blanckenhagen* (note 9): 231ff.; Schefold, "Zur Geschichte der Wandmalerei Campaniens," *Antike Kunst* 19 (1976): 118f. On the other hand, see W. J. Peters, "La composizione delle pereti dipinti nella Casa dei Vetii à Pompei," *Mededelingen van het Nederlands Instituut de Rome* 39 (1979): 95ff.

56. Picard, *Auguste et Néron,* Paris, 1962.

57. Drerup (note 15): 12f.

58. Schefold, *Vergessenes Pompeji* (note 4), pls. 78–79.

59. Ibid.: 117ff., pls. 15–16, 98ff.

60. Gullini (note 30), pls. 8–12.

61. Schefold (note 38), pls, 37, 39.

62. Ibid., pls. 50, 51.

63. "diaphan." See Drerup (note 15): 12f.

64. R. König and G. Winkler, *Plinius Naturkunde,* Munich, 1978: 35.

65. Künzl (note 20).

66. Note 30 and Schefold (note 38), pls. 50 *(Medea)* and 51 *(Briseis).*

67. B. Neutsch, *Der Maler Nikias von Athen,* Bern and Leipzig, 1939. See also Schefold, "Die Andromeda des Nikias," *Studies in Honor of Arthur Dale Trendall,* Sydney, 1979: 155ff.

68. Schefold, *Die Griechen und ihre Nachbarn* (Propyläenkunstgeschichte 1), Berlin, 1967: 122ff., figs. 234–40, pls. 21f.

69. P. Herrmann, *Denkmäler der Malerei des Altertums,* Munich, 1906– , pl. 46; P. Mingazini, "Una copia dell'Alexandros Keraunophoros di Apelle," *Jahrbuch des Berliner Museen* 3 (1961): 7ff.

70. J. W. von Goethe, *Die Metamorphose der Pflanzen. Metamorphose der Tiere,* in *Gesammelte Werke* I, Zurich, 1949: 516ff.

71. H. von Hofmannsthal, *Gesammelte Werke, Reden und Aufsätze* 3, 1980: 283, 285; and V. A. Schmitz, "Hofmannsthal und die Antike," in *Den alten Göttern zu,* Bingen am Rhein, 1982: 157ff.

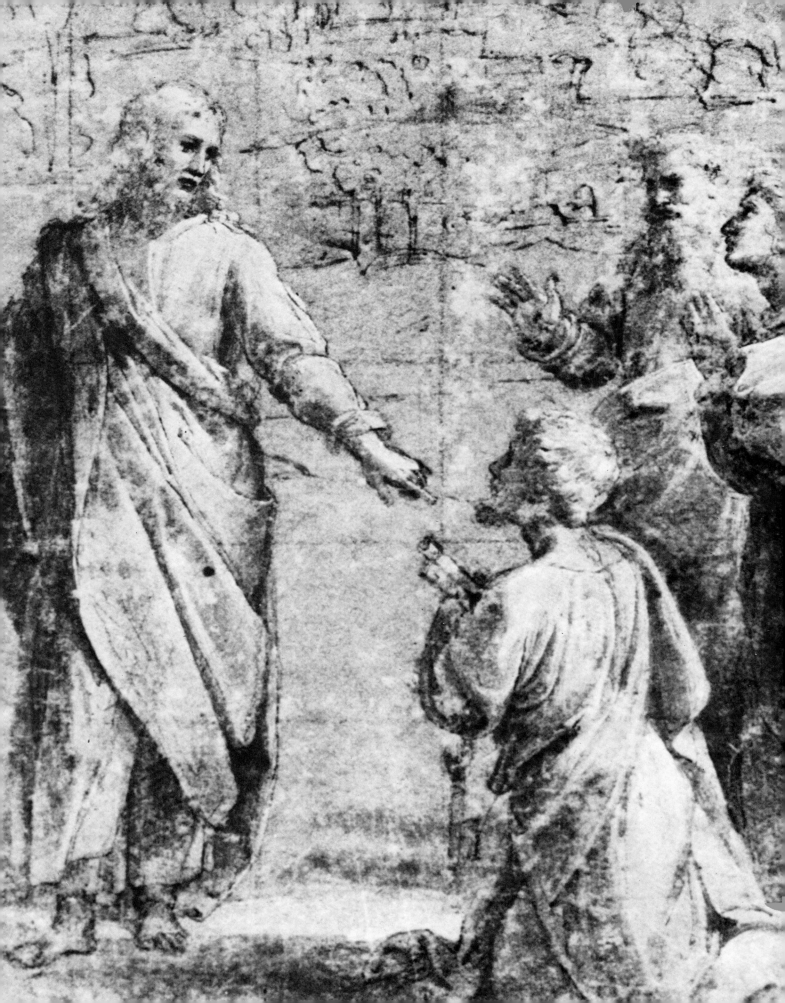

John Shearman

The Organization of Raphael's Workshop

In celebration of the great exhibition at the Art Institute of Chicago "Roman Drawings of the Sixteenth Century from the Musée du Louvre, Paris,"[1] I want to discuss some of the best drawings by Raphael or his workshop from that exhibition in relation to the organization of Raphael's shop.[2] More precisely, I will focus on how he changed, modified, and improvised on his system over a number of years.

Vasari recounts an anecdote in which Giulio Romano told him that he had helped Raphael with the famous portrait of *Leo X and His Two Cardinal Nephews* (Florence, Palazzo Pitti). Although I cannot see Giulio's hand in this picture, I believe the evidence of the anecdote. Two salutary points can be taken from this example: First, the artists never meant us to be able to see the dilution of the master's responsibility, and second, the workshop was involved even with the most personal work painted for Raphael's major patron.

Before proceeding, where was this workshop, and how was it composed? It is very difficult to say where it was located. After 1517 Raphael was living in the Palazzo Caprini, where he had his studio. A Ferrarese ambassador relates how he went to the Palazzo Caprini but could not get up into the workshop, as Raphael said he was busy. This is the place where, from 1517 onward, Raphael was likely to have prepared his cartoons, made his drawings, and painted the easel paintings. Where he worked before 1517 remains a mystery.

Next, how was the workshop organized? Sebastiano del Piombo, who was not well disposed, called it a synagogue and Raphael the prince of the synagogue. He probably was not being quite as rude as we think: Since the word *synagogue* meant no more than a congregation, he was simply calling Raphael the head of the other team. It is rather like someone who comes from Princeton talking about a professor from Harvard. Determining who was in this establishment is also a problem. Although the shop apparently expanded and contracted according to the work on hand, there seems to have been a wide variety of more or less casual affiliations. Visitors from northern Italy, even from northern Europe, floated in and out. Specialists and independent, mature artists such as Giovanni da Udine worked there as collaborators rather than strictly as assistants. Raphael inherited the practices of Perugino and of Perugino's master, Verrocchio, where the same curiously casual relationship existed.

The long-term apprentice-become-assistant type of person in the studio was probably really limited to Giovanni Francesco Penni (from about 1511) and Giulio Romano (from about

1516). In documents of 1517–18, there are references to unnamed *garzoni*—that is, assistants—sent by Raphael to France, Venice, Ferrara, and Naples on various errands. These documents also reveal that the assistants sometimes made cartoons for paintings which Raphael then thought of as his own.

Raphael was certainly not a lazy man; indeed, his productivity is staggering. It seems fair, then, to assume there would have been no workshop unless the pressure of demand forced that solution upon him. Some of these pressures were undoubtedly of his own making. One, however, concerns his place in a revolution in drawing, which must be examined.

The problem comes to a focus, like so many problems, with Leonardo da Vinci. In his work, there was a significant shift of effort or resources back in the direction of the preparatory work and away from the actual execution. That shift is first fully documented by the surviving drawings for the *Last Supper,* executed in the 1490s in Santa Maria delle Grazie, Milan. In the surviving fragments of the inventive stage, that is to say, rough pen sketches, he fixed the composition and the postures of the figures and experimented with them. The pen sketches were followed by an elaborate series, of which a few survive, of what I propose to call definitive studies, very careful drawings from life, of heads, hands, and sections of drapery. These are the studies in which the invention was checked against the model. They were presumably supplemented by studies, which no longer survive, for the architecture, furnishings, landscape, and utensils on the table. Consider the quantity that then results. There are thirteen figures in the *Last Supper.* For each one, several studies of heads, hands, and pieces of clothing would have been made. There would also have been inventive sketches at the beginning of the process, and then all the supplementaries. Perhaps there were about 150 to 200 preparatory drawings for this fresco.

It is imperative not to oversimplify this shift of effort, which in modern technology we would describe as a shift of resources away from production back to research and development. This shift affected the appearance of works of the High Renaissance in two crucial senses: It contributed an unprecedented degree of novelty to each work and also, apparently paradoxically, it contributed a great feeling of resolution or deliberation.

There was a gradual shift in this direction throughout the fifteenth century in Florence. While the tendency did not begin with Leonardo, it was very suddenly accelerated by him. The survival of earlier drawings is too haphazard and occasional to gauge accurately what actually happened in the fifteenth century. Nevertheless, it seems that the most important artist in this development before Leonardo was his master, Verrocchio. Verrocchio, incidentally, was also Perugino's master. While Raphael was not, strictly speaking, Perugino's pupil, he did know that workshop from the inside. How much Perugino conformed with this tendency is hard to say, because he did not leave a great number of drawings. Even so, the principle was accessible there to the young Raphael, who immediately made it worse, adding another laborious step to perfection. There is a group of large and elaborate head studies for the Apostles in the *Coronation of the Virgin* (Rome, Vatican), at which he worked in 1502–03, such as the *St. Thomas* (Lille, Musée Wicar) or the *St. James* (London, British Museum). A final stage in the analytical approach to the work, they are unlike the drawings of any earlier artist, since they were made after the cartoon. The cartoon is normally the point at which preparatory work stops. Used infrequently, this additional step toward perfection Raphael reserved for very special occasions. This one was for his first altarpiece for a major artistic center,

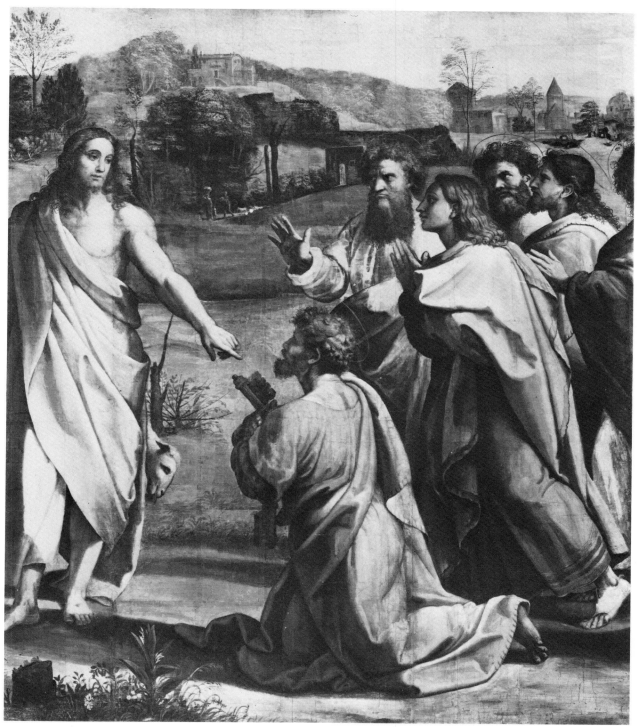

Figure 1. Raphael (Raffaello) Stanzio, Italian (1483–1520). *Cartoon for Tapestry of Christ's Charge to St. Peter* (detail), 1515/16. Present dimensions of entire cartoon: 343 x 532 cm. London, Victoria and Albert Museum.

Perugia. Another was at the end of his life, for the *Transfiguration* (Rome, Vatican), for which he made a splendid series of heads after the cartoon, such as *St. Matthew* (London, British Museum).

In Rome in the years before he was forming his workshop, Raphael must have measured himself against Michelangelo. The intensity and quantity of the preparatory material for the Sistine ceiling, from vestigial pen sketches to highly resolved life studies to the separate analysis of parts, down to hands, pieces of clothing, and heads, set a formidable precedent. In extrapolating from the surviving pieces to guess at the total number of drawings made for the Sistine ceiling, one reaches an estimate of several hundred. In fact, this is the scale upon which Raphael worked in his first big Roman commission, the frescoes of the Stanza della Segnatura in the Vatican, begun probably at the end of 1508 and finished in 1511. For the *Disputà* alone there survive between forty and fifty; the total number for that fresco was somewhere around 300.

The point of emphasizing the vast scale of preparatory work is to focus on the pressures created by large-scale decorative commissions. Pressure was the penalty of Raphael's success, but he handled the pressure in a unique way. Neither Leonardo nor Michelangelo introduced assistants to any significant degree in the production of what passed for their own works; assistants were never involved in the preparatory drawings. Raphael was the first artist to work at this intense level of preparation and also to run a big workshop. The questions remain: What compromise did he strike; how did he cope with the problem of quality control?

Raphael certainly reached the threshold of success knowing very well how big workshops were run. One close friend, Ridolfo Ghirlandaio, could tell him how Domenico Ghirlandaio orchestrated his many assistants. Domenico was a rather easygoing master who gave his workshop little drawn material, as one sees rather clearly in the upper registers of the Cappella Maggiore of Santa Maria Novella in Florence. That was one option; it produced rather visible variations in quality.

An option that was not open to Raphael was Perugino's. An artist with a passionate dedication to excellence, Perugino coped with the problem of pressure following success by economizing on invention. He repeated cartoons; he cannibalized previous designs to rearrange the parts. That system could not survive in the more critical climate of the new century. To the younger generation, inspired by Leonardo and Michelangelo, invention was everything. Vasari relates a rather pathetic story of Perugino's painting the most important high altarpiece that Florence had to offer in the Church of SS. Annunziata in 1506–08. When it was set up, the Florentines jeered. Bewildered, Perugino asked: "But, why? When I did it before, you praised me."

Significantly, as a very young artist, Raphael had provided drawings for older men such as Pinturicchio, Berto da Giovanni, and Domenico Alfani to paint from. This experience must have shown him how his drawings could be intelligently or unintelligently interpreted.

When Raphael moved to Rome in 1508–09, he had no need for assistants. The pressure upon him, personally, began about 1510, toward the end of work on the Stanza della Segnatura. The problem of possible work by assistants in architectural details of the last major fresco, the *School of Athens,* is insoluble. How can one make attributions for pilasters painted by the yard? It is much easier to spot qualitative inconsistency in the figural parts, where one finds it peripherally and rather clearly. In the window embrasures, painted in 1511, there is some poor-quality work, but we do have drawings for those parts by Raphael. Those window embrasures were preceded by the fictive reliefs underneath the fresco of *Parnassus.* In the Alexander relief, the handling is

Figure 2. Raphael. *"Modello" for Christ's Charge to St. Peter,* c. 1515/16. Black chalk, pen and brown ink, brown wash, heightened with white, oxidized, squared in black chalk, on brown prepared paper; 22.4 x 35.5 cm. Paris, Musée du Louvre, Cabinet des Dessins.

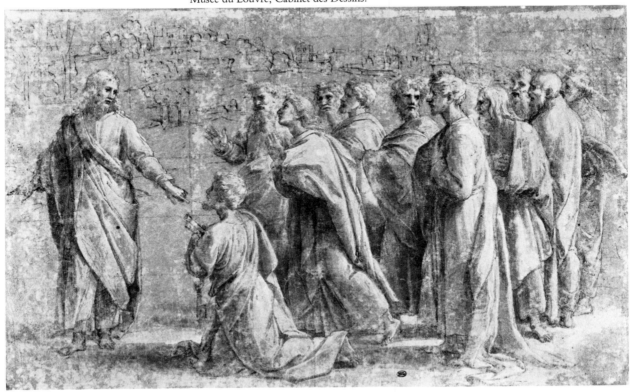

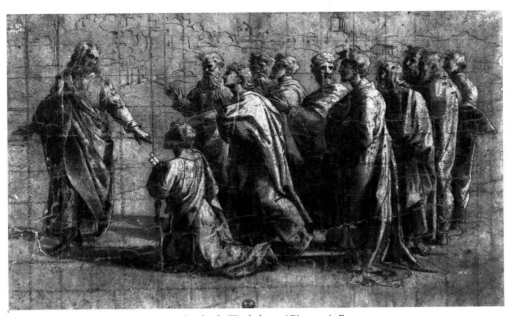

Figure 3. Raphael Workshop (Giovanni Francesco Penni?). *Copy of "Modello" for Christ's Charge to St. Peter,* c. 1515/16. 22.9 x 36.2 cm. Florence, Galleria degli Uffizi, Gabinetto dei Disegni.

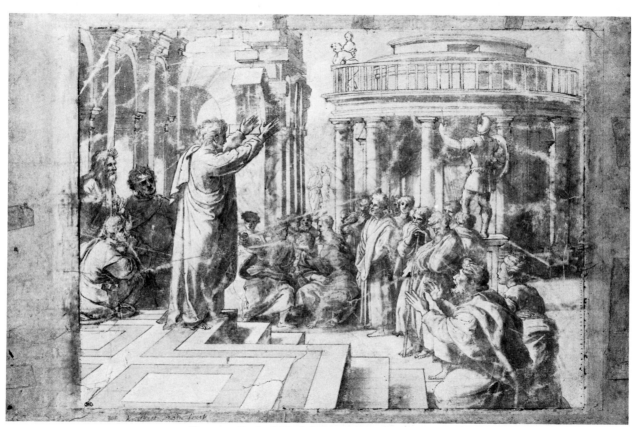

Figure 4. Raphael Workshop. *Study for Tapestry of St. Paul Preaching at Athens,* c. 1515/16. Black chalk, pen and ink, brown wash, heightened with white; 27 x 40 cm. Paris, Musée du Louvre, Cabinet des Dessins. Photo courtesy the Réunion des Musées Nationaux.

rather inexpressive, sometimes rather ridiculously so. In a similar group of figures from the *School of Athens,* one sees the lively handling in the expressive character and emotion of the description of texture and lights of Raphael's own work. While those reliefs under *Parnassus* can scarcely be Raphael's execution, they were his invention.

Raphael moved on, in 1511, to decorate the second room in the Vatican, the Stanza d'Eliodoro. Here the same assistant was entrusted, toward the end of the work in that room, about 1514, with greater responsibility. Large parts of the last main wall fresco, the *Repulse of Attila,* painted in 1513 or in early 1514, can be attributed to this same assistant. In the left-hand portion, the marvelous portrait group, including Raphael's patron, Pope Leo X, is of the highest possible quality; as a matter of fact, even the splendid horse is a portrait. The descriptive quality of this left-hand portion is on a different level from some of the really absurd figures in the other parts. These were painted by the same rather weak personality who painted the reliefs in the previous room. In any case, these weak parts do frame parts that are really beautifully drawn and expressively painted, such as the important figure of Attila himself, who, I have no doubt, is by Raphael.

The fresco medium inhibits retouching; the wall has to be painted while the plaster is wet. Although there was a certain amount of retouching done when the wet plaster was dry, that tended to drop off, so that not much of it was left. Thus, we are back where we were with essentially the wet plaster painting without retouching. Giulio Romano told Vasari that Raphael was in the habit of going over his assistants' work until it looked in the end like his own entirely. Now, that was possible in oil painting, as well as in the gouache medium of the tapestry cartoons, where a contrasting quality—actually an elevation of quality—exists between some rather clumsy underpainting, which was revealed by X-rays, and the often better painting on the surface. But that kind of raising of the quality cannot happen in fresco.

So the pressure first fell on painting. Given existing workshop practice, it is not surprising that Raphael first made this compromise. But next the pressure fell on drawings, and this seems to me a new departure. Raphael was the first master to find himself in the predicament of being unable to meet the demands of extraordinary intensity of preparation, which was, of course, very time-consuming.

While Raphael was a very pragmatic artist, he was not systematic. Nevertheless, he followed one natural principle: that the inventions at all costs should be his. Otherwise, how could he be a master in his own workshop? At some later point, he could subcontract or delegate some of the definitive work to an assistant.

After finishing the frescoes in the Stanza d'Eliodoro, Raphael tried two experiments in his next important task, the cartoons for the tapestries for the Sistine Chapel. This was a public work in which he was to be measured directly against Michelangelo's most recent triumph on the ceiling. In the case of the cartoon for *Christ's Charge to St. Peter* (fig. 1), he probably executed all the preparatory drawings. Presumably he made composition sketches first, which are now lost, to show himself the figures in their optimal arrangement. Those figures would have been clothed.

A fragment of an original drawing in the Louvre exists along with an offset which is at Windsor Castle. (The offset is made by pressing a damp sheet of paper over the drawing.) It represents the whole of the drawing, from which Raphael then tore off the figure of Christ. Perhaps he made this offset, which naturally reverses the design, in order to check what the

group looked like in the direction of the eventual tapestry, which would itself reverse the direction of the cartoon. This explanation may be false, however. We do have several other examples throughout his career of offsets made from drawings, some of them lost drawings, in which that explanation simply does not apply. Some offsets were made for record purposes only. This explanation is more plausible here, because that group was to be profoundly changed by the substitution of a new Christ. Actually, the substitution of a new posture for Christ may indicate a change of subject. Indeed, the original subject of this tapestry was not John 21:16–17 ("Feed my Sheep"), but a subject that occurs earlier (John 20:22), when Christ teaches the Apostles and says: "Receive ye the Holy Ghost."

The process of checking invention against life in group life-studies would be followed by detailed analytical studies of heads, hands, and sections of costume. Subsequently, this definitive work was subsumed into the *modello*. The *modello* for *Christ's Charge to St. Peter* (fig. 2) is one of the drawings featured in the Art Institute's exhibition. Raphael's creative and self-critical instincts were still alert even at this stage. There are major changes in some costumes and especially in the position of the keys between the very fine underdrawing in black chalk and the final pen work. Save for the most generalized indications, the landscape was improvised on this sheet.

The progression of the drawings culminating in this cartoon is uncomplicated except for a workshop facsimile of the Louvre *modello* in the Uffizi (fig. 3). In front of the original, one can tell which is the creative drawing and which the copy. One's instincts tell one which is by an artist whose nerves were on edge, still exploring, still creating, and which by an artist who knew only too well what followed next.

In addition, other things can be measured: different scales of beauty in, for example, the arrangement of St. John's hair, or different scales of sensitivity to light. The Louvre drawing is so much more descriptive of emotion, with more varied and explicit sentiment, than is the Uffizi drawing.

The production of the facsimile in the workshop is very puzzling. In the Uffizi there is a copy by the same hand of another *modello* for the cartoons which is in all respects *en suite* with *Christ's Charge to St. Peter;* it is perhaps part of what was originally a complete set. There are several other cases of Raphael's *modelli* surviving with their facsimiles; there are many more cases where only the copy survives, probably because sometimes there were more copies than originals. For example, in Oxford there are no less than three copies of a lost first draft for the *Mass at Bolsena.* These facsimiles sometimes record *pentimenti,* causing considerable confusion, because the presence of *pentimenti* usually indicates an original drawing. However, since they are not genuine *pentimenti,* they are a clue to the purpose of these copies. Indeed, in the Uffizi copy of the Louvre *modello,* there are some minor *pentimenti* recorded alongside the tower. The copy does, in fact, record changes of mind on Raphael's part as to the exact alignment of the tower.

Whereas these copies were sometimes made simply to teach assistants how to draw, most of them were made for record purposes. Raphael's original *modello* served probably two purposes central to the creative process. First, it satisfied the master; this was, as it were, the final check before the enlargement to the cartoon. Second, it satisfied the patron. For that reason, these are highly finished drawings.

A copy has no role in the preparatory process. It is more likely to have a role *ex post facto,* preserving for posterity the steps in the master's creative path. There are many signs that this

was of special concern in Raphael's circle, where this record-keeping function became a secretarial task. The secretary was Giovanni Francesco Penni, who increasingly performed exactly that sort of function in the workshop. Born in Florence in 1496, he seems to have been the weak assistant noted above in the Stanza della Segnatura.

The surviving drawings for the ten tapestry cartoons do not allow the reconstruction of a systematic approach by Raphael. Instead, they demonstrate the reverse—Raphael's pragmatism. A case in point is the cartoon of *St. Paul Preaching at Athens*. A beautiful autograph red chalk drawing for it in the Uffizi is interesting because it shows that Raphael did not always begin with compositional drafts of the whole. In this case, he began by selecting a few key figures for prior development.

The final step was different in this case, too. Another drawing in the Louvre (fig. 4) *en suite* with the Louvre *modello* for *Christ's Charge to St. Peter* has the same provenance but is surely not by Raphael; it is much too crude and clumsy. Nor is it a copy of a lost drawing. On the contrary, this is the one which is copied in the other Uffizi drawing. Visible on this sheet are all the signs of its occupying a genuine place in the creative process: for example, changes of mind that seem improvised, not merely recorded. Furthermore, working calculations have been made at the side and a scale marked out along the top with a compass. This scale was meant to be expanded to the size of the whole cartoon and enlarged to a scale of Roman *palmi*. In addition, there are on the sides of the drawing carefully calculated points, also made with the compass, to fix the perspective construction. These calculations are part of the mechanical process of actually making this drawing; a copyist would not put these in.

In this drawing, Raphael delegated the task of producing a highly finished *modello* from his invention; in other words, he brought an assistant draftsman into the preparatory process. The use of an assistant at this developmental stage was a response to the pressure caused by a new standard of preparatory work. In experimenting from case to case, Raphael found that he could progressively delegate some of the laborious definitive work. By no means did he ever delegate the inventive stages of any work in which he was ultimately involved as painter. In some cases the assistant participated in the preparatory work by providing fair copies—that is to say, tidy drafts—of an invention which was left in a rather messy state by Raphael.

The use of assistants to copy rough sketches, keep records of drawings, and make life studies was a novel departure in workshop practice. Such a delegation of responsibility is reminiscent of a bureaucracy or even of a good fifteenth-century chancellery. In fact, by the years 1515–16, when the cartoons were made, Raphael belonged to three bureaucracies: his own workshop, the *fabbrica* of St. Peter's (the large office overseeing the building of the new church), and the sinecure post as papal clerk, *scriptor brevium*.

As Bramante had organized the *fabbrica* of St. Peter's, it was really a vast design operation requiring a huge number of drawings. Consequently, Bramante had already delegated a good deal of work; his practice in that architectural drawing office did require records. As a result, many of the most important drawings for St. Peter's are not by any of the major architects involved in designing the new church.

When Raphael became the architect of the new St. Peter's in 1514, he inherited Bramante's practices. Furthermore, he adopted Bramante's system for his own architectural office. For example, the most important drawing for the Villa Madama, made in 1517 (Uffizi 273), is not in Raphael's hand. This drawing, representing the first known stage in the design of that

Figure 5. Raphael. *Psyche Loggia,* showing the *Wedding Feast* and the *Council of the Gods* and scenes from the story of Psyche, 1517–18. Frescoes. Rome, Villa Farnesina. Photo courtesy the Accademia Nazionale dei Lincei, Rome.

Figure 6. Raphael. *Venus and Psyche,* 1517–18. Fresco. Rome, Villa Farnesina. Photo courtesy the Accademia Nazionale dei Lincei, Rome.

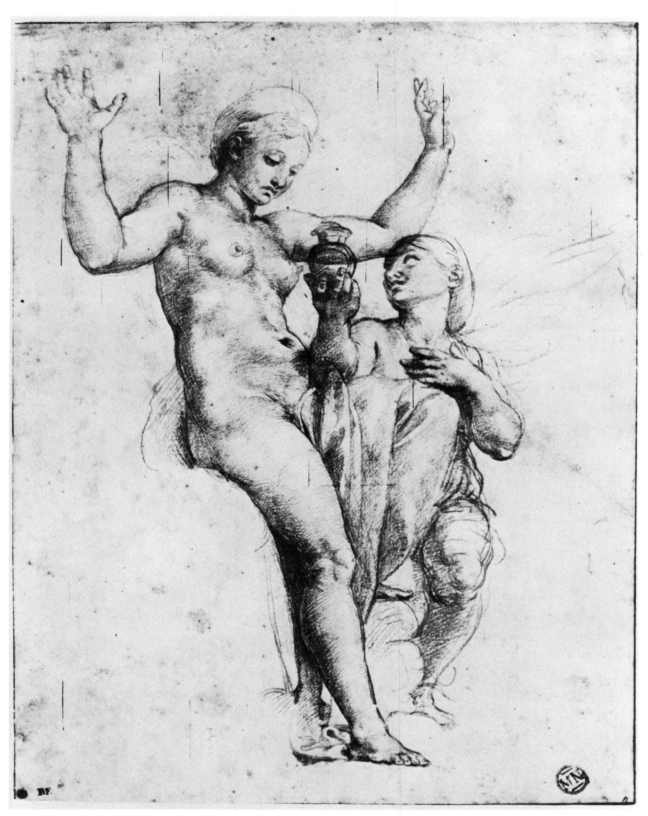

Figure 7. Raphael. *Study for Venus and Psyche*, c. 1517.
Red chalk; 26.3 x 19.7 cm. Paris, Musée du Louvre,
Cabinet des Dessins.

extraordinary building, is a fair copy of Raphael's original, now usually attributed to Giovanni Francesco da Sangallo.

Returning to the cartoons, their preparatory development in this bureaucratic framework is now clearer. Raphael may justifiably have felt that the result was satisfactory in terms of control and the consistency of quality. Nevertheless, he was simultaneously applying a different system with much less successful results in the third of the Vatican rooms he decorated, the Stanza dell'Incendio, painted between 1514 and 1517. While Raphael may have begun with the best intention of painting the room himself, he subsequently became diverted. What follows is an extraordinary breakdown of consistency. That lack of consistency is directly related to his varying involvement, from total preparation to almost nothing. Beginning with the fresco from which the room takes its name, the *Fire in the Borgo,* it is my belief that all the known drawings for this fresco are by Raphael or are copies after his drawings. The fresco itself is, in all aesthetically significant parts, an autograph work. I find it a very imaginative and brilliant work. The *Battle of Ostia* is rather a different case. His involvement quite far along in the process is documented by a drawing in Vienna (Albertina). Raphael very proudly sent this drawing to Dürer in 1515 as an example of his hand. Dürer recorded this event in the inscription he made on the drawing. In relating this drawing from the Albertina to the fresco, it becomes apparent that there was no room for one figure it depicts. Since Raphael so carefully made this drawing, the figure must indicate that, at a fairly late stage in the process after he conceived this figure, the whole design was shifted somewhat to the right. To my mind, his first idea would have enormously improved the fresco, since it would have eliminated the badly drawn figure performing the perfectly ridiculous function of pushing a hole in the bottom of his own boat. Neither its viewpoint nor its scale conforms with the rest of the fresco.

Had the figure been removed and the frame come down over the group and further over on the side so as to leave room for the figure in the Albertina drawing, it would have been a far more consistent and Raphaelesque design. It would appear that Raphael worked and planned only to have some overenthusiastic and semicompetent assistant come along and change his intention. In this case, that assistant was probably Pellegrino da Modena, although some art historians think it was Giulio Romano.

Descending the scale of consistency, we come to the next fresco, the *Coronation of Charlemagne.* Raphael did provide some rather beautiful drawings for the banks of bishops and the group of choristers, a few of which do not survive. His drawings for groups were very incompetently put together by his assistants, so that the resultant perspective is inconsistent. It is not a well-conceived work. The actual execution is mainly by Giulio Romano.

At the bottom of the scale is the *Oath of Leo,* where very little, if any, of the work is by Raphael himself. The result is a catastrophe. It is a composite of some half-understood recollections of Raphael's earlier works—imitations really—especially from the *Mass at Bolsena.* Both in its execution and in its invention it is expressively absurd.

If the unhappy results of excessive uncontrolled delegation are clear to us, they were surely clear to Raphael, and it never happened again. In later schemes, he developed the preparatory system used for the tapestry cartoons; he interjected his own contribution at every stage after the invention if, that is, he could not do it all himself. With the mounting pressures in the last three years of his life, 1517–20, Raphael remained very productive. His energy forces me to be very selective. Therefore, I have to omit a discussion of the

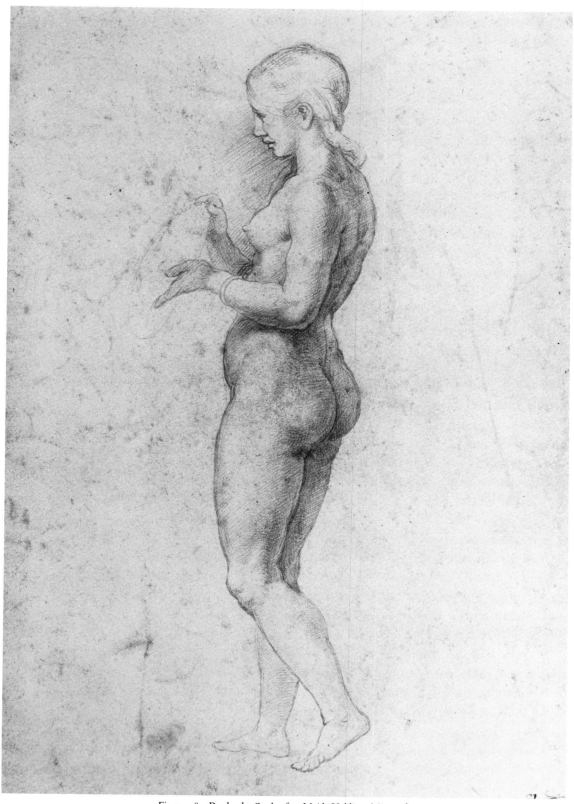

Figure 8. Raphael. *Study for Maid Holding Mirror for Psyche*, 1517. Red chalk; 37.5 x 25.4 cm. Paris, Musée du Louvre, Cabinet des Dessins. Photo courtesy the Réunion des Musées Nationaux.

Transfiguration except to say that, since its cleaning, it seems to me to be entirely by Raphael, as are all the preparatory drawings.

I have chosen to focus on the *Psyche Loggia* in the Villa Farnesina, painted for Agostino Chigi between 1517 and 1518 (fig. 5). Unfinished as we see it now, it was to have more frescoes on the walls and in the lunettes. On the ceiling are the two major scenes: the *Wedding Feast* and the *Council of the Gods*. Along the lower portion of the ceiling are scenes relating episodes in the story of Psyche. Two invention sketches, one in Oxford and one in Cologne, by Raphael exist. They are a very rare kind of drawing, each serving slightly different purposes. In one, Raphael wrestled with a problem, thinking on paper; in the other, he jotted down ideas in a series as they came into his head.

A worked-up chalk drawing in the Louvre (fig. 7) depicts Venus and Psyche. It consists of two overlapping life studies, to which he added something from his invention in the lower part, which explains the different character of this part from the more concrete, completely realized upper part of the same figure. It is in the lower part, where he was least decided in this drawing, that he changed his mind in the final design (fig. 6), so that Psyche kneels eventually on a cloud. This drawing matches, in quality and technique, the very finest drawings for the Farnesina *Loggia*. The finest of all is also in the Louvre. It is the drawing of a maid holding a mirror for Psyche as she arranges her hair (fig. 8). It is the finest actually because it is so well preserved. And it is the best preserved of all because for most of its life it was laid down on a mount and so protected from fading by light and from the rubbing and retouching which have slightly faded the appearance of drawings like this one. In the case of the *Venus and Psyche* drawing in the Louvre, the damage is not serious. Nevertheless, it is not as crisp as the drawing of the maid holding a mirror for Psyche.

The problem of discrimination in these drawings is not related to variations in style, because, after all, Raphael freely changed his style, but to variations in quality. Definitions of quality need to be deduced from the material, not imposed upon it. The drawing of the maid holding a mirror for Psyche mercifully sets its own very high standards of quality. It has an extraordinary delicacy of touch and a sensitivity of design. Particularly noteworthy is how beautifully the hair is taken around the maid's shoulder. The drawing is so comprehensively descriptive, especially of texture, substance, and light. Note, for example, the reflections down her back in the transparent shadows. Above all, the drawing is descriptive of emotion. While Raphael is not infallible anatomically—some of the knee joints do not bear too close scrutiny—his drawings have a perfect clarity in the statement of structure, even if it is not a natural one.

No other mind in Raphael's workshop had his range. Although his assistants could attend to one or two problems, they did not have the capacity for so many all at once.

A lesser but distinctive personality produced the drawing in Haarlem for Hebe in the *Wedding Feast* (fig. 9). Whereas in some respects this is a perfect imitation of Raphael's style, in other respects it is not a strong drawing, especially structurally. Although this artist saw the parts clearly, he saw them alone and not as part of a whole. If one considers the attachment of the arm to the shoulder, for example, it is seriously wrong. Equally unclear is the relation of the rather carefully described muscles to an overall plane for the back which goes through a horrible twist halfway down. Furthermore, the light is less subtle; the shadows are opaque. So, too, it is less comprehensibly descriptive, especially of sentiment. This personality looks very much like Giulio Romano.

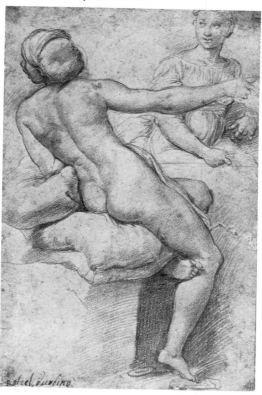

Figure 9. Raphael Workshop (Giulio Romano?). *Study of Hebe, for the Wedding Feast,* 1517. Red chalk; 25.7 x 16.4 cm. Haarlem, Teylers Museum.

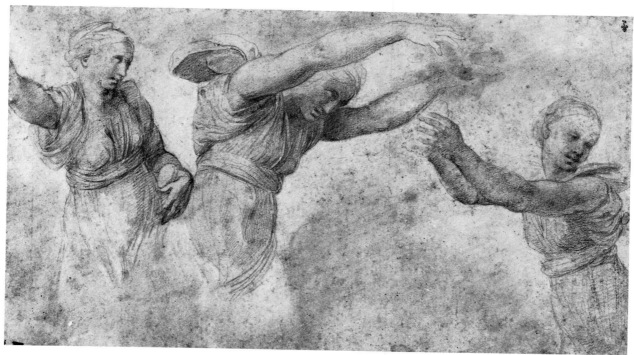

Figure 10. Raphael or Workshop. *Study for the Wedding Feast,* 1517. Red chalk; 19.7 x 34.9 cm. Chantilly, Musée Condé. Photo courtesy Giraudon, Paris.

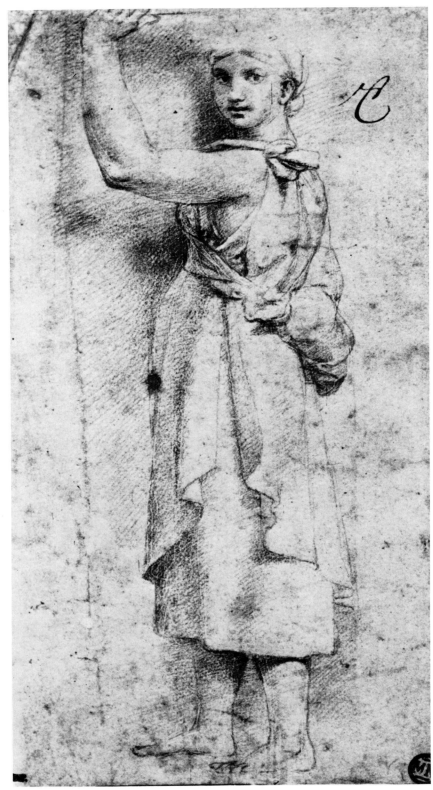

Figure 11. Raphael. *Study of Allegorical Figure of Commerce, for a "Basamento" Figure,* c. 1511/14. Red chalk over stylus tracing, lightly browned paper; 25.8 x 13.1 cm. Paris, Musée du Louvre, Cabinet des Dessins.

Another drawing for the *Wedding Feast* at Chantilly (fig. 10) has different weaknesses from the Haarlem drawing's. It is rather soft structurally and oddly awkward in parts. Due to its poor condition, I hesitate to dismiss it as Raphael's. It could be by Raphael, or perhaps by Penni rather than by Giulio. Actually, I hesitate more and more in making attributions. This is a common experience for those of us working on the great draftsmen of the Renaissance. One begins to allow a greater stylistic range as one proceeds, tending to give back to the major artists so many drawings which had been denied to them in the pseudo-scientific period of art history, 1880 to 1930. Now I sense a danger that this pendulum may swing too far; we may lose our nerve and also lose all critical instincts. It is, after all, easier to say that these drawings are by Raphael.

In summation, I still believe that some of the drawings for the Farnesina Loggia are not by Raphael; there may be two assistants in the preparatory work. In the end, all the painting is by assistants.

The doubts that I have about the Chantilly drawing are repeated in the case of the study for a *basamento* figure for the Stanza d'Eliodoro (fig. 11). A few years ago it would have been perfectly clear to me that this was by Penni; it is not any longer. I now think that it is probably really by Raphael, even though it is less brilliantly alive and sensitive than the drawing of the maid holding a mirror for Psyche, because it has been rubbed and otherwise damaged. It is, in other words, a very tired drawing where the other is very fresh. Although it was probably executed about 1514–15, after the major frescoes in the room were finished, I have left it out of its proper chronological sequence because I wanted to analyze the methodological problem first. That *basamento* is thematically very important in the Stanza d'Eliodoro, for it displays the benefits of papal rule, especially those of Pope Leo X. It is also important historically because it is the first of a new type of *basamento* design with fictive supporting sculptures. Due to its significance, it is quite logical that it should have been invented and fixed in some detail by Raphael. The execution of the fresco is certainly not his but probably Penni's.

The evidence gleaned from the drawings teaches us a great deal about the organization of Raphael's workshop and the flexibility with which Raphael used his assistants to fulfill his numerous commissions.

1. Editor's note: Held October 4, 1979, to January 6, 1980. The catalogue, of the same title, is distributed by the University of Chicago Press.

2. This is a transcript that the author was unable to correct of the first part of his lecture; the second part, on the drawings for the Sala di Costantino at the Vatican Museum, Rome, was not recorded and therefore cannot be included here.

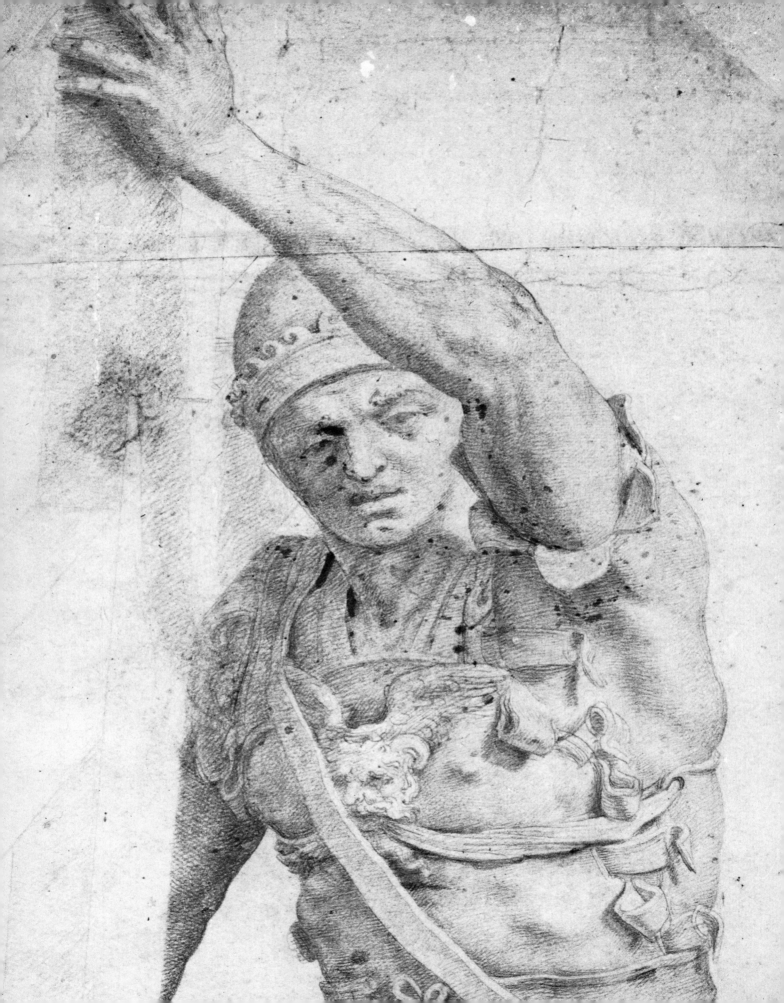

Sydney J. Freedberg

A Fugue of Styles: Roman Drawings of the Sixteenth Century

It was Raphael, above all, who was the great source and exemplar, not only of modes of drawing but of ideas on which the subsequent development of style in painting would depend throughout the sixteenth century.[1] He is in this even more significant than Michelangelo, whose genius, though more expressive and exalted than Raphael's, was much narrower.

Let us begin, thus, with three drawings by Raphael of extraordinary importance and quality; they all come from the period of Raphael's career when he had attained his highest powers. The study for a caryatid figure (see fig. 11, p. 56) for the lower walls of the Stanza d'Eliodoro must have been done in 1514 or very near it, at a time when Raphael was on the threshold of his highest development of the early sixteenth century's classical painting style. Because this figure was intended to fulfill a role like that of an element of architecture, it illustrates with particular directness a motive that lay at the very core of Raphael's conception of the human form: his will to build a human structure which should be as controlled and as secure as a structure of classical architecture, and no less calculated in the purity of shape and in the harmony of proportion that it would display. This caryatid figure is the demonstration of this motive in its simplest and essential form.

With far greater complexity this principle is demonstrated in Raphael's study for the Venus and Psyche figures of his decoration in the Villa Farnesina in Rome, done in 1517–18, and here the demonstration has been made with the quintessential aspect of the human presence, the nude (see fig. 7, p. 51). A contour line that purifies and refines the forms of the anatomy moves like a slow music around them. But the shapes that it defines grow from this contour into three dimensions; Raphael has conceived his figures not in some abstract purity of silhouette but as existent forms: rounding presences that are exactly consonant in their suavity and amplitude with the shapes the contour has defined. This mode of re-creating form is a resurrection, first with the means of drawing and then, still more, in the painted figures, of the classical style of antiquity. It is an accommodation of nature toward the perfection of an idea; but the idea stops far short of any quality of abstractness. Raphael has preserved in his description of the figures the vibrant, light-reflecting surface of living flesh, and Venus seems as convincingly sensual and invitingly tactile as a Venus ought to be. The lesser figure of

← *Detail of fig. 10.*

Psyche is, as it were, folded into the monumental attitude of Venus, and Psyche's figure communicates a sense of controlled energy like that of an unwinding spring; not just her posture but the very draftsman's means suggest the tensile life her form contains. The swift, flexible line of Psyche's leg and thigh makes a deliberate and expressive contrast with the slow, closed contour of the statuary Venus.

What I have referred to as an intention in Raphael like that of an architect is eloquently demonstrated in one of the designs he made in 1515 for a set of tapestries to be hung in the Sistine Chapel: This is for the scene of *Christ's Charge to St. Peter* (see fig. 2, p. 45). Raphael has set the figures of the twelve apostles out as a dense arrangement of columnar elements, almost uniform in height and exactly parallel to the front plane of the sheet; and the effect of a logic like that of an architect is still more apparent in the enlargement of the drawing into a full-scale cartoon. Because the sense of order is so stringent each single departure from its geometry takes on heightened meaning, expressive as well as formal. Threaded through the assembly of columnar shapes is a rhythmic impulse, made by postures and by gestures, that is like an accelerating wave; when it arrives at the left-most boundary of the group of apostles it leaps like a spark across a gap onto the separate, poised, monumental, slow-turning figure of the Christ. This absolutely disciplined design carries a powerful charge of dramatic meaning. It is typical of Raphael that he should see not only the grand and general sense of his invented image but the smaller and specific things that lend it an effect of immediate and poignant life: His differentiation of the physiognomies and expressions of the apostles is as strong as it is subtle.

Giulio Romano was a phenomenal artistic prodigy. When he did the drawing of the *Madonna and Child* (fig. 1) for a painting in the Louvre, he was about sixteen years old; the time of execution is about 1515. Giulio was, at this point, Raphael's most faithful and comprehending pupil, but this was an attitude that would not long endure. In Giulio's drawing the smooth, swift, rounding movement of the contour is almost as authoritative as in Raphael's; at the same time, within this generalization, it seems that Giulio responded to the fine, small irregularities and accidents of nature in a way that is more intimate than Raphael's, and it is a symptom of this same accentuated sensibility to the effects of nature that Giulio's lighting is various and fragmentary beyond anything we find in contemporary drawings by Raphael himself, and more communicative of the complex appearance of a visual truth. Here, even in this youthful work done in Raphael's very shadow, there is the symptom of an incipient unsettling of that beautifully controlled balance Raphael had achieved between the depiction of natural appearance and its idealization. Giulio would soon begin, quite wilfully, to upset this balance, and create the most aggressive evidences, first in Rome just after Raphael's death, then elsewhere in Italy, of a post-classical and sometimes even anti-classical style, to which we give the name Mannerism.

The process of change from the classical style of the High Renaissance can perhaps be characterized as the unraveling of a great aesthetic synthesis, a synthesis in which what in ordinary experience seem opposites were for a brief time reconciled, made to work in melded union and in harmony: ideal and real, permanent and transitory, static and mobile, grace and force; the antonyms could be multiplied indefinitely. Quite contemporaneously with Giulio Romano's inversion of Raphaelesque synthesis into a system of stylistic opposites—of aesthetic antithesis, in fact—another and more widespread stream, destined to be more enduring through the sixteenth century, was extracted from the synthesis of classicism: The ornamental

Figure 1. Giulio Romano (1499–1546). *Madonna and Child,* c. 1515. Red chalk heightened with white on beige paper; 21.3 x 17.6 cm. This and all of the following figures illustrate drawings by Italian artists; are in the Cabinet des Dessins of the Musée du Louvre, Paris; and are reproduced courtesy of the Réunion des Musées Nationaux, Paris.

Figure 3. Perino del Vaga (1501–1547). *Annunciation,* c. 1523/25. Pen and brown ink, brown wash, heightened with white; 19.5 x 26.2 cm.

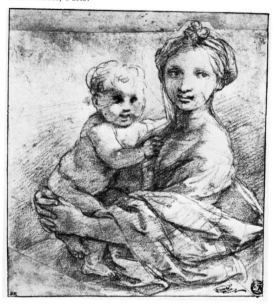

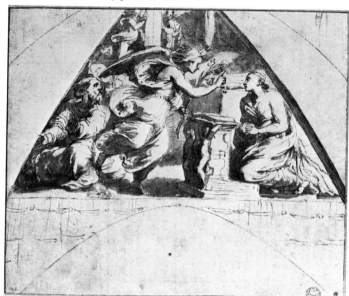

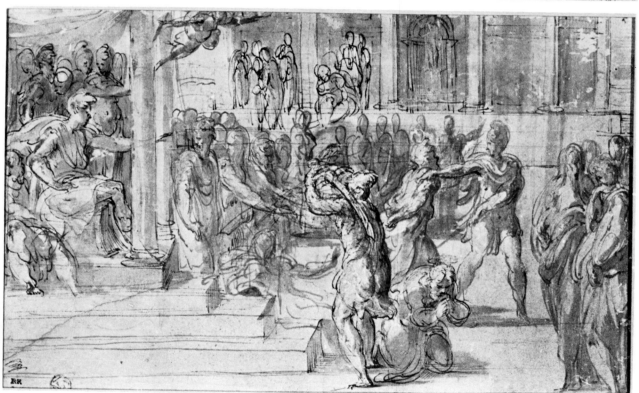

Figure 2. Francesco Parmigianino (1503–1540). *Martyrdom of Saints Peter and Paul,* c. 1526. Pen and brown ink, brown wash, heightened with white, partially oxidized; 17.5 x 28.8 cm.

aspect of the classical style was extended in this younger mode especially into grace of movement, melodic or balletic, conveyed by both attitudes and compositions, and in drawing conveyed by the very quality of line. Francesco Parmigianino, a young painter from the north of Italy who came to Rome only in 1524, four years after Raphael died, was the most important innovator of this major mode within the post-Raphaelesque, post-classical style of Mannerism. The splendid sheet with a design for a *Martyrdom of Saints Peter and Paul* (fig. 2)—used for a chiaroscuro woodcut but never executed as a painting—indicates the kind of transformation this young genius imposed upon antecedents in the art of Raphael, which he had studied with great sympathy but with no less of a transforming will. Raphael's quasi-architectural design, of the kind that we have seen in his tapestry cartoons, has been liquefied, so to speak, by Parmigianino; the figures become elements of fluid rhythm and the design an impulsion of sequential rhythmic waves. What had been a deliberate and measured articulation of dramatic sense in Raphael has been replaced, in Parmigianino's new conception of the nature of a work of art, by a way of thinking in which narrative or dramatic value takes second place while primacy belongs to the elegance of the design into which the artist—quite literally—bends the narrative. It is not only upon the precedents of Raphael that Parmigianino performed this transformation into the gracile, ornamental vocabulary of his Mannerism. In his drawing of a Sybil (cat. no. 37), this facile draftsman's magic has been worked upon the grand Sybils of Michelangelo's Sistine ceiling, who have been translated by Parmigianino into an image of swiftest calligraphy, an almost evanescent patterning of visual delight.

A nearly exact contemporary of the young Parmigianino in the post-Raphael school was Perino del Vaga, a Florentine by origin, who had come as a late adolescent to Rome and, still in his teens, had been a precocious and very gifted participant in Raphael's late workshop. Even within Raphael's lifetime Perino had shown an inclination to interpret his master's models in a way that resembled Parmigianino's, seeking to accentuate their character of grace, and shifting the emphasis of meaning from narrative efficiency to ornament. His design for an *Annunciation* (fig. 3) painted in the vault of the Pucci Chapel in the Church of the Trinity in Rome, soon after 1523, is almost identical in intention and in means of draftsman's style with Parmigianino's. It is certain that influence was exchanged between the two, probably more from the Parmesan to Perino. The distinctions between them in their drawings in these years, in which they worked in company in Rome (until the sack of the city in 1527 that dispersed its artists for some years), arose from a less venturesome and less inspired temper in Perino: His shapes are more cautiously defined, and his rhythmic patternings, though no less pervasive than Parmigianino's, are more orderly.

Both Parmigianino and Perino were protagonists in the development of their shared view of art into that matured and ultimately refined stage of Mannerism to which we give the name Maniera. Parmigianino, after the great dispersion following the sack of Rome, practiced in northern Italy and spread his example of Maniera mainly there. Perino, after some ten years' work in Genoa, returned to Rome and offered his Maniera as an example to younger artists in the city; in popularity surely, and very nearly in authority, his model took precedence even before Michelangelo's. The remarkable drawing of a *Battle of the Amazons,* done in Rome about 1540 (fig. 4), displays the prodigious sophistication of Perino's Maniera *disegno*—the Italian word conveys the double sense in which I use it here, both of drawing and of design. Single figures spill from the pen in fluent, quick calligraphy and then are woven in a filigree

Figure 4. Perino del Vaga. *Battle of the Amazons,* c. 1540/42. Pen and brown ink, gray wash, heightened with white, over touches of black chalk; 20 x 27 cm.

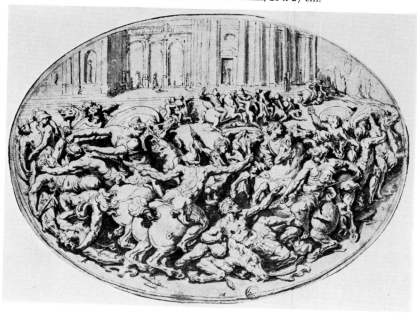

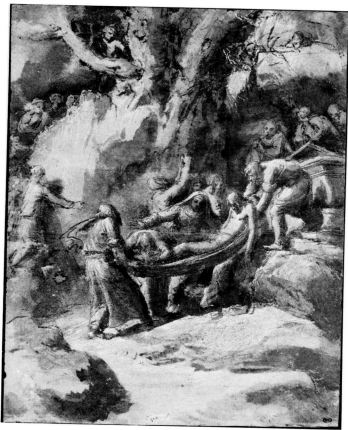

Figure 5. Polidoro da Caravaggio (1490/1500–1543?). *Entombment of Christ,* before 1527. Pen and brown ink, brown wash, heightened with white, over black chalk; 27.6 x 21.2 cm.

Figure 6. Michelangelo Buonarroti (1475–1564). *Two Men Carrying a Body,* c. 1545/50. Red chalk; 28.1 x 17.5 cm.

Figure 7. Michelangelo Buonarroti. *Two Youths Wrestling*, c. 1545. Red chalk; 23.6 x 19 cm.

Figure 8. Michelangelo Buonarroti. *Crucifixion*, c. 1550. Black chalk; 24.2 x 13.2 cm.

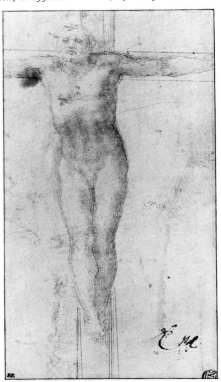

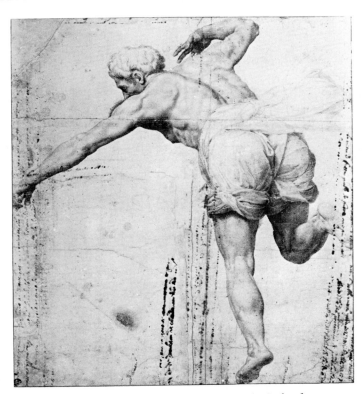

Figure 9. Daniele da Volterra (1509–1566). *Study of a Bending Man, Seen from the Back, for the Deposition*, c. 1545. Black chalk; 50.1 x 43.7 cm.

that vibrates with the interaction in it of the lines and lights. In its extreme sophistication and finesse the drawing has become a precious object—appropriately, for it was made as a *modello* for a carving in crystal set into an object of the utmost actual preciousness, a jewel box called the Cassetta Farnese (Naples, Museo di Capodimonte), which was itself an outsize jewel and a production of the Maniera aesthetic, commissioned for the Cardinal Alessandro Farnese.

Not all the artists who emerged from the atelier of the late Raphael inclined in the same direction as Perino, or in that of the posthumous Raphael disciple Parmigianino. Polidoro da Caravaggio, a very close contemporary of these two, shared with them a good measure of their impulse toward a calligraphic style, but their gracile movement is not Polidoro's main concern. Like Giulio Romano (from whom, in fact, Polidoro had learned more than from Raphael himself), Polidoro employed a deepened and complex chiaroscuro to convey a vibration of interacting visual and emotional effect, powerful to a point that borders upon roughness. A tragic theme, the *Entombment of Christ* (fig. 5), deepens and extends this mode into the vehicle of a passionate and disturbing drama. Polidoro has not only accepted his Mannerist contemporaries' unclassical liberties of representation and of form; he has applied this license to be unclassical also to the domain of feeling, and there he has attained a kind and reach of expression that is private and afflicting as it never was in Raphael but that is not less urgent and profound.

The earlier phase of Michelangelo's career as draftsman is the time of his least equivocal adherence to High Renaissance classicism, as in the middle span of his painting on the Sistine ceiling. When we confront the sublime genius at a later time, his conceptions have moved into a region of even grander and—if that can be conceived as possible—more nearly absolute power. The analogy in Michelangelo's painting of the drawing style he then displays is in Michelangelo's own invasion of a post-classical terrain, as in his fresco of the *Last Judgment.* The study (fig. 6) of two men carrying a body (is it that of Christ?) confronts us like a block of sculpture seen in abrupt and startling perspective—in itself, this foreshortened view is an extraordinary idea. To the figures, Michelangelo has given a power of squared, dense shape, of the weight and massiveness of sculpture, but their contours—quick, rough swings and stabbings with the chalk—are of a supremely inspired energy, charging the massiveness of form and propelling their bulk as of a sculpture toward us.

The subject of two wrestling youths (fig. 7) does not call forth so exalted a conception as the previous drawing, but even in its depiction of a struggle that seems—at least to me—more in play than in passion, the will of the artist to inspire form with the movement that denotes life is brilliantly apparent. The figures themselves are posed so as to make dynamically impelled interwoven rhythms; but the higher dimension of the energy that they convey is made by the sparkling, shifting lighting and the swift, unfixed, repeated stroking movements of the line.

The *Crucifixion* drawing (fig. 8), one in a series of this theme, comes from a late phase of Michelangelo's career. Here the analogy in style with his painting is with his last work in that medium, the *Crucifixion of St. Peter,* of 1546–50 (Rome, Vatican). As in that fresco, and unlike the anatomical virtuosities in the *Last Judgment,* Christ's body is a generalized, even rather abstract-seeming form: a great bulk still, but heavy and, by Michelangelo's former standards, inert. The effect conveyed by the anatomy is of course appropriate to the subject matter, Christ dying on the Cross, and in part determined by it; but the quieting and abstracting coincidence of meaning between this form and its subject has not been made only for this occasion. The subject matter, because it is so much repeated in Michelangelo's late drawings, is

Figure 10. Daniele da Volterra. *Study of a Soldier, for the Testing of the True Cross,* c. 1545. Red chalk; 36.5 x 26.3 cm.

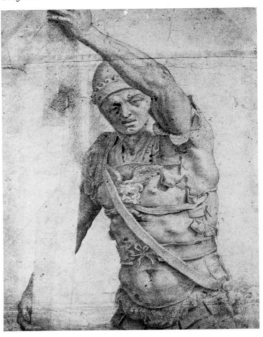

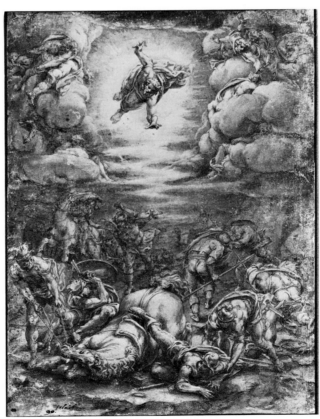

Figure 11. Lelio Orsi (1511–1587). *Conversion of Paul,* c. 1554/55. Pen and brown ink, brown wash, heightened with white; 42.6 x 30.5 cm.

an indication of the kind and depth of religious devotion to which the aging artist had now turned, steeped in the rising mentality of the Counter Reformation. The drastic loosening in the *Crucifixion* drawings of what had been Michelangelo's earlier overwhelming affirmation of physical being, and the diminution of the figure's vital energy that accompanies this, are the indices of the domination in the late Michelangelo of Christian and religious values not only over his prior Renaissance aesthetics but over his prior ethics also. This stilled and simple drawing of Christ crucified, so eloquent of a contained and utterly spiritual passion, communicates a meaning like that of a prayer, made in an image rather than with words. What is in this drawing, however, is a mid-stage only in Michelangelo's late process of transmuting his images of human substance into spirit. The process culminated in the last, unfinished piece he left, on which we know he was at work six days before he died, the *Rondanini Pietà* (Milan, Castello Sforzesco).

Daniele da Volterra was the most ardent of Michelangelo's young disciples in Rome in the years that followed the master's unveiling of his *Last Judgment* fresco in the Sistine Chapel. A few years only after that event, about 1545, Daniele executed a great altar painting for the Church of SS. Trinità dei Monti in Rome. The chapel for which it was conceived, of which the whole design was by Daniele, was destroyed, but the altar fresco, a depiction of the *Deposition,* survives. Even in its much damaged state it remains a most impressive work, feelingly reflective of the most recent mode of Michelangelo in its richly woven, moving composition, in its power of narration, and in the breadth and the expressive action of its figures. The extent of Daniele's dependence for inspiration upon Michelangelo but also his marked differences from him are revealed in a fine study for the most athletic figure in the altar, at its upper right (fig. 9). With a will to self-conscious display of virtuosity like that in the *Last Judgment,* Daniele invented the most complicated posture that the situation could allow, brilliantly—but also ostentatiously—demonstrating his command both of the Michelangelesque canons of anatomy and of the most elaborate illusionist foreshortening. The mode of drawing also has been based on one of Michelangelo's which was of great importance for his followers: a mode of careful finish and high polish, which Michelangelo employed for drawings he meant as complete objects, and often as presentation pieces, rather than spontaneous studies. It is this drawing mode in Michelangelo which most closely approaches the contemporary Maniera. Daniele's translation of this mode is still more precise and careful of anatomical detail than in Michelangelo, more deliberate in the temper of the line, and more suggestive of the polish of some marble statuary in its surfaces; Daniele's figure has been frozen, like a statue, in the middle of its acrobatic movement.

A second drawing by Daniele (fig. 10), for one of the lateral paintings in this same chapel, now also lost, indicates how handsome an effect of authority Daniele's deliberate, knowing, and sculptural manner could convey. Another drawing by Daniele (Hamburg, Kunsthalle) serves to identify the subject in figure 10: a Roman soldier, but presumably of the Christian faith, who holds the True Cross, the miraculous power of which has just resurrected a dead man. The soldier is, again, a statuary presence, his form defined with utmost clarity of line and modeled elaborately with rounded bosses and concavities of light and dark. He is an elegant statue, wearing an armor ornamented with a calligraphy of belts and ribbons, and his proportion is less according to Michelangelo's idiom than to that of the post-Raphaelesque Maniera, refining and attenuating shape.

Lelio Orsi, a contemporary of Daniele's, was only for the briefest moment an actual member of the Roman school. He was in Rome for about a year, in the middle 1550s, visiting from his native province of Emilia. But the impact on him of this year of Roman study was profound, and it had the effect of converting his studio in Novellara into a virtual outpost—a kind of artistic colonial settlement—of the Roman school, of Michelangelo's school within it in particular. Orsi's *Conversion of Paul* (fig. 11) was clearly inspired by Michelangelo's late fresco of the same theme, of 1542–45; the relationship requires no further explanation. Like Daniele, Lelio has taken on a Michelangelesque style of anatomy; in Lelio's transcription, much more than in Daniele's, the exaggerations of the musculature serve as matter for fine rhythmic sweeps and flourishes, asserting the value in these forms of ornament, as in the contemporary Maniera. Reformed by Michelangelo, and touched more than casually by the Maniera, Lelio in this sheet revealed how in one essential respect he continued to exploit an aesthetic capital native to the north of Italy: a sumptuously varied, visually and dramatically excitant light, suggesting the most brilliant manipulations of Titian or Correggio.

Battista Franco, another artist whose origin lay in northern Italy—in Venice, to be exact— was exposed to Michelangelo's example quite early in his career, with profound and durable effect. Franco's first activity when he came to Rome in the middle 1530s was the copying in drawing of the master's Sistine ceiling; two decades afterward, again in Rome, Franco in a sheet of studies (fig. 12) still based his repertory of types and attitudes on the nudes and prophets of the Sistine. It is not only Michelangelo's persons that Franco imitated; he had borrowed early from Michelangelo's mode of swift license in the handling of his draftsman's tools. The borrowed mode in Franco becomes, necessarily, something different: The liberated line in its movement expresses, not as in Michelangelo an energy of forms or a passion of idea, but an energy of ornament, as the line swings in penman's arabesques or knots up into filigree. More than Daniele da Volterra or Lelio Orsi, Franco had assimilated Michelangelo's example to Maniera. How Mannerist in temper—how finely elaborate or even precious—Franco's draftsmanship could be is apparent in the differently finished, and therefore controlled, draw- ing, a design for a plate in majolica illustrating a subject from Homer, *Achilles Putting on His Armor* (fig. 13). In this model for a decorative piece Franco's usual Michelangelism has all but been suppressed, and the forms instead recall the suave purities that belonged to Raphaelesque example, from which the artists of the Maniera had deduced exactly this same kind of stressed, self-conscious, and abstract-seeming rhythmical beauty that the handling of this sheet shows.

The drawings that I have grouped around the example of Michelangelo may be touched or even partly penetrated by the vocabulary of Maniera, but—as the example we have just seen in Battista Franco's work may serve to indicate—it is from Raphael's style that the full-blown Maniera of the mid-century descends. We have already seen how Raphael's immediate inheri- tors, after 1520, extrapolated his grace of form into a style of ornament. Perino del Vaga, whose career began in just this post-Raphaelesque context and ended in the mid-century with a full development, in his paintings and drawings, of Maniera, is the principal connecting link in Rome with the artists of a half-generation or a generation later than his own. These artists represent the Maniera at its apex—a dominating style in Rome at the mid-century, but even then contested by the varieties of Michelangelism and soon to be opposed as well by yet another mode of art.

A characteristic example of the culminating phase of the Maniera is Prospero Fontana's

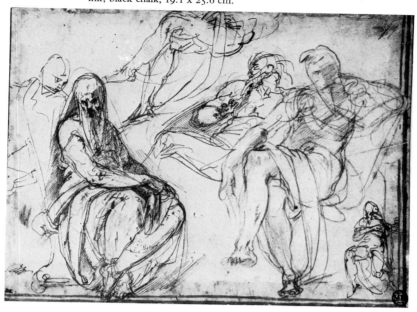

Figure 12. Giovanni Battista Franco (c. 1510–1561). *Sheet of Studies with Several Figures,* c. 1550. Pen and brown ink, black chalk; 19.1 x 25.6 cm.

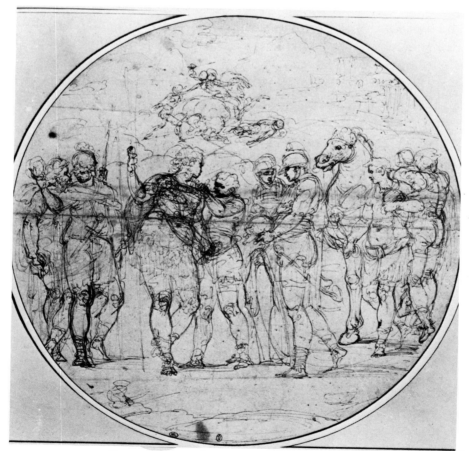

Figure 13. Giovanni Battista Franco. *Study of Achilles Putting on His Armor,* for majolica plate, c. 1545/51. Pen and brown ink; diam. 30.5 cm.

modello for a fresco by him of a Bacchic scene in the Villa Giulia in Rome, of 1553–55 (fig. 14). The basic similarity of the whole design to Perino's drawing for the Cassetta Farnese, of some ten years before, is evidence enough of the community the two artists shared in style; this is no less complicated in its patternings of rhythmic interlace. Here, indeed, the richness of the visual texture was increased as Fontana, again an artist of North Italian origin, from Bologna, wove into the linear design the pulsings, swellings, and diminutions of a varied light. The scene conveys a mood of revelry, quick and restless, elegant both in the appearance of its actors and in its tone of antique literary learning.

No artist of the mid-century more beautifully embodied the Maniera's aspiration to elegance than Taddeo Zuccaro. His study for a group of four muses, painted for a fresco once in the Casino Bufalo in Rome but now detached, is a surpassing demonstration of just that quality of style (fig. 15). A temper of high elegance is given by Taddeo's slow-ascending flow of line, perfectly controlled, which moves upward not just in a serpentine but in an elongated spiral through the female forms, to curve back then upon itself in a partial, evaporating descent. But this armature and the long-rhythmed beauty of the figure of the foremost Muse especially that has been shaped around it were taken by Taddeo only as the general idea that he intended. The same sensibility that made this general effect insisted that he articulate it in detail with the subtlest varying modulations of the line and with a gentle pulsing of the light, no less subtly modulated, upon the figures. The purely ornamental beauty of the drawing and the effect of an extraordinary elegance are removed by this exercise of an intimate sensibility from the risk of seeming an abstraction; however obliquely, the elegance of the image and its high refinement seem still relatable to nature.

It is surely to be expected that the practitioners of a style that was in an essential way concerned with the idea of art *as* ornament should be particularly expert in the invention of ornament in the literal meaning of the word. That this is indeed the case is demonstrated by one very typical example from the drawing oeuvre of Francesco Salviati (cat. no. 51), perhaps the most brilliant of all the artists of the mid-century's high Maniera. The occasion for this inspired exercise of decorative fantasy was a design for the border of a tapestry, for a member of the papal family of the Farnese (perhaps the one now in the Museo di Capodimonte in Naples). A cornucopia of motifs, various, graceful, and full of an inventive wit, has been spilled out with swift fluency upon the paper, making ingenious and unexpected relations among things: Salviati's conception extends the Raphaelesque tradition of *grotesquerie* into a new dimension of cleverness and complication. The effect of this running sequence of images might be compared to what we imagine for a contemporary courtly conversation—an outpouring in the lightest vein of grace and wit.

Giorgio Vasari was the greatest *régisseur* of decorative enterprises of all the painters in the time of the Maniera and as such he was, even more than Salviati (his good friend and exact contemporary), engaged with the design of ornament. He was no less brilliantly inventive in this field than Salviati, and he was even more responsive, in his practice of the art of ornament, to the interrelation between his ornamental matter and the architecture to which it was to be applied. An example of Vasari's mode that is as beautiful as it is typical is the project—used only approximately rather than exactly—for the semi-dome of a chapel in the Church of S. Pietro in Montorio in Rome, done on commission from Pope Julius III exactly in the middle of the century (cat. no. 60). The sense—that of an architect, as Vasari was, as well as a painter—of an ordering of

Figure 14. Prospero Fontana (1512–1597). *Bacchanalian Scene (Feast of the Gods)*, 1553/55. Pen and brown ink, brown wash, heightened with white, over traces of black chalk, squared in pen and brown ink; 36.8 x 47 cm.

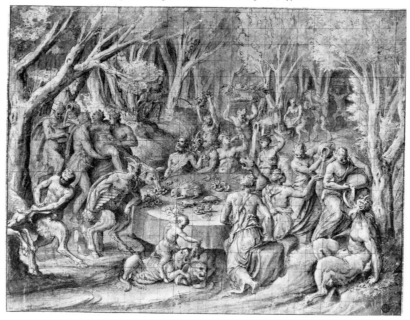

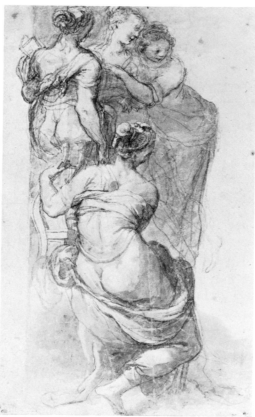

Figure 15. Taddeo Zuccaro (1529–1566). *Study of Four Muses, for the Muses on Parnassus*, c. 1559/60. Black chalk and brown wash; 40 x 23.3 cm.

Figure 16. Giorgio Vasari (1511–1574). *Return of Pope Gregory XI from Avignon,* c. 1572/73. Pen and brown ink, brown wash, over black chalk, squared in black chalk; 37.3 x 48.3 cm.

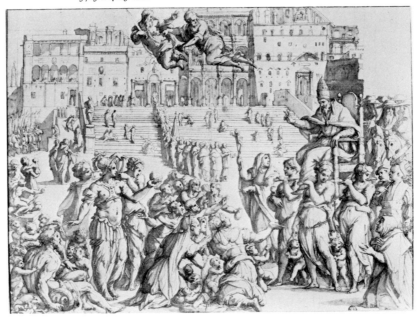

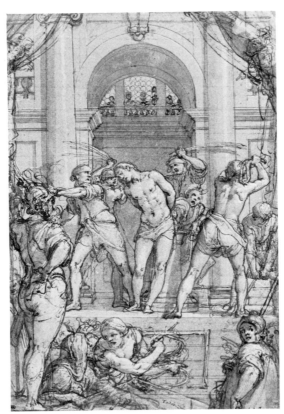

Figure 17. Federico Zuccaro (1540/41–1609). *Study for the Flagellation,* before 1573. Pen and brown ink, brown wash, heightened with white, on blue paper; 35 x 22.3 cm.

the decoration according to a grid of geometric forms is evident, as it is not in the design by Salviati; but the geometry is elegant in its shapes and richly complicated, no less than are the motifs, figural or grotesque, that are applied to it. Even the logic that has been asserted in this ornamental scheme is in the Maniera mode.

If Vasari's language in his designs for ornament is, like Salviati's, that of the elegant courtier, his formal, large-scale figure paintings—allegories, mythologies, or narratives of secular or religious events—are in another and less sympathetic vein. Vasari, the first great historian of art, was at least as verbally inclined as he was visual and tended almost inevitably to academicize his practice of Maniera. The result, as in the study, late in his career, for the fresco in the Vatican's Sala Regia, suggests not a courtly mode but a bureaucratic one: learned (it teems with Raphaelesque quotations we are meant to recognize), rhetorical and somewhat pompous, and, for all the stylish posturing of Vasari's actors, rather stiff (fig. 16).

Vasari's tendency toward an academicizing of Maniera was mainly negative in its effects upon the quality, aesthetic and expressive, of his art; but, as a tendency, it was not wholly unrelated to a movement that intended, and in fact had, a clearly positive effect. In the early 1570s, artists who belonged to a more recent generation began to be restive with the high Maniera, finding its complexities and extreme sophistication excessive, no longer aesthetically tolerable. Federico Zuccaro, a much younger brother of Taddeo Zuccaro, was the leading artist on the Roman scene of this moderating, and even to some degree reforming, persuasion. Federico's study for a fresco of the *Flagellation* he painted in 1573 in the Roman oratory of the Gonfalone exemplifies the means that he evolved to chasten the Maniera and diminish its extravagance (fig. 17). Proportions of anatomy are much more normative; attitudes less elaborate and artificial, conveying a more convincing truth of action and thus of narrative; composition has been made legible and rational. Despite what persists nonetheless of Maniera in the whole tonality of both the drawing and the picture, Federico's mode, more even than Taddeo Zuccaro's, suggests a real affinity with the inheritance of Raphael. Federico's reaction against the extremes of Maniera, like that of the colleagues of his generation who shared in it, was in one essential sense a reaction against artificiality. The corollary of this reaction was the conceiving of art as an instrument of a reawakening concern with nature; but it is revealing of the hold that the Maniera aesthetic still retained on Federico that this concern should only minimally emerge in his paintings. It is rather in the medium of drawing, relatively private, that it assertively appears. Examples are in Federico's extensive series of portrait drawings, which reveal an actuality of physical, and no less of psychological, presence with great sensitivity and truth (fig. 18).

The reaction against the extremes of Maniera had in fact begun much earlier than Federico's; its first clear indices occurred, indeed, in the very time, just at the mid-century, when the domination of artistic style by the high Maniera reached its peak. A drawing by Siciolante da Sermoneta (fig. 19), a finished model for an altar painting of the *Virgin and Child Surrounded by Saints* in the Church of S. Martino in Bologna, is one of the first instances of a reaction, datable about 1547. The painting develops more exactly what the drawing indicates: a powerful insistence on the clarifying of effects of form, both in single-figure elements and in the ordering of composition; accompanying this stress on order is a stress on the assertion of existence, which the artist means to achieve not just by draftsman's rendering of sharply defined detail but by the force of contour and modeling of form. The disciplines Siciolante has

73

conceived for his invention are antithetic to the mentality of the Maniera; however, beneath their clarity of form and their incidents of sharp detail the figures still are unliving: pure and statuary abstractions. In his reaction to the Maniera, Siciolante was not able to detach himself from the basic abstractness of Maniera vocabulary. This was, in the end, an only partial declaration of a new aesthetic. To indicate at once how it is to be distinguished from Maniera and is yet related to it, this style carries the appellation Counter-Maniera. It has its own line of succession and development through the second half of the century, quite parallel with the continuing life of the Maniera. As this stylistic line developed, it divested itself only gradually of its Maniera skin of abstractness in surfaces and in the character of design, and became more natural-seeming and more flexible. It is Gerolamo Muziano, who brought to Rome the results of an early education in northern Italy and Venice, who gave the Counter-Maniera mode its full expression in the 1580s. His study for an altarpiece (cat. no. 31) he painted for St. Peter's before 1584, of Saints Jerome and Romuald, demonstrates how ideas of Venetian origin, ultimately Titianesque, have softened the former hardness of Maniera surfaces and given the figures and design an at least incipient mobility. It is specifically a Venetian recollection that heightens the sense, not normally in Maniera, of the natural credibility of the actors in the picture by associating them with the richness of atmosphere and lighting of a landscape. Still reticent in action and expression, but of evident sincerity in religious meaning and emotion, the drawing—even more than the painting—was conceived according to a mode that has in significant respects detached itself from the Maniera.

One more artist, Federico Barocci, helped importantly to relax the hold of the Maniera upon Roman art. He was a native of Urbino, a place in which, in the sixteenth century, Venetian and Roman influences tended to converge; and he was twice in Rome, in the '50s and early '60s, on extended visits. But, beyond the art Barocci left in Rome itself, that of his followers who worked there became, somewhat later in the century, a major influential force. Barocci's drawing for an *Adoration of the Shepherds* (as far as we know, never used to make a painting) dates in all likelihood from the 1560s, during the artist's second stay in Rome (fig. 20). If there is Maniera in it, it consists of little more than overtones. The main sense of the drawing is of a naturalism of description and a truth of space that are unaccustomed in Maniera images, and of an energy of presence that is made both by the actions of the figures and by the power of excitement of the light.

It should be clear by now why, in the title of this essay, I referred to a fugue of styles. Limiting ourselves only to the middle years of the sixteenth century, in the '50s and '60s, we have seen the coexistence of the height of Maniera, ornamental in the extreme and highly stylized, and of a discreet moderation of that mode; of the late work of Michelangelo, unamenable to any tag of style; of the contamination of that style by Michelangelo's followers with elements of the Maniera; of a style antagonistic to Maniera yet inescapably marked by it, which I have called the Counter-Maniera; and of an incipient assertion of a vital naturalism, as in the work just considered by Barocci.

There is a next and decisive step which, though it occurred still within the chronological limits of the sixteenth century, in effect belonged to the new century to come, resolving in a series of mighty creative acts the complexities of the artistic situation I have just described. The principal author of this new art that would provide the bases for the artistic styles of the seventeenth century was Annibale Carracci, a Bolognese by origin but resident in Rome for

Figure 18. Federico Zuccaro. *Two Little Girls,* bust
length, c. 1590/95. Black and red chalk; 19.9 x 17 cm.

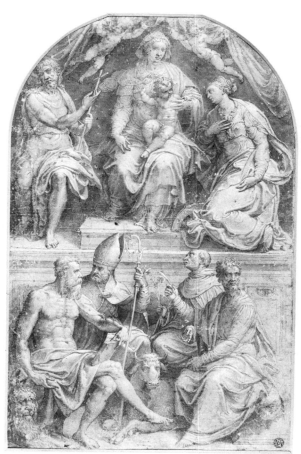

Figure 19. Girolamo Siciolante da Sermoneta (1521–
c. 1580). *Study for the Virgin and Child Surrounded by
Saints,* c. 1547. Pen and brown ink, brown wash, height-
ened with white, over black chalk; 41.7 x 26 cm.

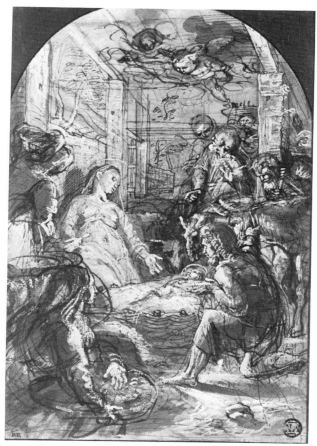

Figure 20. Federico Barocci (1536–1615). *Adoration of the
Shepherds,* 1560s. Pen and brown ink, brown wash,
heightened with white, on brown prepared paper, upper
part squared; 23.9 x 15.5 cm.

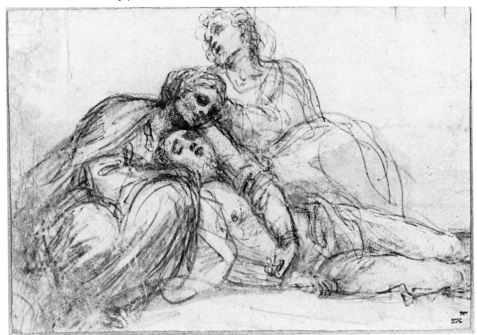

Figure 21. Annibale Carracci (1560–1609). *Study for a Pietà,* late 1590s. Black chalk, pen, and brown ink; 18.6 x 25.7 cm.

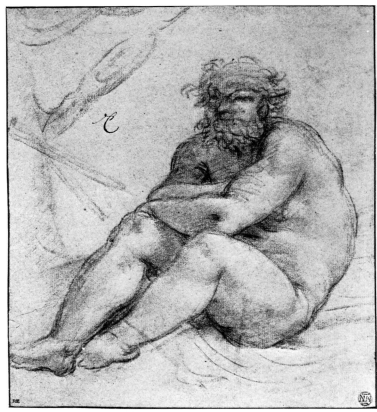

Figure 22. Annibale Carracci. *Study of Silenus, for Bacchus and Silenus,* c. 1599. Black chalk, heightened with white, on gray-blue paper; 27.6 x 23.7 cm.

fifteen vastly influential years from 1595. The intimations of concern with nature we have seen piecemeal in earlier sixteenth-century artists became, in Annibale, profound and entire realizations; in his drawing for a *Pietà* (fig. 21) he gives us, with a rough energy of line, the sense of powerful physical existence, possessed by emotions that ring deep, natural, and true. With a passionate conviction, Annibale incorporated the truth of human substance into his art. A last sheet I shall consider (fig. 22), a study by Annibale for the Silenus in his painting—once the cover of a harpsichord—of *Bacchus and Silenus,* now in the National Gallery in London, confirms amply what the finished painting tells us. Here, probably in the very last year of the sixteenth century, Annibale revealed to us the joy he took in the experience of sheer sensuous existence, and in the aliveness of the body and, not one bit less, of the mind and spirit that inhabit it. Annibale's reassertion of the primary role of art as interpreter of nature was the inversion of the Maniera aesthetic in which nature had been wrought into the material of art. His view in some essential sense resembles that of the masters of the High Renaissance, pre-Maniera style: the classical Raphael, or Michelangelo in his Sistine years. But Annibale's new world was much more earthy; that exaltation of the human presence in the terms that Raphael and Michelangelo created at the beginning of the sixteenth century could never come again.

1. Editor's note: This essay was sponsored by the Samuel Marx Fund. It is based on the exhibition held at the Art Institute of Chicago: "Roman Drawings of the Sixteenth Century from the Musée du Louvre, Paris." Drawings from that exhibition not illustrated in this volume are noted in parentheses by catalogue number. The catalogue, of the same title, is distributed by the University of Chicago Press.

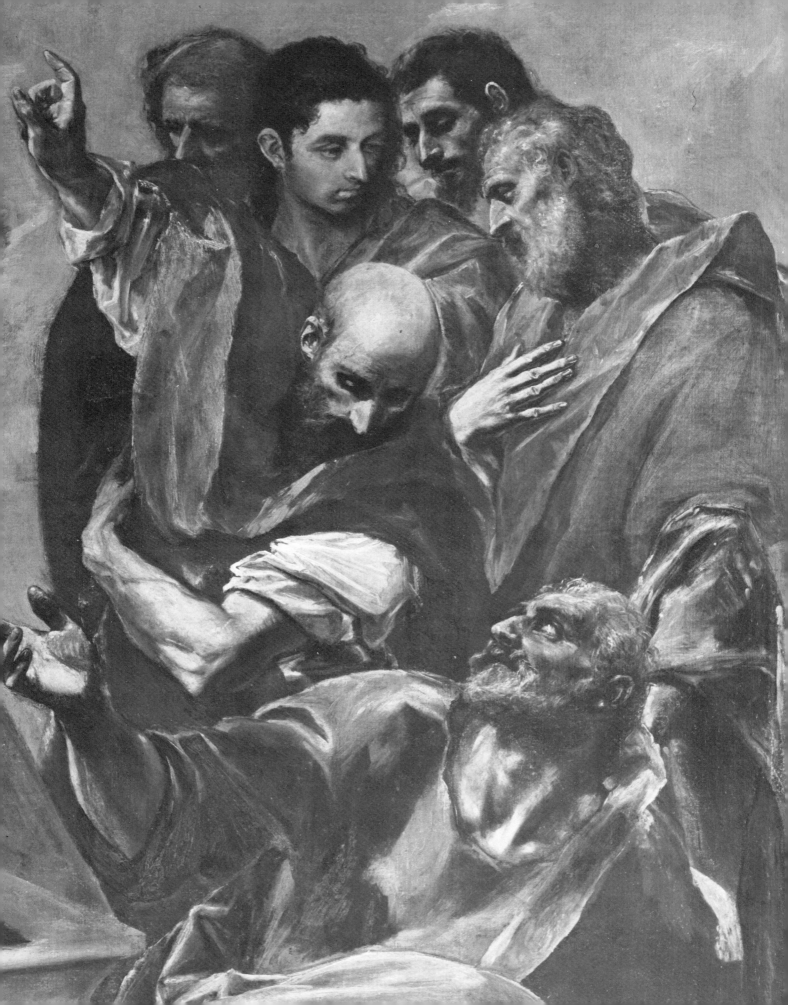

Ellis Waterhouse

Earlier Paintings in the Earlier Years of the Art Institute: The Role of the Private Collectors

I did not find it easy to formulate a short title for what I want to write about. The chosen title resulted from the discovery that the Art Institute has a Department of Earlier Paintings.[1] To me, this title is unusual but very sensible, for it reflects the current embarrassment about the use of the term "modern art," which means something different to each generation. The current euphemism for the term in most museum publications is "1800 to the present." Keeping this in mind, I am going to confine myself to a discussion of those paintings from the Art Institute's vast collection which date before the period "1800 to the present."

When the Art Institute was founded—and I am far from sure that this does not remain true today—the quality of a museum was judged by the world at large on its collection of paintings. At present a remarkable collection of modern pictures may enhance the prestige of a museum more than a good collection of old masters.

Despite the very recent vogue for such things fostered by art historians starved for subjects to study and dealers with depleted stocks of more admirable pictures, Chicago is lucky not to have more than a single Bouguereau in the collection—and that was a gift received in 1901.[2] Bouguereau's work is representative of the style of art which brought prestige to a gallery in 1882, when the Art Institute was founded and Charles L. Hutchinson became the first president of the trustees (fig. 1).[3] It is of this heroic period, while Mr. Hutchinson was president, from 1882 until his death in 1924, that I want to write. In the field of old master paintings, however, the protagonist is rather Hutchinson's close friend and associate in all cultural matters, Martin Ryerson (fig. 2).[4] Mr. Ryerson did not become a trustee until 1890. He was made honorary president in 1926, a position he held until his death in 1933. But I think the "earlier years" in my title can be considered as coming to an end by 1924, when the whole pattern of the museum world and the art trade in the United States changed. After the 1890s, the rapid growth of museum collections and the competition between museums ushered in the modern age.

It might seem that my topic is an internal or domestic Chicago theme which would be impertinent for a foreigner to discuss. Nevertheless, during the present century, the growth of the great American museum collections has been so rapid—and those who look after them have been so busy thinking about the next acquisition—that a reflective consideration about

what has happened in the past, and about who was responsible for it, has never had a high priority. Indeed, this rapid growth of American museums has aroused the admiration and envy of less acquisitive curators in Europe, causing them to take a greater interest in the history of American museum collecting. Consequently, I thought it permissible to write on this subject. Furthermore, it might be of interest to those who have an idea of the presuppositions on which a great museum operates today to consider how these ideas have changed in what is not much more than the span of a single long lifetime.

The notion that the great modern cities of America should form museums in which the achievements of the old world could be made available to the untraveled citizens of the new was unknown before the 1870s. A museum philosophy and a policy for museum development did not spring up fully formed, like Minerva from the head of Jove. The history of art was very much in its infancy in the 1890s in American universities (which even then were fifty years in advance of English ones in this matter). The philosophy of collecting was understandably first formulated in the old Eastern universities. At Harvard, Charles Eliot Norton lectured on the fine arts from 1875 to 1900, while the Fogg Art Museum opened in 1895. At Princeton, Alan Marquand, as instructor in the history of art, set up a one-man department in 1882, founding a small university museum in 1888. Yale, which by accident had acquired a remarkable collection of early Italian pictures in 1871, made no serious use of it until well into the twentieth century.

We can best judge the difference of atmosphere between 1895 and the present by noting that when the Fogg Art Museum first opened, it "was planned by the architect, Richard Morris Hunt, to hold casts and photographs and the small Fogg collection of paintings and curios, as at that time the belief was held that it would never contain important original works of art."[5] The word "curios" is particularly fascinating in this context. It is almost the last time that it occurs in the United States, being a survival form of the Encyclopedists' notions of what a museum should be.

These ideas were replaced in the 1890s in Philadelphia, Chicago, and Boston, where new civic museums were developing by the theory that a museum should be a collection of masterpieces. The concept of Charles Eliot Norton, it was probably known to Ryerson, who went to the Harvard Law School. To the European mind, it was a notion of extraordinary naïveté. Even with the formidable resources of scholarship available today, it is scarcely practical. Moreover, the notion of what constitutes a masterpiece had not then been extended by the vagaries of art historical fashion to include works by such painters as Bazzani, "Monsù Desiderio," or Dirk van Baburen. In the 1890s the European art trade had hardly thought of the idea of American art collecting extending beyond the acquisitions of American millionaires who did all their buying in Europe. Indeed, how an art museum in the Middle West could set about forming a collection of masterpieces almost staggers the imagination. Even the concept of a highly qualified museum director or curator had not yet been formulated.

No doubt William M. R. French, first director of the Art Institute, who served from 1879 until 1914, was an excellent head of the art school. He also functioned as the first curator.[6] But some of his recorded observations do not suggest that the collection of earlier paintings in the Art Institute owes very much to his taste or knowledge. In the case of the most important acquisition of a picture made during his term of office—El Greco's *Assumption of the Virgin* (fig. 4)—the trustees paid no attention to his views at all.

Figure 1. Louis Betts, American (1873–1961). *Portrait of Charles L. Hutchinson,* c. 1914. Oil on canvas; 44¾ x 35½ in. The Art Institute of Chicago, Gift of Mrs. Charles L. Hutchinson (28.659).

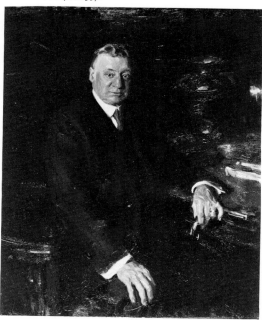

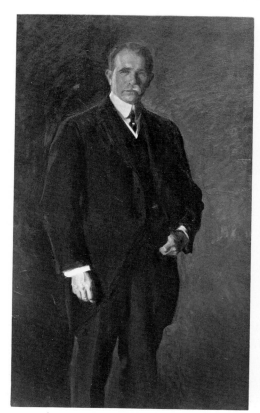

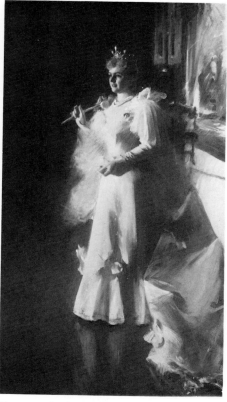

Figure 2. Louis Betts. *Portrait of Martin Ryerson,* c. 1913. Oil on canvas; 65½ x 37½ in. The Art Institute of Chicago, Ryerson Collection (33.1183).

Figure 3. Anders Zorn, Swedish (1860–1920). *Portrait of Mrs. Potter Palmer,* 1893. Oil on canvas; 100 x 55 in. The Art Institute of Chicago, Potter Palmer Collection (22.450).

Few suppositions have changed as much in the museum world since the 1880s as those bearing on the competence and qualities required of a museum director. I do not mean the kind of director whose responsibility is expected to be limited to fund-raising. It was probably the Metropolitan Museum of Art in New York which first felt the necessity, in 1905, to have a "professional" director. In the absence of properly trained American candidates, its trustees appointed an Englishman, Sir Caspar Purdon Clarke (a sort of Sir John Pope-Hennessy *avant la lettre*). His reputation as director of the Victoria and Albert Museum in London was that of a capable administrator, for he reduced to order its rather chaotic Far Eastern collections. His competence in matters of art can be judged by two of his *obiter dicta* culled by Roger Fry, who very briefly, in 1906, became curator of what would now be called "earlier painting" at the Metropolitan Museum of Art. One, in connection with classical sculpture, was: "I prefer casts."The other was: "It is absurd to pretend that one can distinguish between Chinese and Japanese works of art." Happily, his directorship did not last long; he gave up after three years for what were said to be reasons of health. In the meantime, it was many years before the Art Institute had to bother about the problem of a knowledgeable director.

If we take 1879 as the date for the commencement of painting acquisitions for the museum, it is clear that old masters were not at first considered of any importance. As far as I know, during the first ten years only a single old master was purchased, in 1889. The painting, entitled *Music,* attributed probably quite wrongly to Brusasorci, is probably the work of Parrasio Micheli. It certainly had no claim to being a masterpiece. As it is no longer in the collection, we need not consider it further. In the following year, 1890, when Martin Ryerson became a trustee, he and Charles L. Hutchinson decided to remedy the situation. One surmises that they also privately agreed that, in addition to enlarging the museum's own collection, they would personally acquire pictures for themselves whose destination would ultimately be the Art Institute. Furthermore, many of these would be lent to the museum, particularly in the summer months when the collectors were not in Chicago. In support of this assumption, it can be deduced from reading the 1925 guide to the museum that ten old masters were on loan from Mr. Hutchinson and ninety pictures from Mr. Ryerson, not including the nineteenth-century pictures. These were so frequently to be seen in the Art Institute as to be listed in the catalogue.

Since it was the taste and choice of these two men which were responsible for the earlier paintings that eventually formed the Art Institute's collection, we need not distinguish, in the time sequence, between public and private acquisitions. Nonetheless, I suspect that pictures by the less famous names were acquired for their private collections.

How were they to set about forming a collection of masterpieces? What sorts of pictures, in 1890, were considered to be such? It may seem odd to us today that, in the early 1890s, the Dutch and Flemish masters of the seventeenth century were considered to be the chief creators of masterpieces. In addition to Rembrandt, Hals, Rubens, and van Dyck, who have never lost their glamor, painters such as Adriaen van de Velde, the Ostades, and Teniers were appreciated. Subsequently they came under a cloud in American eyes with the advent of the passion for Italian pictures at the end of the 1890s, a passion that lasted until after World War II.

In 1890 Hutchinson and Ryerson, who usually traveled together with their wives in the summer, were in Paris for the G. Rothan sale, which took place May 29–31 of that year. It was certainly one of the most important sales of the season. Hutchinson bought a pair of portraits by Nicolaes Maes,[7] while Ryerson bought three Dutch pictures, the most important

of which was Cornelius Huysmans's *Hollow Road*. Huysmans, a relatively obscure artist then, is still almost unknown today. *Hollow Road* is one of his finest works in a public collection. Ryerson seems normally to have acted solely on his own judgment, without "professional" advice. The purchase of this picture indicates a remarkable sureness of judgment from the very beginning of his patronage.

But such pictures were not the "masterpieces" for which the two friends were looking. One may well wonder how, in 1890, two Chicago businessmen could find sufficiently accredited masterpieces for their new ideal collection. For J. Pierpont Morgan, to whom all the dealers in the world brought their most expensive wares, it was easy.

The 1890s were not a time when all the nobility and gentry of Europe were anxious to sell their ancestral possessions. This state of affairs developed only in the present century. Certain members of the immensely rich newer families, the Rothschilds, the Pereires, and the Demidoffs, were the great collectors of the nineteenth century. However, the Rothschilds were not selling; the Pereires had dispersed most of their collections in 1872. There remained the Demidoffs, who had become famous for spending large sums to purchase pictures at auction over the preceding forty years. The most flamboyant member of the family was Anatole Demidoff, first prince of San Donato. Abandoning Florence for Paris after the collapse of the grand duchy of Tuscany in 1860, he had sold off his Dutch collection at enormous prices in Paris in 1868. When he died in 1870 his other pictures were sold.

With the realization that there was a good deal of money to be made out of pictures, Anatole Demidoff's nephew Paul, second prince of San Donato, bought a replacement collection of Dutch pictures for San Donato during the 1870s. He continued making his purchases right up to the moment in 1880 when, having bought the property of Pratolino, he decided to hold a sale of all but the family contents of San Donato. A huge catalogue was issued—a well-bound copy weighed thirteen pounds—with many engravings.[8] It was, perhaps, the largest art-sale catalogue of the nineteenth century. It certainly contrived to make the pictures famous. Nevertheless, the sale seems to have been a disappointment. As far as I can determine, most of the Dutch seventeenth-century pictures were brought in at quite high prices. They remained available for sale during the next ten years. A speculative Bostonian named Stanton Blake bought nine Dutch and Flemish pictures from Prince Paul Demidoff. He attempted to sell them in 1889 to the Boston Museum of Fine Arts, which secured various benefactors to subscribe or give them to the museum. Most of them were not of very high quality. Indeed, they were inferior to those Chicago later bought. Nonetheless, they presumably drew the attention of the Chicago trustees to the fact that a number of the Demidoff pictures were still available. Borrowing money from a number of its trustees, the Art Institute made a bulk purchase of more than a dozen Demidoff pictures in about 1890. The trustees spent the next few years persuading individuals to provide the money to donate them one by one.

The two most important paintings purchased from the Demidoff sale were Frans Hals's *Portrait of an Artist* and Rembrandt's *Young Woman at an Open Half Door* (fig. 5). They were presented to the Art Institute finally in 1894 by Mr. Hutchinson and Mr. Ryerson, respectively. The two friends had, no doubt, originally advanced most of the money for their purchase. A few paintings had already been donated by benefactors who otherwise did not show an interest in the collection. Terborch's *Music Lesson* was presented in 1891 by railway

magnate Charles Yerkes, who soon afterward transferred his collections and interests to New York. At the time of his death in 1905, he was planning to establish a private gallery in New York similar to the one later established for the Frick collection. The plan was thwarted by his widow. Judging from the photographs of the house reproduced in the 1910 sales catalogue, it would seem to have been a mercy that it was not built.

The years up to the middle 1890s were busily occupied with the settlement of the Demidoff business. Other important paintings that came to the Art Institute from the Demidoff collection include Rubens's *Portrait of the Marquis Spinola;* van de Velde's *Marine Scene;* Quentin Massys's *Man with a Pink;* Jan Steen's *Family Concert;* and Jan van de Cappelle's *The Calm: Marine.*

In 1893 a considerable impetus to the formation of the Art Institute's collection of paintings came from the World's Columbian Exposition, held in Chicago. It witnessed the construction of the building that formed the nucleus of the present Art Institute complex. The trustees of the museum reached an agreement with the sponsors of the Exposition to construct a hall for the World's Congress which would revert to the Art Institute at the end of the Exposition for the museum's permanent use.

As a reminder of that extravagant and idealistic time, I cannot resist pointing out the portrait painted by Anders Zorn in 1893 of Mrs. Potter Palmer attired in the gown and jewels she wore when she officially opened the Columbian Exposition (fig. 3). Zorn's presence there as the official Swedish delegate was valuable in other ways. He met Charles Deering, who amassed a remarkable collection of Zorn's prints, which he bequeathed to the Art Institute. In addition, Zorn probably advised Deering in the selection of pictures for his Spanish villa at Sitges. The finest of these have found their way into the Art Institute.

Another visitor to the Columbian Exposition was the great pundit of the Eastern Seaboard, Charles Eliot Norton. Paying his first—and probably only—visit to Chicago on this occasion, he was impressed by the ferment created by the Exposition. His words had an impact on those concerned with art throughout the United States. Under the influence of his friend Ruskin, who was safer to follow selectively at a distance than at home in England, where his many absurdities and inconsistencies made him an unreliable mentor, Norton commenced proclaiming the doctrine that medieval and Renaissance artwork was what was most needed in America. This lesson was appropriated with enthusiasm by a pupil of Norton's—and a rather mistrusted pupil—Bernard Berenson. Writing on Italian paintings in New York and Boston, Berenson deplored the general lack of Italian pictures in American collections.[9]

It would seem that these notions were adopted by Mr. Ryerson. In the following year, he bought the four Perugino predella panels of scenes from the life of Christ. They were lent to the Art Institute for exhibition and bequeathed to it at his death in 1933. In fact, these pictures had already been on the market for five years in 1897. At the sale in London in 1892 of the Earl of Dudley's paintings, the dealer Durand-Ruel, who did not normally buy old masters, acquired the four Perugino panels along with a small portrait of Alessandro de' Medici quite wrongly ascribed to Bellini.

Durand-Ruel was one of the first of the great European dealers to establish a gallery in New York. When he opened the gallery in 1889, his purpose was to capitalize on the enormous demand developing in the United States for Impressionist and Barbizon paintings. Presumably, he brought to New York the five old masters purchased at the Dudley sale which

Figure 4. Domenico Theotokopoulos, called El Greco,
Greek, active in Spain (1541–1614). *The Assumption of the
Virgin,* 1577. Oil on canvas; 158 x 90 in. The Art Institute
of Chicago, Gift of Nancy Atwood Sprague in memory
of Albert Arnold Sprague (06.99).

Ryerson eventually bought. The de' Medici portrait noted above was attributed by Berenson to Bronzino and by van Marle to Andrea del Sarto. Although an excellent picture, it was not one of those in the Ryerson collection that was periodically lent to the Art Institute.

One of the most fascinating and puzzling Italian pictures in the collection was bought in Paris at about this time from Emile Gavet. The only painting in Chicago listed in Berenson's *Florentine Painters of the Renaissance,* it is, nonetheless, attributed incorrectly there to Francesco Botticini (fig. 6).[10] Its subject is the Epiphany. I remember seeing it in the Ryerson house on Drexel Boulevard in 1927. It was not regularly lent to the Art Institute, nor was it donated to the museum until after Mrs. Ryerson's death in 1937. The implication is that the Ryersons reserved a few favorite pictures, perhaps those not considered of great "importance," for their own private pleasure. The *Epiphany,* a tondo, is one of the many examples of a painting bought by Ryerson on his own judgment which continues to seem a very good acquisition today.

The first five years of the new century were devoted to the rather delayed settling of the accounts of the Demidoff pictures. The *Portrait of Helena Du Bois,* by Anthony van Dyck, and the *Watermill with the Great Red Roof,* by Meindert Hobbema, entered the museum in this period. But the exact dates of their acquisition are unclear. Neither was listed in the 1880 Demidoff sales catalogue. Although the 1961 museum catalogue assigns them 1894 accession numbers, the 1925 catalogue records that the Hobbema was eventually presented by Mr. and Mrs. Frank Logan in 1903, while the van Dyck was presented in memory of William T. Baker by his children in 1905.

The only other major acquisition of these years was the set of four great decorative pictures by Hubert Robert, which appeared at the François sale in Paris in 1900. Four different donors were found in the same year to give them to the museum.[11]

Up to this point, I do not think that the outside world had paid much attention to the Chicago collections of old masters. There were some respectable masterpieces, but nothing of such outstanding distinction that its counterpart, or better, could not be seen elsewhere. In 1906, however, a picture appeared in the Art Institute that was not only a very brave and farseeing acquisition at the time but remains—with the possible exception only of Seurat's *La Grande Jatte*—the most spectacular picture in the collection today. It is El Greco's *Assumption of the Virgin* (fig. 4).

Now that El Greco is almost a household word, it is not easy for us to realize how bold a gesture it was to acquire in 1906—and at the price of forty thousand dollars—a picture by this master. Until the appearance of Cossío's great book on El Greco in 1908, the artist's name was hardly known to ordinary art lovers.[12] The first El Greco exhibition was held in Madrid in 1902, where it was probably not seen by any non-Spaniards. Although numerous publications about him appeared during the next ten years, his reputation remained modest. As late as 1919, when the National Gallery in London bought a far from exemplary specimen, the *Agony in the Garden,* one of the trustees, Lord Curzon, voted for it only with extreme reluctance. He announced that he would personally strangle the director if he ever recommended another El Greco! To buy an El Greco at all in 1906 was a singular act. Even so, the Metropolitan Museum of Art had bought a *Nativity* in 1905, and the Museum of Fine Arts, Boston, had bought a portrait in 1904 on the advice of John Singer Sargent. It was probably because the Metropolitan Museum had lately acquired the *Nativity* that Chicago had the chance of purchasing the *Assumption.* While the late Art Institute director John Maxon revealed a good deal of

the story—including the fact that William French, the director, was against the purchase—I fancy that a good deal remains to be told.[13]

Although shown in the museum from 1906, and bearing a 1906 accession number, the *Assumption* was not, in fact, paid for until 1915, by Nancy Atwood Sprague. Her gift permitted the reimbursement of the original donors. Mrs. Horace Havemeyer told me more than fifty years ago that she had purchased the picture and lent it to the museum until a donor could be found. Mrs. Havemeyer would normally have lent the *Assumption* to the Metropolitan Museum. But, as that museum had just bought the large *Nativity,* the directors felt they could not risk antagonizing public taste by exhibiting another El Greco, let alone buying one.

Exported from Spain in 1904 by Durand-Ruel, the painting was hung in his New York gallery. Mary Cassatt, who had imbibed from Degas an admiration for El Greco, saw the *Assumption* there. Acting as artistic adviser to Mrs. Havemeyer, she urged her friend to buy it. But the Havemeyers, to their great regret, could find no place for it, even in that enormous New York town house on East 66th Street, where three Manet *Toreadors* in a row faced the visitor on entering the hall. Mary Cassatt then turned to another friend, Mrs. Potter Palmer. Her persuasion, no doubt, was influential with Mr. Hutchinson and Mr. Ryerson, who convinced their fellow trustees to acquire it. I doubt if it was generally known that the El Greco was not actually the property of the museum for a number of years. In Cossío's 1908 monograph, it is definitely listed as belonging to the Art Institute. Because almost all his significant works were buried in unvisited Spanish churches, El Greco is one of the few major European painters whose works were still available on the market in the early twentieth century. The acquisition of the El Greco put Chicago on the map as one of the museums that had to be visited by serious art historians. It remains one of the most important European pictures in an American collection.

Oddly enough, in 1908 Charles Deering already owned one of the least important of his El Grecos. It was on loan to the Art Institute in the 1920s and is still in the possession of his descendants. But the Deering Spanish pictures, which were exhibited on anonymous loan from Mrs. Deering at the Art Institute from 1922, were not collected for Chicago but for the Deerings' favorite retreat at Sitges near Barcelona. They were acquired largely from the Spanish market on the advice of the art critic Miguel Utrillo, who was, I think, their agent there for a number of years. In 1906 he published the first little picture book on El Greco.[14]

In later years the best of the Deering Spanish pictures came to the Art Institute, either through Mr. Deering's will or through the generosity of his daughters. Most notable among them is the Ayala altarpiece, which is probably the most important Spanish primitive work in America. Equally significant is the Martorell *Saint George,* which seems to me the most beautiful Spanish fifteenth-century painting in existence. The acquisition of the El Greco *Assumption* in 1906, therefore, indirectly led to Chicago's housing one of the most memorable groups of Spanish paintings outside Spain.

Between 1906 and the 1920s—that is to say, until the end of the "earlier years" of the title of this essay—no "earlier paintings" of any consequence were acquired for the permanent collection. Nevertheless, a large number of such pictures were often on loan from the Ryerson collection. A few, though not of great consequence, were lent by Cyrus McCormick, Jr. It was known that most of these Ryerson pictures would eventually pass to the museum. In fact, an informative catalogue of the "earlier paintings" from the Ryerson collection was written by

Figure 6. Attributed to Francesco Botticini, Italian (1446–1498). *The Epiphany,* after 1475. Tempera on panel (tondo); diam. 31 in. The Art Institute of Chicago, Ryerson Collection (37.997).

Figure 5. Rembrandt Harmensz van Rijn, Dutch (1606–1669). *Young Woman at an Open Half Door,* 1645. Oil on canvas; 40⅜ x 33½ in. The Art Institute of Chicago, Ryerson Collection (94.1022).

Figure 7. Giovanni Battista Tiepolo, Italian (1696–1770). *Madonna and Child with Saints Dominic and Hyacinth,* 1740/50. Oil on canvas; 108 x 54 in. The Art Institute of Chicago, Ryerson Collection (33.1099).

Robert B. Harshe, the director of the Art Institute from 1921 to 1938. Carefully modeled on the 1915 catalogue of the Fogg Art Museum at Harvard, it was available for inspection at the museum.[15] The catalogue of the Fogg Art Museum, incidentally, was the first serious catalogue of paintings to be produced by an American museum.

Although it was announced that the Ryerson catalogue was to be published shortly—in 1927, which is about the date when it was completed—for unknown reasons it never appeared. While it has far too little information about accession dates, some of these facts can be deduced from other sources.

The rest of what I shall say is concerned with the growth of the collection formed privately by Mr. Ryerson. John Maxon rightly described him as "still the greatest benefactor of the Art Institute." He clearly had strongly defined personal tastes. The first thing that one notices about his collection is that it is wholly lacking in Duveen pictures. These normally form a considerable part of the great private collections formed in America between about 1906 and Ryerson's death in 1933. It is true that the Art Institute's Rogier van der Weyden portrait of *Jean de Gros* at one time did belong to Duveen, who had bought it in 1905 with the Rudolphe Kann collection *en bloc*. But it was a small picture, and Duveen disliked small pictures, which he contemptuously referred to as "postage stamps." He sold it to the dealer Kleinberger, from whom Ryerson bought it in 1913. Ryerson, in fact, bought more pictures of real consequence from Kleinberger than from any other dealer. He purchased from Kleinberger the Giovanni di Paolos, the Flemish and German pictures from the 1913 Nemes sale, and the great Tiepolo altarpiece, also in 1913.

Tiepolo's *Madonna and Child with Saints Dominic and Hyacinth* (fig. 7) was, in fact, the first major work by that master to enter an American collection. Hitherto, only Tiepolo sketches had appeared for sale. The purchase represented a taste well in advance of its time. Since then, of course, it has been somewhat eclipsed in importance by the stunning series of four *Stories of Rinaldo and Armida* painted by Tiepolo. The series was presented to the Art Institute in 1925 by James Deering, the brother of Charles.

Ryerson does not seem to have liked Venetian paintings; the Tiepolo was somewhat of an exception in his collection. He did, however, purchase in 1910 the signed Gerolamo da Santa Croce painting of the *Madonna and Child,* which has the distinction of being the earliest known work by that unimportant artist. Indeed, Ryerson's aversion to Venetian painting seems to have been openly admitted. According to Daniel Catton Rich, when Charles and Mary Worcester approached Art Institute director Robert Harshe in 1926 to discover which paintings the museum wished to acquire, they were told that "German primitives . . . and Renaissance masters of Venice were completely lacking" in the collections.[16]

It was to the early French and Flemish masters that Ryerson directed his attention. In the years before World War I, he watched the great exhibitions in Europe—the Flemish primitives at Bruges in 1902, and the so-called French primitives in Paris in 1904—seeking to fill gaps in these fields in the collection. Purchased before 1914 were Rogier van der Weyden's *Jean de Gros* and *Madonna and Child,* Hans Memling's *Madonna and Child with Donor,* Gerard David's *Lamentation,* Colijn de Coter's *Madonna and Child with Angels,* the pendants of *Saint Bridget* and *Saint Augustine* by followers of Cornelis Engelbrechtsz, and at least two other early Flemish pictures. During these years, prices for such pictures were still quite reasonable, although Flemish primitives were fairly popular in American collections. More remarkable, and well in

advance of public taste, was the acquisition, in about 1913, of the Thuison altarpiece, followed in 1914 by that of Maître de Moulins's *Annunciation.* The *Annunciation* was the first example of work of this important artist to enter an American collection. The Thuison altarpiece, painted in the Abbéville-Amiens district, remains a unique work. The seven panels in the Art Institute depict scenes from the life of Christ and patron saints. Although not quite complete, it was still a valuable acquisition. The central sculptured group has disappeared. In addition, one half of one of the four original panels, each painted on both sides, is missing. While not of the highest quality, it is nevertheless a splendid and sumptuous example of a large medieval altarpiece. It has not received the attention it deserves for the simple reason that there is nothing with which to compare it.

The purchase of both these French artworks reflects a very individual taste. I would guess that Ryerson had decided that personal acquisition with the view to eventual bequest to the museum was preferable to purchase by committee. He noted that it had taken fifteen years for the museum to get the El Greco paid for, and that the trustees had not been unanimous in recommending it. Indeed, when these French works were bought, the El Greco had not yet been officially given to the museum.

What makes the Ryerson collection so remarkable is that it is not a series of pictures amassed by the process of committee buying. This process is what museums tend to suffer from. Instead, it is a series of pictures displaying a personal taste. Many of them would not have been acquired if a committee had had to make the decisions. Moreover, the taste displayed is often well in advance of generally accepted taste.

The splendid Giovanni di Paolos, which I imagine are among the most popular pictures in the collection, were also acquired in 1913. They depict six scenes from the life of St. John the Baptist. Giovanni di Paolo is a curious, and often tiresome, painter. The Sienese school, of which he was a member, became fashionable to collect after the Siena exhibition in 1903. American collectors displayed a certain weakness of taste in their purchases of the Sienese, but the Ryerson pictures remain, in my opinion, the best in the United States. When a missing companion piece to one of them turned up in 1971, it was bought by the Norton Simon Foundation for an exorbitant sum.

During World War I, Lucas van Leyden's *Epiphany,* a masterpiece of quite exceptional importance, was acquired by Ryerson. In the last years of his life, he continued to remain in advance of sophisticated museum taste. A visit to London in 1924 led to the acquisition from Langton Douglas of two paintings. One was the Duecento diptych depicting the *Madonna and Child* and the *Crucifixion.* This kind of picture is much esteemed today, but in the 1920s it must have been considered a curiosity. This purchase reinforces my sense of the spirit in which the collection was assembled. From the beginning, both Hutchinson and Ryerson were very conscious of the educational value of works of art. More than acquiring pictures which the Chicago public would naturally like, they felt a duty to acquire pictures which the Chicago public could be educated into liking. Many remarkable acquisitions have been made during the past fifty years since the Ryerson pictures passed to the Art Institute, but they have been less challenging.

Speaking of the older European museum collections, an eminent Viennese scholar once said that there are two kinds of pictures: those that you buy, and those that you find in a collection. In many American museums, owing to the frivolous practice of de-accessioning pictures which the president or director of the moment does not happen to like, there are far

fewer pictures to *find* in this way. But such discoveries are almost always rewarding. They indicate that different generations are able to understand and appreciate different aspects of earlier art. Sometimes, of course, a hitherto unknown artist of the past becomes fashionable because the art trade has found a great stock of his works and organizes an ingenious advertising campaign. But other reappraisals are much more sincere. The exhibition held in Chicago in 1970–71 of Italian eighteenth-century painting awakened a great many people to values and qualities of art that had long been neglected.[17] Such exhibitions are very much in the spirit that Mr. Hutchinson and Mr. Ryerson had in their hearts when they presided over the earlier years of collecting at the Art Institute.

One could also mention the Art Institute's great collections of nineteenth-century painting, prints and drawings, and Far Eastern art. But, in the earlier years of the Art Institute, it was the earlier paintings that were especially in the minds of those who played the largest part in building up this great collection. On an occasion such as a centennial year, it is an act of reasonable pietas to look back to the beginnings and to try to think ourselves into the frame of mind of the founders of the Art Institute's collections. It was a frame of mind that it would be healthy to continue today.

1. Editor's note: In 1981 the department's title was changed, as its scope was broadened to the Department of European Painting and Sculpture.

2. *The Bathers.*

3. Hutchinson, a prominent Chicago citizen since his move to the city in 1856 from Massachusetts, was president of the Corn Exchange National Bank. He donated about twenty paintings to the Art Institute.

4. Ryerson, the single largest donor to the Art Institute, gave over sixty old master pictures alone. He also donated the Ryerson Library to the museum in 1901.

5. Fogg Art Museum, Harvard University, *Collection of Medieval and Renaissance Paintings,* Cambridge, 1919: ix.

6. French, the brother of the American sculptor Daniel Chester French, graduated from Harvard University in 1864. By 1867 he was living in Chicago, where he became secretary of the Chicago Academy of Design. When the Chicago Academy of Fine Arts was founded in 1879, he was put in charge of the art collection. This organization subsequently became the Art Institute in December 1982. (A portrait of French by Louis Betts, executed about 1905, is in the Art Institute.)

7. These are the *Portrait of a Gentleman* and *Portrait of a Lady.* In 1923, Kate Buckingham gave the Art Institute another picture by Maes, a *Portrait of a Man.*

8. *Catalogue des objets d'art et d'ameublement, tableaux dont la vente aux enchères publiques aura lieu à Florence au Palais de San Donato le 15 mars et les jours suivants,* Charles Pillet, Victor le Roy (Brussels), and Charles Mannheim (Paris), 1880.

9. B. Berenson, "Les Peintures italiennes de New-York et de Boston," *Gazette des Beaux-Arts,* ser. 3, 15 (Mar. 1896): 195–96.

10. New York, 1909: 119. It is possible that the artist may be the younger Botticini, Raffaello. But the only other picture known to me that seems to be by the same hand is a *Madonna Adoring the Christ Child* at the Williams College Museum of Art, Williamstown, Ma., which has eluded attribution equally successfully.

11. These are entitled *Fountains, Obelisk, Landing Place,* and *Old Temple.*

12. M. B. Cossio, *El Greco,* 2 v., Madrid, 1908.

13. J. Maxon, *The Art Institute of Chicago,* London, 1977: 8–9.

14. M. Utrillo, *Domenico Theotokopoulos, "El Greco,"* Barcelona, 1906.

15. R. B. Harshe, "Martin A. Ryerson Collection of Paintings and Sculpture, XIII to XVIII Century Loaned to The Art Institute of Chicago," unpub. ms., 1926, in the Ryerson Library of the Art Institute of Chicago.

16. D. C. Rich, *Catalogue of the Charles H. and Mary F. S. Worcester Collection of paintings, sculptures, and drawings,* Chicago, 1938: v.

17. *Painting in Italy in the Eighteenth Century, Rococo to Romanticism,* exh. cat., the Art Institute of Chicago, 1970. The exhibition was also held at the Minneapolis Institute of Arts and the Toledo Museum of Art.

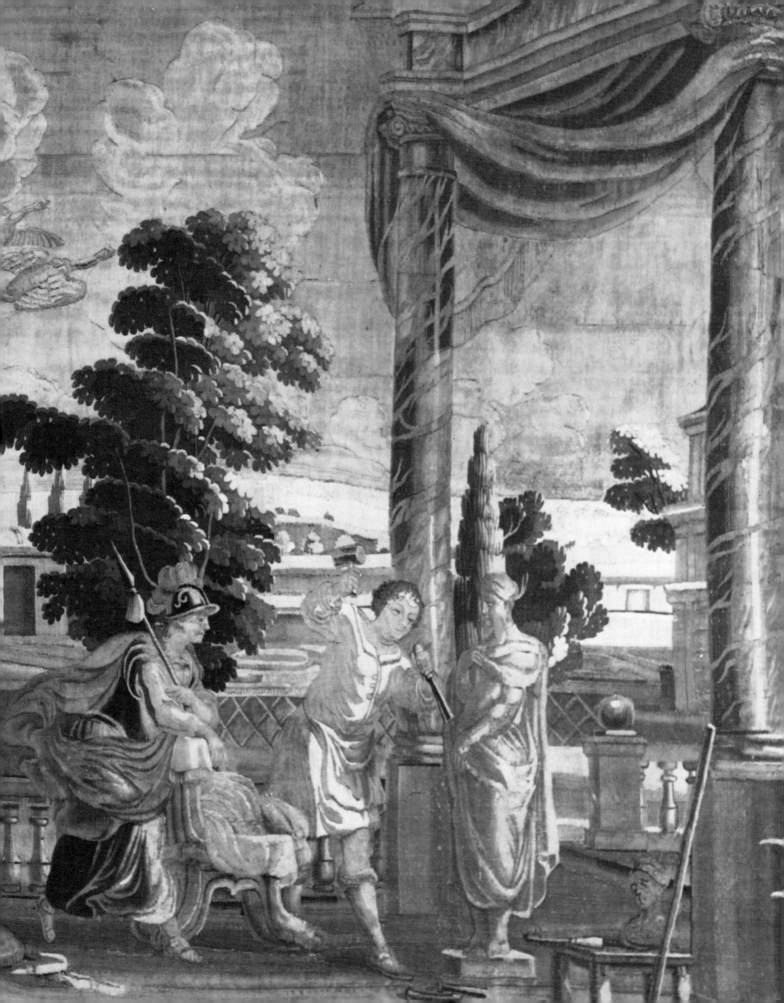

Wendy Hefford

The Chicago *Pygmalion* and the "English Metamorphoses"

In 1953 Mrs. Arthur Cutten gave to the Art Institute of Chicago a tapestry (fig. 9) with a story from Ovid's *Metamorphoses:* Pygmalion, disdaining the women on the island where he lived for their loose morals, creating a life-size statue of a woman in ivory so beautiful that he prays to Venus for a wife "like the ivory maiden." The happy ending to the story, with the goddess of love transforming Pygmalion's statue into living flesh, is not shown in the tapestry; although there is room for a third scene. The small figures are set in a panorama comprising the portico of a noble mansion, a formal garden with covered alleys of topiary work, an ornamental fountain, and a distant landscape. The tapestry is sixteen feet six inches wide by only six feet eleven inches high. The border that it now lacks was most likely to have been one of two narrow patterns found on *Pygmalion* tapestries of the same design in England: either ribbons crossed over a pole, or a bead-and-reel molding.

The Chicago tapestry was attributed to an English workshop of the late seventeenth or early eighteenth century on the authority of H. C. Marillier, who in 1930 published the *Pygmalion* and related pieces in *English Tapestries of the Eighteenth Century*.[1] This work was based on the many small photographs of tapestries in English country houses which Marillier collected in the course of advising on tapestry repair to be carried out by the famous firm of Morris & Co., of which Marillier was Managing Director. He also worked for Christie's and noted all tapestries passing through the sale rooms. Marillier amassed hundreds of these little photographs, which were arranged according to subject in an encyclopedic handwritten catalogue given to the Victoria and Albert Museum in 1946. From among the tapestries with stories from Ovid, he grouped together in one volume of his catalogue all those found in England with narrow borders and low in height which he felt to have a common style, and entitled them "The English Metamorphoses."

This attribution of Marillier's depended on an assumption that tapestries found in great numbers in England and practically unknown elsewhere must have been made in England. He felt uneasy, however, about this statement, scrupulously pointing out that the mark of the English factory at Mortlake[2] on the tapestry with the subject of *Narcissus* at Stone House, Kidderminster, was the only English mark he had found among the multiple series he had listed, and that the Stone House mark was only applied and might not belong to the tapestry. Moreover, a set of *Metamorphoses* tapestries at Boughton House in Northamptonshire,[3] which

includes a tapestry from the same cartoon as the Stone House *Narcissus,* has on it the initials M. W., which he thought might indicate that they, at least, were not English. Marillier's unease was intensified in 1935, when Marthe Crick-Kuntziger published an article showing that another group of tapestries numerous in England, with ciphers of the initials MW and PW, which Marillier had thought were woven in England, were to be attributed to the Antwerp tapestry merchants Michael and Philip Wauters.[4] Her argument was founded on documents concerning the art and trade of Antwerp published by J. Denucé, Keeper of Records in that town.[5] In 1936 he brought out a third volume with even more relevance to the manufacture of tapestries in Antwerp, detailing a period of tapestry sales to England.[6]

Marillier appears not to have studied these published documents, though he wrote in 1940: "I have never felt completely happy about the origin of the Metamorphoses since the Wauters discovery, though the Antwerp inventories make no mention of them." This statement was part of a brief article entitled "The English Metamorphoses. A Confirmation of Origin,"[7] in which Marillier accepted the discovery of four tapestries of the story of Cadmus, which all showed clear Mortlake marks, as vindicating his original theory. Had he lived in 1971 he would have exulted to see at an exhibition in the Vigo-Sternberg Galleries, London, a set of three *Metamorphoses* tapestries with this English mark: a *Mercury and Herse, Cephalus and Procris,* and *Arcas and Calisto.*[8]

Yet these two last subjects were taken from the same designs as two of the *Metamorphoses* at Boughton House, marked with the initials M. W., which Marthe Crick-Kuntziger had shown to be, like the MW cipher, the mark of Michael Wauters used as an alternative on tapestries belonging to series he also signed in full.

In 1953 Mr. George Wingfield Digby gave a paper on Antwerp tapestries made for the English market, in which he accepted the Antwerp identification of the Boughton House tapestries.[9] Twenty years later, an exhibition of Antwerp tapestries with a scholarly catalogue[10] featured an *Arcas and Calisto* from a set of seven tapestries in the town hall at Nijmegen. Three of those tapestries are from the same cartoons as the three *Metamorphoses* at Boughton. The Nijmegen tapestries have no mark; but, as tapestry designed for the Flemish market, fourteen feet high and in a wide baroque border, they have the Flemish character which Marillier could not find in the versions reduced in height made for sale in England.[11]

The writers of the Antwerp catalogue seem not to have known of the three tapestries with English marks shown at the Vigo-Sternberg Galleries, and therefore felt no particular need to supplement the evidence of the M. W. initials for the Antwerp manufacture of this series of tapestries from designs shared by sets at Boughton and Nijmegen. It is nevertheless surprising that while referring to Denucé's work they did not check to see whether the documents which he published in 1936 might firmly identify the Nijmegen set and others from the same cartoons.

After Michael Wauters's death in 1679, the business was carried on by his daughters and their husbands, with Maria-Anna, the eldest daughter, whose initials were the same as her father's, nominally in charge. The firm, with various changes, survived into the early eighteenth century. Eventually a precious bundle of documents was deposited with the Insolvency Court of Antwerp, including details of sales to England between 1682 and 1704.[12] These do not simply give the titles of the series sold, but sometimes name the individual pieces in each set, a process invaluable for series of Ovid's *Metamorphoses* that often had a different story told in each tapestry rather than showing many episodes from the same story in one set. Moreover,

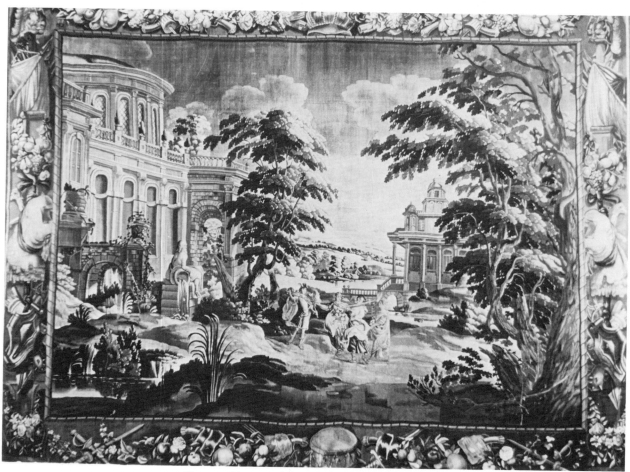

Figure 1. *Mercury and the Nymphs,* from *Het Stauwerken*
series, 1660s or 1670s (or before 1678), Flemish (for sale
by the Antwerp merchant Michael Wauters). Nijmegen,
Townhall. Figures 1–2, 4–5 courtesy the Mayor and
Aldermen of Nijmegen. With the exception of figures 21,
23, 25, and 26, all figures illustrate tapestries woven in
wool and silk.

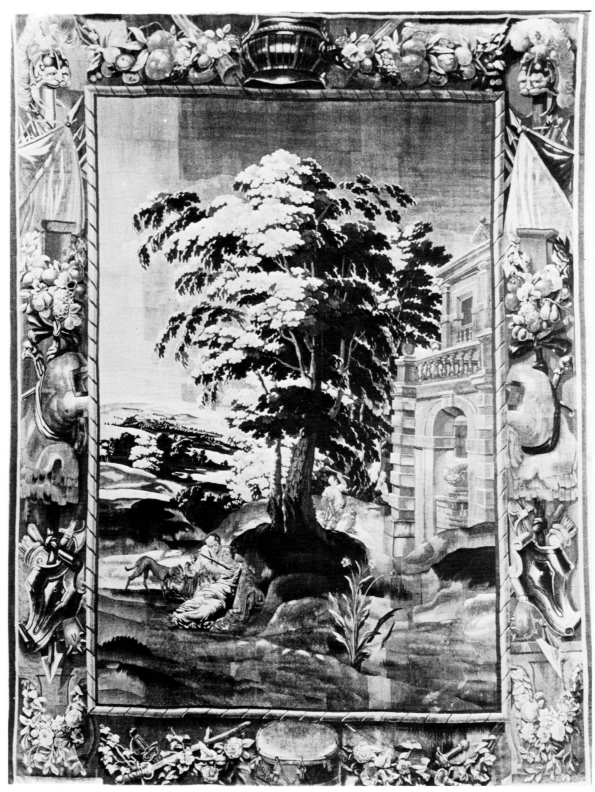

Figure 2. *Cephalus and Procris,* from *Het Stauwerken* series, 1660s or 1670s, Flemish (for sale by the Antwerp merchant Michael Wauters). Nijmegen, Townhall.

these documents record the size of each subject, sizes usually in descending order from eight to three ells[13] so that the customer could choose subjects to approximate to his wall space. The sizes and subjects chosen varied a little, naturally, from set to set; but should one discover a set of tapestries which fitted both the subjects and their proportionate sizes, then this should be sufficient to identify the series of the tapestries with the series of the documents.

This, I believe, can be done with the Nijmegen tapestries. The seven subjects of that set are, in descending order of width:

Mercury accosting the nymph Herse (fig. 1)
Echo with Narcissus, and Narcissus at the Fountain (fig. 7, Castle Ashby)
Atalanta and Meleager (illustrated in Marillier, pl. 33b, the Boughton version)
Arcas aiming an arrow at his mother, Calisto, changed into a bear (fig. 5)
Europa beguiled by Jupiter disguised as a bull, and abducted (fig. 4)
Apollo pursuing Daphne (illustrated in Marillier, pl. 29b, from the Leverhulme sale)
Cephalus casting the dart, and the death of Procris in his arms (fig. 2)

In October 1682 the Antwerp firm sent to London a set of six pieces entitled *Het Stauwerken*,[14] comprising:

Mercury and the nymphs, eight ells wide
Narcissus at the fountain, seven ells wide
Atalanta and Meleager, six ells wide
The Flight from . . . (presumably Daphne from Apollo), five ells
Where Calisto is changed into a bear, four ells
Europa on the bull, three ells

The first three subjects and their proportions correspond exactly to the subjects of the Nijmegen tapestries; the other four correspond in subject but vary slightly in the order of their width. This happens also with the subsequent sets listed in these documents, which also add three alternative subjects: *Procris,* the other subject of the Nijmegen set, and two not so far found associated with tapestries from these cartoons, *Coronis* and a piece entitled *Where Pan plays.*[15]

If the Nijmegen *Metamorphoses* can be equated with the Wauters product of *Het Stauwerken,* then so can the sets recorded in England by Marillier's photographs which show them to be from the same designs. These are at Boughton *(Narcissus, Atalanta and Meleager, Calisto)* and at Castle Ashby in Northamptonshire *(Narcissus, Calisto, Procris),* and were formerly at Borve Lodge[16] *(Narcissus, Calisto, Daphne's flight).* The set, which can still be seen at Castle Ashby, confirms the origin of the series from Michael Wauters's workshop: His MW cipher is woven into the border of *Narcissus* (fig. 8).[17]

It is hardly surprising that a number of these pieces should survive in England when six sets of *Het Stauwerken* are known to have been exported to England between 1682 and 1686 alone. There is nothing to show that the series was new in 1682, although no *Het Stauwerken* appeared in the inventory of cartoons belonging to Michael Wauters, taken on his death in 1679.[18] Certainly the border designs, though pinched in width to make the tapestries for export to England comply with heights fashionable there, are consistent with designs of the 1660s and 1670s. There is, moreover, a tradition that the Nijmegen set was left behind by mistake by negotiators of the Peace of Nijmegen in 1678.

Figure 3. *Mercury and the Nymphs,* from *Het Stauwerken* series, late 17th century, English, after a Flemish design. London, Vigo–Sternberg Galleries (in 1971). Photo courtesy Charles Sternberg.

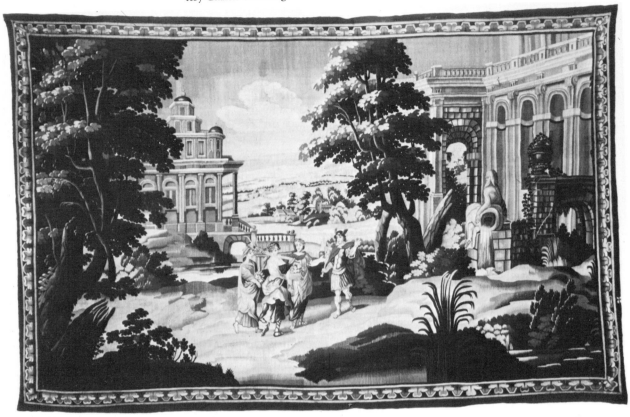

Figure 4. *Europa* (detail), from *Het Stauwerken* series, 1660s or 1670s, Flemish (for sale by the Antwerp merchant Michael Wauters). Nijmegen, Townhall.

So the most dubious series of the "English Metamorphoses" is definitely identified as an Antwerp product of Michael Wauters and his successors, both by M. W. initial and cipher marks, and by documents of sales of the series from 1682. What, then, of the three pieces from the same cartoons, only in reverse, which have the Mortlake mark—the *Mercury and the Nymphs* (fig. 3), *Calisto Changed into a Bear* (fig. 6), and *Cephalus and Procris* (from the same cartoon as fig. 2)—which were at the Vigo-Sternberg Galleries? If in England in the 1680s John Vanderbank could pirate the designs of the great Le Brun and weave English versions of the Gobelins tapestries of *The Elements*,[19] then there seems no reason why other enterprising English workshops should not crib popular designs from among the commercial successes of Antwerp. The virtual cessation of recorded sales to England of *Het Stauwerken* after 1686[20] might indeed reflect the emergence of a native version for sale in London.

Comparison of the marked English pieces with the set marked by the cipher of Michael Wauters at Castle Ashby confirms the likelihood that the Vigo-Sternberg tapestries are copies. As stated, the cartoons of the Sternberg pieces are in reverse of the Flemish ones. This would be normal in a copy made in mirror image on a horizontal loom. In addition, the physical characteristics of the Sternberg and Castle Ashby sets differ slightly, suggesting different workshops. The Castle Ashby weave has a count of sixteen to seventeen warp threads to the inch, the Sternberg pieces one of eighteen to the inch. At Castle Ashby the reds in the tunic of Arcas and in the cloak of Narcissus are modeled with brown, as though a particular shade of red has changed color[21]; in the English pieces the reds are perfectly preserved. Antwerp tapestries sometimes contained excellent reds, as in a tapestry of Orpheus playing to Pluto and Proserpina, in the Art Institute of Chicago, with the cipher of Michael Wauters. But some of the Wauters tapestries were intended for a more highly priced market, and so were more finely woven and had better dyes.[22] The Antwerp tapestries made specifically for the English market, such as some *Playing Children,* with the mark of Philip Wauters, and the *Liberal Arts,* from cartoons owned by Michael Wauters (both sets at Cotehele in Cornwall), have warp counts of sixteen to the inch and show defective reds. By contrast, in the English workshops, whether at Mortlake or the independent factories, eighteen was the lowest warp count usual and the red dyes never failed.

As the Stone House *Calisto, Procris,* and *Narcissus* with the suspect Mortlake mark were also shown by Marillier to be in reverse of the Flemish *Het Stauwerken,* the mark on them does probably belong, and they, too, are English copies.[23]

Given that this particular *Metamorphoses* series has survived in England both as Flemish imports and as English copies, should one therefore suspect the English origin of the designs of the *Cadmus* tapestries published by Marillier in 1940? These four tapestries at Chirk Castle in North Wales have the Mortlake mark; but the style of their figures is reminiscent of other large-scale figures designed for the Antwerp merchants, and the border surrounding them is an exact copy, in many of its features, of the border designed for Michael Wauters on the Castle Ashby *Het Stauwerken.*

Each of these narrow borders has in the top corners a large bird with outstretched wings, holding in its beak a ribbon with a pendant swag of fruit. Along the top are shallow loops of blue ribbon wound with red, on which perch two doves. In the center top are differing features, but each is flanked by animal skins falling in identical folds. In the lower corners a woman sits slumped (fig. 8), holding in her hand a ribbon which supports a swag of laurel;

Figure 5. *Calisto* (detail), from *Het Stauwerken* series, 1660s or 1670s, Flemish (for sale by the Antwerp merchant Michael Wauters). Nijmegen, Townhall.

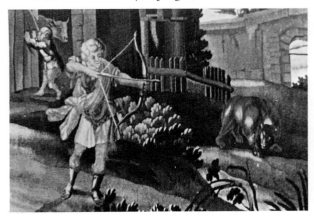

Figure 6. *Calisto Changed into a Bear* (detail), from *Het Stauwerken* series, late 17th century, English. London, Vigo-Sternberg Galleries (in 1971). Photo courtesy Charles Sternberg.

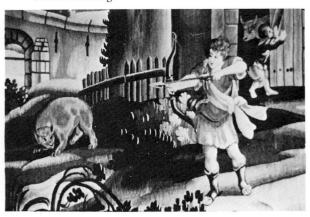

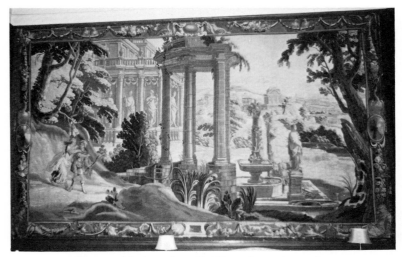

Figure 7. *Narcissus,* from *Het Stauwerken* series, probably 1670s, Flemish (cipher of Michael Wauters). Northamptonshire, Castle Ashby. Photo courtesy the Marquess of Northampton.

Figure 8. Detail of figure 7 showing cipher of Michael Wauters.

then comes more of the blue ribbon wound with red, with fluttering birds clinging to it. Further in, a hound leaps toward the center, where two rabbits flank a pedestal (at Castle Ashby) or a basket of flowers (at Chirk Castle). The side borders differ, and one piece of *Cadmus* has in the top border a springing cat, which corresponds to the hound below. Not only, however, are most of the elements of the composition the same, but they are clearly woven in reverse in the *Cadmus* tapestries. The woman in the right-hand corner there mirrors the one in the left-hand corner at Castle Ashby. At Castle Ashby the left-hand rabbit raises its paw; at Chirk Castle the right-hand rabbit does likewise. This suggests that the *Cadmus* tapestries with the English mark were copied, borders and all, from an Antwerp original having a border almost the same as that used sometimes on *Het Stauwerken*.

The inventory of 1679 shows that Michael Wauters owned two sets of *Cadmus* cartoons, one with large figures, as at Chirk Castle, and one with small. Further, the records of sales published by Denucé show that between 1682 and 1689 six sets of *Cadmus* tapestries were sent from Antwerp to London.[24] And here, too, the subjects and, to some extent, their measurements as itemized correspond with those of the tapestries at Chirk Castle. The four pieces depict Europa, sister of Cadmus, carried away by the bull; the men of Cadmus, who was sent in search of his sister, disturbing a dragon, and Cadmus killing it to revenge their deaths; Cadmus building the town of Thebes; and finally the marriage of Cadmus and Harmonia, daughter of Venus and Mars, before a flaming altar attended by a high priest. The Antwerp sets sent to England included pieces entitled *Europa on the Bull, Cadmus Slays the Dragon, Building the Town,* and *The Sacrifice.* In the last subject the clerk, perhaps not too well versed in mythology, described what was to him the main feature of the marriage scene.

Yet another subject of the seven in the Antwerp series, Cadmus sent by his father in search of his sister, is at Lyme Park in Cheshire, along with pieces of the *Building of Thebes* and the *Rape of Europa*[25] from the same designs as the tapestries at Chirk Castle. The Lyme Park tapestries also seem to provide the missing link of Flemish tapestry which should be found between Flemish records and English tapestries of the same description, for the Chirk Castle scenes are in reverse of the Lyme Park ones; the warp counts are eighteen and sixteen, respectively; and the reds at Lyme Park, while better than in the general run of Antwerp exports to England, do not have the same bright scarlets as the tapestries at Chirk Castle.

So the very foundations of Marillier's arguments for an English origin for the various series of the *Metamorphoses* which he had grouped together, i.e., the English provenance of many of the sets and the genuine English marks found on some pieces, must be seen as no more than proof of an enormous export trade from Antwerp to England and an attempt by English manufacturers to capture some of the market by copying the more successful designs. The sales of the *Cadmus* tapestries, like *Het Stauwerken,* appear to have ceased in the early 1690s. This could mean that their designs were going out of fashion; but it might rather reflect the success of English competition.[26]

Looking at the *Pygmalion* tapestry and its fellows, in this new context, their low height, a warp count of sixteen, and reds intermingled with brown would seem to suggest for them, too, an Antwerp origin. In style, too, the great houses of the *Pygmalion* series are close to those in *Het Stauwerken,* with the mark of Michael Wauters, and the figures are similar to those in the *Esther* tapestries at Petworth with the cipher of Philip Wauters, his brother (fig. 18, and illustrated in Marillier, pls. 16a,b). Surely, then, *Pygmalion* might also be recorded in the

Antwerp archives pertaining to the Wauters family: But a search for it in the documents published by Denucé proved vain. There was no reason, however, for thinking that the series took its title from the Pygmalion subject. In order to check further, it was necessary to reconstruct the whole series, identifying all the subjects in it.

Of the two very narrow borders Marillier had noted as a feature of the "English Metamorphoses," the crossed-ribbon binding round a rod and the bead-and-reel, the latter can be seen on the Petworth *Esther* tapestries with the mark of Philip Wauters (fig. 18), which immediately disposes of any traditional association with English tapestry factories.[27] In fact, these borders are simple reproductions in tapestry of designs for carved wooden moldings such as might be found on the paneling of the rooms into which these very tapestries were set. Their use was widespread, too, in earlier French and Flemish tapestries, representing the inner or outer molding of a carved frame at the edges of broad ornamental borders. But, if unreliable as an indication of origin, the "type borders," as Marillier called them, are useful when found on tapestries of similar subject matter and style in the same ownership, helping to build a picture of the entire series from the various combinations of subjects surviving. Marillier's breakdown of the *Metamorphoses* into their component subjects rather obscured the structure of each particular series;[28] yet it should be remembered that without the information that he recorded no reconstruction would have been possible, so many sets having been sold and broken up since his day.

Working from the Pygmalion subject, three tapestries in the crossed-ribbon border were owned by Lady Denman: *Pygmalion* (fig. 10); a *Narcissus* of the type to be seen in figure 20; and a woman committing suicide by leaping into the sea, which Marillier called *Halcyone* or *Ino* (Marillier, pl. 33a). With the *Pygmalion* owned by Sir Ernest Horlick was the same type of *Narcissus,* both in a bead-and-reel border.[29] At Cotehele in Cornwall, *Pygmalion* is associated with a tapestry portraying Venus and a youth whom Marillier called Telemachus (Marillier, pl. 36a). Lionel Harris of the Spanish Art Gallery purchased from a house in Scotland three pieces in a different border, with fruit: *Pygmalion, Alpheus and Arethusa* (of the type seen in figure 12) and *Cephalus and Procris* (like the one in Marillier, pl. 32a). Finally, Herrmann had four pieces in the crossed-ribbon border: *Pygmalion* in two parts, the *Cephalus and Procris* design, and two more— *Theseus and Ariadne* (as in figure 13), and a piece which Marillier called the *Departure of Telemachus* from Calypso's island (see fig. 19 and Marillier, pl. 36b), in which a youth dressed in cloak and tunic, holding a traveler's staff, walks toward a ship that is manned and waiting for him, while a weeping woman with bared breast is consoled by her companions.[30]

The designs thus associated with *Pygmalion* tapestries could also be found in differing combinations without a surviving *Pygmalion* in the following houses. In the Manor House, Uttoxeter, were *Narcissus, Alpheus and Arethusa, Cephalus and Procris, Theseus and Ariadne.* At Grove, Craven Arms, were *Telemachus and Venus, Theseus and Ariadne,* the *Departure of Telemachus.* At Charterhall, Duns, were *Alpheus and Arethusa* and *Theseus and Ariadne.* At Welbeck Abbey were the suicide of *Halcyone* or *Ino* and *Theseus and Ariadne.* These varied combinations of the same designs prove that they did all belong to what, for convenience, can be called the *Pygmalion* series. Therefore it is possible to add three more subjects in the same style which are associated not with the *Pygmalion* tapestry directly but with those elsewhere associated with it.

At The Vyne, near Basingstoke, the *Telemachus and Venus* in crossed-ribbon border is *en suite* with a woman sitting at a writing desk on a terrace, gazing soulfully at Cupid, who flies

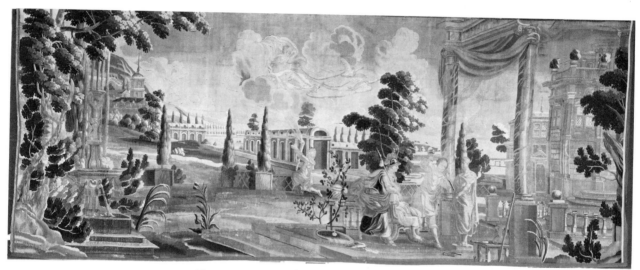

Figure 9. *Pygmalion,* from "Pygmalion" series, 1670s or 1680s, Flemish (here attributed to a design by Daniel Janssens, probably for sale by the Antwerp merchant Philip Wauters). 210.8 x 502.9 cm. The Art Institute of Chicago, Gift of Mrs. Arthur Cutten (53.303).

with a letter toward a departing ship. This particular piece was unknown to Marillier, but the same design in truncated form, lacking the ship, he called *Ovid's Muse* (Marillier, pl. 34b). A set at Arundel Castle in the bead-and-reel border[31] contained *Narcissus, Telemachus and Venus, Alpheus and Arethusa, Cephalus and Procris,* the *Departure of Telemachus,* and yet another subject, *Vertumnus and Pomona* (Marillier, pl. 37a). The latter was again in bead-and-reel in the collection of the Earl of Buckinghamshire along with an *Alpheus and Arethusa;*[32] while the dealer Van Straaten had both these subjects in crossed-ribbon borders along with another new subject, *Arethusa Telling Her Story to Ceres* (Marillier, pl. 30a).

Adding up the individual subjects produces a series of eleven pieces.[33] This would have been an unusually large number for an Antwerp series. Most of the cartoons owned by Michael Wauters were for sets of eight pieces, though one was for nine and one for ten. Actual sales between 1682 and 1704 showed that the most frequently purchased number was six to a set, with an occasional eight pieces, but often only four—several subjects in each set being regarded as alternatives. *Het Stauwerken* had nine optional subjects, and it is conceivable that an extremely popular series might be increased to reach eleven or twelve subjects. On the other hand, these eleven known subjects originally might have been part of two series designed by the same artist, which, because of their similar appearance and subject matter, came to be treated as alternative purchases in one series.

Most of the subjects in the *Pygmalion* series are self-evident from the scenes portrayed; but some are less easily identified. *Pygmalion* itself contains an alien element, the figure with helmet and spear watching the sculptor at work. Marillier called this figure "a hero," though that hero is clearly wearing a long skirt. There is a shield on the ground behind this figure which in the Chicago tapestry is plain (fig. 9), but which at Parham Park in Sussex (fig. 10)[34] and at Cotehele (fig. 11) bears the Gorgon's head, identifying the mysterious figure as Minerva. She had no place at all in the Pygmalion story. Seventeenth-century tapestry did show her, however, watching another sculptor, Prometheus, giving life to the first man, helped by her advice.[35] Could the votive torch of Pygmalion praying to Venus in the background of the tapestry have been confused in the artist's mind with an attribute of Prometheus, who gave fire to mankind, and the two myths have merged in one tapestry? The stories share the metamorphosis of a life-size statue into living flesh.

Equally puzzling, but more happily resolved, were the subjects of four other designs in the series. Telemachus, suggested by Marillier as the hero of two of these tapestries, does not appear in Ovid's *Metamorphoses.* The stories of his departure from Calypso's island and his meeting with Venus were not told by Homer, either, and may not have been current in Europe until the publication in 1699 of Fénélon's *Les Aventures de Télémaque,* too late for our series. In any case, the tapestries do not depict these stories; for the young Telemachus had to be thrown from a cliff to make him leave Calypso's island, and his meeting with Venus was so far from friendly that he had to be protected by Minerva. The two scenes could represent the meeting of Aeneas with his mother, Venus; and Aeneas deserting Dido to sail to his destiny in Italy. But Aeneas was usually represented dressed as a warrior, not in the civilian attire of the young man in the tapestries. Nor would the story of Aeneas take into account the box that Venus is handing to the young man, or the rowing boat behind him.[36]

Similarly, it is hard to see why Cupid is acting as mailman to *Ovid's Muse.* He is present, too, in the *Halcyone* or *Ino* subject, so showing that the woman killed herself for love, and

Figure 10. *Pygmalion* (detail), from "Pygmalion" series, 1670s or 1680s, Flemish. West Sussex, Pulborough, Parham Park. Photo courtesy the Trustees of Parham Park.

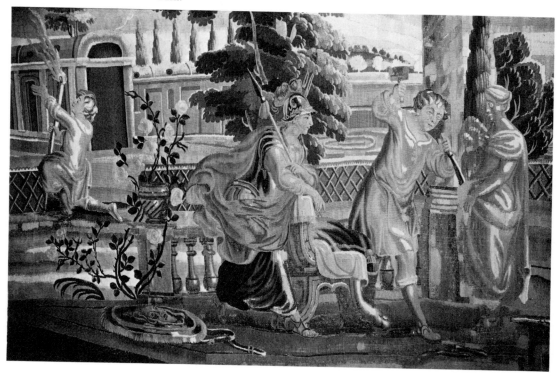

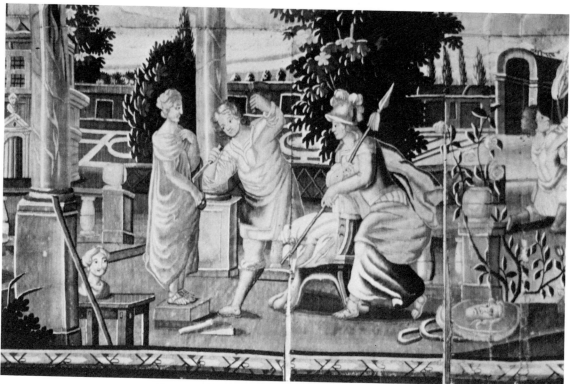

Figure 11. *Pygmalion* (detail), from "Pygmalion" series, 1670s or 1680s, Flemish? Cornwall, Cotehele. Photo courtesy The National Trust.

ruling out Ino, who, driven to madness, threw not only herself but also her young son into the sea. Halcyone, killing herself when her husband was proved drowned, could be the subject of this tapestry; but why, in that case, is the sun in the sky? The sun was usually depicted in mythological tapestries only to indicate the presence of the sun god, Apollo.

The two tapestries of the departing lover and the deserted woman writing to her love are linked by a profusion of books and musical instruments around each unfortunate woman. No story from Ovid's *Metamorphoses* fits these tapestries. I began to wonder, however, whether they might not illustrate Ovid's *Heroides,* in which various unhappy women bemoan their lot in letters written to their absent lovers. In particular, I was attracted by the letter of the poetess Sappho to her young lover Phaon, after he had left her on the island of Lesbos and sailed to Sicily. Sappho's occupation would explain the books and musical instruments, the tools of her trade. Her letter (as written by Ovid) threatened suicide from the Lovers' Leap at Leucate, overlooked by the Temple of Apollo, the god to whom both as lover and as poet she would appeal. This might explain the presence of the sun and of Cupid in the tapestry of the suicide leaping into the sea.

It was in searching through editions of the *Heroides* in the hope of finding illustrations to these three subjects, to support their identification, that I found a version of the fourth subject, used as the headpiece to Sappho's letter.[37] In it, Venus hands a jar to a young man coming ashore from a row boat. The story is that of Venus and the elderly boatman Phaon, who took pity on an old woman and rowed her across the sea without payment, only to find that she was Venus in disguise. The goddess gave him as reward youth and beauty, which, being difficult to render visually, were represented by the gift of a box or jar. The various Greek comedies[38] telling the tale made this Phaon in his youthful guise the lover of Sappho, mixing history and fable. Although the story of the *Venus and Phaon* tapestry was not told in Ovid's *Metamorphoses,* a metamorphosis was involved which might gain it admittance to such a series, particularly if Sappho's story from the *Heroides* was acknowledged by some vague title such as "stories from Ovid."[39]

Although there were now eleven subjects (twelve if Prometheus had any substance) to be checked in the Antwerp archives, the documents published by Denucé still failed to produce a reference that seemed singly or collectively to apply to the *Pygmalion* series. It may, of course, have had a misleading title. Among the sales of the Wauters firm from 1682 to 1704 were numerous sets of *Jupiter and Io* which, when itemized, proved to have no single subject connected with that story.[40]

Failing simple documentary proof of a Flemish origin for the *Pygmalion* series, could this be deduced from technical comparisons in the light of the clear differences found between Antwerp exports to England and the English copies as seen in the *Cadmus* and *Het Stauwerken* tapestries? The Chicago *Pygmalion* has a warp count of sixteen threads to the inch; so does the Parham *Pygmalion* and a piece of *Cephalus and Procris* which has the fountain from a *Pygmalion* tapestry woven in at one side, which was in the hands of Mayorcas, Ltd., London. All three tapestries display the characteristic Flemish dark red streaked with brown. And by a singular piece of good fortune, there is at the Detroit Institute of Arts an *Alpheus and Arethusa* tapestry (fig. 12) with the Mortlake mark. This tapestry has a warp count of eighteen and contains triumphant reds. Its design is in the same direction as an *Alpheus and Arethusa* with distinctive border[41] *en suite* with a *Pygmalion* in reverse of the Chicago and Parham pieces. All this would seem to argue once more for a series that began life in Antwerp and was copied in England.

Figure 12. *Alpheus and Arethusa,* from "Pygmalion" ser-
ies, probably late 17th century, English (possibly from
the workshop of Stephen de May). 181.6 x 266.7 cm. The
Detroit Institute of Arts, Gift of Clarence H. Booth
(49.415).

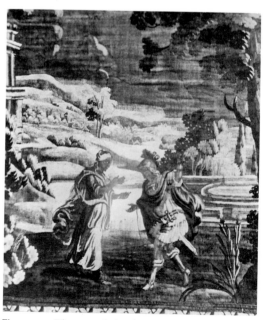

Figure 13. *Theseus and Ariadne* (detail), from "Pygmal-
ion" series, 1670s or 1680s, Flemish. Uttoxeter, Manor
House. (From the Marillier catalogue.)

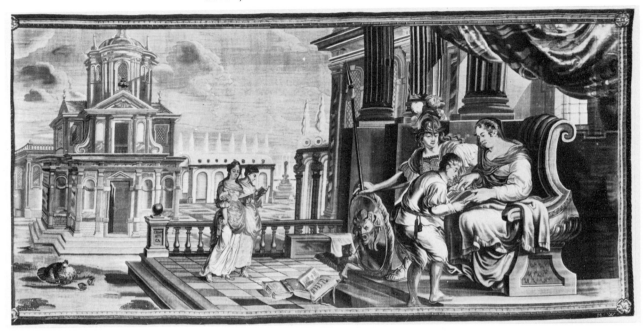

Figure 15. Detail of figure 14 showing head of a boy.

Figure 16. Detail of figure 12 showing head of Alpheus.

The complete picture, however, is not quite so clear-cut. The Cotehele *Pygmalion* (fig. 11) is also in reverse of the Chicago and Parham pieces (figs. 9, 10), and has an intermediate warp count of seventeen and tones of pinkish red in the cloak of Minerva which differ from those in the other tapestries. Yet the Castle Ashby tapestries of Michael Wauters also have a warp count of seventeen, and the *Venus and Phaon* at Cotehele, like the *Pygmalion* there in its warp count, does have the defective reds of the Castle Ashby pieces. So reversal of cartoon alone cannot show whether a tapestry is Flemish or English, but there does still seem to be a physical distinction between the two.[42]

As many pieces of the *Pygmalion* series look like Antwerp tapestries made for the English market, can the designs for the series be identified as the work of an artist employed by the Wauters family, and so resolve all question of origin? Certainly there are many stylistic connections between various Antwerp series and *Pygmalion*. Marillier saw a "strong family resemblance" in the *Ulysses* tapestries (Marillier, pls. 42a, b); and I think that to this he could have added the *Esther* series (fig. 18 and Marillier, pls. 16a, b) and the *Tobias*[43] and *Phaeton* series.[44] The curiously narrow head in profile and curve of neck and shoulders given to the statue in *Pygmalion,* and to Ceres listening to Arethusa, and to Arethusa as she runs from Alpheus, occur also in Calypso watching Ulysses build his boat and in Nausicaa from the *Ulysses* series, in Esther listening to Mordecai, and in Tobias and his bride in the marriage scene, also in some of the sisters of Phaeton. The *Esther* and *Tobias* series have the mark of Philip Wauters. These tapestries, like the *Pygmalion* series, are peopled with figures swathed in indeterminate draperies, with rather ill-coordinated limbs and with faces of similar types. Taking the three women in *Esther Before Ahasuerus* (fig. 18): Esther is related to Sappho in the letter scene; her standing attendant can be compared in profile with Minerva in *Pygmalion,* Arethusa in *Alpheus and Arethusa,* and one of the attendants of Nausicaa in the *Ulysses* series; while the kneeling attendant's face corresponds to Sappho's in the *Departure of Phaon* (fig. 19). Apollo in the *Phaeton* tapestries is remarkably like Phaon in the scene with Venus; and Phaeton asking to drive his father's chariot has the face and turn of head of Cupid in Sappho's suicide. The chariot in the Phaeton tapestry was obviously by the same coach builder as the chariot of Venus bestowing her gift on Phaon.

The buildings in the *Pygmalion* series have for the most part fairly plain façades decorated only by pilasters, fenestration, and some rustication of the lower stories, with prominent balustrades, soaring marble porticoes, and this dignified ensemble made homely by leaded lights in the windows. Similar buildings can be found in the tapestries listed above; but the closest correspondence is with the buildings in *Het Stauwerken.*[45] *Pygmalion,* therefore, has stylistic links with tapestries produced by Philip and Michael Wauters.

There is yet another link suggesting the name of an artist for all these series. The Antwerp exhibition presented a set of the *Liberal Arts*[46] made for Michael Wauters, the subject being listed in his inventory of cartoons in 1679, and one of the surviving tapestries having his initials in the border (fig. 14). Daniel Janssens is named in one of the documents published by Denucé as the artist of the Antwerp series with this title.[47] The *Liberal Arts* contains the same rather solid, strongly marked architecture that is found in the *Pygmalion* series, and, though basically in an urban setting, features one element of a formal garden, which is shown in *Grammar* (fig. 14) and in *Arithmetic,* as though the designer used this motif by habit. This is the topiary arcade topped by a line of pointed trees which occurs time and again in the *Pygmalion* series; promi-

Figure 17. *Three of the Liberal Arts* (detail), from the *Seven Liberal Arts* series, 1660s or 1670s, Flemish (for sale by the Antwerp merchant Michael Wauters). Photo © A.C.L. Brussels.

Figure 18. *Esther Before Ahasuerus* (detail), from a set, probably 1670s, Flemish (mark of Philip Wauters). Sussex, Petworth House, private collection. Photo courtesy the Earl of Egremont.

Figure 19. *Departure of Phaon* (detail), from the "Pygmalion" series, probably Flemish. Herrmann. (From the Marillier catalogue.)

nently in *Venus and Phaon*, in *Sappho Sending Her Letter*, and in *Pygmalion* (fig. 9); in the background of *Alpheus and Arethusa*, *Cephalus and Procris*, *Arethusa Telling Her Tale to Ceres*, and without the line of trees in *Vertumnus and Pomona*. The same feature appears in *Esther Before Ahasuerus* (fig. 18) and in the *Coronation of Esther*, in *Ulysses Discovering Achilles* at the court of Lycomedes, and in *Phaeton* asking to drive his father's chariot.

Close similarities, too, are to be found in the figures. The *Liberal Arts*, who are on a very large scale compared with the little figures in the *Metamorphoses* tapestries, wear the same amorphous garments and present striking similarities of stance and feature. The distinctive profile of the boy learning his grammar (fig. 15) is found again in Alpheus (fig. 16). The two main female types among the *Liberal Arts*, one with a rather pert profile and swept-back hair, and one full or three-quarter face with heavy jowl and soulful eyes, can be seen in the two girls reading on the terrace in the middle distance in *Grammar* (fig. 14) and in the large figures at the right of a tapestry showing all seven Liberal Arts together (fig. 17). Geometry, in the rayed hat, is the image of Sappho in the *Departure of Phaon*, and Sappho's nearest companion there is like Music, who plays the virginals behind Geometry. What is more, although the large-scale figures of the *Liberal Arts* are better drawn than the manikins in the *Metamorphoses* tapestries, in many instances the artist seems still to have had trouble in making heads and necks fit happily to shoulders (fig. 17).

If we can accept that Daniel Janssens was the designer of the *Pygmalion* series, this gives a rough date for their designs, before his death in 1682; and it draws these tapestries firmly within the circle of the Wauters family. The solitary surviving bill from Janssens for work done for Michael and Philip Wauters before 1679 shows that the artist, although then living in Mechlin, was virtually workshop designer to the brothers.[48] The bill itemized all the odd jobs that such a designer would be given: single figures or whole new cartoons to add to existing series, a border pattern sent from Mechlin, six days' work in Antwerp on one project, four on another. A memo to the Forchoudt merchants in Vienna listed complete sets designed by Janssens for Antwerp tapestry makers: eight pieces of the *Liberal Arts*, eight pieces of *Apollo and Daphne*, eight pieces of *Landscapes with Little Figures*.[49] The document is unfortunately not dated. These sets may have been designed as early as the 1660s, when Janssens worked in Antwerp and was Master of the Guild of Painters there. Michael Wauters owned in 1679 cartoons of the same numbers and subjects as those listed, so they were probably the ones designed by Janssens. Michael also had cartoons for *Esther* tapestries which might have dated from after the memo was draw up, and could be those used by his brother, Philip Wauters. The latter had *Esther Before Ahasuerus* tapestries for sale in March 1676, describing their designer as "a certain worthy apprentice of Rubens."[50]

One figure in the *Pygmalion* series was not originally designed by Janssens. This is Narcissus enamored of his own reflection (fig. 20), where Narcissus derives from a design by Antonio Tempesta engraved by P. de Jode and published in Antwerp in 1607 (fig. 21).[51] This figure had been used in at least one tapestry of the early seventeenth century,[52] and it is possible that Janssens borrowed the figure from such a tapestry rather than directly from the engraving. In spite of this alien element, the *Narcissus* tapestry does seem to owe the rest of its design to Janssens and to belong to the *Pygmalion* series. The two women watching Narcissus have the two female facial types found so often in Janssens's work, and the scene is set in a landscape with one of the palatial mansions in his style. Also, as has been shown, the *Narcissus*

Figure 20. *Narcissus* (detail), from the "Pygmalion" series, probably Flemish. Uttoxeter, Manor House. (From the Marillier catalogue.)

Figure 21. P. de Jode, Flemish, engraver, *Narcissus,* 1607, after Antonio Tempesta, Italian (1555–1630). Engraving. Figures 21, 23, 25–26 courtesy the Soprintendenza per i beni artistici e storiche, Bologna.

Figure 22. *Death of Procris,* Flemish? London, Mr. Laurence West. Photo courtesy Mr. Laurence West.

Figure 23. P. de Jode, engraver, *Death of Procris,* 1607, after Tempesta. Engraving.

Figure 24. *Atalanta's Race,* probably 1690s, English (workshop of Stephen de May?). West Sussex, Uppark, private collection. Photo courtesy Mrs. R. J. Meade-Fetherstonhaugh.

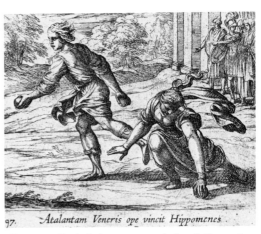

Figure 25. P. de Jode, engraver, *Atalanta's Race,* 1607, after Tempesta. Engraving.

has been found several times associated with *Pygmalion* pieces in the same borders and in the same collections.

This was an important point to establish in reconstructing the *Pygmalion* series, because there also exists, hitherto undetected, a whole series of *Metamorphoses* tapestries based on the designs of Tempesta, some of them in a crossed-ribbon border.[53]

At Uppark in West Sussex there are three of these tapestries: *Atalanta's Race* (fig. 24), *Circe and Picus* (fig. 27), and the *Apulian Shepherd*. Atalanta and her competitor, Hippomenes, the latter throwing down the three golden balls given to him by Venus to delay the fleet-footed Atalanta, have been faithfully copied from Tempesta (fig. 25), as have two of the spectators at the left of the tapestry (to the right in the engraving): Only the heads of the two main figures have been altered slightly, and the scene set in a wooded landscape with the two lions into which the couple were to be changed. Similarly in *Circe and Picus* the attitudes and garments of the goddess and of Picus, who is being turned into a bird for repulsing her advances, are copied from Tempesta (fig. 26); while their heads have been redrawn in seventeenth-century style and a new wooded landscape provided. Marillier illustrated (pl. 29a) an *Apulian Shepherd* at Grove which shows a wide landscape with a vast ornamental fountain in the background and five nymphs dancing to a tambourine played by a sixth nymph, while in the foreground the mocking shepherd is transformed into an olive tree. This leaves out from the Tempesta design only the figure of another nymph playing the triangle. At Uppark the differences are greater: Five nymphs remain, one of the dancers also being left out; and the shepherd himself does not feature in the tapestry, although it is wide enough, a broken tree stump being put in his place.

These three tapestries have brilliant reds and a warp count of eighteen, so are likely to have been woven in an English workshop. A tapestry owned by Mr. Laurence West (fig. 22) shows another Tempesta design, the *Death of Procris* (fig. 23), with a narrow molding border of leaf and dart pattern.[54] This tapestry has a warp count of sixteen and reds now streaked with brown, suggesting a Flemish origin. Again the scene, as with all this series, is set within a wood; and while the figures are extremely close to the originals, the faces have been altered. In this tapestry, too, the position of the dog in relation to Cephalus has been changed. The additional figure of a startled Cupid has been borrowed from a contemporary tapestry of Bacchanalian children in which some boys and a goat are frightened by a grotesque mask (Marillier, pl. 10b).

The Marillier catalogue contains two tiny and rather dim photographs of more Tempesta pieces. A tapestry with figures corresponding to his *Aurora and Cephalus,* again set in an indeterminate wooded landscape, was sold by the Earl Fortescue in 1930; while at Easton Neston is a fragment with *Procris Handing Cephalus the Dart*. Neither of these pieces has its original border.

The tapestries at Uppark provide clues to the date and provenance of some at least of the English copies of *Metamorphoses* tapestries. Uppark was built in the 1690s, and the tapestries must have formed part of the original furnishings of the house, since they were made to fit paneling that has not, so far as can be seen, been altered since the house was built. This approximate dating coincides with the slackening sales of Antwerp tapestries to England in the late 1680s and 1690s. More important, in the left corner of *Circe and Picus* (fig. 27) is a little waterfall over three jagged rocks, with a tree growing from the bank above, two small rocks

Figure 27. *Circe and Picus,* probably 1690s, English (workshop of Stephen de May?). West Sussex, Uppark, private collection. Photo courtesy Mrs. R. J. Meade-Fetherstonhaugh.

136. *Circes concubitum detestatur Picus.*

Figure 26. P. de Jode, engraver, *Circe and Picus,* 1607, after Tempesta. Engraving.

Figure 28. *Month of July,* c. 1700, English (workshop of Stephen de May). London, Victoria and Albert Museum, T. 52-1948.

in the stream below, and foliage from the near bank in silhouette against the water and the massive rock far left. This waterfall and its immediate surroundings are the same in every particular as a waterfall in a tapestry at the Victoria and Albert Museum, London, signed in full by Stephen de May (fig. 28). This tapestry was part of a set of four[55] that featured tiny figures taken from the backgrounds of the designs of the *Months* woven at Mortlake for Charles I, surrounded in these later versions by new landscape to cover the parts where foreground figures would have been in the original design. For Stephen de May to have filled one of these gaps in a harvest scene with this incongruous little waterfall, he must have had the cartoons for it at hand in his workshop; and he is likely to have been the maker of the Uppark *Tempesta Metamorphoses* tapestries.

Stephen de May's family had begun as weavers at Mortlake in the manufactory established by James I. By 1690, when Mortlake was moribund, Stephen had a workshop of his own, using the designs of a number of subjects formerly made at Mortlake, including the *Months*. Accounts paid to him by clients show his workshop to have been highly active in the period from 1690 to 1710. He used the designs of the *Months* full scale as well as in adapted form, and one large double panel of May and July, now privately owned in San Francisco, is likely to be from his workshop. It is of particular interest here because it has the same spiral border pattern with an oak leaf in the corners that is found on the Detroit *Alpheus and Arethusa* (fig. 12).

Examination of the *Pygmalion* series in the context of Marillier's "English Metamorphoses" has shed new light on a number of tapestry series of the second half of the seventeenth century. At least four series have been identified and shown to have a Flemish origin, though later copied in England. The Chicago *Pygmalion* and its Flemish companions appear to have been designed by Daniel Janssens for production either by Michael Wauters of Antwerp or, as the cartoons do not appear in his inventory, more probably by his brother, Philip Wauters. Most likely designed in the early 1670s, the series was made chiefly for the English market and exported so successfully that an enterprising English manufacturer, possibly Stephen de May, was copying it around the late 1680s or 1690s. For a truly English *Metamorphoses*, unless the metamorphosis is that from Flemish into English tapestry, we must look elsewhere.

1. H. C. Marillier, *English Tapestries of the Eighteenth Century. A Handbook to the Post-Mortlake Productions of English Weavers*, London, 1930, intro. and pp. 79–91, pls. 29a–37b. (References to Marillier's plates have been used to supplement the illustrations where possible because of the large number of tapestries involved in this study.)

2. The mark of a white shield with the red cross of St. George was used extensively by later English workshops having no connection with the Mortlake manufactory.

3. Marillier (note 1), pls. 31b and 33b.

4. M. Crick-Kuntziger, "Contribution à l'histoire de la tapisserie Anversoise: les marques et les tentures des Wauters," *Revue Belge d'Archéologie et d'Histoire de l'Art* V, 1 (Jan.–Mar. 1935): 35–44.

5. J. Denucé, "Art-Export in the 17th century in Antwerp: the Firm Forchoudt," *Historical Sources for the Study of Flemish Art*, I, Antwerp, 1931; and "The Antwerp Art Galleries: Inventories of the Art Collections in Antwerp in the 16th and 17th centuries," ibid., II, Antwerp, 1932.

6. Denucé, "Antwerp Art—Tapestry and Trade," *Historical Sources for the Study of Flemish Art* IV, Antwerp, 1936.

7. Marillier, "The English Metamorphoses. A Confirmation of Origin," *The Burlington Magazine* LXXVI (Feb. 1940): 60–63.

8. *Four Hundred Years of English Tapestry*, Vigo-Sternberg Galleries, London, 1971: 30–33, cat. nos. 17–19.

9. G. F. Wingfield Digby, "Tapestries by the Wauters family of Antwerp for the English market," *Het Herfsttij van de Vlaamsche Tapijtkunst*, Brussels, 1959: 227–44.

10. *Antwerpse Wandtapijten*, Het Sterckshof, Deurne, 1973: 67–69, cat. no. 32, and intro. by Dr. E. Duverger.

11. The practice of hanging tapestries above a dado of wainscot, which called for tapestries only eight feet or so high, seems to have been an English fashion, to judge from the letter of Philip Wauters to dealers in Vienna in September 1676 offering hangings "of little depth, in the English taste . . . 3½ ells deep" (cited in Denucé, "Art-Export in the 17th century . . ." [note 5]:200). The Flemish ell was twenty-seven inches.

12. Denucé (note 6):86–111 (Insolv. Boedelskamer, no. 1231).

13. Since the Flemish ell was twenty-seven inches, and the Chicago *Pygmalion* is six feet eleven inches high by sixteen feet six inches wide without a border, the addition of a narrow border would bring it to approximately three and one-half by eight ells, the size of the largest tapestry usually found in an Antwerp set for the English market.

14. Denucé (note 6): 87–88. A literal translation of

the title of this series has no relevance to the subject matter of the tapestries, so it is best left untranslated.

15. Ibid.: 88,93.

16. Leverhulme sale, June 25, 1926. Marillier stated that these tapestries were formerly at Lacock Abbey and were sold at Christie's, London, June 11, 1918.

17. In Marillier's day this edge must have been turned under, or he did not see the mark.

18. Denucé, "Art-Export in the 17th Century . . ." (note 5): 298–303.

19. W. G. Thomson, *Tapestry Weaving in England*, London, 1914: 140–43.

20. The documents in Denucé (note 6: 110) include only a sale of two pieces in 1693.

21. Dr. G. T. van Ysselsteyn (*Tapestry Weaving in the Northern Netherlands* II, Leiden, 1936: lxxvii) noted of the Nijmegen *Stauwerken,* which she called *Celadon and Astrée,* that "there is conspicuously little red." The dyes of the Nijmegen *Arcas and Calisto* exhibited at Deurne were tested by Liliane Masschelein-Kleiner and Luc Maes, "Etude technique de la tapisserie des Pays-Bas Méridionaux. Les tapisseries anversoises des XVI et XVII siècles. Les teintures," *Bulletin de l'Institut Royal du Patrimoine Artistique* 16 (1976–77, published 1978): 143–47. Brazilwood, a very fugitive dye, was found in small quantities in combination with a fast dye in the red-colored wools of this tapestry. It is possible that the red dyes that have faded contained a greater proportion of brazilwood or even relied on it entirely, although its fugitive property was known. More of the faulty dye seems to have been used in the Nijmegen set than in the Castle Ashby *Stauwerken,* and the Nijmegen pieces are also slightly coarser, having a warp count of sixteen to the inch.

22. The *Orpheus* tapestry at Chicago has a warp count of seventeen–eighteen to the inch compared with the *Pygmalion* tapestry there, which has only fifteen–sixteen warp threads to the inch. Differences in quality were clearly distinguished in tapestries listed in the inventory of Michael Wauters, where sets over five ells high were all described as "fine" and from five ells (a set of *Liberal Arts*) down to the three and one-half ells made for the English market the sets were called "coarse." The different qualities and colors could have come from the different workshops to which Michael Wauters sent cartoons for weaving. His inventory of 1679 listed only cartoons and finished tapestries, no looms.

23. The set was sold at Christie's, London, May 6, 1937. Its present location is unknown, preventing warp count and assessment of color.

24. Denucé (note 6): 88, 91, 96, 99, 103, 109.

25. Marillier (note 1: 38) wrote about these tapestries, mistaking the identity of two of them, but commenting on the closeness of the border design to the Stone House *Metamorphoses.*

26. The Chirk Castle *Cadmus* tapestries were thought to be recorded in the purchase of four unnamed tapestries for Sir Thomas Myddelton in 1672 at a cost of £49 12s. This would have been rather early for the English copy of an Antwerp *Cadmus:* But this bill can hardly have been for the four *Cadmus* pieces, which are so large that their price would have worked out at 11s. 6d. the square ell. In 1670 Sir Sackville Crowe was quoting prices of 25s. the ell or 23s. if particularly cheap English tapestry.

27. Marillier (note 1): 81.

28. This led the Deurne cataloguer to link the *Narcissus* of the Manor House, Uttoxeter, which belongs to the *Pygmalion* series, with the completely different *Narcissus* of *Het Stauwerken.*

29. Marillier noted a set of six owned by Sir Ernest Horlick. Four pieces in a spiral ribbon border are of mythological subjects with designs differing both from *Het Stauwerken* and from the *Pygmalion* series.

30. This subject in a wide border with urns, flowers, and fruit in a Flemish style was sold at Sotheby Parke-Bernet, New York, November 2, 1973, lot 349.

31. Sold at Christie's, London, December 13, 1962.

32. Sold at Sotheby's, London, May 13, 1977, lot 9; and February 21, 1978, lot 5.

33. There is, of course, no guarantee that this is the complete series. The set could be named from an unknown twelfth piece.

34. The Parham Park tapestry in crossed-ribbon border is almost identical in other respects to the Chicago piece.

35. As in a Brussels set of *Prometheus* tapestries of the second half of the seventeenth century, in the Palazzo Ducale, Urbino.

36. Marillier wrote delightfully about this subject to A. J. B. Wace at the Victoria and Albert Museum, in regard to the tapestry at Cotehele: ". . . one that I have classified as Telemachus landing on a bank from a boat and to whom Venus is handing what appears to be a box of chocolates."

37. *Ovid's Heroides,* trans. by Harold C. Cannon, London, 1972: 99. The illustration is from an engraving by Giuseppe Zocchi, for a French edition of 1762.

38. See "Phaon/Sappho," in W. Smith, *Dictionary of Greek and Roman Biography and Mythology,* London, 1858.

39. Ovid's name was quite frequently taken in vain, most blatantly in "verdures avec des petites figures du Metamorphose d'Ovide, representant l'histoire de Renauld et Armide" (verdures with small figures from Ovid's *Metamorphoses,* representing the story of Rinaldo and Armida); see Denucé (note 6): 278.

40. The subjects and their usual sizes given in Denucé (note 6: 90ff.): *Jupiter and Mercury,* eight ells; *The Rape of Proserpina and Cyanna in a Fountain,* seven ells; *The Forge,* six ells; *Hermaphrodite and Salamacis; Piramus* and *Ganymede* identify three tapestries from Studley Royal (sold at Christie's, London, January 31, 1980) as the largest three of the *Jupiter and Io* series. A letter to Marillier from their former owner mentions also a *Ganymede,* confirming the identity. At least sixteen sets of this series were sold from Antwerp to London.

41. French and Co., 1930. These appear to be two of the three pieces that Lionel Harris purchased in Scotland.

42. There are also minor differences in the cartoons from which the Cotehele *Pygmalion* was woven: The figures are less skillfully modeled, positions of figures relative to background have been altered, leaded lights changed from diamond to square shape, and trees (easier to weave) hide much of the great house. If Michael and Philip Wauters sent their cartoons to be woven in different workshops, this might account for small differences and for reversals. But the same results might have been due to weaving from repaired and repainted cartoons after much use.

43. Illustrated in Wingfield Digby (note 9), fig. 10; discussed by Marillier (note 1): 111.

44. Discussed by Marillier, ibid.: 97.

45. Van Ysselsteyn (note 21) attributed the designs of *Het Stauwerken* to Daniel Janssens for the figures, Pieter Spierincx for the landscapes. But Marillier showed that the figures of *Atalanta and Meleager* at least come from a tapestry now in the Bowes Museum, and they do not reveal much of Janssens's style; whereas the landscapes with buildings are closer to his work than to that of Spierincx.

46. *Antwerpse Wandtapijten* (note 10): 70–72, nos. 33–38, pls. 22–25. In Britain sets of the *Liberal Arts* can be seen at Cotehele in Cornwall and at Cawdor Castle, Nairn. At Cotehele the border is identical with the one on *Grammar* that is signed M. W.

47. Denucé, "Art-Export in the 17th Century . . ." (note 5): 272. Stadsarchief Antwerpen I. B. 853.

48. Denucé (note 6): 112–13.

49. At least two possibilities for parts of *Pygmalion* in disguise. Denucé, "Art-Export in the 17th Century . . ." (note 5): 272.

50. Ibid.: 199.

51. The whole series of engravings is reproduced in *Incisori Toscani del XV al XVII secolo,* Catalogo generale della raccolta di stampi antiche della Pinacoteca Nazionale di Bologna, IV, Bologna, 1976.

52. A tapestry on the London art market in 1974.

53. The crossed-ribbon border is also found on other series such as a pastoral and mythological set at Cotehele.

54. This illustration of the tapestry is distorted because the photograph had to be taken while the tapestry was in the course of restoration at the Textile Conservation Center, Hampton Court Palace, and the tapestry was too weak to hang.

55. Four tapestries only six feet three inches high sold at Christie's, London, June 24, 1919.

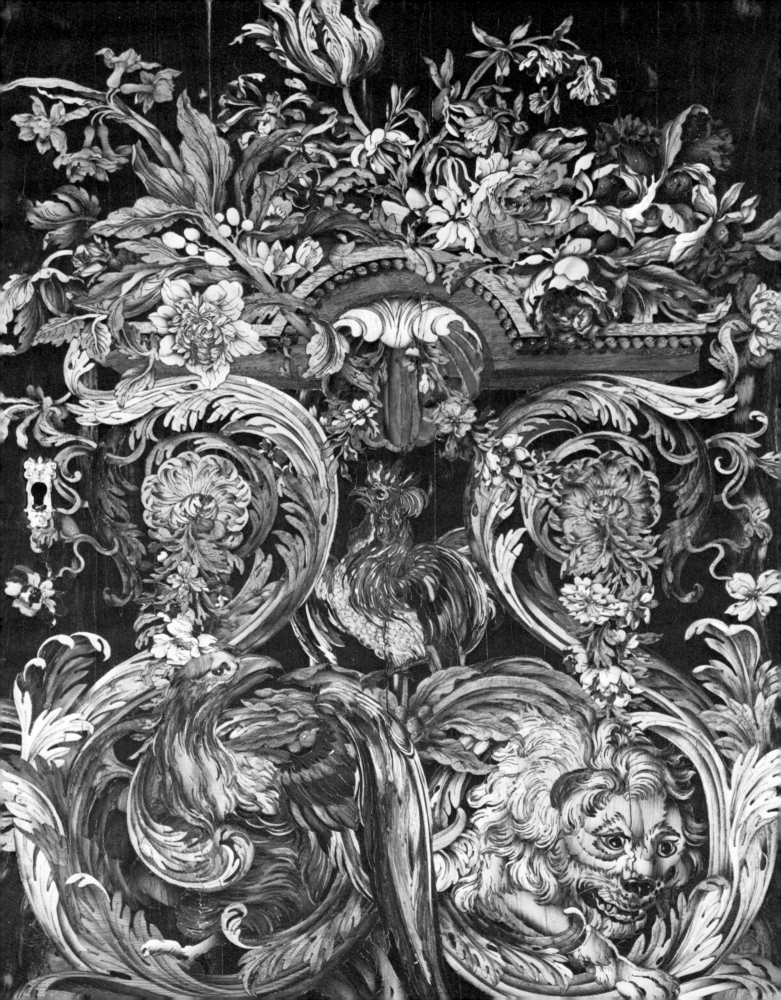

Gillian Wilson

A Late Seventeenth-Century French Cabinet at the J. Paul Getty Museum

In late 1976, a few months after the death of J. Paul Getty, the trustees of the museum he founded agreed to acquire a late seventeenth-century French cabinet from the estate of Lord Gort (fig. 1 ff.). The cabinet, last seen by the public in the 1950s when it was lent to the Bowes Museum at Barnard Castle,[1] is almost identical to a cabinet owned by the Duke of Buccleuch.[2] It is kept in one of his Scottish seats, Drumlanrig Castle. There was some effort on behalf of the British government to refuse an export license for the Gort cabinet, but it was eventually granted, primarily because of the existence in Britain of its pair, standing in a house that had recently been opened to the public.

The morphology of both cabinets is quite remarkable. While they could be classified as cabinets-on-stands, both the decoration of the cabinets and the design of the stands place them outside the general run of cabinets made in the late seventeenth century. The Getty cabinet is veneered with ebony and set with panels of marquetry of natural and stained woods, tortoise-shell, pewter, brass, horn, and ivory. Six of the ten drawers are decorated with pairs of birds among flowering branches; the sides of the cabinet show dogs lying on caskets, enclosed within oak wreaths, with a bird and a ribbon-tied floral garland above, and acanthus scrolls below (fig. 3). At the center of the back of the stand is a circular frame enclosing a bird perched on an oak branch, surrounded by rinceau, swags, ribbons, and flowers. The door of the cabinet is decorated with a crowing cockerel above an eagle and a lion, emerging from scrolls. Above is an arched pediment on which rests a profusion of flowers (p. 118). At the top of the cabinet is a cornice inlaid with brass fleur-de-lys set in a tortoiseshell ground, while at the base is a running Vitruvian scroll of brass and pewter set in a ground of horn, painted red and blue. The cabinet is supported at the front by two large painted wooden figures. Hercules, with a lion's mask on his head, stands to the right (fig. 4), and the female figure on the left may represent Omphale. The bronze mounts on the cabinet are confined to the keyhole escutcheons and a medallion of Louis XIV flanked by military trophies above the door.

The pictorial marquetry on the door enables us to date the cabinet fairly accurately. The cockerel represents France standing triumphantly over the lion of Spain (and the Spanish Nether-lands) and the eagle of the Austrian Empire. Clearly, this symbolism refers to the victories of France in the wars between 1672 and 1678, which ended with the Treaty of Nijmegen, when Spain lost Franche-Comté and Austria lost Freiburg. The theme is found on a number of objects

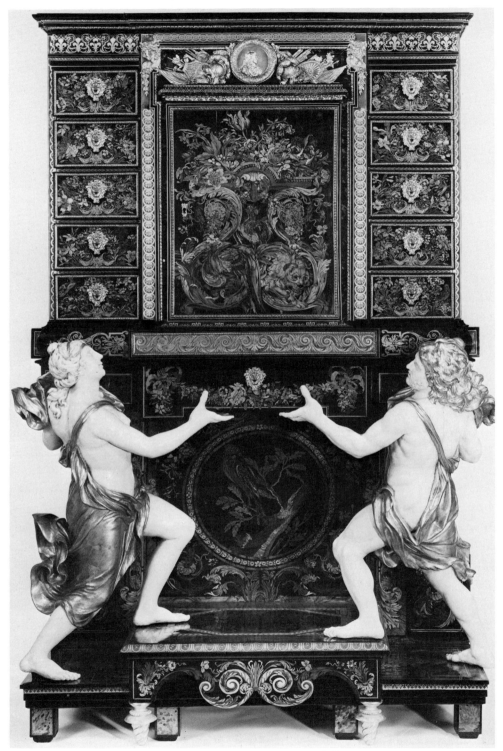

Figure 1. *Cabinet-on-stand,* French (Paris, Gobelins Manu-
factory?), c. 1675. Cabinet veneered in ebony, set with
marquetry panels of natural and stained woods, tortoise-
shell, pewter, brass, horn, ivory, paint; painted wood
figures; stand set with marquetry panels of natural and
stained wood; bronze mounts; 230 x 151 x 66.7 cm.
Malibu, The J. Paul Getty Museum (77.DA.1).

of this period. A silver-gilt frame in the Victoria and Albert Museum[3] bears these animals at its base, with the cockerel holding the leashes of the fallen lions and eagle in its beak (fig. 5). The frame was made by Pierre Germain, and it originally contained a miniature of Louis XIV by Bernard. It was given to the king by Abbé le Houx and was described in some detail in the *Mercure de France* in 1677.[4] The frontispiece of *Campagnes de Louis XIV,* a publication in four volumes that appeared in 1678, shows the cockerel of France attacking the lion, which has already fallen on the eagle-bearing standard of the Austrian Empire.[5]

The medallion of Louis XIV (fig. 6), who is shown dressed *à la romaine,* was cast from an original made by Jean Varin in 1659 (fig. 7), which shows the ruler at the age of twenty-one. The smaller medallion inside the cabinet (fig. 8) is also cast from a model by Varin, made in 1663, when Louis was twenty-five (fig. 9). Unlike the larger medallion on the exterior, the interior medallion is an exact reproduction of the 1663 Varin medal—featuring not only the obverse inscription but also the reverse design with the *Devise du Roi.*[6] The military trophies flanking the large medallion, as well as the inclusion of the figure of Hercules, who, after all, supplanted Apollo in the decoration, begun in 1678, of the Salon de la Guerre at Versailles, make it equally apparent that the theme of the cabinet is the celebration of military victory.

It is not possible, at this point, to say for whom the cabinet and its companion at Drumlanrig were made. They do not appear in any of the known inventories, and the date of their arrival in Britain is not known. They are not found listed among other such cabinets in the inventories of Louis XIV,[7] and it is doubtful that they were made for the king's use. It is conceivable that they were royal gifts; work in the archives of the *Présents du Roi* in the Quai d'Orsay may reveal their original ownership.

Nor is it yet possible to say who made them, although it is certain that they must have been made in Paris. The name of the renowned André Charles Boulle (1642–1732) has been suggested, but so little is known of his work that a secure attribution to him cannot be made at this time.[8] It is more likely that they were made at the royal workshops at the Gobelins, an establishment known to have produced pieces of equal elaboration.

A third piece of furniture, a table also at the J. Paul Getty Museum (fig. 10 ff.), must have been made by the same hand, or at least decorated by the same marqueteur. This table is also decorated with tortoiseshell, ebony, brass, pewter, horn, and woods. On the surface of the top (fig. 11) are four birds which are almost identical to the four birds on the drawers of the cabinet. They must have been cut from the same template or engraving, with only the positioning of their legs altered to fit their surroundings (figs. 12–19). It is possible that these birds may appear on other pieces of furniture of this date for which a signed engraving exists, enabling us to give the cabinet and the table to a specific maker. But such engravings are extremely rare. In their details the birds strongly resemble others found on *pietra dura* plaques of this or earlier date that would have been made either at the *Opifficio délle pietre dure* in Florence or by Italians working at the Gobelins. It is likely that such plaques, available to the marqueteurs at the Gobelins manufactory, were the inspiration for these small finches and sparrows. Or, there may have been a common source for both, as yet unidentified.

The standing cabinet's wooden figures of Hercules and Omphale are extremely-well carved and are fine pieces of sculpture in their own right. There were a number of accomplished carvers and sculptors at the Gobelins and in Paris capable of this work: The names of such artists as Philippe Caffieri, Jean Baptiste Tuby, Martin Desjardins, and Antoine Coysevox can

Figure 2. Detail of figure 1, showing the interior of the
cabinet.

Figure 3. Detail of figure 1, showing the side of the cabinet.

Figure 4. Detail of figure 1, showing Hercules.

Figure 5. Pierre Germain, French (1645–1684). Frame (detail of base), c. 1677. Silver gilt. London, Victoria and Albert Museum, Jones Collection.

Figure 6. Detail of figure 1, showing the gilt-bronze medallion of Louis XIV on the exterior of the cabinet, cast from a medal by Jean Varin (see figure 7).

Figure 7. Jean Varin, French (1596–1672). Medal of Louis XIV at age twenty-one, 1659. Bronze. London, British Museum.

Figure 8. Detail of figure 1, showing the gilt-bronze medallion of Louis XIV in the interior of the cabinet, cast from a medal by Jean Varin (see figure 9).

Figure 9. Jean Varin. Medal of Louis XIV at age twenty-five, 1663. Bronze. London, British Museum.

be mentioned. The figures on the Getty cabinet are identical in all respects to those on the Drumlanrig piece: All four must have been carved from two original models, apparently long since destroyed. While each figure appears to support the cabinet with one hand, in the other hand, hidden from view, each holds a short stick which serves no functional or decorative purpose (fig. 20). This extremely puzzling feature may indicate that the figures were not originally made for the cabinet but for some other context. Were they part of a room decoration? Did the hands now bearing the sticks once hold candelabra, and, if so, what did the figures support with their exposed hands?[9] If they were originally included in some other decorative scheme, they probably were carved at an earlier date than that of the cabinet.[10]

When the cabinet was acquired by the Getty Museum, the figures were covered with dark brown bronze paint (fig. 21). The whole cabinet was in relatively poor condition: The carcass was sound, but the marquetry was loose in many places. During its restoration by H. J. Hatfield, London, it was noticed that in areas where brown paint had peeled away, a cream-colored paint layer existed that was almost completely intact. The cream-colored paint has heavy craquelure (fig. 22), showing that the surface had been exposed to air for many years. It was also discovered that the hair and lion's mask of Hercules had been gilded, as had been the ribbons binding Omphale's hair. The brown paint was chemically analyzed, but all the components used in the paint—chalk ($CaCO_3$), vermillion (H_9S), wax, beaten-copper flakes, burnt-sienna pigment, lead, litharge (Pb_3O_4), and gold—are traditional elements, none being of recent manufacture and, therefore, undatable.[11] Although the contrast between the cream figures and the dark background of the cabinet is somewhat startling, it is quite in keeping with the Baroque style: One has only to stand in the Salon de la Guerre and see the juxtaposition of white and colored marbles with the gilt and darkly patinated bronzes to understand that such schemes were typical of the period.

The known provenance of both the Getty and the Drumlanrig cabinets is as yet fairly short. In about 1900 the Getty cabinet belonged to the second Earl of Dudley, and it stood in Witley Court, Worcestershire, one of his country seats.[12] In the early decades of the century, Witley was sold to Sir Herbert Smith, who apparently had made his fortune selling blankets to the government during World War I. However, Witley was almost totally destroyed by fire in 1937. The cabinet was saved; it was sold in Northampton by Jackson Stops and Staff on September 29, 1938.[13] It was acquired for £250 by Mrs. Violet van der Elst, a famous eccentric of her day, who took it to her great nineteenth-century pile, Harlaxton Manor, Lincolnshire.[14] She placed the cabinet at auction at Christie's on April 8, 1948, when it was sold to Lord Gort for £240.[15] It remained in his possession until his death, when it was acquired by the Getty Museum.

The companion cabinet at Drumlanrig is reputed to have been given by Louis XIV to Charles II, who in turn gave it to his illegitimate son, Lord Monmouth, the child of Lucy Walters. Monmouth had married Anne, Countess of Buccleuch, in 1663, and on that day the dukedom was created. As Monmouth was banished by Charles in 1679 and executed in 1685, the story of such a gift is unlikely. In addition, there are no documents to support it: As yet, the Drumlanrig cabinet has not been found in the extensive Buccleuch archives, in which a number of grandes cabinettes are mentioned, but none with sufficient description to identify this piece.

On the other hand, the now well-known nineteenth-century dealer Edward Holmes Baldock (whom Geoffrey de Bellaigue recently revealed as the user of the EHB stamp that has confused furniture historians for so long[16]) worked frequently for the Buccleuch family, selling

Figure 10. *Table,* French (Paris, Gobelins Manufactory?), c. 1675. Veneered in ebony, set with marquetry panels of tortoiseshell, ebony, brass, pewter, horn, and stained and natural woods; 72 x 110.5 x 73.6 cm. Malibu, The J. Paul Getty Museum (71.DA.100).

Figure 11. Detail of figure 10, showing top.

Figures 12–15. Details of figure 1, showing marquetry birds from cabinet drawers.

Figures 16–19. Details of figure 10, showing marquetry birds from top.

Figure 20. Detail of figure 1, during restoration, showing
right hand of Hercules holding a short stick.

Figure 21. Figure 1, before restoration, showing Hercules
and Omphale covered with brown bronze paint.

Figure 22. Detail of figure 1, during restoration, showing
craquelure of cream-colored paint on the face of Hercules.

them furniture he made, furniture he "improved," and genuine earlier pieces. It was he, for example, who sold to them, in 1832, the famous Beaumarchais desk that is now at Waddesdon Manor.[17] The Buccleuchs also owned the desk made for the Elector of Bavaria, now in the Musée du Louvre, Paris, which may also have been sold to them by Baldock. It was Baldock who sold the pair of cabinets by Domenico Cucci to the Duke of Northumberland in 1824.[18] Working in the early decades of the nineteenth century, Baldock seems to have been able to procure such pieces from France, and he found a ready market for them among the British aristocracy. It is conceivable that it was he who owned both the Drumlanrig and Getty cabinets, selling one to the Buccleuchs and the other to the Dudleys. It is also possible that it was Baldock who covered the cream figures with brown paint, both to cover up damage and to make them slightly less startling in appearance. Extensive work must be done in both the Dudley and the Buccleuch archives to establish this, and at the moment the introduction of Baldock's name in connection with the cabinets is quite tentative.

The fact that no certain provenance can be established for the Getty cabinet before 1900 and that the name of its maker is not yet known in no way detracts from its extreme beauty and importance. It stands today, suitably decorated with blue-and-white Kangxi pots, in the museum's gallery as the finest piece of furniture of its date in America, and indeed it vies with other late-seventeenth-century French cabinets in the private and public collections of Europe.

1. Illustrated in *Le Dix-Septième Siècle Français*, Collection Connaissance des Arts 3, Paris, 1958: 53.

2. Illustrated in Nancy Mitford, *The Sun King*, New York, 1966, opp. p. 192. The major differences in the decoration of the two cabinets are as follows: The central door of the Drumlanrig cabinet, while bearing an identical lion, eagle, and cockerel, has on its upper third a ribbon bow, from which are suspended two floral pendants flanking a floral hymenal crown. Birds perch at the tops of the scrolls that encircle the lion and the eagle. The sides of this cabinet are decorated with large vases of flowers on lambrequins of pewter and horn, rather than with the dog, casket, and oak wreath on the Getty piece. The drawer fronts of the Drumlanrig cabinet have fewer flowers, and there is no Vitruvian scroll running along the base. The false drawer front below the cabinet is decorated with a scrolled strapwork platform set with acanthus leaves and supporting a large central spray and small sprays of flowers at either end. At the center of the back of the stand of the Drumlanrig cabinet is a hexagonal frame surrounding an oak branch on which several birds are perched. The surrounding decoration of the central panel of the back is also of different design, as is the floral decoration on the outer sections of the base. While in both cabinets the marquetry on the inside of the door consists of a vase of flowers on a plinth with incurving legs, each cabinet features quite a different design. The interior of the Drumlanrig cabinet is decorated with a watercolor scene of a garden and a large fountain. The Getty cabinet's interior contains an arrangement of pilasters, capitals, and mirrors. Neither scheme is thought to be original.

3. Acc. no. 738-1882; discussed in R. Lightbown, *French Silver*, London, 1978: 59, no. 40. The frame is decorated with twin lions, symbolizing the political division of the Low Countries into the United Provinces and the Spanish Netherlands during the seventeenth century.

4. I am grateful to Anna Somers-Codes, Assistant Keeper, Department of Metalwork, Victoria and Albert Museum, London, for this information.

5. See *Collections de Louis XIV*, exh. cat., Orangérie des Tuileries, Paris, 1977: 247–48, no. 242, ill. p. 246.

6. The reverse, like the obverse, bears the date 1663. The identical medal in the Drumlanrig cabinet is dated 1664.

7. See J. Guiffrey, *Inventaire Général du Mobilier de la Couronne sous Louis XIV (1663–1715)*, Paris, 1885.

8. The only documented pieces made by Boulle are the pair of commodes made for the Trianon in 1708, which are today in the Musée de Versailles.

9. Someone was equally confused by the inclusion of these sticks in the Drumlanrig cabinet. A carver, who was perhaps local, extended the stick held by Hercules into a somewhat crudely carved club, while Omphale's was lengthened into a large palm frond. Covered with gold paint, these additions would seem to be relatively recent.

10. See, for instance, a pair of sculpted and painted blackamoors, of approximately the same size and in poses similar to those of the figures on the cabinet, who hold a large terracotta vase in their hands. They were made in Florence about 1690 and were exhibited at *The Twilight of the Medici*, exh. cat., Detroit Institute of Arts, 1974: 394, no. 226, ill. I am grateful to Deborah Shinn for pointing this out to me.

11. The paint layers were analyzed by John Twilley.

12. Presumably, the Earl of Dudley bought Witley Court from the fifth Baron Foley at the end of the nineteenth century. It is possible that the cabinet was bought with the house, as the Foleys were also great collectors.

13. Lot 582. It is illustrated in the sale catalogue and described as a "rare marqueterie and Boulle Flemish cabinet."

14. I am grateful to Anthony Winston for this information.

15. Lot 142. It is not illustrated in the sales catalogue.

16. G. de Bellaigue, "Edward Holmes Baldock," *Connoisseur* 189, 762 (Aug. 1975): 290–99; 190, 763 (Sept. 1975): 18–25.

17. Bellaigue, *Furniture, Clocks, Gilt-bronzes*, I, *The James A. de Rothschild Collection at Waddesdon Manor*, Fribourg, 1974: 308–26, no. 65.

18. P. Verlet, *French Royal Furniture*, London, 1963: 101, no. 1, figs. 1a–e, and color frontispiece.

Lorenz Eitner

Géricault's Compositional Method: Sketches for the *Farrier's Signboard* in the Art Institute

Complex works of art, besides belonging to general art history, also have a history of their own, the story of their internal development. The stages through which they pass between conception and execution may involve changes that deeply affect the meaning of the finished work but are often no longer apparent in it. To grasp the significance of such a work, it is not enough to examine its final state: It is necessary to look into the process that gave it birth, into the earlier intentions, discarded solutions, and passing influences that lie hidden, but are not inconsequential, beneath the surface of their completed form. This requires an examination of the preliminary sketches and studies that document the process. The habitual methods artists use in constructing their work are an important determinant of their style. They differ from artist to artist and can be understood only through an effort of reconstruction in which the preliminaries are gathered and put into the sequence in which they spell out the course of the creative process. Such an effort of reconstruction, a form of archeology, can yield fascinating insights into the intimate aspects of the artist's individuality; into his habits of invention and image-making; into his struggles, decisions, and renunciations. There is great drama in watching an idea unfold and assume new, often unexpected forms and meanings.

The following observations concern a particular artist's manner of working. It is based on a group of sketches that in themselves may seem small and perhaps inconsequential. They form part of a pair of sketchbook fragments acquired by the Art Institute of Chicago through the generosity of Mrs. Tiffany Blake. Collectively referred to as the *Chicago Album,* these fragments contain drawings that were executed by Théodore Géricault during two important moments of his life. The earlier, which will particularly concern us here, dates from 1813 through 1814. These years span the time of Napoleon's fall and the first restoration of the Bourbon monarchy. Still early in Géricault's career, it was a time when he strenuously searched for new subject matter and a new style. I shall concentrate on only four pages from this sketchbook fragment, in which there are some twenty sketches.

At the age of only twenty-one, Géricault had won an important success at the Salon of 1812, the great biennial picture exhibition which presented to the French public work by living

French artists. At this Salon, the last to be held under the empire, Géricault submitted the painting *Charging Chasseur,* the "portrait" of an officer of the elite guard of the emperor commanding a charge (fig. 1).

Although exhibited at the Salon as a portrait, it really is an emblematic image. The particular originality of this painting is that it does not express an idea in biographic or historic terms. It is not about a person or an event but rather about dramatic conflict. The spirit of war is embodied in the furious animal. The officer, representing the human ethos, imposes his will on the raging beast. The visual impact of the image as well as its significance hinge on the representation of a contest between what might be considered a force of nature, the demonic energy of the horse, and the higher moral purpose of a human being. In this rapidly improvised work, a work in every sense *youthful,* Géricault gave a first proof of what was to be his special achievement: the casting of modern subject matter into powerfully expressive forms that transcend the merely contemporary and present their theme in a broadly human perspective.

Aware of his need for further study, Géricault spent the two years following the painting of the *Charging Chasseur* in an attempt at self-training, doing work of a private sort and of modest scale. The years of Napoleon's decline and fall did not fill him with tensions or anguish. He seems to have witnessed the collapse of the empire as a fascinated but passive spectator. The ideas that occupied his mind when France's fate hung in the balance can be sampled in some of the leaves of the earlier of the two partial sketchbooks in the Art Institute. These sheets are crowded with small drawings full of lively activity but giving no very clear indication of the direction in which Géricault was going. Many of them are casual sketches from life; others are ideas for military subjects, or for pictures that may have been inspired by the martial excitements of the time, but contain no hint of the harsh realities of war. The mood throughout this part of the sketchbook is cheerful and brisk; a profusion of diminutive horsemen dart about the pages on horses that prance and rear. There is much petty movement in these small compositions, but nothing of the *Chasseur's* powerful momentum. The execution of the drawings is light and precise, and their tonal refinement is echoed in the delicacy of color and tone that distinguishes the several small oil studies that Géricault based on them. There are ideas in the Chicago sketchbooks for the *Three Trumpeters* (Washington, D.C., National Gallery) and for the *Polish Lancer* (Glasgow, Art Gallery). If the *Charging Chasseur* of 1812 had represented Géricault's earlier distinctive manner, these small-scale military subjects of about 1813–14, together with the sketches for them, indicate a second style, a further development that brought with it a shift from expressive vehemence to refined naturalism and descriptive subtlety. These works apparently did not fully satisfy his ambition. There is evidence among the drawings in the Chicago sketchbooks and other works of that time of a striving for larger, more complex, and more significant themes. But his efforts in this direction remained unrealized, with only one exception: the *Farrier's Signboard,* in the Zurich Kunsthaus (fig. 2).

Larger than the small military compositions of this period, and designed for display rather than private study, this picture may have been undertaken half playfully as a favor for some particular farrier of Géricault's acquaintance. Vigorously brushed in oil on a roughly carpentered door or shutter, it may have served for a time as the shop sign of an actual smithy. Elaborate signboards, sometimes of high artistic value, were a common sight in Paris. The reason why Géricault painted this work is unknown. He was certainly not paid for it, but may have been tempted by the challenge the project offered him, and the chance to try his hand experimentally

Figure 1. Théodore Géricault, French (1791–1824).
Charging Chasseur, 1812. Oil on canvas; 292 x 194
cm. Paris, Musée du Louvre. Photo courtesy the
Réunion des Musées Nationaux.

Figure 2. Géricault. *Farrier's Signboard*, 1813–14. Oil on
panel; 125 x 103 cm. Zurich, Kunsthaus. Photo courtesy
Walter Dräyer, Zurich.

Figure 3. Géricault. *Folio 53v from the Chicago Album.*
Graphite, gray-brown wash on ivory wove paper; 23.3 x
17.5 cm. All of the sheets from the *Chicago Album* date
from 1813 to 1814 and are in the Art Institute of Chicago,
Margaret Day Blake Collection.

at compositions of monumental conception, though within a moderate format, and without any need to consider the tastes and opinions of Salon juries, critics, or the general public.

The *Farrier's Signboard* marks a turning point in Géricault's development. It measures only about four feet in height and three in width, but it rivals in grandeur and power—despite its humble destination—Géricault's much larger Salon entry of 1812, the *Charging Chasseur*. The drama of conflict between human and animal force is common to both. New, and of great importance to Géricault's later development, is the powerful, static monumentality of its composition, the sombre massiveness of its figure, and the dramatic urgency of its expression. The picture has little in common with the small, elegant, colorful military compositions that immediately preceded it; its severe grandeur suggests a conscious renunciation of their light-hearted brilliance. The overall effect of the *Farrier* is one of blunt directness and corporeality. From the brownish gloom of the cavernous smithy the figures emerge into a grazing light that powerfully models their bodies. The enormous horse is dappled with restless highlights that are like an expression of its inward excitement. The farrier stands in a defiant posture, legs apart and firmly planted on the ground, one muscular arm raised to restrain his horse, the other grasping an iron hammer as if it were a weapon. Everything about the picture's execution suggests speed; its rude energy of touch is like a repudiation of the delicacy of execution that had marked Géricault's earlier work. He painted the *Farrier* directly on the unprepared wooden boards, indifferent to their gaping joints and protruding nailheads. Yet the picture is by no means a spontaneous improvisation, but the product of an intricate and rather gradual development. The *Farrier's Signboard,* in fact, offers the earliest instance of a progressive sequence of closely linked sketches that was to become Géricault's usual method of composition.

This method is illustrated in the Chicago sketchbooks by the more than twenty small pencil drawings on folios 38, 39, 40, and 53, which spell out successive steps by which not only the forms but also the significance of the image slowly assumed their final disposition. The process is so continuous, the development so steadily progressive that we receive an almost cinematographic demonstration of the workings of Géricault's mind in the labor of invention and composition.

Although the sketches are no longer in their original sequence in the present pagination of the sketchbooks, their proper order can be reconstructed with the aid of linkages from sketch to sketch. The work of composition developed in four stages representing, perhaps, as many fresh starts or changes of mind. But, with characteristic economy, Géricault preserved something of each and carried it over into the subsequent stages. Géricault's first ideas for the *Farrier's Signboard* offer very little hint of the final solution. The least developed of these sketches, and quite likely the earliest, on folio 53v (fig. 3), shows a horse in oblique rear view, rising, not unlike the horse of the *Charging Chasseur,* while the farrier busies himself with the animal's right foreleg. It is the first rough jotting for a genre scene, illustrating the typical activity of a farrier.

Such a scene appears much more fully elaborated on folio 40r of the Chicago sketchbooks (fig. 4). A massive draft horse in profile view, facing to the right, is about to be shod by the farrier, who stands in front of it, somewhat to one side, holding his hammer in one hand while placing a nail on the hoof that is being held up to him by an assistant who faces him from the right. In the background, Géricault has indicated doorways, masonry, arches, windows—the setting of the rustic smithy. On the verso of the sheet, the architecture of this shed is detailed

further. Though small, these sketches are remarkably precise and definite. Géricault visualized the scene in his imagination, for there is no reason to suppose that he sketched it from life, in the profuse descriptive detail of a popular genre tradition. It is a scene entirely appropriate for a shop sign, according to the conventions of that type. On folio 38r and v (figs. 5–6), Géricault drew again, with even more precision, the figures of the farrier and his assistant, and the assistant's arms holding the hoof that is about to be shod. A childish hand, certainly not Géricault's, has irreverently added a pipe to the farrier's mouth.

Géricault's next step was to simplify the composition and to deprive it of its genre character. On folio 38r, together with a detail study for the scene of shoeing, there is a small, lightly drawn sketch that shows the horse, fully harnessed, facing to the left. It is held by the farrier, who raises his arm, as he confronts the rearing animal, to seize it by the reins. On folio 39v (fig. 7), there are similar sketches. One of them, near the top of the page, shows the farrier standing in front of the horse, raising his hammer as if to fasten the shoe. This is a quasi-narrative touch that still connects this second version of the composition to the genre emphasis of the first. A small individual study of the farrier in the act of shoeing is to be found on folio 38v. The other sketches of this compositional version all stress the confrontation of man and animal, without suggesting any particular action. Farrier and horse face each other in an arrangement that, in contrast to the casual realism of the earlier version, is quite strikingly formal and symmetrical. All descriptive work has been reduced or suppressed.

In the following revision of the composition, on folio 39r (fig. 8), the horse, still facing to the left, is turned obliquely toward the viewer. The farrier, somewhat overshadowed by the animal's height, now is positioned more distinctly behind, rather than in front of, it. The horse no longer rears but stands, head thrown up, its right foreleg bent back, ready to be shod. This is the last, rather slight vestige of what was originally the main action of the composition. The effect of the successive changes up to this point has been to simplify and monumentalize the group. The extended, friezelike arrangement of the two earlier versions now becomes compressed into a tall, triangular grouping in which the horse strongly predominates. Its head, formerly almost level with the farrier's, now rises high above it to form the dramatic apex.

The final solution suggested itself at this point. Géricault turned the horse to the right and placed the farrier squarely in front of it, one arm raised to hold the rein, the other grasping the hammer. Not all elements are fully integrated. The massive pyramidal shape of the horse frames the figure of the farrier. The animal's impetuous rise is countered by the farrier's commanding gesture and firm stance. One stable form is made to encompass the conflict of the two figures. The rightward turn of the group at this, the final stage of the compositional process, is a characteristic oddity of Géricault's method, anticipated by a similar reversal in the final development of the *Charging Chasseur* and later repeated in nearly all of Géricault's major projects.

The successive steps in the composition of the *Farrier's Signboard* lead from a diffuse and rather structureless realism to terse monumentality, from detailed description to expressive suggestion. Every change tends to simplify and concentrate the composition, raising the subject from the plane of casual genre to momentous symbolism. The fact that this development is confined to a series of small pencil sketches contained in no more than four sheets of a crowded sketchbook can mislead one to think of them as hasty improvisations and to overlook their actual precision and consecutiveness—the logic that runs through the sequence. Every one of these tiny drawings contributes some particular feature to the composition's develop-

Figure 4. Géricault. *Folio 40r from the Chicago Album.*
Graphite on ivory wove paper; 17.3 x 23.1 cm.

Figure 5. Géricault. *Folio 38r from the Chicago Album.*
Graphite on cream wove paper; 17.4 x 23.1 cm.

Figure 6. Géricault. *Folio 38v from the Chicago Album.*
Graphite on cream wove paper; 17.4 x 23.1 cm.

Figure 7. Géricault. *Folio 39v from the Chicago Album.*
Graphite on cream wove paper; 17.5 x 23.2 cm.

ment; every one embodies a thought. In their progress toward an image almost entirely unforeseen at the outset, the drawings spell out, if put in their proper sequence, the tempo and direction of Géricault's thought.

His imagination worked slowly but very concretely. His greatest difficulty was in finding a starting image: in this instance, the shoeing scene. Once he had found this he was able, by means of piecemeal transformations, to mold it to his gradually unfolding intention. He began to understand his image and its latent meaning only as he worked on it. In the course of these transformations, he treated the various parts of his composition as distinct, detachable entities. Without radically changing their appearance and their gestures, he constantly modified the positions of his figures relative to one another, treating his composition as an assemblage of parts, rather than a coherent structure. In composing the *Farrier's Signboard,* he moved its component parts about, gathering them up into ever more compact groupings. The process was a completely arbitrary one, prompted at every point by expressive and stylistic considerations, quite unaffected by any direct observation. Géricault did not develop this composition from visual observation.

The thumbnail sketches for the *Farrier's Signboard* in the *Chicago Album* constitute the earliest known compositional sequence of some complexity in Géricault's work. Modest as they may seem, they are an important document of the beginnings of a method that was to reach its most complete expression in his *Raft of the Medusa* (Paris, Musée du Louvre), a method expressive of his personality and as much a part of his style as his choice of colors or his treatment of the human body.

His gift of distinct visualization, his need for a definite form at every step of the work, and his dislike of vague or incomplete shapes guided this process. All the preliminary versions of the *Farrier's Signboard* are, in their own way, complete and capable of larger-scale execution, as is shown by the separate figure studies that accompany them.

Géricault's *Farrier's Signboard* restates the dramatic theme of his *Charging Chasseur,* the contest between man and animal, a subject of obsessive interest to him, not merely for its immediate visual impact but for its deeper significance. The horse played a double role in his work: that of model and of symbol. In either role, it stood for an aspect of nature: for its physical attraction on the one hand, for its sublime or threatening force on the other. In several of his most important works subsequent to the *Farrier's Signboard,* he was to pit powerful horses against a heroic breed of men, as if to express a view of man's relationship to nature, or of the antagonism within man between the strictly human and the natural, passionate self. It is fascinating to observe, in the course of the *Farrier's Signboard's* gradual development, that this significance emerges only at the late stage, as if brought to the surface by unconscious pressures. It attains its full force only in the final, painterly execution, which gives weight and substance to the compositional idea.

The *Charging Chasseur,* painted at a time when France was in the midst of a great military campaign, stressed the drama of physical contest between man and horse, but subordinated it to a larger historical meaning. In the *Farrier's Signboard,* that contest constitutes the entire meaning and has no historical associations. The rearing horse of the *Charging Chasseur* gave that composition its movement and dominated its effect. The farrier's firm stance and muscular effort halt the horse's motion and defeat its rebellious energy. In the *Charging Chasseur,* horse and rider had been not so much in conflict as in competition; united in their motion,

each sought to dominate the other without slowing the impetus of their mutual leap. In the *Farrier's Signboard,* by contrast, there is a deadlock of opposing forces; physical restraint stifles movement. There is more drama here than one would expect in a simple signboard. The farrier has a heroic, almost tragic grandeur that challenges the viewer.

The looming monumentality of this image seems to lift the subject above the petty circumstance of genre to a broader meaning. The *Farrier's Signboard* could figure without ridicule as an allegory of passion subdued by the will. It could also be read in other ways: as France conquered but unappeased; as the horse of war tamed for peaceful work; as practical reason triumphant over emotion. There is little likelihood that Géricault deliberately intended to express any of these meanings in what was, after all, a shop sign for a smithy. But it is indicative of his epic conception of reality that so modest an enterprise should assume such powers of suggestion in his hands.

A mere genre subject stated in such elevated terms is an extremely rare, if not unique, occurrence in this period. It does not derive from any broad tradition of moralizing or social realism; nor can it be supposed that Géricault intended the shop sign to carry any particular personal or political message. In 1814 the glorification of the working man had not yet become a favorite, or even a possible, cause for artists. Twelve years later, the American painter John Nagle attempted such a theme in his monumental portrait of *Pat Lyon in His Forge* (Boston, Museum of Fine Arts). It celebrates an individual citizen-hero, rather than a symbolic figure, and is certainly uninfluenced by Géricault's painting. Although Géricault cannot be considered as a precursor of the social realism of Millet or Courbet on the strength of this one painting, his picture may have become known in circuitous ways to artists of that generation. Two decades later, the figure of a working man of rather similar expression and stance was turned to political use by Daumier in his famous lithograph *Ne vous y frottez pas!!,* of 1834, whose defiant proletarian hero, signifying the freedom of the press, might be taken for a reincarnation of the farrier.

In Géricault's own work, however, this painting was to have an unexpected sequel. In the late summer of 1814, shortly after the completion of the *Farrier's Signboard,* he learned that a regular Salon would be held a few months hence. The announcement caught him, as well as all French artists, completely unprepared. The nation was still stunned by Napoleon's fall: Allied armies occupied Paris; the throne of the restored Bourbon king, Louis XVIII, stood shakily in the shelter of Russian, Austrian, British, and Prussian arms. For this very reason, the royal government was anxious to display signs of stability. The opening of the exhibition was decreed for the first of November.

Uncertain whether to exhibit, Géricault hesitated until it was almost too late. Finally, giving way to the pleas of friends, he decided to submit again his success of the previous Salon, the *Charging Chasseur*—a rather daring choice under the circumstances, since reminiscences of the heroic past were not welcome. To counterbalance this reminder of past military glory, he also projected and very rapidly executed a new picture of nearly identical dimensions which recalled the recent French defeats. To this he gave the title *Wounded Cuirassier Leaving the Battle* (fig. 10). Exhibited as pendants, they were the only pictures of the Salon of 1814 that spoke of the enormous events of the recent past, the empire's last triumphs and its final catastrophe.

The actual execution of the *Wounded Cuirassier* was accomplished in the astonishingly short time of two or three weeks. But this rush to completion came after an earlier, and perhaps

Figure 8. Géricault. *Folio 39r from the Chicago Album.*
Graphite on cream wove paper; 17.5 x 23.2 cm.

Figure 9. Géricault. *Folio 53r from the Chicago Album.*
Graphite and black crayon on ivory wove paper; 23.3 x
17.5 cm.

Figure 10. Géricault. *Wounded Cuirassier Leaving the
Battle,* 1814. Oil on canvas; 292 x 227 cm. Paris, Musée
du Louvre. Photo courtesy the Réunion des Musées
Nationaux.

longer, period of groping experiment during which Géricault only gradually found his subject and its compositional form. His first idea seems to have been to show a soldier in distress on the field of battle. The earliest sketches show the solitary, unhorsed cavalryman sitting on the ground in an attitude of dejection. An oil study in the Louvre marks the outcome of this initial planning. The fallen horseman, a cuirassier, is alone on the field of battle. He half reclines against a mound of earth. His arm supports with effort the weight of his body and of his heavy cuirass. In the far distance, barely visible, his squadron rides off into the glow and smoke of battle.

Having brought his project to this point, Géricault—evidently dissatisfied—radically changed his mind. The thought suddenly struck him that he could adapt the composition and something of the dramatic theme of the recently completed *Farrier* for his new project. This enabled him to cut short his preliminaries and dispense with the process of gradual, sequential development; that work had already been done. By falling back on a design already fully explored—though in connection with a very different subject—Géricault was able to go directly to the definitive version of his new picture. A series of pencil drawings in a sketchbook at the Louvre and an oil study in the Brooklyn Museum present the composition that he adopted in the end, fully worked out except for minor details. The action has completely changed: The heavily armored cuirassier walks down a slope. His cumbersome, descending body expresses the lassitude of defeat. With his left hand he holds his useless saber, and with his right he tries to restrain his excited, resisting horse. The composition is in effect a reversal of the composition of the *Farrier,* with minor adjustments in the position of the cuirassier's legs and the hindquarters of his horse. Géricault has transformed the defiant farrier into a defeated soldier, while retaining the crucial dramatic motif of a conflict between the man and the animal.

Though a hurried and in some ways incomplete effort, the *Wounded Cuirassier* marked an important advance in Géricault's early development. Less felicitous than the *Charging Chasseur,* it is a much more forceful and original work. The challenge of the imminent Salon probably precipitated this perhaps premature attempt at a highly dramatic painting of large size, in a style that he had only just begun to form. Nearly all his work in the preceding two years had been of modest dimensions and elegant execution. But the leap into monumental format and energetic expression was not unprepared. The *Wounded Cuirassier* was the direct offspring of the *Farrier,* and that image had had its birth in the pages of the *Chicago Album.* The seemingly slight drawings on four sheets of these sketchbooks contain the germ of one of the pivotal masterworks of French Romantic painting.

Jeffrey Weidman

William Rimmer:
Creative Imagination and
Daemonic Power

While it is often contrived to relate paintings and sculpture, the three works by William Rimmer in the collection of the Art Institute of Chicago—the painting *Horses at a Fountain,* the granite bust of *St. Stephen,* and the bronze sculpture *Dying Centaur*—all exhibit what was called by Rimmer's contemporary, J. E. Cabot, the "ability to feel expression."[1] Expressive feeling could be considered a leitmotif in Rimmer's oeuvre. To varying degrees, these works are what might be called "soulscapes," representing the coalescence of feeling-toned theme and form, in which deeply personal aspects are mingled with more impersonal, universal concerns. They possess a symbolic, numinous quality and are charged with mythic power. Their amalgamation of non-Christian and Christian motifs enriches their symbolic content while revealing Rimmer's creative imagination and daemonic power.[2]

The painting called *Horses at a Fountain* (fig. 1), after a label on its stretcher, is unique in Rimmer's oeuvre for bearing both two signatures and two dates (1856 and 1857) on the recto surface. The small size and scale of the picture might suggest that it was meant as a sketch for a contemplated larger work, but the painting's finished condition, as well as the double signatures and dates, argues against this possibility. It is a fully realized, self-contained artistic statement. While the title may not be Rimmer's choice, it adequately describes the action.

On closer examination, the seemingly straightforward scene takes on a mysterious and enigmatic character. The cause of the horses' disturbance is not readily apparent; perhaps it is the falling water or the fantastic denizens of the fountain. The lithesome figures and horses engaged in unspecified, somewhat frenetic action combine with the transitional time of day (dawn or dusk) to create an unsettling ambiance. The obscurity of this central scene is enhanced by the tenebrous lighting; it is difficult to see the shadowed figure to the right in the archway, the crucifix or stick in the left corner. Above all, the fountain, with its provocative combination of architectural elements, Roman crosses, winged genii, and demonic, gargoyle-like creatures, creates an elusive, disturbing image.

The interweaving of genre figures with a quasi-Roman architectural construction in a shadowy atmosphere suggests that Rimmer might have known paintings by the Dutch seventeenth-century artist Pieter van Laer and other Bambocciate. Rimmer's integration of these elements, however, seems unique. The central fountain could be Rimmer's own creation; I have found no source for it. While fountains, ruins, shrines, and monuments appear in a number of his draw-

ings and paintings, none of these works presents any image like this unsettling architectural assemblage.[3] The fusion of non-Christian and Christian materials appears to have been an idea that Rimmer explored during the 1850s as well as throughout his career.[4]

The mysterious power that emanates from Rimmer's *Horses at a Fountain* is due in part to its understatement and enigmatic imagery. The painting's impact is so strong that even if documentation were extant by which to interpret its iconography more fully, its force would not be diminished. This is also the case for Rimmer's bust of *St. Stephen* (figs. 2 and 3), about which, fortunately, there is a large amount of documentation to enrich our understanding. The most significant documentation exists in eleven of the nineteen letters written to Rimmer by Stephen Higginson Perkins (1804–1877) between 1860 and 1864 (now in the Boston Medical Library in the Francis A. Countway Library of Medicine, Boston). Rimmer's typical signature, "W. Rimmer," and the date 1860 are incised at the back, below the subject's right shoulder.

The review in the *Boston Evening Journal* for December 12, 1860, of the *St. Stephen's* initial exhibition at Williams and Everett's art gallery in Boston was quite favorable. The life-size bust caused some excitement, perhaps more as a curiosity executed by a physician living in the nearby small town of East Milton than as a legitimate work of art.

The *St. Stephen* is a pivotal work in Rimmer's career. It marked his debut as a serious artist, being the psychological turning point in his life. It altered his self-image from that of a country doctor who occasionally produced a work of art in relative obscurity, to an artist who devoted himself to his creations and who, within a few years, would be actively teaching artistic anatomy in Boston. His former avocations increasingly became his vocations. Although quite a proficient doctor for sixteen years at the time of the execution of the *St. Stephen,* he never generated adequate income to support his family. It was not until he was appointed as a lecturer at the Lowell Institute in October 1863 that he decided to relinquish his medical career. His artistic reputation at the point of the execution of the *St. Stephen* was as a portrait and tradesman sign painter; in 1838 he had been in the sign-painting business with Elbridge Harris.

Reckoning the monetary worth of his bust according to a stonemason's hourly wages, Rimmer was astonished when knowledgeable friends placed its minimum value at $500. One of these individuals, Stephen Perkins, Rimmer's friend since 1858, who commissioned his next sculpture, the *Falling Gladiator* (1861), did his best to publicize the bust. It was largely through Perkins's efforts that the *St. Stephen* became known in the United States and Europe.

The five busts by Rimmer that precede and follow the *St. Stephen,* while interesting in subject and workmanship, cannot compare, in power and intensity, with his sculpture of 1860.[5] In conceiving the *St. Stephen,* Rimmer probably had several sources in mind. One of these might have been Washington Allston's painting *The Angel Releasing St. Peter from Prison* (fig. 5), in which the general composition and the emotion expressed by St. Peter are similar to those of Rimmer's bust.[6] Although this picture was not exhibited until 1861 at the Boston Athenaeum, Rimmer might have known copies. Through Perkins's connections, he might have had access to the original, owned by Robert William Hooper, who was a member of the Athenaeum. Even more significant as a source was the principal head of the late-second-century-B.C. Hellenistic sculptural group *Laocoön,* probably known to Rimmer in the form of the plaster cast owned by the Boston Museum (not to be confused with the Museum of Fine Arts, founded in 1870). Rimmer could also have studied the two plaster casts of the entire sculptural group owned by the

Figure 1. William Rimmer, American (1816–1879).
Horses at a Fountain, signed 1856 and 1857. Oil on canvas;
8¼ x 10 in. The Art Institute of Chicago, Gift of Mrs.
Eugene A. Davidson (75.583).

Figure 2. William Rimmer. *St. Stephen*, 1860. Granite; 21¾ x 13⅛ x 15 in. The Art Institute of Chicago, Roger McCormick Purchase Fund (77.230).

Figure 3. View of figure 2 from the right.

150

Athenaeum when he visited its sculpture gallery on October 8, 1860, about a month before beginning the *St. Stephen.*[7]

In the sculpture gallery Rimmer also could have seen plaster busts of *Socrates* and *Homer,* both conceived in the classical tradition of life-size bearded heads of older men. Although several busts of Socrates exist, there is no record at the Athenaeum by which to identify the bust formerly in their collection. The bust of *Homer,* however, is still extant at the Athenaeum. The busts might also have attracted Rimmer by their subject matter. In terms of form, they are particularly noteworthy in their similarity to the *St. Stephen*'s hair, beard, and mustache, which, despite their verve and movement, are still rather formulalike.

While these antique works may have contributed to Rimmer's initial concept of the *St. Stephen,* the dominant influence seems to have been the principal head of *Laocoön.* Rimmer's bust, however, is neither a paraphrase nor a pastiche of these sources; it reveals assimilation of their formal elements and presents a marked departure from them.

The similarities shared by Rimmer's *St. Stephen,* Allston's *St. Peter,* and the principal head of the *Laocoön* group are: the head turned and thrown back, the raised right shoulder, the parted lips, the open and upturned eyes, the wrinkled forehead and knitted eyebrows, and the flow of the mustache into the beard. Rimmer's treatment, however, is much less generalized and more suggestive than that in the *Laocoön.* While the sense of suffering and anguish is conveyed in both sculptures by the treatment of individual features, in the *St. Stephen* the angle of the head toward the right shoulder suggests rather than depicts the raised right arm. Significantly different is the upward surge of *St. Stephen*'s head, which suggests triumph, in contrast to the downward position of the head in the *Laocoön,* which suggests defeat. This formal embodiment of release might have impressed Rimmer in Allston's painting, where St. Peter's head also shows the influence of the *Laocoön.* While the *Laocoön* conveys a desperate submission to fate and to imminent death, *St. Stephen*'s heavenward gaze implies an endurance of suffering, but a refusal to accept the death of the physical body as the final end. By his sacrificial gaze, *St. Stephen* transcends corporeal death and seems to embody the compassionate essence of his final words: "Lord, lay not this sin to their charge."[8]

Except for the almost indistinguishably carved word, "Stephen," at the base of the bust, literary devices have been eliminated by Rimmer; the form itself carries the meaning. Although the subject was selected partially out of gratitude to Stephen Perkins, the transformation of the underlying image derives from Rimmer's own experience. The subject of St. Stephen being stoned appealed to Rimmer; he had used it in two works after 1845.[9]

Stephen was also a character in Rimmer's long philosophical prose narrative, "Stephen and Phillip," symbolizing man's daemonic (i.e., divine) and demonic natures. In the manuscript, Rimmer portrayed Stephen as the daemonic nature imprisoned in the corpse of the fleshy body. Stephen-Phillip states: "Alas . . . a man's grief is often his only fortune, and his sorrow like his poverty the only indication of his life. This is all that is left one, and to forget it would be to lose all that I have, the sense that preserves to me my only companion, myself."[10] Suggestive of another dimension to Rimmer's bust, the passage elucidates a deeply personal aspect of the work. It helps explain the faint inscription which reinforces the symbolic intention. The inscription may also allude to inscriptions on antique sculpture.

Because of his own hardships, Rimmer identified with St. Stephen's sufferings. Isolated both psychologically and socially due to the secret Rimmer family belief that his father,

Thomas Rimmer, was by birth the French dauphin, destined to be Louis XVII, he was equally isolated by extreme poverty and frustration. From 1841 to 1859 he and his wife, Mary, lost five of eight children in infancy. At some undetermined point, his wife became an invalid. To earn a meager living for his family, he made shoes, practiced medicine, and painted portraits and other occasional commissions.[11] Under these circumstances, it is remarkable that Rimmer had the energy to undertake a personal, uncommissioned work of art.

The use of granite for an indoor sculpture like *St. Stephen* was unconventional. Rimmer's bust was one of the first works exhibited in America that was cut in native stone other than marble. The decision to use this particular material, which was readily accessible and in abundant supply from the nearby Quincy quarries and, therefore, inexpensive, was Rimmer's own. The hard, dark granite is also symbolic of the heroic severity of the subject, sustaining the personal metaphor of the indomitable artist struggling under harsh circumstances. Whether Rimmer was fully conscious of this symbolic dimension of his bust is not known, but the physical act of continually striking the obdurate granite could have provided him with some measure of release from his own sufferings; the bust's execution was analogous to a self-imposed martyrdom that probably supplied some physical and emotional catharsis.

The mature visage of *St. Stephen*—approximating Rimmer's age of nearly forty-five—is unlike the traditional depiction of the martyr as a young man. Judging from extant photographs of the artist, there is little resemblance between *St. Stephen* and the artist, except in the depiction of the rather full nose with the flared nostrils. Nonetheless, it is still justifiable to regard the *St. Stephen* as a symbolic self-portrait.[12]

From his medical studies, Rimmer had gained a familiarity with anatomy and with individuals in desperate pain. By 1831–32 he had also developed a facility at anatomical rendition in a plastic medium; at the age of fifteen he had already carved the superb little gypsum figure *Seated Man* (Museum of Fine Arts, Boston). He cut at least six works in granite before carving the *St. Stephen*. The only surviving example, *Head of a Woman* (Corcoran Gallery of Art, Washington, D.C.), which immediately preceded the *St. Stephen,* indicates Rimmer's high technical accomplishments. Despite his sculptural talent and medical knowledge, Rimmer's working methods for the *St. Stephen* were unusual and highly exacting.

No preparatory sketches survive for the *St. Stephen*. Indeed, Rimmer probably did not use any;[13] nor did he utilize any intermediary stages of clay or plaster models, any assistants customary at the time for transferring a sculptural conception into enduring form, nor any model, other than that held in his own mind. He had no studio; he cut the bust "on a barrelhead in his woodhouse."[14] Rimmer attacked the stone directly; his tools needed constant sharpening. The work caused cutting and blistering of his hands, swelling of his arms, and physical and mental exhaustion. Metaphorically and almost literally tearing the anguished features of the saint from the rock itself, Rimmer completed the bust in only four weeks.[15] The handicaps under which he worked are, however, not apparent in the finished work. Executed with consummate skill, its form and expression show that the conception has been carried through without any hesitation whatsoever.[16] Difficult as the material may have been, *St. Stephen* is a highly controlled work with bold form, subtle modeling, and linear accents; dynamic animation gives the bust a sense of spontaneity.

The *St. Stephen* eschews many of the neoclassical conventions advocated and practiced by Rimmer's contemporaries. Instead of their typical marmoreal surface treatment,[17] Rimmer

indicated the chisel's presence; certain areas are left rough and coarse. The flickering bits of mineral constituting the rock animate the surface, enhancing the dynamic impact of the head and conveying a sense of pulsating life underneath the surface. The incredibly delicate and subtle modulation of the surface and the precise, sensitive cutting of the features solicit our empathy while contributing to the richness and strength of the bust.

While our attention is riveted on realistically rendered individual features, we are also encouraged to move around the bust by the upward and backward thrust of the head over the subject's right shoulder. This line of movement is continued at the back of the bust by a pronounced edge sweeping from the lower left to the upper right. The linear animation of the hair is also carried through to the back of the head. This conception of sculpture as a three-dimensional form to be experienced in the round may derive from Rimmer's study of antique art, although it was already apparent in his *Seated Man*.

The tension and movement of the form are relieved slightly by the baldness of the head and by the "V shape" of the open shirt, a shape that also serves to emphasize, paradoxically, the tense backward movement of the head. The details and formal relationships of the bust demand our total intellectual and emotional involvement. *St. Stephen*'s form compels our vicarious participation in the saint's and, by extension, in the artist's suffering. The *St. Stephen*, like the later *Dying Centaur* and Rimmer's other masterly sculptures, is not meant merely for passive contemplation, but for provocative confrontation.

The *St. Stephen* is a shattering expression of personified anguish. As such, it is no wonder that it did not find a ready buyer. It is Rimmer's artistic genius that raises his work from a personal level, endowing it with universal import. By distilling this vital, haunting, and numinous image from the dross of his own experience, and by doing so in terms of formal values rather than literary paraphernalia, Rimmer created an enduring work of art.

The *St. Stephen* was soon followed by another major sculpture, the life-size *Falling Gladiator* (National Museum of American Art, Washington, D.C.),[18] commissioned by Stephen Perkins and exhibited shortly after its completion on June 10, 1861. In many respects, it was the most all-consuming work Rimmer ever did.

With the help of friends such as Stephen Perkins and William R. Ware, Rimmer became involved in the artistic and intellectual life of Boston. In January 1862 he joined the prestigious Boston Art Club.[19] During 1862 and 1863 he produced a number of large allegorical drawings relating to the Civil War.[20] By early 1862 he was teaching in the Studio Building and soon had developed a reputation for astounding lectures on artistic anatomy. Rimmer's artistic and pedagogical reputation increased sufficiently for him to be invited to give a series of ten lectures for the Lowell Institute in Boston beginning in October 1863.

The success of these lectures made it possible for the male artists who attended Rimmer's lectures to establish a private art school in Boston in 1864 with Rimmer as its director.[21] During this year, Rimmer published a primer on drawing, *Elements of Design*. His first public commission, the granite statue of *Alexander Hamilton* on Boston's Commonwealth Avenue, was unveiled on August 25, 1865, shortly before he began a lecture series at Harvard College. Critical reaction to the statue was unfavorable, leading him to accept an offer from Peter Cooper in New York to become director of the School of Design for Women at Cooper Union for the Advancement of Science and Art. During the four years he held the post, 1866–70, Rimmer retained his newly acquired home in Chelsea, spending the summers there and

Figure 4. William Rimmer. *Dying Centaur,* 1968 (copy-righted in 1967), after a plaster model of 1869. Bronze; h. 21½ in. The Art Institute of Chicago, Gift of Mr. and Mrs. Marshall Field (76.393).

traveling in New England. Despite his heavy administrative and teaching responsibilities at Cooper Union and despite newspaper criticism of his pedagogical program, Rimmer's years in New York were quite fruitful.[22] Producing a large number of works, he also achieved the social acceptance denied him in Boston. He called the four years he spent in New York "the happiest of his life."[23]

Just as the *St. Stephen* can be seen as the work that inaugurated the decade of the 1860s, the *Dying Centaur* is the last sculpture of these important ten years. It represents an artistic reflection and culmination of the psychological and philosophical maturity that Rimmer had gained since 1860.

The original plaster cast of the *Dying Centaur* is owned by the Museum of Fine Arts, Boston. The bronze cast owned by the Art Institute of Chicago (fig. 4) was made in 1968 from a plaster cast now owned by the Yale University Art Gallery as one of an edition of fifteen bronzes copyrighted in 1967 by Kennedy Galleries, New York. It is faithful to Rimmer's original sculptural conception.[24] Although Rimmer did not put a date on his *Dying Centaur,* he did place his signature, "W. Rimmer," on the top of the base, between the hooves.

Nineteenth-century criticism of Rimmer's *Dying Centaur* was restricted to commentaries on the expert handling of the anatomy and the successful joining of the human and animal parts. It received very little substantive critical attention until the twentieth century, probably due to the unusual subject, as well as to its essentially nonliterary character. Rimmer left no comments on his sculpture. It is not mentioned in Stephen Perkins's letters. Bartlett devoted only one line to it, stating that it "was made in odd hours, in 1871, without the employment of a model."[25]

A slightly earlier date than 1871 is suggested by a stylistic analysis which, in turn, is confirmed by a newspaper notice of the *Centaur*'s inclusion in the Annual Exhibition of 1869 of the School of Design for Women at Cooper Union in New York.[26] Rimmer could have worked on the *Centaur* only intermittently, for his teaching and administrative duties at Cooper Union during the spring of 1869 were very demanding.

It is not surprising that Rimmer dispensed with a model. He preferred to work rapidly without preliminary sketches; no drawings for the *Centaur* exist. From the richness and complexity of material brought to bear on the image, it is likely that Rimmer's thoughts on the sculpture occupied him for a considerable time during the spring of 1869. The *Dying Centaur* marks his return to expressive, dynamic sculpture, which he had not fully explored since his *Falling Gladiator* of 1861. Realizing his lack of interest and his limitations in a more superficially reposeful sculptural mode, he returned to the mode more suited to his talents.[27] Choosing a classical theme but an unusual one for a sculptor in America, he used it as a profound, expressive vehicle for symbolic content.

The idea of sculpting a centaur—and one on a relatively small scale—might have been initially suggested to him by a standing sculpture of *Chiron* that Stephen Perkins was working on in 1865. The photographs of his centaur that he sent Rimmer have not survived, but it is noteworthy that Perkins mentioned his initial model as being "about twenty-two inches long"—very close in size to Rimmer's *Centaur*.[28] Later, Rimmer may have consciously attempted to memorialize his overall debt to Perkins by commemorating his mentor's work in this fashion.[29]

Although Rimmer's *Centaur* may be the first sculpture of this subject done in America, it was a popular theme in contemporary European sculpture. One of the main influences for this

theme may have been an English publication, James Stuart and Nicholas Revett's *The Antiquities of Athens* (1762–94). Plate XII in Volume 2 illustrates a Parthenon metope in which a fallen centaur is pulled backward by a Lapith who has him locked around the head. Although the engraving is awkwardly executed, the treatment of the transition from animal to man, the severance of the left arm at the shoulder, and the protrusion of the abdominal muscles may have guided Rimmer.

More contemporary centaur sculptures were Berthel Thorvaldsen's 1814 relief of *Nessus Abducting Dejaneira* and his 1837 work showing *Chiron Instructing Achilles,* as well as Antoine Louis Barye's 1846 and 1848 versions of *Theseus Slaying the Centaur Bianor* (fig. 6). Whereas Thorvaldsen's works may have had little to offer Rimmer, the protrusion of the abdominal muscles in Barye's *Centaur* is similar to Rimmer's treatment. Barye's form is less fluid and expressive than Rimmer's, which makes a subtle transition from animal to human anatomy. If he knew Barye's sculpture, he may have been attempting to improve on the French master's work.[30]

The closest European sculptural parallel to Rimmer's *Dying Centaur* is Antonio Canova's 1819 sculptural group of *Theseus Slaying the Centaur* (fig. 7), which also recalls the Parthenon metope sculpture in the general position and form of the centaur. Both Canova and Rimmer depicted the centaur kneeling with his body tilted to his left. There are also similiarities in the details. The backward thrust of the torsos and heads in both sculptures as well as the upraised right arms, doubled-under left front legs, and extended right legs seem to indicate Rimmer's familiarity (probably through prints) with Canova's sculpture. Rimmer handled these features in a more subtle and fluid manner than did Canova. The significant difference is that Rimmer's sculpture—more compact and more plastically dynamic than Canova's work—is meant to be experienced from all sides.

Formally, Rimmer's *Centaur* improves upon Canova's sculpture. In his *Falling Gladiator* of 1861, Rimmer had alluded to Canova's *Hercules Throwing Lychas,* but in a less inclusive manner. In light of his documented negative criticism of Canova's sculpture, it is probable that Rimmer was correcting what he considered to be Canova's faults in an effort to show his presumed superior talent.[31]

Besides Rimmer's aesthetic confrontation with the works of these European sculptors, he might have been consciously competing with the work of the American artist Samuel F. B. Morse. Rimmer could have seen both his 1812 plaster study (fig. 8) and the 1812–13 painting of the *Dying Hercules* after they were acquired by Yale University in 1866. A copy of the painting had been in the Boston Museum since 1841. Morse's title might have suggested to Rimmer the idea of a centaur in the act of dying; other possible sources had only shown the centaur subdued or about to be slain. Both Morse and Rimmer concentrate—in a small sculpture—on a single, nude, dying, protesting male figure. Additional similarities occur in the expert handling of expressive anatomy, especially in the area of the abdominal muscles, a raised right arm, the head turned upward, and the body weight leaning to the left. Compared to Rimmer's tension-filled work, however, Morse's sculpture seems relatively relaxed. I agree with Marcia Goldberg's suggestion that Rimmer consciously sought to exaggerate the individual aspects of Morse's sculpture;[32] the head and torso are bent back to a greater degree, enlarging and tightening the stretched muscles in the neck and in the abdomen; the fall of Rimmer's *Centaur* onto its doubled-under left leg contrasts with the relatively unstrained left arm and evenly distributed weight of

Morse's figure; the legs in Morse's work maintain a relatively relaxed balance, while the legs of Rimmer's *Centaur* strain to hold a tense equilibrium.

It is possible, therefore, to regard Rimmer's *Dying Centaur* as a consciously conceived competition piece for accepted sculptural masterpieces such as the Parthenon metopes and works by Barye, Canova, and Morse. This competitive spirit is evident in his other sculptures, like the *St. Stephen.*

Rimmer's study of the aforementioned sculptures reflects his commitment to a Greek ideal in his art. The *Centaur* suggests this ideal in its subject matter, youthful body, calm face, and severed arms. In both the earlier statue of *Osiris* (1865) and the *Centaur,* the unrealistic detail of the severed arms reinforces the associations with the classical ideal. Rimmer's interest in antique art underlines his concern for the spiritual quality of existence. These works—in their evocation of a mythic, spiritual content—suggest his attempt to find sculptural equivalents for those intangible spiritual qualities underlying the phenomenal world.[33]

The truncated limbs imitate antique sculptural fragments, consequently evoking the lost culture that gave birth to the artistic ideal. The severed arms enhance the *Centaur*'s tragic power. We empathize with the wounded creature, whose humanity strikes us as both profoundly personal and universal. Our associations are with the idea for which the sculpture stands and with the fragmented, wounded subject. It is Rimmer's compositional use of the "partial figure" that links him to modern sculpture as a forerunner of his younger French contemporary, Auguste Rodin.[34]

The *Dying Centaur* is a sculpture of contrasts reconciled. The composition appears to be organized around a point of intersection from opposing lines of movement, which function as a spiral subtly locking the figure into a hovering balance. Reclining with its body twisted to the left, upward, and backward, its head is thrown backward, the hair falling over the upper shoulders. The left front leg is doubled under, the other three legs splayed simultaneously outward, forward, and backward. The left arm, if present, would have continued upward to the left. Apparently severed at the shoulder, the broken limb has left an uneven surface in contrast to the right arm, severed just below the elbow, thrust upward, following the general stretching of the torso. The energized upward movement of the raised right arm is held within the balance of the spiral by the weight of the body and the disposition of the legs. A tense equilibrium is established, made all the more powerful by the weight of the body, which is precariously held in the subtlest balance; we sense that it will imminently give way and collapse. The formal point of equilibrium, precariously established by the reconciliation of opposed dynamics, creates a formal and thematic harmony. The formal contrasts of the heavy body, which seems to press into the physical world, and the upraised face and arm, which seem to aspire to an extraterrestrial sphere, create the tension and power of the *Dying Centaur.*

Part of the *Centaur*'s strength derives from the richness of experiencing its many vantage points. We are encouraged to move around it, to observe its many aspects. When fully experienced, the seemingly impotent quality elicited by its absent left arm and its extended raised right arm is mitigated by the sculpture's creative, phallic power.

The *Dying Centaur* is far from being a mere exercise in anatomical ingenuity. Rimmer was dedicated to anatomical fidelity, not for its own sake, but for the dramatic power it enabled him to achieve.[35] The stress of the accurately rendered anatomical parts is harmonized into an expression of the agony inherent in the figure itself.

The *Centaur*'s highly animated rippling surface, with its pattern of highlights and shadows, enhances its dramatic power. While this is more apparent in the bronze casts, it is far from being obscure in the original plaster.

The formal power and theme of the *Dying Centaur* have no parallels in nineteenth-century American sculpture. In the sources from which Rimmer might have gained inspiration, the centaur is depicted as a bestial creature, forcibly subdued, about to be killed by a Lapith or a Theseus. Rimmer's *Centaur* is alone, the sole protagonist; there is no other figure to gain our sympathy.

In Rimmer's visual sources, the centaur symbolized human depravity or man's sensual nature. When depicted as Chiron, on the other hand, he represented self-sacrifice. Chiron, the teacher of Achilles, volunteered to die in the place of Prometheus. Schooled in medicine and the arts, he may be regarded as a mythological analogue to the teacher-artist-physician Rimmer, who sacrificed his own material comforts for the sake of art in the face of an uncomprehending public.[36]

The *Dying Centaur* may represent the dualism in man: the conflict between his animal and human natures, his irrational and rational tendencies.[37] Since it fails to account for all the sculptural details, this interpretation is only partially valid. Rimmer's *Centaur* is in no way a repulsive creature. The horse body is ample and strong, the human torso is powerfully wrought, the face is relatively calm and placid. Although the raised right arm may be a defiant gesture, it can be seen equally as reaching toward that which transcends the corporeal. In harmonizing the human and animal parts of his sculpture, Rimmer has created a kind of beauty similarly articulated by Nathaniel Hawthorne in his novel *The Marble Faun,* published in 1860.[38]

Rimmer's reconciliation of man's lower and higher natures is an unusual approach to this subject. Equally unusual is his representation of the dying creature, whose rational nature rises up out of its irrational nature while at the same time being in harmony with it.

Rimmer's belief in death as a part of the cyclical life-pattern of the soul's immortality is expressed in the *Dying Centaur* by the use of a form bending backward and turning back on itself. This motif suggests a holistic view of existence.[39] The belief in eternal life is discussed in Rimmer's manuscript of "Stephen and Phillip." In this visionary work Rimmer dealt with the contrast, struggle, and harmony of man's lower and higher natures as embodied in the respective personages of Phillip and Stephen, who "loved each other as brothers."[40]

A seemingly obscure literary source for Rimmer's choice of a centaur to express the theme of corporeal natures reconciled with the theme of the soul's immortality is Edward Young's book *The Centaur Not Fabulous* (1754), which would have been available to Rimmer in a revised and abridged edition published in Philadelphia in 1846.[41] The book deals with the two themes expressed by Rimmer in his *Dying Centaur,* the 1846 version stressing the "salvation of the human centaur's immortal soul."[42] In Young's book, the centaur is considered "blind" to himself and earlier in the book a young centaur's death is related.[43] It is possible to see the blind characteristic of Young's centaur in Rimmer's sculpture; however, even if sight is denied the figure, it is contestable that the arm and the eyes are not in communication.[44]

Rimmer's belief in the totality and harmony of man as articulated by him in his manuscript, "Stephen and Phillip," and the provocative themes expressed by Edward Young provide literary sources for an interpretation of the *Dying Centaur* as representative of the reconciliation of man's

Figure 5. Washington Allston, American (1779–1843). *The Angel Releasing St. Peter from Prison,* 1812. Oil on canvas; 124¾ x 108½ in. Boston, Museum of Fine Arts, Gift of Robert William Hooper (21.1379).

Figure 7. Antonio Canova, Italian (1757–1822). *Theseus Slaying the Centaur,* 1805–19. Marble; 156 x 144 x 60 in. Vienna, Kunsthistorisches Museum.

Figure 6. Antoine Louis Barye, French (1796–1875). *Theseus Slaying the Centaur Bianor,* c. 1850. Bronze; 21½ x 19 x 7 in. without base. Northampton, Ma., Smith College Museum of Art (1973.4).

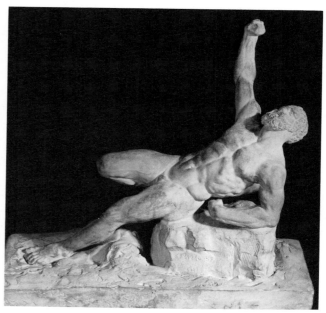

Figure 8. Samuel F. B. Morse, American (1791–1872). *Dying Hercules,* 1812. Plaster; 20 x 22½ x 9 in. New Haven, Yale University Art Gallery, Gift of Rev. E. Goodrich Smith (1866.4).

dual human natures and of the immortality of the soul, which incorporates and transcends these two seemingly irreconcilable aspects.

The impact of the *Dying Centaur* is increased when we consider the possibility that Rimmer conceived his sculpture, on one level, as a symbolic memorial to the Civil War in keeping with his desire to find an aesthetic embodiment for the heroic individuals engaged in that conflict. Rimmer was not interested in creating journalistic works, but in memorializing human deeds in a suitably heroic, ideal form. His large, emblematic Civil War drawings of 1862–63, while impressive, are diminished by their relatively rigid, didactic, and allegorical character.[45]

Rimmer continued to create war-related works of art in which both humans and horses are depicted monumentally and heroically. Considering the Greek-oriented culture in which American art was immersed, it may be possible to regard the *Dying Centaur* as Rimmer's attempt to create a symbolic monument to the self-sacrificing young men who had participated in the Civil War.

Because he is unbearded, the *Dying Centaur* cannot be totally identified with the self-sacrificing Chiron. That the figure is a centaur lends credence to it as a self-sacrificing creature. The youthful depiction symbolically ties the sculpture to the young men who gave their lives for the war effort. As their deaths contributed to the salvation of the nation, so the death of the centaur will lead to the salvation of its soul.

Other currents which no doubt contributed to Rimmer's work on his *Dying Centaur* were the self-sacrifices he had made in his own life. In addition to those personal problems already mentioned, Rimmer was also having difficulties with Peter Cooper and his son-in-law Abram Hewitt at Cooper Union, which culminated in his resignation in 1870. But it would be too shortsighted to view the *Dying Centaur* as a mere embodiment of Rimmer's frustrations and personal disappointments. While the concept of struggle against fate is a leitmotif of his art, it is usually mitigated by the redeeming factor of the quality of his artistic and existential attitude. A spiritual position of relative detachment allowed him to creatively approach his personal suffering. Such is the case with the *Dying Centaur,* where a spiritual element transcends the contrasts of earthly travails.

Whereas the *Dying Centaur* is a personal, subjective metaphor for Rimmer's own struggles, it is also an objective statement of his artistic purpose and of his views on the nature of man. An optimistic work, it confirms his belief in man's harmonious totality.

Rimmer executed only four sculptures in the ten years following the *Dying Centaur,* while at least twenty sculptures by Rimmer have been recorded for the period between the *St. Stephen* and the *Dying Centaur.* As with the earlier *St. Stephen,* the *Dying Centaur* was a summation of many currents transfused into one overpowering statement. They are both pivotal works in Rimmer's oeuvre.[46] The richness of materials brought to bear on their conception, execution, and final form make them two of his most complex and rewarding sculptures. The works in the Art Institute show William Rimmer to have been perhaps the finest and most important sculptor in nineteenth-century America. Through his creative imagination, he imbued his art with expressive feeling and daemonic power, thereby creating mythic works infused with numinosity.

This essay is based on the author's Ph.D. dissertation for the School of Fine Arts, Indiana University, Bloomington, "William Rimmer: Critical Catalogue Raisonné," 1982.

1. "Introductory Note" to W. Rimmer, *Elements of Design,* Boston, 1864 (rev. ed., Boston and New York, 1879). Cabot's observation was applied to the Art Institute's *Horses at a Fountain* and *Dying Centaur* by M. M. Naeve, "A Picture and Sculpture by William Rimmer," *Bulletin of The Art Institute of Chicago* (Mar.–Apr. 1977): 20.

2. The word *daemonic* derives from the Greek *daimon,* meaning a god, genius, or spirit. I am using the word with its original meaning. In this sense, it has come to signify a profoundly creative artistic force.

3. See Rimmer's drawings *Horses and Man Before a Fountain,* c. 1868 (Fogg Museum of Art, Harvard University, Cambridge), and *Soldier's Monument,* c. 1870 (whereabouts unknown), and his paintings *English Hunting Scene,* 1871 (Museum of Fine Arts, Boston) and *Ideal Subject (Landscape),* 1871/72 (whereabouts unknown).

4. An early instance can be found in Rimmer's painting *The Flower of the Forest* (Mrs. S. T. Crawford, Boston), which I have dated 1841. Beginning with two paintings of c. 1850, *Scene from "The Tempest"* (Richard Manoogian, Detroit) and *Scene from "Macbeth"* (Kennedy Galleries, New York), which appear to be about the contrast of good and evil (white magic, as represented by Prospero, and black magic, as represented by the three witches and Hecate), Rimmer seems to have become increasingly concerned with such themes.

5. The marble bust of his eldest daughter, *Mary Rimmer,* 1849 (Boston Medical Library in the Francis A. Countway Library of Medicine), and the granite *Head of a Woman,* 1859/60 (Corcoran Gallery of Art, Washington, D.C.), predict little of *St. Stephen*'s strength. Neither do the plaster *Ideal Bust,* c. 1863/68 (whereabouts unknown) and the marble busts of *Horace Mann* and *Abraham Lincoln,* 1866/67 (both Museo Historico Sarmiento, Buenos Aires, Argentina).

6. K. F. Campbell ("Dr. William Rimmer and the American School of Anatomy," M.A. thesis, University of Iowa, 1953: 49) was the first to suggest this influence. In 1850 Stephen H. Perkins published in Boston at his own expense eighteen engravings after some of Allston's drawings which he had found in Allston's studio and which he commissioned from J. and S. W. Cheney, *Outlines and Sketches by Washington Allston.* Perkins presented Rimmer with a copy of this book, which exerted a deep influence on the artist, according to L. Kirstein in *William Rimmer 1816–1879,* exh. cat., Whitney Museum of American Art, New York, 1946 (reprint 1961): [6]; and in draft material for this catalogue. This material is in the William Rimmer papers of Lincoln Kirstein-Richard S. Nutt owned by Mr. Nutt, Providence, R.I., all of which can be found as well in the Archives of American Art, Microfilm Reel No. N682/641-737.

7. Rimmer's visit is documented by a note signed by D. M. Foster, Keeper of the Gallery (Boston Medical Library). The *Laocoön* cast is listed in the Boston Museum *Catalogue of the Paintings, Marble and Plaster Statuary . . . ,* 1841: 15.

8. St. Stephen's supposedly last utterance is given in the New Testament, Acts of the Apostles, 7:60. A British writer (I.B., "Studios in Florence, No. I," *Once a Week* [Dec. 19, 1863]: 721) noted a similar distinction between the *Laocoön* and Rimmer's *St. Stephen,* calling it a "Christian Laocoön" and referring to it as "no victim, but a self-devoted sacrifice."

9. That Rimmer painted *The Stoning of St. Stephen* can be inferred from a verso inscription on Rimmer's drawing of that subject in the collection of Mrs. R. Rex Price, Renton, Washington. The location of the painting is unknown. An unorthodox Christian with a transcendentalist outlook, Rimmer may have been attracted to St. Stephen because he preached the relativism of religious forms.

10. Rimmer, "Stephen and Phillip," Ms. in the Boston Medical Library, Francis A. Countway Library of Medicine: 171. This handwritten manuscript is not dated but was probably written between 1855 and 1879. It was edited and annotated by the artist's daughter, Caroline Hunt Rimmer. Dedicated to his wife, the manuscript consists of 192 pages divided into a prelude and three chapters.

11. See T. H. Bartlett, *The Art Life of William Rimmer: Sculptor, Painter, and Physician,* Boston, 1882 (reprint Boston and New York, 1890; New York, 1970). For the period from 1840 to 1857, see pp. 14–28.

12. This idea of self-portraiture was noted by L. Kirstein (note 6): [7].

13. Bartlett (note 11): 29.

14. Letter from S. H. Perkins, May 3, 1861, to Hiram Powers in Florence; Powers Papers, Archives of American Art.

15. Bartlett (note 11: 29–30) noted that Rimmer's "emotion neither reasoned, nor waited for preliminaries. He worked with . . . desperate rage . . . , his whole body exhausted in aching sympathy with the activity of his spirit."

16. M. Goldberg ("William Rimmer: An American Romantic Sculptor," M.A. thesis, Oberlin College, 1972: 26) came to a similar conclusion. This is the first attempt to chronicle the *St. Stephen*'s history.

17. For example, see Horatio Greenough's *Angel and Child,* 1832 (Museum of Fine Arts, Boston), or Thomas Crawford's *Orpheus,* 1839 (Museum of Fine Arts, Boston, on loan to the Boston Athenaeum).

18. See Bartlett (note 11), fig. 18.

19. Ibid.: 94.

20. These drawings include *A Border Family,* 1862 (Fogg Museum of Art, Harvard University, Cambridge); *The Struggle Between North and South,* 1862; *Secessia and Columbia,* 1862; *Dedicated to the 54th Regiment Massachusetts Volunteers,* 1863 (all Museum of Fine Arts, Boston).

21. The scope, intensity, and influence of Rimmer's teaching compares with that of Thomas Eakins, his artistic contemporary during the 1870s. Rimmer and Eakins shared certain fundamental concerns; they are linked by their passion for anatomical study, by their progressive teaching which provoked the calumny of their contemporaries, and by the posthumous appreciation of their art. Both studied medicine, both used science in their art, and both were interested in photography. They shared a zeal for study of the nude model and for human and animal anatomy. Both practiced and recommended dissection. Eakins's approach tended to be more objective, more rigorously and systematically scientific than Rimmer's more subjective approach. Both men found their artistic source in the antique. Where Eakins tended toward the objective, Rimmer refined the objective into an ideal. Rimmer's mythic art was his way of dealing symbolically with profoundly personal issues. Eakins de-emphasized personal involvement. His subjects are, on the whole, more mundane than those of Rimmer, which reveal greater visual and literary allusion. Finally, for both artists, art was a moral issue.

22. See Bartlett (note 11): 51–59.

23. Ibid.: 59.

24. Rimmer's clay model of the *Dying Centaur* has not survived, but the plaster cast, executed by him or by someone else from his clay model before May 27, 1869, when it was exhibited

(see note 26), was bequeathed to the Museum of Fine Arts, Boston, in 1919 by Caroline Hunt Rimmer (who, in her will, testified as to its originality). Rimmer may have hoped that his sculpture would be cut in marble or granite. The presence of blow-holes in the face and chest of the Boston plaster cast would suggest that the contemplation of a bronze cast was unlikely, since, unless rectified, these marks would have been automatically transferred to a bronze. Such blow-holes would not have been reflected, however, in a stone sculpture. Thus, the fact that the blow-holes were not filled in is one argument in favor of Rimmer having intended to use the plaster as the model for a stone sculpture. Sometime during 1905, three of Rimmer's friends, William Ware, Edward R. Smith, and Daniel Chester French, formed the Rimmer Memorial Committee to gather funds and make arrangements for the casting into bronze of Rimmer's *Dying Centaur, Fighting Lions,* and *Falling Gladiator.* The sculptures were cast in this order. The men were assisted by sculptors Augustus Saint-Gaudens and Gutzon Borglum. The relationship of the original plaster cast of the *Dying Centaur* at Boston to the subsequent twentieth-century plaster and bronze casts is exceedingly complex. Extensive archival research has led me to the following conclusions about the provenance and interrelationships of the various casts.

The *Dying Centaur* was the first sculpture to be cast in bronze (in 1905) under the auspices of the Rimmer Memorial Committee. Its patina was completed by Borglum by mid-January 1906. A bronze cast of the *Dying Centaur* was given to the Metropolitan Museum of Art in 1906 by Edward Holbrook, president of the Gorham Company, Providence, which cast it. Since the blow-holes are missing, it was not made from the original plaster cast (then on loan to the Boston Museum). Indeed, the Metropolitan's sculpture attests to the existence before 1906 of a plaster cast in which the blow-holes were eliminated. A plaster cast of the *Dying Centaur* now at the Yale University Art Gallery seems to have been made from the original plaster cast in 1905, presumably at the Gorham foundry. The anatomical articulation of the Boston plaster cast of the *Centaur* is slightly sharper than in the Yale cast, the surface of which is generally smoother, less dry, and less rough than that of the original plaster cast. It seems likely, therefore, that the Metropolitan Museum's bronze *Dying Centaur* was cast from this first twentieth-century plaster. The second twentieth-century plaster cast of the *Dying Centaur* associated with the casting project of the Rimmer Memorial Committee was a plaster, also made at Gorham, that Smith presented on November 5, 1906, to the Avery Library of Columbia University, along with plaster casts of the *Fighting Lions* and the *Falling Gladiators* (current whereabouts of all three unknown). The Yale cast was acquired in 1968 from Kennedy Galleries, New York, which, significantly, had purchased it from Lincoln Borglum, son of Gutzon. Before selling it, the gallery created the edition of fifteen bronzes of which the Art Institute's is number six. Thus, the Yale cast appears to be the parent of all the twentieth-century bronze casts and, perhaps, of the lost Avery plaster cast, as well.

25. Bartlett (note 11): 124.

26. *Boston Daily Evening Transcript,* June 2, 1869: 2. The pronounced backward pull of the body of the *Centaur* is similar to that of other works by Rimmer dating from 1866 to 1870, including the male figures of *Evening* in two 1866 drypoints (Boston Medical Library and Museum of Fine Arts, Boston), a drawing dated December 15, 1869, and a large drawing on canvas done between late December 1869 and February 1970 (both Museum of Fine Arts, Boston).

27. In 1867–68 Rimmer had attempted to create ideal sculpture with idyllic classical subjects and form. Included in this group are *Chaldean Shepherd, Endymion, Orpheus;* see Bartlett (note 11): 59, 145.

28. In a letter of August 24, 1865 (Boston Medical Library), in which he also enclosed two photographs. The dimensions of Rimmer's plaster cast of the *Dying Centaur* are 21 ½/22 x 26¼ x 22 in.

29. Perkins was a main force behind Rimmer's preoccupation with reposeful, classically oriented sculpture. None of these sculptures ever materialized into what Perkins envisioned as major works, to be cut in marble in Florence. In Perkins's last extant letter to Rimmer, dated December 23, 1868 (Boston Medical Library), he encouraged the artist to "put at least one work expressing your ideas of beauty and dignity and exhibiting your full science into a permanent form . . ." It is likely Rimmer conceived his *Dying Centaur* in this spirit.

30. In Boston Rimmer could have been introduced to Barye through William Morris Hunt, who owned a considerable number of the French sculptor's bronzes. Barye's sculptures were sufficiently popular in America to warrant an exhibition of 124 of them in 1874 at the Corcoran Gallery of Art, Washington, D.C. Significantly, Barye intended his sculpture to be experienced three-dimensionally, as did Rimmer.

31. Bartlett (note 11: 122) recounted Rimmer's criticism of Canova's work: "He made some fine statues; but, if I may venture an opinion on the works of so great an artist, I should say that he strains a little for effect, and has too much mannerism to be altogether agreeable."

32. Goldberg (note 16): 45.

33. Rimmer was interested more in the principles underlying antique art than in mere narrative, didactic superficialities, which, no doubt, he believed his American contemporary sculptors most admired in antique art. In an unidentified and undated newspaper notice in the Rimmer Newspaper Clipping Scrapbook (Boston Medical Library) entitled "Art Instruction for Women—The Cooper Institute School of Design," Rimmer is quoted as stating that: "People talk of the study of the ancients in art, but what does it mean except that we should look at the real world and strive to express it, for that is what they did."

34. A. Elsen (*The Partial Figure in Modern Sculpture from Rodin to 1969,* exh. cat., The Baltimore Museum of Art, 1969) investigated this topic. However, he did not mention Rimmer. The *Falling Gladiator* as the harbinger of Rodin's work has been well discussed by A. TenEyck Gardner (*Yankee Stonecutters: The First American School of Sculpture 1800–1850,* New York, 1945: 38), among others. In terms of Rimmer's allusion to classical fragments, M. M. Naeve (*The Classical Presence in American Art,* exh. cat., The Art Institute of Chicago, 1978: 27) observed that Rimmer's *Dying Centaur* "reveals the widespread acceptance of the Classical fragment, which routinely had been restored until the nineteenth century. Rimmer was among the first to endorse the concept as a compositional device."

35. Rimmer wrote about drawing, "Make no display of technical anatomy. A work of art should be something more than the solution of a problem in science" (*Art Anatomy,* Pt. II, Boston, 1877, drawing 12). Rimmer's annotations on 81 drawings in the Museum of Fine Arts, Boston, are a rich source for Rimmer's beliefs. *Art Anatomy* was reprinted in 1884, 1889, 1905, and 1919. An edition was published in London in 1884 and a recent edition in New York in 1962.

36. Gardner (note 34) saw the *Centaur* as a "perfect symbol for the career of William Rimmer." The *Dying Centaur* lacks emblematic elements such as a beard that would identify it as Chiron and, thus, that would more completely substantiate this interpretation.

37. Kirstein expressed it best: "The *Dying Centaur* . . . shows . . . the wrench of the cerebral against the muscular animal" (note 6: [1946]:[15], or [1961]:[14]).

38. ". . . there is something very touching and impressive in this statue of the Faun. In some long-past age, he must really have existed. Nature needed, and still needs, this beautiful creature; standing betwixt man and animal, sympathizing with each, comprehending the speech of either race, and interpreting the whole existence of one to the other" (New York, 1958: 7).

39. Rimmer's preoccupation with themes of eternal life and the soul's immortality is particularly prevalent during the 1860s in such works as *St. Stephen* and *Osiris*. His *Falling Gladiator* of 1861 can, on one level, be viewed as a kind of Christian soldier, an embodiment of the national soul's fight against the demonic force of secession at the outbreak of the Civil War. Sometime between 1861 and 1863 Rimmer attempted a bust of a *Dead Girl (Miss W.F.)* (whereabouts unknown). In this same decade, he twice treated the subject of Endymion. These various themes of the soul's immortality are repeated in Rimmer's drawings between 1865 and 1870, such as *Morning, Evening, Soothsayer, On the Wings of His Creator* (all Museum of Fine Arts, Boston).

40. Rimmer (note 10): 287. Interested in spiritualism, Rimmer is reported to have possessed certain "psychic" senses. Bartlett related an instance when Rimmer used automatic writing and discussed his intuitive and clairvoyant abilities (note 11: 18, 21).

41. This obscure but viable source was suggested by E. J. Nygren, "William Rimmer's *Dying Centaur,*" unpubl. Ms. for Yale University, 1969: 20.

42. Ibid.: 20–21. Pages 124–26 of Young are cited.

43. Ibid.: 21. Pages 143 and 58 of Young are cited.

44. The *Dying Centaur*'s somewhat bulging, apparently lidless eyes may protrude from their sockets due to the extreme strain caused by the upward stretch of the torso and the backward arch of the head. The eyes could also be related to the antique and neoclassical sculptural convention of pupil-less eyes utilized by Rimmer and his contemporaries. Finally, the eyes may be a formal expression of the *Centaur*'s striving for the transcendent. The idea of the "eyes as the windows of the soul" was a well-known Transcendentalist belief shared by Rimmer.

45. See note 20.

46. Rimmer was able to extract from his own personal tragedy an art of universal, mythic import. In this sense, the *Dying Centaur,* while similar in many respects to Rimmer's earlier sculpture of *St. Stephen,* is also quite different and, given its formal qualities, must be interpreted differently. *St. Stephen*'s implied gesture and explicit physiognomy are more agonized than the *Centaur*'s. While the initial impact of the *St. Stephen* may be more overwhelming, the *Centaur* is no less potent in emotional power. The *Dying Centaur* appears to be a more subtle, less overtly symbolic self-portrait than the *St. Stephen.* The formal expression of the *Centaur*'s theme seems to reveal a more profound, balanced, and integrated distillation of experience.

Evan Turner

Thomas Eakins: The Quest for Truth

Thomas Eakins looked to the artists of the past solely for the lessons they could teach him in the pursuit of his own art. Those artists were few indeed: notably Velásquez, Ribera, and his own master, Gérôme. But among those few is one who may seem somewhat surprising for an artist so committed to the tenets of mid-nineteenth-century French realism, namely the fifth-century Greek sculptor Phidias. Eakins frequently cited the example of the great sculptor of the Parthenon in his work with students at the Pennsylvania Academy of the Fine Arts. The sculptor so fascinated him that among the very few subjects drawn from literature or history he even considered painting is *Phidias Studying for the Frieze of the Parthenon,* known from a study that was never executed.[1]

There is no evidence that Eakins ever saw the Parthenon marbles in London. Hopeful scholars have speculated that en route home from his only European trip, of three and a half years, between paying his Paris hotel bill in mid-June 1870 and reaching Philadelphia on July 4, he may have paused in London. Whether or not he did so, the great processional reliefs were very much part of his day-to-day existence thereafter, for during his teaching years full-scale plaster reproductions hung in the studio classrooms of the Pennsylvania Academy of the Fine Arts.

The evidence can leave no doubt that Eakins was fascinated by the problems presented by relief sculpture. Three of the most important of the all too few commissions he received during his life were for reliefs.[2] Ironically, in pondering his total oeuvre, scant attention is given this aspect of his achievement, perhaps because it was not well known. Thus, the recent acquisition by the Art Institute of Chicago of his first two reliefs, *Knitting* and *Spinning,* is particularly noteworthy (figs. 1 and 2).[3]

Understandably, Eakins welcomed the commission to create these two relief sculptures for an "open fireplace" in the town house being built for the affluent Philadelphian James P. Scott at 2032 Walnut Street (fig. 3). As the artist subsequently observed, Scott's architect, Theophilus Parsons Chandler, "easily induced me, for the work was much to my taste."[4]

Fortunately, one can deduce a considerable amount of Eakins's thinking about this particular art form. One of the famous lectures on perspective that he was invited to give at various eastern art schools was devoted to "The Laws of Sculptured Relief."[5] While the date of that lecture cannot be firmly established, it seems safe to assume it was written while he was deeply

involved in the realization of *Knitting* or shortly thereafter. The lecture is exceedingly technical in defining how to render correctly in relief a tip-top table such as is found in the Scott piece.

In the course of reading the more general observations of the paper, one discovers that Eakins felt there were essentially two approaches to the solution of relief sculpture. The less successful approach was represented by Ghiberti's later doors for the baptistry in Florence. Eakins believed the shortcoming of that method was the decision to place the "near figures which are of the greatest interest . . . in full or nearly full relief, and the distant parts . . . [in] a very flat relief," which meant that when the relief was "viewed in the light most favorable for showing the form, the near figures throw shadows on the distant landscape and other parts," thereby undermining the illusion.

A far more satisfactory solution was that of the Greeks. As Eakins observed, the "change of scale [in Ghiberti's reliefs] is a departure from the simplicity of the Greek frieze. The Greeks choose subjects for their reliefs exactly suited to their means of expression." The subtlety of execution of the Greek works fascinated him, as is evident from his observation that "nine-tenths of the people who have seen casts of the frieze of the Parthenon would say [incorrectly] the figures are backed by a plane surface, so gentle are its numerous curves which are instantly seen on looking endways or putting in a skimming light." Understanding his distinction between the two approaches to relief sculpture clarifies the challenges he faced in creating his first subject reliefs.

Arriving at the Scott house, essentially French Renaissance in its detailing, one entered a hall flanked on each side by sitting rooms. This hall led into the single most imposing space of the house, a great stair hall going up through the center of the edifice. Apparently, against the far wall on the left, the stair mounted to a landing that ran the length of the left wall before turning to a second flight; this great landing faced the large fireplace on the right wall. Alas, the house was gutted by fire in recent years, and to date no photographs have been found suggesting the original appearance of this area. Nevertheless, it is reasonable to conclude that the reliefs were designed for this chimneypiece, given the splendor of the space and recognizing, as Eakins did, that they were to be seen "three feet above the eye."[6]

Eakins clearly had a difficult problem of multiple viewpoints. Upon entering this space from the hall, a viewer would see the reliefs on his right, above eye level. Oppositely, a viewer would also see them from above as he crossed the landing and, in turn, at changing levels of vision, but off center, as he descended the final flight of stairs. Surely, therefore, *Knitting,* with its circular element, the table, more parallel to the relief surface than is the spinning wheel, was on the left-hand side.

In choosing these subjects, Eakins turned to a theme that had intermittently occupied him for the past six years, that of women, dressed in turn-of-the-century costumes, deeply absorbed in their handiwork. The motif first appeared in the chaperon knitting industriously while safeguarding the daring young woman posing in the nude for William Rush as he carved his famous *Nymph and Bittern* (fig. 5). That Eakins created a succession of variants on this theme may be, in part, his calculated attempt to attract patrons; the general post-Centennial fascination in the early days of America would have made this a popular subject.[7] However, the steady improvement evident in the painting of each successive picture, the increasing conviction with which each figure rests on the ground, and, in the spinning subjects, the dexterity with which the twirling wheel is rendered with progressively greater assurance

Figure 1. Thomas Eakins, American (1844–1916). *Knitting*, 1882–83. Plaster; 18½ x 15 in. The Art Institute of Chicago, Marian and Samuel Klasstorner Fund Income (78.438).

Figure 2. Thomas Eakins. *Spinning*, 1882–83. Plaster; 18½ x 15 in. The Art Institute of Chicago, Marian and Samuel Klasstorner Fund Income (78.437).

Figure 3. Theophilus Parsons Chandler, American (1845–1928). James P. Scott Residence at 2032 Walnut Street, Philadelphia, 1883.

Figure 4. Augustus Saint-Gaudens, American (1848–1907). *Dr. S. Weir Mitchell*, 1884. Bronze. East Greenwich, R.I., Mr. A. Middleton Gammell Collection.

indicate that these subjects were yet another example of his presenting himself painterly problems to solve.[8]

The reliefs are closely related to earlier watercolors. In contrast to the more usual practice in which the spontaneous watercolor precedes the much more studied oil, Eakins, in almost every case, evolved a specific subject in oil before painting it in watercolor. After all, watercolor allows no correction. The reliefs become, therefore, that much more interesting when seen as yet another step in the study of a previously considered idea.

The *Knitting* relief is most closely related to a watercolor, now at Princeton, painted some years earlier, in 1877 (fig. 6). Beyond the anticipated technical difficulties, the subject presented few problems. Eakins had worked with his model, Mrs. King, a number of times since she first posed as the Rush chaperon.

Matters did not go quite as smoothly with *Spinning*. The relief is essentially a restatement of a watercolor made a year earlier, in 1881 (fig. 7). In addition to painting his sister Margaret spinning, he also depicted her in a watercolor brilliant for the subtle skill with which he used a restricted color range (fig. 8). That watercolor might even have been an alternative study for a potential relief. These were Eakins's last paintings of his favorite sister, because unexpectedly, given her robust good health, she died of typhoid fever just before Christmas of 1881.[9]

With Margaret's death, Eakins had to find a new model to pose for his relief; he chose one of his students at the academy, Ellen Wetherald Ahrens.[10] The intensity of Eakins's concern for exactitude, an attitude that epitomized the French realistic tradition in which he had been trained, is evident from his observation to Scott: "[A]fter I had worked some weeks, the girl in learning to spin well became so much more graceful than when she had learned to spin only passably, that I tore down all my work and recommenced."[11] Such precision of method must have frustrated a patron impatient to complete his new house!

The reliefs are a study in contrasts: the youthful spinner in opposition to the older woman (the difference in the treatment of the flesh on each arm epitomizes the artist's belief that consistency in the treatment of every part was essential if a figure was to be convincing as a whole); the simplicity of the girl versus the elegance of the woman (evident in the way each sits, the turn of each foot, even in the choice of the common stool versus the splendor of the Affleck "Chippendale" chair); the study of one from the back and one from the front; and the static nature of the great circular surface of the tip-top table in contrast to the twirling wheel of the spinner. How characteristic of Eakins that in two such formal commissions he should permit his great delight in animals to be expressed in the cat's pursuit of the knitter's escaped ball of thread!

Eakins was being quite realistic when he wrote Scott: "The mere geometrical construction of the accessories in a perspective which is not projected on a single plane but in a variable third dimension, is a puzzle beyond the sculptors whom I know."[12] Unfortunately, this important commission, so challenging of solution that it required extended weeks of work, ended in disappointment. An extensive correspondence, as yet unpublished,[13] presents the artist's side of the problem: his concern about the abilities of the stonecutter who was to translate the clay model into the material appropriate to the chimneypiece, his frustration at the patron's most inappropriate suggestion that the works should be left unfinished, and then his lengthy efforts to receive even a partial remuneration when the works were finally rejected.

Matters were settled on June 8, 1885, when Eakins noted in his account book: "In settlement according to arbitration, the panels being returned to me to be my property and $500 paid to me to release Mr. Scott from all liability for his order."[14]

No evidence has been published explaining Scott's reasons for rejecting the reliefs. Possibly the creation of a great chimneypiece was proving disproportionately expensive. Perhaps the pieces were not sufficiently "modern." In their depth of relief and nervous surface agitation (which, ironically, were nearer to Ghiberti's solution than to Phidias's), *Knitting* and *Spinning* were far removed from the elegant description of the widely admired reliefs created by Eakins's contemporary, Augustus Saint-Gaudens. Scott probably knew Saint-Gaudens's work firsthand; in 1884 the sculptor created a fine likeness of Philadelphia's nationally known urbane physician and man of letters, Dr. S. Weir Mitchell (fig. 4). Curiously, it is the same Dr. Mitchell who is said to have lent Eakins the Affleck chair on which the woman sits in *Knitting*.

Only ten years later, in work for the Trenton Battle Monument, would Eakins more closely approach the subtle nuances of modeling and the very low relief found in Saint-Gaudens's reliefs or, probably more to the point, in the Parthenon frieze.

Eakins's second sculpture commission was far more ambitious and, unlike the first, was completed. In 1891 for Brooklyn's Memorial Arch, dedicated "To the Defenders of the Union, 1861–1865," he created two life-size sculptures of horses on which were to be mounted William R. O'Donovan's figures of Abraham Lincoln and Ulysses S. Grant. As important as the commission was for the artist, it received little local attention. Thus, the interest of Riter Fitzgerald, the art critic of *The Philadelphia Evening Item,* must have meant a great deal to Eakins. On December 9, 1895, the *Item* announced that the reliefs were to be unveiled in Brooklyn the next day.[15] One gathers from Fitzgerald's writings that Eakins's work was criticized, most notably in the artistic circle surrounding Frederick William Mac-Monnies, who had created three major groups for the arch, including the quadriga surmounting it, and who may have hoped to do the two great reliefs as well.

A month later, therefore, on January 7, the *Item,* displaying its characteristic zeal in taking up causes, devoted a front-page column to the matter, defending Eakins against the charge. And the accusation was an unbelievable one: The critics argued that Eakins did not have a correct understanding of equine anatomy! Of the many counts contemporary critical opinion might have chosen to lodge against the artist, this was the most improbable; no other American artist had devoted so many hours to the study of horses, including repeated anatomical dissections with his students. Strongly supporting Eakins, the *Item*'s critic, Riter Fitzgerald, suggested that if such doubts were seriously entertained, a commission of artists should be created to examine the charge and disprove it.

In light of this commitment to Eakins, as evidenced by this story and others, it is hardly surprising that the artist painted the critic's portrait (fig. 9), now in the Art Institute of Chicago. Riter Fitzgerald was a diverting combination of mild eccentricity,[16] considerable perception, and intense loyalty to the causes he espoused. He was Philadelphia's most interesting critic; indeed, he was a delightful anomaly in the American critical world of the day. As he himself observed:

> It is the business of the great majority of the Philadelphia newspaper critics to notice and praise only. *The Item,* on the other hand, expresses its opinions, without fear or favor.[17]

Figure 5. Thomas Eakins. *William Rush Carving His Allegorical Figure of the Schuykill River,* 1876–77. Oil on canvas; 20⅛ x 26¼ in. Philadelphia Museum of Art, Gift of Mrs. Thomas Eakins and Miss Mary Adeline Williams. Photo courtesy the Philadelphia Museum of Art.

Figure 6. Thomas Eakins. *Seventy Years Ago,* 1877. Watercolor over pencil on paper; 15⅝ x 11 in. The Art Museum, Princeton University, Frank Jewitt Mather, Jr., Collection (57.118).

Figure 7. Thomas Eakins. *Spinning (Home-Spun),* 1881
(detail). Watercolor on paper; 14 x 10⅞ in. New York,
The Metropolitan Museum of Art, Fletcher Fund, 1925.

Figure 8. Thomas Eakins. *Spinning,* c. 1881. Watercolor
on paper; 11 x 8 in. Roanoke, Va., Mrs. John Randolph
Garrett, Sr., Collection.

Born on July 4, 1844,[18] he was the son of Thomas Fitzgerald, who established the *Item* as a daily in 1852 and built it into one of the city's most successful papers by the time of his death, in 1891. Thomas was successful as a dramatist as well. The newspaper's strong commitment both to municipal improvements and to the arts was adopted by his sons.[19]

Riter led a picturesque early life. As his obituary recorded:

> He received an excellent education, early developed a brilliant intellect, and within a few months after obtaining his majority, or to be exact in 1865, he was appointed by President Andrew Johnson to the counsul of The United States at Moscow, Russia. This important consular post he held for six months and resigned because of failing health. . . . He remained in Europe for some two years . . . studying music and art.[20]

Newspaper accounts indicate that Riter amassed a considerable private collection, composed largely of works by American artists.[21]

During the autumn of 1895, when for the purposes of this paper its activities are of greatest interest, the *Item* devoted a front-page column to the visual arts virtually every weekday and a feature piece inside the paper on Sunday. Even the numerous front-page columns demanded by such absorbing stories as the Holmes murder trial at the end of October, Pennsylvania's football victories at Thanksgiving, or the disturbing labor negotiations of the street railway workers just before Christmas rarely displaced Riter Fitzgerald's daily column.

A distinct critical personality emerges as one reads these columns, which wander widely in their reportage of art news from all parts of the world; they are rich in editorial opinion. Fitzgerald displayed a self-assurance, clearly writing with no sense of judgment from superiors. He did not hesitate to attack the Establishment. His criticisms were as wide-ranging as his enthusiasms. He rebuked the commissioners of city property for their incompetent program to restore the great collection of colonial portraits at Independence Hall. The initial plans that would eventually lead to the creation of the Philadelphia Museum of Art in Fairmount Park were explored from every point of view; everyone involved was criticized. Even as the streetcar strike loomed, Fitzgerald took a strong position on the projected museum; on December 13 he wrote:

> The scheme was, from the beginning, a foolish one. I understand that Mr. Widener is responsible for it. This would speak well for Mr. Widener's enterprise if he were spending his *own* millions but to expect the *public* to erect a gigantic Art Gallery in the Park that he may present his not-any-too-good collection of pictures to it while he charges the people eight cents carfare that they may visit it—oh, that is too much, my dear Mr. Widener, too much.

Ironically, not only was income from the city's streetcars a significant factor in the Widener fortune, but the Widener collection ultimately went to the National Gallery in Washington, D.C., instead of to the Philadelphia Museum of Art.

Fitzgerald was not only Eakins's friend but also a great admirer of his art. Furthermore, he befriended Eakins's pupil and surrogate son, the sculptor Samuel Murray. Fitzgerald's comments on their work are most useful, since, although secondhand, they surely reflect Eakins's own thoughts. And any information that contributes to a better understanding of Eakins's attitude toward his work is invaluable, as he wrote so little himself.

The major art event of autumn 1895 was the late November exhibition of the Art Club in

Philadelphia; Fitzgerald discussed it with praise and criticism in a succession of columns. After questioning whether the exhibition's most widely admired sculpture, a *Venus and Adonis* by Auguste Rodin, was in fact from the artist's hand, he extolled what he considered the outstanding sculpture:

> The gem of the exhibition is the portrait statuette of Mrs. Eakins by Samuel Murray [fig. 11]. It is a most excellent likeness of the subject, full of sensitive modeling and graceful action. There is a tendency just now to an abuse of the figure motive in sculpture and it is quite refreshing to see it done as it should be with respect to the human figure and the grasp of life. It requires rare ability to take a moving, living being as a model and convey to the inanimate clay all the character of that being. Murray has done this. He is by far Philadelphia's leading sculptor. He has genius. He surpasses them all.

The exhibition was rich in landscapes, possibly reflecting the enthusiasm for such pictures by Philadelphia's collectors. There were few portraits, but one omission seemed particularly unfortunate to Fitzgerald:

> The absence of good portraits is one of the notable features of the exhibition. With the solitary exception of the Tarbell painting, which is in an entirely different vein, there is not a portrait to be seen which at all compares with that of Mrs. Dr. Leonard by Thomas Eakins which the Selection Committee thought proper to reject. Why was this portrait rejected? Was it personal prejudice that caused its rejection?[22]

He himself suggested the reason: "It would have killed all the other portraits except the lovely Tarbell figure, which is an exquisite work."[23] It is no longer possible to judge the Selection Committee's taste, because this three-quarter-length portrait of the wife of the early X-ray specialist met, according to her daughter, "with an accident and is no longer in existence."[24] Fortunately, the preliminary sketch for it (fig. 12) does exist.

The major event of Philadelphia's winter season of 1895 was the 65th Annual Exhibition of the Pennsylvania Academy of the Fine Arts. Anticipation was high after it became known in October that a major local patron of the arts, Mr. George Elkins, had donated the handsome sum of $5,000 to be awarded to the most distinguished American painting in the exhibition (alternatively, it could be distributed as two prizes of $3,000 and $2,000); such a grand prize would surely attract major works.

Fitzgerald immediately advocated in his column that no American living abroad should be viewed as a candidate for the prize.[25] He and his readers recognized this stipulation would eliminate an artist such as Sargent who was revered by Philadelphia's social leaders. Fitzgerald further urged local collectors to purchase American art rather than feeble foreign pictures or fourth-rate old masters. Even the city's most impressive collector, John G. Johnson, was soundly criticized for his lack of knowledge about America's artists.[26] He expounded his belief that no artist should be permitted to submit more than three works, thereby giving a greater number a chance at the prize.[27] Clearly, he wanted to give every advantage to the artists. He even urged that the final selection of the all-powerful Hanging Committee should be taken out of the hands of the academy's board, since the committee's placement of a work could severely affect critical reaction.

By general agreement, as Fitzgerald put it, the exhibition was "the most notable in the

Figure 9. Thomas Eakins. *Portrait of Riter Fitzgerald*, 1895.
Oil on canvas; 76 x 64 in. The Art Institute of Chicago,
Friends of American Art Collection (50.1511).

Figure 10. Thomas Eakins. *Preliminary Sketch for Portrait
of Riter Fitzgerald*, c. 1895. Oil on canvas; 13 x 10½ in.
New York, Kennedy Galleries. Photo courtesy O. E.
Nelson, New York.

Figure 11. Samuel Murray, American (1870–1941). *Mrs. Thomas Eakins,* 1894. Plaster; 24¾ x 8⅝ x 9¾ in. Washington, D.C., Hirshhorn Museum and Sculpture Garden, Smithsonian Institution (1966.3754).

Figure 12. Thomas Eakins. *Study for Portrait of Mrs. Charles L. Leonard,* c. 1895. Oil on panel; 13¾ x 10¾ in. Washington, D.C., Hirshhorn Museum and Sculpture Garden, Smithsonian Institution (1966.1512).

history of the institution."[28] The Elkins prize was considered the primary explanation for the quality and the number of submissions. Abbot Thayer's *Caritas* hung in the place of honor, subsequently receiving the larger part of the Elkins prize.

While Eakins exhibited three pictures and one sculpture (his latest bas-relief, *The Continental Army Crossing the Delaware,* for the Trenton Monument), he is known to have submitted four paintings. On December 6 he wrote the academy: "My picture of Frank Cushing (fig. 13) went to the academy today without its frame for which I beg your indulgence. The frame itself is at the house and if you cannot send for it Monday I shall send it myself."[29]

The academy still has the receipt recording that the picture was submitted, but nothing more is known. It may have been rejected. Without identifying them, Riter Fitzgerald refers to "several pictures which were rejected and several of them very much better than those which found places upon the academy walls."[30] Rejection would have been an astonishing decision, because it was one of the most unusual portrait achievements of Eakins's career. Earlier, Fitzgerald had even heralded its creation in recording, on October 16, that the artist was painting the portrait of the Indian ethnologist Frank Hamilton Cushing: "Mr. Eakins will make a superb picture. . . . The Indian costume is wonderfully picturesque and the Indian details of the picture will add to its value historically." He expressed the hope it would "be finished in time for the academy exhibition in December," adding, "It ought to be purchased for the Smithsonian Institution in Washington."

Be that as it may, the Cushing portrait was not exhibited, but two major full-length portraits were. These were the likenesses of John McClure Hamilton (fig. 14) and of Riter Fitzgerald. Hamilton, an academy student, had recently earned considerable success as a portraitist in London. He had just returned from England—for what turned out to be a brief period—and he had played an active role as a member of the Hanging Committee. Fitzgerald discussed the portrait at some length. It was one of the very few works to be reproduced in the *Item* with a line drawing:

> It is broadly treated and is skilful in execution. Hamilton stands there in all the vigor of life in an easy, graceful pose. It is the fashion now-a-days to criticize Eakins. The small fry, who wallow beneath him, are in the habit of saying that he is too matter-of-fact, too monotonous in tone, etc.; but in the case of Hamilton he has lifted his subject, body and soul, and placed them [sic] upon the canvas. It is the living embodiment of the man with all his individuality and characteristics. One of the critics said: "Hamilton looks as if he was waiting for the gun to go off to start a footrace." This was intended as an adverse criticism, but the learned gentleman was paying the highest kind of compliment to Eakins's work. If the portrait is sufficiently lifelike to convey the impression that he is about to start upon a footrace, Eakins is to be congratulated upon his art, and Hamilton to be congratulated upon the selection of his artist.[31]

As to Fitzgerald's portrait, it must have been painted during the autumn. In his column the sitter may even have provided a clue to the specific time; on October 8 he noted that Samuel Murray was engaged in doing the bust of "a prominent newspaperman." Given his patterns of reference to himself in his writings, he may well have been speaking of himself here. His admiration for and interest in the young sculptor has already been noted. Murray's work has not yet been studied with method—certainly none of the known busts represents a newspaperman—but if Fitzgerald was the sitter, one can probably assume Eakins painted his portrait at

the same time. Frequently during these years, the master and the student, sharing a studio at 1330 Chestnut Street, did likenesses simultaneously, side by side.

In any case, due to his great interest in Eakins, Fitzgerald must have discussed his portrait with the artist as he progressed. His description is of particular interest, therefore, for suggesting how the artist saw his work:

> The portrait of Mr. Riter Fitzgerald is, without question, one of the finest in the exhibition. The subject is seated in a graceful position in an easy chair in his library. The right leg is thrown across the left and the expression upon the face denotes that he is pondering over some thought advanced in the book which is open on his lap. The chair is placed diagonally across the painting, giving the artist an excellent opportunity not only to paint it effectively, but to pose his subject in a most natural and unaffected manner. There is no element which enters into the painting of a portrait that admits of such great variety, or contributes as much to its pictorial interest as that of accessories. Eakins is a master of these. The background of this portrait, row upon row of books upon their shelves, is colored with that harmony which imparts an agreeable sensation to the observer. In portraiture, when action is usually out of place, the painter may resort legitimately to the many aids which these accessories afford. When these are skilfully combined with a perfect likeness, a great picture is the result. In this instance the subject is broadly painted and the whole is a most faithful representation. It is undoubtedly one of the finest portraits Eakins ever painted. It is also one of the greatest works in the present exhibition.[32]

How rarely does one find a sitter's views expressed with such method!

The third picture exhibited was the ill-fated likeness of Mrs. Leonard noted above. After reminding his readers of the earlier Art Club rejection, Fitzgerald observed:

> The sitter is a most interesting subject, with clear-cut features, an expressive face, and a three-quarter posture which is at once natural and graceful. It is richly colored [she wore a red dress with brown fur around her shoulders] and has lifelike qualities which will commend it to all. How the Art Club came to reject such a gem is one of those mysteries which only the erratic members of that club can explain.[33]

At about this date (the date is not known but Goodrich suggests 1895), Eakins painted an even more ambitious full-length seated portrait of a lady in evening dress, a likeness of Fitzgerald's sister, Mrs. A. Hallam Hubbard. That such an important work was never exhibited (unless it was one of the still unidentified portraits shown in Eakins's only one-man exhibition held in 1896 at the Earles' Galleries) may suggest the family's dissatisfaction which led subsequently to the destruction of the work by Mrs. Hubbard's daughter. Sadly, the whereabouts of the preparatory sketch, which Mrs. Eakins kept, is still unknown.

Beautiful paintings of lovely women were viewed as particularly appropriate decoration for the opulent houses of late nineteenth-century America. There were distinguished international figures to respond to the demand, notably John Singer Sargent and Anders Zorn. Although Sargent always felt a certain identification with Philadelphia—his works were greatly praised whenever they were exhibited there—he made only one major descent upon the city to paint portraits, in 1903.

Philadelphia's most respected portraitist of elegance was Cecilia Beaux. When one views her work—for example, the portrait of Mrs. Clement A. Griscom with her daughter, Frances,

Figure 13. Thomas Eakins. *Portrait of Frank Hamilton Cushing,* 1895. Oil on canvas; 90 x 60 in. Tulsa, The Thomas Gilcrease Institute of American History and Art.

Figure 14. Thomas Eakins. *Portrait of John McClure Hamilton,* 1895. Oil on canvas; 80 x 50¼ in. Hartford, The Wadsworth Atheneum (1947.399). Photo courtesy The Wadsworth Atheneum, Hartford.

Figure 15. Cecilia Beaux, American (1855–1942). *Mother and Daughter*. Oil on canvas; 83 x 44 cm. Philadelphia, Pennsylvania Academy of the Fine Arts, Gift of Miss F. C. Griscom, 1950.

Figure 16. Thomas Eakins. *The Black Fan* (Portrait of Mrs. Talcott Williams), c. 1891. Oil on canvas; 80¼ x 40 in. Philadelphia Museum of Art, Gift of Mrs. Thomas Eakins and Miss Mary Adeline Williams.

dressed for the young woman's coming-out party (fig. 15), a work that was one of the great successes of the academy's 69th Annual Exhibition in 1900—one sees how far removed it was in attitude and technique from Eakins's relatively few efforts in the same genre (fig. 16). The idealization and the assurance of Cecilia Beaux's characterization, the summary flamboyance of her brushwork, are qualities that led William Merrit Chase to say of this likeness: "The composition breathes with simplicity and freedom."[34] But these qualities are far removed from the frankness of perception and, in comparison, the almost labored technique found in Eakins's work.[35] It is hardly surprising, therefore, that Eakins did not receive requests for this kind of portraiture; that two major works in this genre have disappeared is in itself revealing. When, a few months later, Fitzgerald wrote his lengthy review of Eakins's exhibition at the Earles' Galleries, he clearly faced the problem:

> This is all very well from "an Art for Art's sake" standpoint, but in the progressive work-a-day world of the present time, the portrait painter, the same as everyone else, must trim his craft to the trade winds. . . . The people demand idealization, and if they don't get it at one shop they will bend their footsteps to another.[36]

One can hardly help but wonder whether these words might have been inspired by his disappointment with his sister's likeness.

However, to return briefly to Mrs. Hubbard, Eakins gave her a preliminary study for her brother's portrait. The gift must have been a very special gesture; Eakins's normal practice, in the creation of the more ambitious of the later portraits, was to make a rapid small sketch (the first one for Fitzgerald's was 13 by 10½ inches;[37] fig. 10) in which the relation of the figures to the floor and to the shape of the canvas was worked out, usually with astonishing speed and brilliance. A second larger study such as that given Mrs. Hubbard (24 by 20 inches) is an exception, and is therefore worthy of note.

Portraiture was to dominate Eakins's work for the rest of his life. Taken as a group, his late portraits display the range of attitude and variety in treatment that a distinguished artist can achieve in painting likenesses. Analysis of the whole oeuvre suggests a division into two groups: those works that were intended as statements of a sitter's public image and those that were clearly private.[38] Among the most fascinating of the so-called private group are the two likenesses of Mary Adeline Williams (figs. 17–18), one in Chicago and the other in Philadelphia.

Addie, as she was known, was born on September 3, 1853.[39] Her mother was a friend of Mrs. Eakins, and the two families were particularly close after the early 1870s, when Benjamin Eakins rented a "fish house" from the Williamses. It was situated near their house at Fairton, New Jersey, on the banks of the Cohansee River. Eakins's early subjects of hunters pushing for rail were painted as a result of the many happy hours spent here hunting with his father.

Addie's mother died at an early age, shortly after Mrs. Eakins, who died in 1872. She had nonetheless produced two daughters and five sons. Eakins's first likeness of a member of the Williams family was the posthumous portrait of her mother that he painted for Addie in 1876 (fig. 19). Its inscription can leave no doubt that it was a gesture of affectionate friendship and even, possibly, of sympathy: "Abbie Swing Williams / wife of Samuel Hall Williams / aged 42 years / painted in 1876 by / Thos. Eakins / friend / of the Family."[40] The artist's skill in rendering a vivid likeness depending upon a photograph (fig. 20) is impressive; placing the

Figure 17. Thomas Eakins. *Portrait of Addie,* 1899. Oil on canvas; 24 x 20 in. The Art Institute of Chicago, Friends of American Art Collection (39.548).

Figure 18. Thomas Eakins. *Portrait of Addie,* 1900. Oil
on canvas; 24⅛ x 18¼ in. Philadelphia Museum of
Art, Gift of Mrs. Thomas Eakins and Miss Mary Ade-
line Williams.

eyes only just above the midpoint of the panel gives them a telling prominence, while the introduction of a bright carmine-colored bow at the collar skillfully picks up colors in the face.

Addie kept in touch with the Eakins family; Margaret was a school friend. In 1882, Mr. Eakins is said to have invited Addie to live with the family to fill the lonely gap left by his daughter's death. The invitation may have been the result of Addie's own unhappiness upon the second marriage of her father, for at that time she left home, seldom to return again. In the following years, she supported herself as a seamstress. As the century drew to a close, she lived for six years with a brother in Chicago.

A considerable number of the far too few late letters written by Eakins were addressed to Addie.[41] They convey interest in her well-being; some make arrangements for her to sew with Mrs. Eakins or to dine with them on a Thanksgiving; others suggest expeditions with the two Eakinses to the circus or to a lecture; one invites her to view Sargent's widely discussed portrait of the English art dealer Asher Wertheimer, on exhibition at the academy. One of Addie's letters, dated April 27, 1899, is important for providing a date for the Chicago portrait, since in it she writes that her work made it necessary for her to postpone a sitting.

The correspondence proves that the portrait in Chicago was painted before Addie joined the Eakins household.[42] It is generally assumed that the startlingly different portrait of Addie was executed a year later, after she was living at Mount Vernon Street. The difference between the two likenesses is, indeed, astonishing. Understandably, many have tried to discover a reason for the change, whether through repeated examination of the two pictures or through fruitless reconsideration of the all too few contemporary references. An explanation will probably never be found. The second likeness will remain one of those haunting puzzles best exemplified by the *Mona Lisa*.

The Eakins household was always one of extraordinary and puzzling interrelationships. In later years, after the death of the artist's father in 1899, these relationships became in some ways even more complicated. Everything and everyone revolved around the artist: Mrs. Eakins dedicating herself intensely to his reputation, Addie Williams taking much of the responsibility for the running of the household, and Samuel Murray being the constant companion on most expeditions.

Eakins's considerable sense of obligation to Addie is evident in his bequest to her of a quarter of his estate. Her willingness, in turn, to donate her share of the greater part of the many pictures remaining in the house at his death when, in 1930–31, Mrs. Eakins donated them to the Philadelphia Museum of Art makes Miss Williams one of the most generous donors to that museum.

Comparing the two portraits of Addie raises once again the pivotal concern to which one repeatedly returns in pondering the artist's late portraits as a group. To what degree did Eakins paint the person before him and to what extent did that person's likeness become a vehicle for stating larger perceptions of the human condition? Without question, his fondness for the person or the sense of identification with his or her plight became a major factor in the freedom with which he treated his subject.

Every comparison of an Eakins portrait with a contemporary photograph is eagerly perused for the clarification it may provide—and such comparisons only emphasize how far the artist goes beyond the camera's bland statement. Eakins's pleasure in the company of his old friend is certainly evident in the snapshot taken some years after the two portraits were painted, which

Figure 19. Thomas Eakins. *Portrait of Mrs. Samuel Hall Williams,* 1876. Oil on panel; 9 x 6 in. Private collection.

Figure 21. Mary Addie Williams and Thomas Eakins, perhaps with one of her brothers and his wife, at Fortesque, New Jersey, c. 1907. Photograph. Private collection.

records an expedition to a "fish house" or camp in the Cohansee River area (fig. 21). It tells us much about Addie: her severity of appearance, her amiable manner and cheerful spirit. This snapshot suggests that the true Addie lies somewhere between Eakins's two painted portraits. Perhaps one would have an even clearer understanding of the Addie in the two likenesses if one could compare them with the photograph the artist made of her and the portrait Mrs. Eakins is known to have painted of her[43]—but their whereabouts are unknown today.

As was observed in relation to the Fitzgerald portrait, there is little contemporary evidence of Eakins's attitudes. One of the most precious provides insight into the later portraits. It is contained in a letter written to Lloyd Goodrich by the widow of Walter Copeland Bryant, the Brockton, Massachusetts, collector of contemporary art (fig. 22): "Mr. Eakins asked Mr. Bryant if he could take all the liberty he wanted to do a fine piece of work as a work of art rather than a likeness. He thought Mr. Bryant too youthful looking and said in fifty years nobody would know." She went on to note: ". . . hand painted for a 70 year old man at Mr. Eakins' request to do as he wished. Mr. Bryant was 50 . . . day beard at Mr. Eakins' request . . ." Evidence of the speed with which the artist could paint such a portrait in his later years is evident in her note: "Painted in three sittings, a total of ten hours."[44]

A few years afterward (Goodrich suggested a date of about 1903), Eakins painted one other portrait for Addie, a likeness of her sister Annie, then married to Dallas T. Gandy and living in Washington (fig. 23). The artist inscribed the picture "To Addie from Tom of Annie." McHenry reported:

> At the time the portrait was painted, Annie Williams Gandy was staying at the Eakins' house, after an operation. On her way to recovery, and dressed as an invalid, she looked paintable indeed, and Eakins, insistent, had carried her up to his studio to pose.[45]

The likeness is admirably simple and to the point with no flamboyance at all. It may well epitomize the nature of a long-standing friendship between the Williams and Eakins families.

Perhaps the crowning irony of Thomas Eakins's later years is the recognition that, in many respects, the brilliance of those portraits then dominating his work is the result of his having received virtually no commissions. Thus, in seeking subjects, as he had done at the beginning of his career with his patient sisters, he had to depend upon friends, upon those who, in many cases, even revered his genius, to become his sitters. Certainly never in the history of American art has any artist painted portraits of such depth; these clearly resulted from a sensitive perception that could be incisively conveyed because of the breathtaking technical dexterity he had achieved through years of arduous work. These qualities are immediately evident in images as compelling as the two *Addie*s. However, as one learns more about the personality and achievements of his other sitters—and considers their likenesses in this light—one becomes only more impressed by the subtleties of this extraordinary man's sensibilities.

1. L. Goodrich, *Thomas Eakins: His Life and Work,* New York, 1933, no. 255.

2. In addition to the *Knitting* and *Spinning,* herein discussed, Eakins received two other commissions, both through William R. O'Donovan; in 1891, for two life-size horses in half-relief for the Brooklyn Memorial Arch; and in 1892, for relief panels representing *The Continental Army Crossing the Delaware* and *The Opening of the Fight* (also known as *The Battle of Trenton*). For a third subject, which was, in fact, carried out by Karl Niehaus, see Z. Buki and S. Corlette, "The Trenton Battle Monument, Eakins' Bronzes," *New Jersey State Museum Bulletin* XIV (1973): 39.

3. The two plasters were first exhibited a year after their commission at the Pennsylvania Academy of the Fine Arts, 54th Annual Exhibition, October 29–December 8, 1883, nos. 414 and 415.

Figure 22. Thomas Eakins. *Portrait of Walter Copeland Bryant,* 1903. Oil on canvas; 24 x 20 in. Brockton (Ma.) Public Library, Walter Copeland Bryant Collection (on loan to Brockton Art Center). Photo courtesy Brockton Art Center.

Figure 23. Thomas Eakins. *Portrait of Annie* (Mrs. Dallas T. Gandy), c. 1903. Oil on canvas; 23¼ x 19¼ in. Washington, D.C., National Museum of Fine Arts, Smithsonian Institution (1961.11.12).

4. Goodrich (note 1): 64. Scott's selection of Chandler as his architect is an indication of his conservative tastes. A far more flamboyant choice would have been the equally well-born Frank Furness, who had designed the Pennsylvania Academy of the Fine Arts a few years earlier and at this time was at the height of his career.

5. "The Laws of Sculptured Relief" consists of the twelve sheets comprising section G of Thomas Eakins's "Lecture Manuscript and Notes," belonging to the Philadelphia Museum of Art. The museum's Eakins catalogue dates the manuscript about 1884. See T. Siegl, *The Thomas Eakins Collection*, Philadelphia Museum of Art, 1978: 109. I am indebted to the museum for permission to quote from the manuscript and to the museum's editor, George M. Marcus, for assistance in this area and others.

6. Goodrich (note 1): 65.

7. The one picture by Eakins in the Art Institute's collection that is not discussed in this article is a preliminary study for the young woman posing in *William Rush Carving His Allegorical Figure of the Schuykill River*. This study, bequeathed to the Art Institute by Dr. John J. Ireland, is ready proof of the artist's abilities and a fascinating document of the artist's working methods. When the study is compared with the final work, one suddenly understands the extent to which Eakins subtly idealized his model to achieve a painting that could challenge the best work of his master, Gérôme.

8. Broadly speaking, it can be said that once Eakins had explored a subject fully, having solved all of its technical difficulties, he did not return to it again. The single exception in his oeuvre is his return to the William Rush theme at the end of his career; but a comparison of the early and late exploration of the theme only emphasizes their differing points of view.

9. Obituary, Philadelphia, *Daily Evening Telegraph*, December 23, 1881.

10. Siegl (note 5): 64.

11. Goodrich (note 1): 64.

12. Ibid.

13. The present whereabouts of Eakins's letters dealing with the Scott commission is unknown. Portions are quoted and certain of the arguments are suggested by Goodrich (note 1): 64–65.

14. Eakins's account book is in the collection of Mr. and Mrs. Daniel W. Dietrich II. They have been most generous in making this fascinating document available to scholars.

15. Hereafter, if the reference in the text includes the date of publication, there will be no footnote, since all references for the *Item* are for front-page stories.

16. For example, announcing the death of William Wetmore Story, perhaps the most revered of the classicizing American sculptors living as expatriates in Italy, Fitzgerald wrote (October 16, 1895): "The general public has been under the impression that Mr. Story was a remarkable sculptor, but the *Item* assures its readers that America has many sculptors today who are far superior to him."

17. December 28, 1895.

18. *Who's Who in America*, New York, 1912: 706.

19. Harrington Fitzgerald was an artist, having studied with Isabey and Fortuny in Paris.

20. March 5, 1911. Fitzgerald died on a train at La Junta, near Colorado Springs. "Mr. Fitzgerald had suffered for years and on the advice of physicians, he sought recuperation in the rarified air of California some two months ago. Failing improvement, he started home, but death overtook him on the way." Milo M. Naeve kindly showed me a copy of the obituary in the Art Institute of Chicago files.

21. So far, little is known about Fitzgerald's collection. In one column he referred to his purchase of a fourth painting by Peter

Frederick Rothermel (November 9, 1895); clearly, he owned his portrait by Eakins. A copy of his will in the files of the Art Institute of Chicago indicates the collection was bequeathed to the Smithsonian Institution in Washington. But what happened thereafter is a mystery, because the collection did not go to Washington. We know that the Eakins portrait stayed in the family. It belonged first to Fitzgerald's sister, Mrs. A. Hallum Hubbard, and then to her daughter, Miss Geraldine M. Hubbard (who is probably to be identified as the next owner cited in the Art Institute records, a niece named Mrs. J. K. Spare of Moyland, Pa.). As of 1933, the picture belonged to the Whitney Museum of American Art. As part of a policy to collect only contemporary American art, it was deaccessioned and sold to the Art Institute of Chicago in 1950.

22. November 21, 1895.

23. November 20, 1895.

24. Goodrich (note 1), no. 492.

25. October 5, 1895.

26. December 3, 1895.

27. December 7, 1895. He was unsuccessful because certain artists, most notably John White Alexander, submitted more.

28. December 22, 1895.

29. Archives of the Pennsylvania Academy of the Fine Arts. The academy's archivist, Cathy Stover, has attacked the curious problem of the Cushing portrait being submitted but not exhibited.

30. December 22, 1895.

31. December 23, 1895.

32. December 22, 1895.

33. Ibid.

34. *Cecilia Beaux: Portrait of an Artist*, exh. cat., The Pennsylvania Academy of the Fine Arts, Philadelphia, 1974: 93.

35. *The Black Fan* is as close as Eakins came to painting what might be called a society portrait. Even this was not quite finished because, it is reported, Mrs. Talcott Williams was so angered by a comment the artist made about her posture that she ended the sitting (E. Dunbar, *Talcott Williams: Gentleman of the Fourth Estate*, Brooklyn, 1936: 215–16).

36. May 15, 1896.

37. Goodrich (note 1): no. 281. These preliminary studies often provide a fascinating insight into the artist's thought processes. In the case of the Fitzgerald portrait, the distribution of his weight on the chair and floor and the ingenuity with which the different elements of the body are placed on either side of the center point of the figure (i.e., the top of the legs) make this a most unusual composition.

38. Painting more than one likeness of the same person is the exception in Eakins's career. Thus, the two portraits he did of Monsignor Turner are particularly valuable since clearly they present two totally different aspects of the same man. One, essentially a half-length (Goodrich [note 1], no. 347) shows the scholarly friend observing the artist with a pleasant quizzical quality. The other (ibid., no. 438) represents the church leader standing in his brilliant vestments, officiating at a funeral. Probably some of Eakins's difficulties in obtaining acceptance for his works resulted from confusion on the part of the sitter's family as to his intent. A documented case is the splendid representation of the timber merchant A. W. Lee (ibid., no. 427). The present owner has a letter from the sitter's daughter expressing distress at the likeness which, in fact, is clearly meant to be a representation of a leader of commerce rather than of a loving father.

39. Siegl (note 5): 154. The major source of information on Miss Williams comes from M. McHenry, *Thomas Eakins Who Painted*, 1946; 131–33.

40. The inscription was first published in *Artists of the 19th*

Century, exh. cat., Frank S. Schwarz and Son, Philadelphia, 1978. I am indebted to Robert O. Schwarz for his assistance in making available the photograph of Mrs. Williams and the holiday expedition snapshot of the artist and Addie.

41. To date, no scholar other than Margaret McHenry (note 39) has been able to examine the letters presumably still in the possession of Miss Williams's descendants; the letters did not go to the National Collection when the portrait of Addie's sister was bequeathed to the Smithsonian by her daughter, Lucy Gandy Rodman.

42. McHenry (note 39: 133) records that Addie "came to live at the house as Sue's companion" in 1899. Certainly she was living there in 1900, remaining until some months after Mrs. Eakins's death in 1939. An invalid, she spent the last two years of her life with Lucy Gandy Rodman in Washington, D.C.

43. McHenry (note 39): 132.

44. Goodrich (note 1), no. 372.

45. McHenry (note 39): 132.

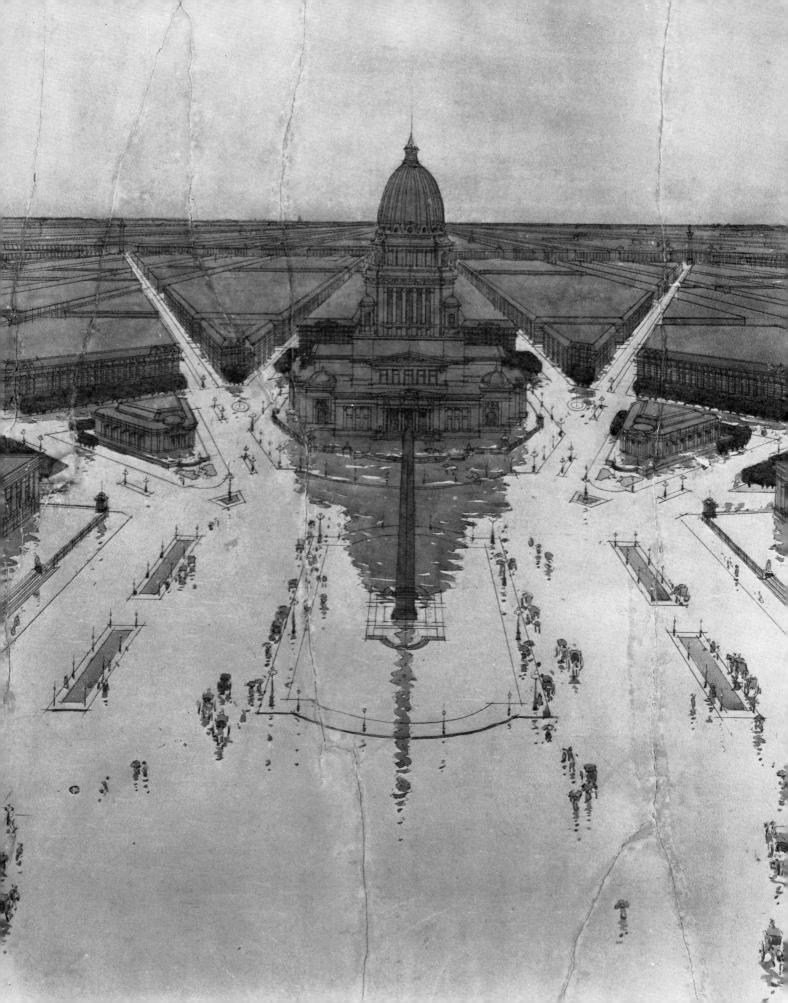

John W. Reps

Burnham Before Chicago: The Birth of Modern American Urban Planning

The World's Columbian Exposition of 1893 made Daniel Hudson Burnham a national figure. The country's best architects, artists, and landscape designers—whose talents he had marshaled to create the fair—acknowledged his leadership and administrative skills.[1] The American Institute of Architects chose him as their president. Harvard and Yale—both of which had refused him admission as a student many years earlier—each awarded him an honorary degree, as did Northwestern University.

Newspapers, magazines, and professional journals alike justifiably gave him much of the credit for creating the great "White City" that had attracted the attention of the world. His fellow Chicagoans regarded him with new respect as the person who had brought fame and honor to their city.

Burnham reaped the benefits of his new status as he resumed the practice of architecture. Important clients sought out his reorganized firm of D. H. Burnham and Company with commissions that within a few years made him a wealthy man.[2] While architectural design and execution required much of Burnham's attention, his interests broadened to embrace the problems of groups of structures in their urban setting and, finally, the layout and redevelopment of entire cities. The Burnham who entered the fair as an architect emerged as an urban designer and city planner.

These activities culminated in the Chicago Plan of 1909. That lavishly published report described and illustrated a host of civic improvements that, if realized, would have transformed the city into a midwestern metropolis combining the glories of modern Paris and Vienna with those of ancient Rome.

In reviewing Burnham's career as a planner, I will not refer in depth to his acknowledged masterwork, the Chicago Plan. I feel much like an author commissioned to write a book on the *Titanic* with the stipulation that he omit the final chapter dealing with the events of the ship's maiden voyage. The analogy is appropriate, for Burnham was truly an American titan, towering over his contemporaries in the new field of city planning and dominating any company in which he appeared.

Yet, just as lesser ships navigated the seas in the era of the *Titanic,* there were other planners on the American scene. We can understand Burnham's achievements—and shortcomings—only if we look at the contributions of these planners at the time Burnham developed

his concepts of city planning. While Burnham—to extend the metaphor—served as a beacon, guiding many in their search for solutions to urban problems, he was also a mirror, absorbing and reflecting images produced by those whose lesser brilliance has been dimmed with time.

In his last major statement on urban planning—his address in 1910 before the International Town Planning Conference convened by the Royal Institute of British Architects in London—Burnham almost totally ignored the accomplishments of other American planners. Summarizing the development of the modern planning movement in his country, he mentioned only the projects in which he had been involved:

> The inception of great planning of public buildings and grounds . . . was in the World's Fair in Chicago. The beauty of its arrangement and of its buildings made a profound impression. . . . As a first result . . . the Government took up the torch and proceeded to make a comprehensive plan for the future development of the capital. . . . Then came the plan of Manila, capital of the Philippines, made under Mr. Taft. . . . Then came Cleveland, Ohio, which State passed a special law in order to allow large towns to employ expert Commissioners, who are to design the public thoroughfares and parks. . . . Then came San Francisco, where an association of private men undertook to back the work. And then came Chicago, where the work was undertaken by the Commercial Club.[3]

Only in passing did Burnham refer to what he asserted were the "many hundreds of Plan Commissions at work . . . throughout the land." The entire passage, even with this qualifier, is so self-serving, ungenerous, and (if one accepts his biographers' analyses of him) uncharacteristic that one is tempted to attribute it to haste, ill health, and the forgetfulness of advancing age rather than to arrogance.[4]

Before tracing Burnham's own remarkable contributions to the modern American planning movement, it might be well to consider the work of his contemporaries and how they may have influenced Burnham's own ideas.[5] Perhaps the most influential was Charles Mulford Robinson, a journalist in Rochester and Philadelphia who supported the efforts of municipal art societies that had been organized in many American cities by the late nineteenth century. Robinson became the most articulate and persuasive spokesman for this movement.[6] His first book, *The Improvement of Cities and Towns* (1901), and a subsequent work of 1903, *Modern Civic Art,* were so popular that they went through several editions.

Although Robinson championed all kinds of civic embellishment efforts, he stated his belief that the goal for every city should be "a well thought-out, artistically conceived general plan."[7] Rather than limit the scope of municipal improvements only to beautification projects, he approved of proposals to move factories and workers to the suburbs, to construct model tenements, and to adopt and enforce housing codes. He also suggested the administrative device to achieve a well-planned city: a commission of professionals. Besides an architect, a landscape architect, a sculptor, and an engineer, he recommended the inclusion of a "member who would not stand for engineering alone, nor for sculpture alone, but for all these together and comprehensively, as one who has made a special study of the general science and art of city-building."[8]

No one at the time fitted this description better than Robinson himself. He soon began a consulting career that, through 1909, took him to at least eighteen cities. He had, however, a greater facility with words than with design, a field in which he had no training. His Denver

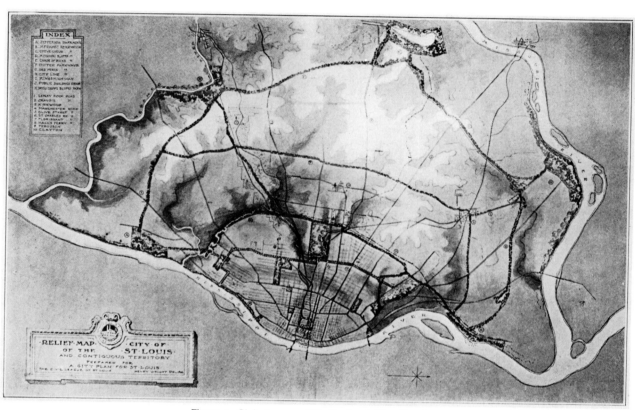

Figure 1. Civic League of St. Louis. *A City Plan for St. Louis,* rendered by Henry Wright, 1906. (From *Architectural Record* XXI [May 1907]: 341.)

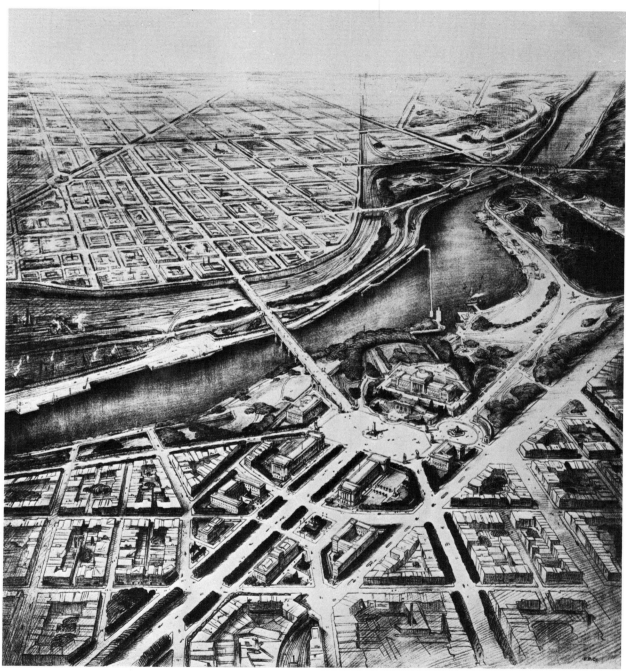

Figure 2. Horace Trumbauer, C. C. Zantzinger, Paul P. Cret. *The Philadelphia Parkway* (Fairmount Parkway), 1907–08.

proposal of 1906, while it introduced the concept of a civic center to that city, needed drastic modification by Arnold Brunner and Frederick Law Olmsted, Jr., and, later, by Edward H. Bennett, Burnham's associate in the Chicago Plan.[9]

While several of Robinson's reports, like that for Denver, focused on a single element of the city, many others embodied the more comprehensive approach he advocated in his books. Most of them tended to be conservative in their recommendations. Interestingly enough, in his Cedar Rapids, Iowa, and Ridgewood, New Jersey, plans of 1908, he included proposals for new radial streets whose awkward connections with the underlying existing grid systems betrayed his lack of design training.

Robinson's verbal talents were better utilized when he joined Austin Lord, Albert Kelsey, Charles Lowrie, and H. A. MacNeil to form the Columbus, Ohio, Plan Commission. In 1908 they issued a handsome, attractively printed, well-illustrated, and understandable report.[10] It advocated a general development strategy for major thoroughfares, parks, and parkways focused on a civic center composed of state, county, and city buildings. Recommendations ranged from these large-scale proposals to such details as removal of overhead wires, the creation of outlying shopping centers, trolley passenger waiting rooms, schools, and neighborhood recreation centers. The report included an old design by Kelsey, evidently done in Paris in 1898, for a public toilet concealed in the base of a monumental sculpture and fountain.

Busy as he was, Robinson continued his journalistic endeavors. He wrote a number of long articles for the *Architectural Record* describing and commenting on planning studies for Washington, Cleveland, St. Paul, Boston, St. Louis, Harrisburg, and Baltimore, along with more theoretical works concerning such matters as the planning of streets in business districts.[11] If Burnham read Robinson's articles and books (and this is probable), he undoubtedly would have found much with which he could agree. Indeed, Robinson drew on Burnham's work as sources for many of his statements of principles and techniques.[12]

Another early planner, John Nolen, began what would be a long and influential career at this time. In 1906 he prepared a plan for Savannah, Georgia, to be followed a year later by a more elaborate proposal for Roanoke, Virginia.[13] After completing a plan for San Diego in 1908, he began work on similar studies of Madison, Wisconsin, and Little Rock, Arkansas.[14]

Like Burnham, Nolen knew of Haussmann's drastic municipal surgery that had grafted an entirely new face on the ancient visage of Paris. Although he included an illustration of these accomplishments in his San Diego report, he proposed no such sweeping changes for the city. Instead, he suggested the development of one tier of blocks leading at right angles from a waterfront esplanade as a series of civic squares to be known as the Paseo, within which were to be placed a casino, the art museum, and the aquarium.

The other major formal element of the San Diego plan was the inevitable civic center. Located a few blocks inland, it was to consist of four buildings—city hall, courthouse, post office, and an opera house—symmetrically arranged around an open square. Around the central area, connected to the existing but largely undeveloped Balboa Park, was to be a system of smaller recreational facilities. To link them together, Nolen planned a series of boulevards and parkways following alignments that skirted sections of the city that had already been developed.

Among the smaller cities of the country that pioneered in planning during this era was Grand Rapids, Michigan. In 1907 two well-known architects, Arnold Brunner and John

Carrère, submitted a plan that, like Nolen's work, accepted the basic rectilinear outlines of the standard midwestern grid. They, too, advocated a system of parkways following stream valleys to provide a kind of green girdle for the town. Their civic center also was fitted into the downtown grid where one older radial sliced awkwardly through the central plaza. The Brunner-Carrère plan, otherwise unremarkable, is worth noting because it at least recognized the problem of housing for middle- and lower-income families. Their recommendations dealt only with the appearance of such structures. Nevertheless, in an era when architect-planners largely ignored housing altogether, this at least represented the beginning of a concern for what eventually came to be seen as a central focus of urban planning efforts.[15]

While Burnham may have examined many plans for small towns, he must have studied with far more care two reports for major urban centers. Both became available to him in 1907 and contained proposals of the scale that he contemplated for his own metropolis.

The Boston report came from the Committee on Municipal Improvements of the Boston Society of Architects.[16] Its publication costs were underwritten by several of the city's most important commercial organizations. It was not a comprehensive plan but a compilation of major projects developed independently by several of Boston's leading designers. One of its proposals called for the creation of inner and outer boulevards to provide circumferential connections to Boston's fan-shaped pattern of major thoroughfares, a system that Burnham used in his Chicago Plan, although with far greater symmetry. Another proposal detailed a plan for new streets in the Fenway neighborhood of the Back Bay. Previously reclaimed by filling, much of the area known as Fenway Park had been an early project of the city's ambitious park program of the nineteenth century.

Several versions of a more elaborate project appeared. These called for the creation of a large island in the Charles River and its development for residential, civic, or recreational purposes. Burnham's own proposals for the Chicago waterfront were equally ambitious, involving the creation of new sites by extensive filling and dredging operations.

One illustration in the Boston report may have reminded Burnham of a project he surely had seen taking shape: the great Kingsway in London slashing a broad avenue through the tangled pattern of existing streets to connect the Strand with the Oxford-Holborn Street axis to the north. In his Chicago report, Burnham used another illustration of this project as one of several examples from abroad that he felt demonstrated the physical and financial feasibility of such municipal surgery.

In contrast to this civic design scrapbook, the plan for St. Louis (fig. 1) addressed a host of issues and proposed a comprehensive and long-range development program. Although no single figure dominated its preparation, two talented individuals aided the several committees of the Civic League: George Kessler, best known then for his park work in Kansas City late in the nineteenth century, and the young Henry Wright, later to become famous for his collaboration with Clarence Stein in such projects as Sunnyside Gardens and Radburn.

In most respects the St. Louis plan resembled those of its period. As a central feature it incorporated an imposing civic center designed by a special commission appointed in 1904. It also endorsed another previously approved project: the development of Kingshighway as the major crosstown thoroughfare to connect three district parks, as well as the much larger Forest Park near the center. Another boulevard proposal originated with the Civic League. The suggested route followed the Des Peres River on the south, curving northward to parallel

Figure 3. *Plan for Central Washington, D.C.,* 1901. (From *Report of Senate Park Commission* [Daniel H. Burnham, Chairman], Washington, D.C., 1902.)

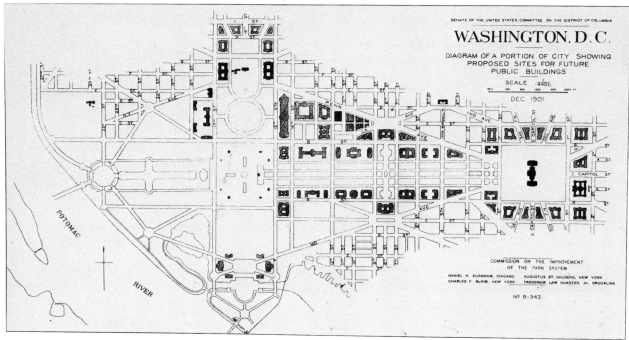

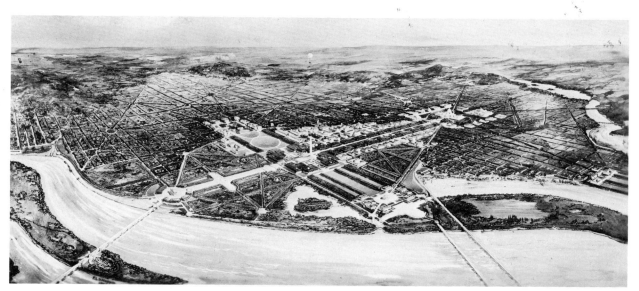

Figure 4. *View of the Washington Plan,* rendering for Senate Park Commission, 1902.

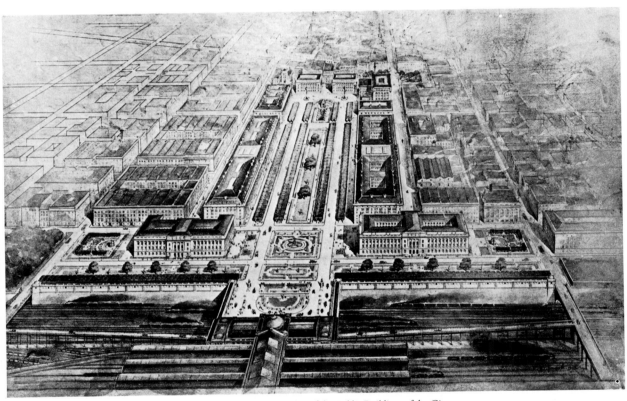

Figure 5. *The Group Plan of the Public Buildings of the City of Cleveland, Birdseye View Looking South*, rendered by W. W. Bosworth, 1905. Photo courtesy The Art Institute of Chicago, The Burnham Library of Architecture.

Kingshighway. Beyond this, the league proposed two other suburban loops to link several large parks and reservations designed to serve the entire region.

To illustrate the fact that similar proposals had been made for other cities, the league reproduced several handsome color plates of such places as Chicago and Providence. This technique soon became a standard approach as groups concerned with city planning sought to stimulate interest in their proposals by comparisons with those suggested or under consideration elsewhere. Municipal rivalry was thus used consciously to promote public improvements by appeals to civic pride.

Also in the spirit of the time, the league proposed a massive redevelopment of the Mississippi waterfront. The report illustrated the St. Louis levee and nearby mercantile district as it then appeared, together with a photograph of the Algiers waterfront. The league design for this area called for a long park to be developed on the roof of a continuous strip of warehouses. Beyond, buildings needing water and railroad transportation would provide a backdrop for the scene, as well as a uniform façade line along the business district paralleling the river. Again, the Algiers waterfront, with its arched entryways to warehouses and loading facilities, was used to illustrate how the results might one day appear.

The distinctive feature of the St. Louis plan may have been based in part on the so-called Model City exhibit at the St. Louis World's Fair in 1904, where several typical municipal buildings of almost domestic scale had been constructed along a single street and around a little public square. In the 1907 report, the Civic League advocated the development of many such centers, each to serve a single neighborhood. Referring rather confusingly to these as "civic centers," the report defined them in these words:

> The term . . . refers . . . to the grouping of the various public, semi-public and private institutions which have for their object and aim the mental, moral or physical improvement of the neighborhood in which they are located. Used in this sense, a civic center would comprise, among other things, a public school, parochial school, public library branch, public park and playground, public bath, model tenement, social settlement, church, homes of athletic or social organizations, police station and fire engine house.

In words foreshadowing those later to be used by Clarence Perry in his well-known and widely followed formulation of the neighborhood-unit concept, the report described the advantages of such a series of community focal points. Moreover, it not only included an illustrative plan of a typical center but also identified the locations in the city where it should be developed. The majority of these sites were in the poorer and more crowded areas of St. Louis. This part of the report concluded with a moving passage pointing out that the Civic League regarded the creation of a system of these neighborhood focal points of the highest importance.[17]

No plan of its period placed as much emphasis on working-class problems as did this document. Consequently, it seems odd that the report did not deal with housing at any length. It only stated the desirability of locating at each neighborhood center a model tenement, presumably to be constructed by some philanthropic organization.

It may have been such timidity that in 1908 moved a major spokesman for urban reform, Benjamin C. Marsh, to condemn the overwhelming preoccupation of planners with civic beautification. In his article "City Planning in Justice to the Working Population," Marsh stated a position shared by a growing number of urban activists:

All public improvements should be scrutinized with a view to the benefits they will confer upon those most needing such benefits. The grouping of public buildings, and the installation of speed-ways, parks and drives, which affect only moderately the daily lives of the city's toilers, are important; but vastly more so is the securing of decent home conditions for the countless thousands who otherwise can but occasionally escape from their squalid, confining surroundings to view the architectural perfection and to experience the aesthetic delights of the remote improvements.[18]

Marsh might have been even more severe in his criticism had he noted that many proposed improvements would reduce the supply of housing for low-income families because of the need to remove existing structures. He could have cited the three new radial approaches recommended first in 1903 and repeated by a special commission three years later to provide vistas to Cass Gilbert's recently completed Minnesota Capitol in St. Paul.[19] He could have noted as well the Fairmount Parkway development in Philadelphia, which connected the city hall, at the center of Penn's great grid, with the art museum, an undertaking discussed continuously since 1892 (fig. 2).

Although Fairmount Parkway was to be one of the few—if not the only—major planned radial boulevards in America to be carved through an existing grid, it was not for lack of effort on the part of the nation's planners. We cannot understand Burnham's work without examining this phenomenon; it may give us some insight into our own attitudes, too.

In every generation and in every profession an issue, technique, or theory emerges to capture the attention and focus the efforts of its practitioners. One scarcely needs dates on printed planning reports to place in time those of the 1920s with their emphasis on zoning, or those of the 1950s with their concentration on slum clearance and redevelopment, in which superblocks replaced the existing fine-grained street patterns. The equivalent vogue in the era of Daniel Burnham was that for the radial boulevards.

Planners justified radial systems on several grounds, the primary one being that they aided in the creation of multiple vistas to and from civic plazas or sites for monumental buildings. For those with less-sophisticated perceptions, however, the planners argued that better access to all parts of the city and the relief of traffic congestion were equally compelling reasons for their establishment. Clearly, Burnham and other architects simply regarded them as vital for aesthetic purposes.

A New York architect, Julius F. Harder, cited both aesthetic and functional reasons in the pages of *Municipal Affairs* when, in 1898, he proposed four grand boulevards to be pushed through Manhattan's grid street system from an enlarged Union Square. Harder illustrated several European city plans to make his point, including one of the central part of Washington as the sole American example of a model street system.[20]

Another reason for creating new thoroughfares was advanced by Robinson in 1903, and subsequently echoed by Burnham in his Chicago Plan; it was obviously based on a knowledge of Haussmann's tactics in Paris. Robinson asserted:

It has been found that often there is no better way to redeem a slum district than by cutting into it a great highway that will be filled with the through travel of a city's industry. Like a stream of pure water cleansing what it touches, this tide of traffic, pulsating with the joyousness of the city's life of toil and purpose, when flowing through an idle or suffering district wakes it to larger interests and higher purpose.[21]

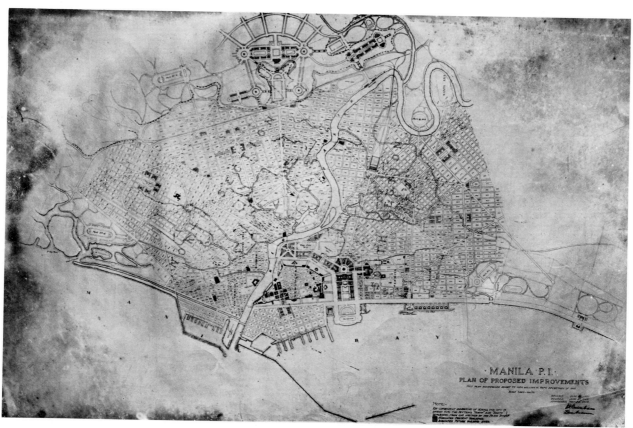

Figure 6. Daniel H. Burnham and Peirce Anderson. *Plan of Proposed Improvements to Manila,* 1905. Photo courtesy The Art Institute of Chicago, The Burnham Library of Architecture.

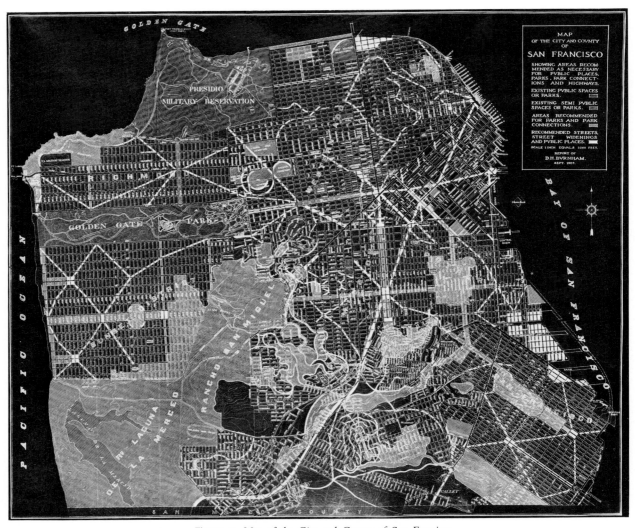

Figure 7. *Map of the City and County of San Francisco Showing Areas Recommended as Necessary for Public Places, Parks, Park Connections and Highways.* (From Daniel H. Burnham and Edward H. Bennett, *Report on a Plan for San Francisco,* San Francisco, 1905.)

Earlier, Robinson had pointed out:

> There is only one American city which has been laid out as a whole on an artistic design. . . .
> That city is Washington. . . . Of the others, the proudest boast of the "gridiron" plan . . . is the
> very dubious one of regularity. This system has not even economy of intercommunication to
> recommend it, since the traveler has two sides of a right angled triangle to traverse to any
> destination that is not on his own street. The vistas granted by diagonal avenues do much for
> the beauty of cities, as one sees abroad or in Washington. Their points of intersection and the
> centers whence they radiate make adornment easy with parks, circles, plazas, and statues.[22]

It was in Washington in 1901 that Burnham found a unique opportunity to apply his concepts of planning on a grand scale and in a truly national arena. Equally important for his later work, his Washington project led to his first European visit. In Paris and other cities in northern Europe and Italy, he saw developments that he had known through books, journal articles, and conversations with his better-traveled colleagues.[23]

The Washington project (figs. 3, 4) originated in a series of informal proposals put forward in 1900 at the annual meeting of the American Institute of Architects, held in that city. The institute's secretary, Glenn Brown, who had earlier published his own proposals for replanning the monumental core of Washington, recruited several others, including Cass Gilbert, to do likewise. Brown succeeded in arousing the interest of Senator John McMillan, chairman of the Senate Committee on the District of Columbia, to pursue the subject. McMillan, in turn, arranged for the use of the Senate's contingency funds to finance the work of what was called the Senate Park Commission. Burnham agreed to serve as chairman, joined by Charles McKim, Frederick Law Olmsted, Jr., and the sculptor Augustus St. Gaudens.[24]

More than a century earlier, Pierre Charles L'Enfant had designed the basic Baroque framework on which the city grew—at first slowly and then, following the Civil War, with far greater speed. His plan called for a great axial boulevard, flanked by major buildings, running westward from the Capitol to intersect a second major axis, extending southward from the White House. The intersection was to be marked by a monument to President Washington, but poor soil conditions led to its location well to the east and slightly south of the spot indicated by L'Enfant.

Related to this monumental central composition of reciprocal vistas was a system of imposing radial boulevards that led to secondary but important concentrations of activity grouped around a variety of public squares and plazas. L'Enfant planned a grid pattern to back up the radial boulevard system. The intersections of the two provided additional sites for statues, fountains, parks, and small civic spaces.

Federal officials had done little to seize this splendid opportunity for civic grandeur. Indeed, they had done much to subvert the intentions of its planner. Uncomfortably close to the centerline of the Mall, the Smithsonian Institution thrust its red bulk into this strategic open space. It had smaller companions to the east and west. The Congressional Greenhouse, erected at the base of Capitol Hill, lay just off the axis of the city's most imposing building. To the west stood the old building of the Department of Agriculture, on a line with the Smithsonian and between it and the Washington Monument. Far worse was the railroad station of the Baltimore and Potomac. Congress, in a burst of misplaced generosity, granted it a site on the north side of the Mall at Sixth Street. Its train shed extended southward almost to the center of

the Mall, beyond which ran the tracks and yards. Between the Mall and Pennsylvania Avenue—L'Enfant's intended grand ceremonial connection between the legislative and executive nodes of the capital—there was a jumble of nondescript buildings. The largest was the old Central Market, whose leftover scraps of fish, meat, and vegetables gave the neighborhood a distinctive aroma.

The members of the Senate Park Commission began work in 1901 by taking what must have been the first design junket in American history: an extended tour of Europe. At Burnham's insistence, it was organized by Charles McKim and Charles Moore, Senator McMillan's assistant and committee clerk. In the shadow of great European examples of urban planning and civic architecture, they discussed, argued, sketched, and photographed, agreeing on the major elements of their plan on the return voyage. Many of the details were refined in a studio on the floor above the McKim, Mead and White office in New York. Models showing the city as it existed and as it might be were constructed in Boston under Olmsted's supervision, while Moore directed a small staff in Washington.

The results were displayed at what must have been the country's first city planning exhibit, at the Corcoran Gallery of Art in January 1902. A long and copiously illustrated report was released the same day; leading newspapers and periodicals were furnished with special drawings that could be clearly reproduced. Large colored renderings, some by Jules Guérin, who would later produce similar dazzling illustrations for the Chicago Plan, helped federal officials and the general public to understand the sweeping recommendations of the commission.

The plan centered on the Mall axis, which was tilted slightly southward to run directly to the Washington Monument. Beyond, on recently filled land, the commission proposed a long reflecting pool, culminating in a memorial to Abraham Lincoln. From this point a new bridge crossed the Potomac, leading to Arlington Cemetery. At the eastern end, a series of public buildings around the perimeter of the Capitol grounds was suggested to provide a suitable architectural frame for this massive structure in an area where at that time only the Library of Congress had been constructed. Wholesale redevelopment of the triangular space between the Mall and Pennsylvania Avenue would make possible the location of a variety of buildings to house major federal and district activities, while at the same time removing the principal eyesore of the central city.

The Washington Monument was to be provided with a formal terrace, while the axial views down the Mall were to be reinforced by several parallel rows of trees on either side of a broad expanse of turf. Stimulated by Burnham's plea, the railroad president agreed to remove the railroad station so that a rail tunnel could be constructed under Capitol Hill to bring the railroad to a new union terminal north of the Capitol. The commission planned to continue the central axis west of the Washington Monument by means of a shallow reflecting basin flanked by formal landscaped gardens reminiscent of the style of Versailles. As its termination, the commission designed the Lincoln Memorial within a circular drive. From it would diverge the approaches to a new bridge spanning the Potomac and a parkway following the bank of the river.

The plan included numerous other recommendations for the improvement of the city, including the expansion of the park system to embrace the Rock Creek Valley, the replanning of the area fronting Lafayette Square, and the development of the new railroad terminal. Such a plan had no American precedents; it established a method of approach and a pattern of

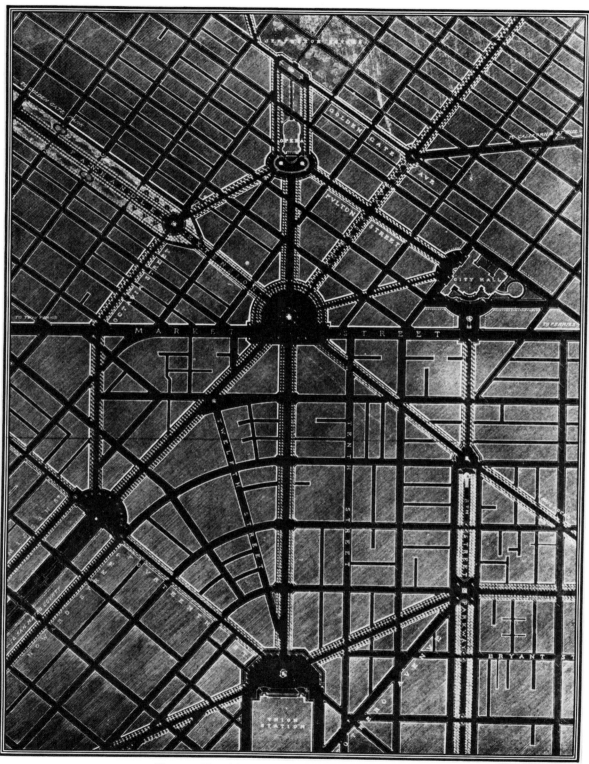

Figure 8. *Plan of the Civic Center for San Francisco.* (From
Daniel H. Burnham and Edward H. Bennett, *Report on a
Plan for San Francisco,* San Francisco, 1905.)

presentation that was soon to be widely imitated throughout the country. Its impact was all the more powerful because, with the support of President Theodore Roosevelt, several new buildings were constructed almost immediately in conformity with its outlines.

Despite overwhelmingly enthusiastic approval throughout the nation, the plan was not realized without controversy. Representative Joseph Cannon of Illinois, then the dictatorial Speaker of the House, fought bitterly to prevent the Lincoln Memorial from being located on the reclaimed tidal flats of the Potomac River. He told Elihu Root that "so long as I live I'll never let a memorial to Abraham Lincoln be erected in that God-damned swamp."[25] Yet, one by one, new buildings and park improvements, including the Lincoln Memorial, were located as the commission had recommended.

In one sense, however, it was all too easy. The essential framework of the impressive city that gradually emerged in three dimensions early in this century had been established by the L'Enfant plan when the site lay vacant. I believe that Burnham and other City Beautiful planners did not fully grasp the difference between building a typical American grid city and building on this unique foundation that merely needed adequate structures to express the design concepts of its original planner. Far less was possible in a fully or partly developed city with fragmented land ownership and inadequate government. The problems were quite different in a city entirely dependent on a local tax base to finance improvements and on a municipal legislature to appropriate funds. Washington, D.C., was not subject to this dependency.

Paris, of course, was the example to which the planners could point, as they did at almost every opportunity; it was a city that had been comprehensively redeveloped in an amazingly short span of years. The influence of Paris on Burnham cannot be overstated. Moreover, his high regard for Haussmann, who had rebuilt it in less than two decades, bordered on reverence.[26] Of the many foreign cities illustrated in his Chicago Plan, only a picture of Paris as reconstructed by Haussmann occupied an entire page. References to Paris in the index are outnumbered only by references to Chicago itself. Burnham visited Paris in 1906 and again in 1907.[27] On his return to Chicago from his second trip, he must have read with deep interest a four-part, exhaustive study of the history of Paris, including Haussmann's accomplishments, that began in the July issue of *Architectural Record* and that is cited in his Chicago report.[28]

Burnham included in the Chicago Plan an illustration showing a comprehensive study for the further improvement of Paris, and several theoretical circulation diagrams prepared by the ingenious French architect-planner Eugène Hénard. He knew of Hénard's work as early as 1905. Hénard's later studies would have come to his attention through the State Department, to which he wrote in 1907 requesting help in obtaining material he referred to as of special importance dealing with "pre- and post-Haussmann Paris."[29]

While Burnham may not have read the words, he surely would have subscribed to the sentiment written in 1899 after the first national meeting of municipal art societies:

Of all modern cities, Paris, more than any other, deserves the title of "The City Beautiful." With its clean paved streets, with its public places surrounded by buildings in harmonious style and decorated with statuary . . . with its river so beautifully bridged . . . it comes nearer than any other to reaching the idea which is the object of the municipal art movement, "The City Beautiful."[30]

It was this ideal that Burnham was to pursue in all of his planning projects.

After the Washington project, Burnham was deluged with requests for his services; he was able to comply with only a few. In 1902 he agreed to work with John Carrère and Arnold Brunner on a special commission to design a civic center for Cleveland (fig. 5). The following year this commission submitted a so-called Group Plan for a great mall extending from a proposed railroad station near Lake Erie to one corner of the city's public square. Flanking the mall and its secondary cross axis, they located a city hall, county courthouse, library, federal building, and two other unspecified sites ultimately developed for the Board of Education and the Public Auditorium.[31]

Under the energetic leadership of Cleveland's progressive mayor Tom Johnson, work began almost immediately with the acquisition and clearance of the dismal tenements, bars, and decaying commercial and industrial buildings then existing. The near unanimous backing by civic leaders and major business interests led Burnham to believe that major projects of this kind could be successfully carried out elsewhere.[32]

Work on three other projects, all involving entire cities, soon occupied Burnham's attention. Because they were far from Chicago and under way simultaneously, he found assistance necessary. In selecting younger associates for his projects, he demonstrated his abilities to inspire persons of talent and energy.

In May 1904, at the invitation of San Francisco's former reform mayor James Phelan, Burnham met the members of the newly formed Association for the Improvement and Adornment of San Francisco and agreed to prepare a plan for the city.[33] That fall he returned with Edward Bennett, an English architect trained at the Ecole des Beaux-Arts, installing him in the cabin on Twin Peaks built at Burnham's request. The two architects spent several weeks touring the city, sketching, photographing, and discussing various possibilities. Leaving Bennett to continue the project, Burnham sailed for the Philippines, where he had agreed to prepare an improvement plan for Manila and to design the summer capital of Baguio on a virgin site some 150 miles away.

Using Washington as the example, Burnham and his junior partner, Peirce Anderson, described and justified a radial system to be superimposed on the existing irregular pattern of Manila (fig. 6). A second map revealed the details of a proposed Sea Boulevard extending the length of the waterfront. The plan also showed the location of a group of public buildings south of the historic Inner City facing a semicircular plaza from which two of the radial boulevards diverged. On the west, the group looked to the sea and a great esplanade extending into the harbor on land to be reclaimed for this purpose. Libraries, museums, an exposition building, and other semipublic structures were to be erected on two gently curving thoroughfares leading to the northwest, where three bridges crossed the river that divided the city.

The Baguio plan, unencumbered by existing development, used many of these elements of formal planning but in a far more symmetrical fashion. Its central axis began at the group of public buildings situated high above the valley. This axis continued through an esplanade to the business and main residential quarter and, beyond, to a complex of municipal buildings at the apex of a triangle formed by two intersecting streets. Burnham's original plan was subsequently modified. Although the formal treatment of the central axis remained, a number of curving streets were introduced at the perimeter in recognition of the irregular topography.[34]

Burnham thought the government would carry out his plans, using them for either Baguio or Manila. He recruited William E. Parsons, a graduate of Yale and the Ecole des Beaux-Arts, to fill the position as government architect. Both Parsons and Governor Cameron Forbes kept Burnham informed of progress on the two projects. Although very few of the radials were pushed through Manila, as Burnham proposed, his belief in the feasibility of this kind of radial street planning was evidently reinforced by news that several of the park, boulevard, and civic-center improvements had begun.

Later in 1905 Burnham submitted his plan for San Francisco (figs. 7-8). The report, which ran to nearly 200 large-format pages, included dozens of photographs, sketches, and maps.[35] Burnham saw the solution to the problem of San Francisco's grid system in "a broad, dignified and continuous driveway skirting the water edge and passing completely around the city." From it and leading to an "inner circuit boulevard"—what he termed "the perimeter of distribution"—many new boulevards and existing or widened grid streets would provide direct connections to major focal points. He used Eugène Hénard's diagram of Paris to illustrate the principle.

Although he stated his goal as a plan "which shall interfere as little as possible with the rectangular street system of the city," his proposals for new thoroughfares indicated his obsession with radial boulevards. A few of these can, perhaps, be justified on functional grounds, and a few others as essential for aesthetic purposes. Many, however, particularly in the outlying neighborhoods, seem little more than geometric exercises to provide graphic consistency.

Certainly, Burnham's curious treatment of the enormous hillside site occupied by the Presidio has no rational or artistic explanation. His proposals for the many steep hills in the city seem more reasonable even if equally ambitious. He advocated acquisition of each hilltop for park purposes, use of circular roadways at the hill's base, and several terraces and winding paths. Telegraph Hill was shown as a typical example.

Where Market Street terminated at the foot of Twin Peaks, Burnham planned a series of formal terraces, colonnades, and statues. To the north he designed an enormous amphitheater, whose location reminded him of "the stadium in the hills at Delphi . . . and the theater of Dionysos." Nearby he placed an Athenaeum, dominated by "a colossal figure symbolical of San Francisco." On the "courts, terraces, and . . . shelters" below he would locate "some few of the greatest works of art." The terraces, he noted, could "be modeled on similar terraces in the Villa Hadrian."

He combined these echoes of the classical world with a Parisian touch for development around his inner ring. Its center lay where Burnham proposed to extend the Panhandle, an existing eight-block parkway leading from Golden Gate Park, to an intersection with Van Ness Avenue at Market Street. Around this core, at varying distances, he located several large civic squares and sites for major public buildings linked to one another and the central square by radial penetrations and a ring boulevard.

The plan contained many other suggestions. Perhaps the most farsighted was a recommendation that as new boulevards were constructed, the city should develop a subway system. Brief references also appear to such matters as schools, cemeteries, hospitals, churches, and the water-supply system.

Civic leaders of San Francisco responded enthusiastically to the plan. Newspaper editorials commended the recommendations; even the reactionary mayor, Eugene Schmitz, added his

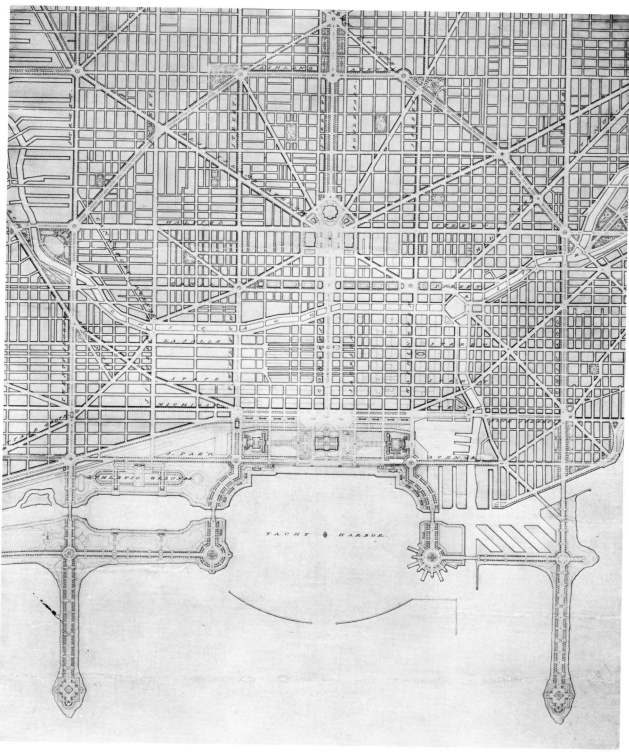

Figure 9. Chicago. Plan of the complete system of street circulation; railway stations; parks, boulevard circuits and radial arteries; public recreation piers, yacht harbor, and pleasure-boat piers; treatment of Grant Park. (From Daniel H. Burnham and Edward H. Bennett, *Plan of Chicago*, Chicago, 1909, pl. 110).

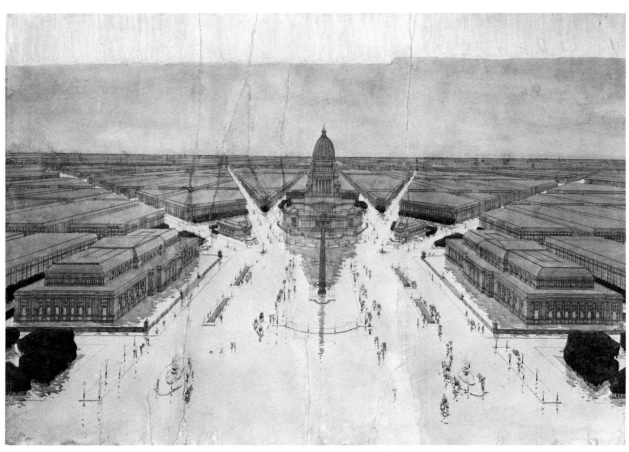

Figure 10. *Chicago. View, looking west, of the proposed Civic Center Plaza and buildings, showing it as the center of the system of arteries of circulation and of the surrounding country,* rendered by Jules Guérin. (From Daniel H. Burnham and Edward H. Bennett, *Plan of Chicago,* Chicago, 1909, pl. 132).

support. Herbert Croly wrote a long and laudatory article about it in the *Architectural Record,* insuring it national prominence.[36] Then came the disastrous earthquake of 1906.

The wholesale destruction of a city seems to offer a unique opportunity for extensive replanning. For a variety of reasons, this almost never occurs; San Francisco, like the London of 1666, was not one of the exceptions. Although officials pleaded with Burnham to come to the city and head a special commission to supervise rebuilding, business pressures and health problems forced him to decline. In the end, San Francisco rebuilt on its prefire pattern. I am not persuaded that this was altogether a misfortune.

This is not the note on which to end, for Burnham's achievements elsewhere had already earned him a place in the pantheon of American planners. His most elaborate and carefully studied planning study had yet to be completed: the lovingly crafted, skillfully composed, lavishly illustrated plan for Chicago of 1909 (figs. 9–11). He regarded it as the culmination of his life's work.

One feature of the Chicago Plan and of its preparation needs to be emphasized: It reflected Burnham's remarkable abilities to incorporate in an integrated plan separate and seemingly unrelated proposals developed by other individuals or groups. He also used his own earlier studies; the replanning of the lake shore originated in his preliminary designs prepared in 1896 with Charles Atwood.[37]

For some of his ideas, he drew on the amazingly farsighted street and transportation proposals advanced between 1893 and 1903 by James F. Gookins. One of the founders of the art society in Crosby's Opera House, Gookins was partly responsible, therefore, for the establishment of the present Art Institute.[38] Recommendations of the Special Park Commission for metropolitan Chicago in 1904 provided much of the basis for the park proposals of 1909. Frederic Delano and the Commercial Club's Committee on Railway Terminals provided useful suggestions that Burnham revised.

The Senate Park Commission plan for Washington also combined the best features of the many proposals for replanning that city. Burnham's accomplishments are not at all diminished by this characteristic. Indeed, I regard his ability to use, with discrimination, the work of others as a measure of his greatness. He knew how to select professional assistants and to learn from his peers. He revered McKim, who had much to teach him. He picked the ideal assistant in Edward Bennett, who, like William Parsons, was to enjoy a distinguished career as a planner in his own right. From the Olmsteds, he learned concepts of both naturalistic and formal landscape design that he combined in his plans with considerable skill.

Burnham possessed unusual administrative talents and organizational skills, which he used to best advantage in undertakings involving associates who were themselves national figures with strong ideas and reputations to maintain. He drove himself as hard as he did them. In all of these joint efforts where he served as leader, there seems to have been remarkably little controversy or prolonged disagreement.

If the Senate Park Commission plan had been his sole accomplishment, Burnham would deserve to be forever honored for fashioning the monumental core of Washington. We can scorn the endless pediments and all the other aspects of applied archeology of which the modernists disapproved. But, because the scale was right, the vision generous, the major elements of central Washington so correct, even horrors like the Rayburn Building, if they do not exactly fade into insignificance, become neutralized by the powerful composition of mass and open space.

Burnham addressed himself to what he perceived as the whole city, convinced that it could be the greatest of all works of art. At the same time, he saw the city as an efficient machine for building prosperity and supplying services. His comprehensive approach brought a new dimension to urban planning.[39]

His sense of integrity led him to refuse professional fees for his civic work in Washington, the Philippines, San Francisco, and Chicago. He felt that public duty was both a privilege and an obligation. Furthermore, he believed that if he received no compensation other than expenses, he was free to submit recommendations unencumbered by any financial obligation to either official or civic clients.[40]

More than any individual, Burnham made urban planning respectable in circles previously untouched by the more narrowly focused efforts to promote municipal art or improved recreation. He moved easily among corporate heads, railroad tycoons, bank presidents, merchant princes, and high public officials. He convinced these leaders of the world of affairs that long-range comprehensive planning deserved as much support and participation as the interests of their own enterprises.

Finally, Burnham changed the focus of American planning. The Chicago Plan covered many aspects of the city that other plans had only lightly touched, such as rapid transit and railroad terminal relocation. Although it is usually regarded as the high point of City Beautiful planning, the Chicago Plan thus marked, as well, the beginning of the emphasis on the City Practical.

Burnham recognized that no effective planning for the city could be accomplished without drawing into the effort the human and physical resources of the entire metropolitan area. The Chicago Plan was notable, too, for the remarkably perceptive and thorough analysis of the legal powers already existing and those needed in the future to guide and control urban redevelopment and expansion.

The plan's quality of presentation, handsome format, arresting color plates, clear diagrams, and understandable text set a standard that all other planners would try to emulate, just as the Washington plan represented in its day a quantum leap forward in excellence of presentation. Burnham thus brought to the American scene compelling visions of the city as it might be, expressed for Washington and Chicago by the splendid renderings of Jules Guérin and others. No one examining these drawings or reading Burnham's words emerges from the experience with his vision unaltered or his pessimism intact.

In the end, it may be this inspirational quality of Burnham's work—the city expressed as a design metaphor—that remains as a more lasting contribution than specific plans and proposals. If time revealed that major elements of his plans were impossible or hopelessly expensive to carry out, if he failed to address the city's social problems, if eventually it was seen that even his vision was flawed in many ways, his documents served their purpose in rallying the support of diverse interests in the cities he planned to improve, embellish, and make more efficient. Burnham of Chicago, in short, was a giant among men and a credit to his place.

1. Even before the fair opened, a testimonial dinner in Burnham's honor was held in New York, a city that itself had hoped to be the setting for the fair. Attended by dozens of architects, artists, and leaders of industry, business, finance, and the professions, the dinner marked Burnham's arrival on the national scene. The event, with a list of the participants, is described in C. Moore, *Daniel H. Burnham, Architect, Planner of Cities,* Boston, 1921, I:69–80. See also a similar treatment in T. S. Hines, *Burnham of Chicago: Architect and Planner,* New York, 1974: 113–16. These two studies of Burnham and his work, the first by one of his close friends and associates, are indispensable to an understanding of American planning at the beginning of

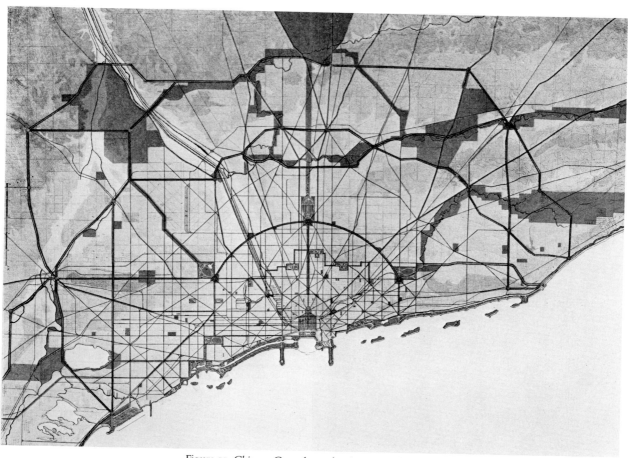

Figure 11. *Chicago. General map showing topography, waterways and complete system of streets, boulevards, parkways, and parks.* (From Daniel H. Burnham and Edward H. Bennett, *Plan of Chicago,* Chicago, 1909, pl. 44).

the twentieth century. The literature on the Columbian Exposition is extensive, two of the most recent studies being D. F. Burg's *Chicago's White City of 1893,* Lexington, Ky., 1976, and R. R. Badger's *Great American Fair: The World's Columbian Exposition & American Culture,* Chicago, 1979.

2. Moore (note 1), I: 82–83. For a discussion of Burnham's architectural practice following the fair, see Hines (note 1): 268–311.

3. D. H. Burnham, "A City of the Future under a Democratic Government," in Royal Institute of British Architects, *Transactions,* Town Planning Conference, London, October 10–15, 1910, London, 1911: 369–70. In his Chicago report of 1909, too, Burnham followed the same pattern, illustrating only those projects he had directed or to which he had contributed; see Burnham and E. H. Bennett, *Plan of Chicago,* Chicago, 1909: 22–28.

4. Burnham arrived in London with his paper still incomplete and perhaps only in outline. See his diary entries for October 10, 11, and 12, 1910, referring to time spent in London preparing his address and to medical attention needed for a foot ailment, in Moore (note 1), II: 136–37.

5. There is a growing literature about these early planners, whom I virtually ignored in the concluding chapter of my book *The Making of Urban America,* Princeton, 1965. See, for example, J. Hancock, "John Nolen: The Background of a Pioneer Planner," *Journal of the American Institute of Architects* XXVI (Nov. 1960): 302–12; W. H. Wilson, *The City Beautiful Movement in Kansas City,* Columbus, Mo., 1964; M. Scott, *American City Planning Since 1890,* Berkeley, 1969: 1–100; two articles by J. A. Peterson, "The City Beautiful Movement: Forgotten Origins and Lost Meanings," *Journal of Urban History* II (Aug. 1976): 415–34; and "Impact of Sanitary Reform upon American Urban Planning, 1840–1890," *Journal of Social History* XIII (Fall 1979): 83–103; S. K. Schultz and C. McShane, "To Engineer the Metropolis: Sewers, Sanitation, and City Planning in Late-Nineteenth-Century America," *Journal of American History* LXV (Sept. 1978): 389–411; P. Marcuse, "Housing Policy and City Planning: The Puzzling Split in the United States, 1893–1931," in *Shaping an Urban World,* ed. by G. Cherry, New York, 1980; and Wilson, "The Ideology, Aesthetics and Politics of the City Beautiful Movement," in *The Rise of Modern Urban Planning, 1800–1914,* ed. by A. Sutcliffe, New York, 1980: 165–98.

6. Robinson produced three articles about urban problems and solutions for the *Atlantic Monthly* in 1899. All were titled "Improvement in City Life," with the third having the subtitle "Aesthetic Progress." The opening paragraphs credit the Chicago Fair of 1893 with having "immensely strengthened, quickened, and encouraged" the "subsequent aesthetic effort in municipal life," but point out that the municipal improvement movement had earlier origins "arising out of the larger wealth, commoner travel, and the provision of the essentials of life." The fair, Robinson asserted, thus "gave tangible shape to a desire" to overcome "the shortcomings of our cities, from the aesthetic point of view" (*Atlantic Monthly* LXXXIII [June 1899]: 771–85).

7. C. M. Robinson, *Modern Civic Art,* New York/London, 1903: 285.

8. Ibid.: 281.

9. Robinson described his plan and the circumstances of its preparation in "Opening the Center of Denver," *Architectural Record* XIX (May 1906): 365–67.

10. A complete list of Robinson's reports apparently has never been compiled. The Cornell University Library has a number of them, while others are referred to in an important extended summary of the state of American planning up to World War I: G. B. Ford (ed.), *City Planning Progress in the United States, 1917, Compiled by the Committee on Town Planning of the American Institute of Architects, Journal of the American Institute of Architects,* Washington, D.C., n.d. While in some cases the dates of the completed reports are in doubt, the following list is in approximate chronological order, followed by the names of a few other cities, for which no date can be assigned without further study. 1905: Detroit, Mi., and Colorado Springs, Co.; 1906: Denver, Co., Honolulu, Ha., and Oakland, Ca.; 1907: Des Moines and Dubuque, Io., and Watertown, N.Y.; 1908: Cedar Rapids, Io., Columbus, Oh., Ft. Wayne, In., Sacramento, Ca., Jamestown, N.Y., and Ridgewood, N.J.; 1909: Pittsburgh, Pa., and San Jose, Los Angeles, and Santa Barbara, Ca.; 1910: Waterloo, Ia.; 1911: Binghamton, N.Y.; 1912: Colorado Springs, Co.; 1913: Alton, Il., Raleigh, N.C., and Topeka, Ka.; date unknown: Greensboro, N.C., Lancaster, Pa., Omaha, Ne., and Peoria, Il. Robinson also served from 1908 to 1918 as secretary of the Rochester Civic Improvement Committee and as Professor of Civic Design at the University of Illinois.

11. Robinson, "The Street Plan of a City's Business District," *Architectural Record* XIII (Mar. 1903): 234–47; "New Dreams for Cities," XVII (May 1905): 410–21; and "Ambitions of Three Cities," XXI (May 1907): 237–346.

12. It would be interesting to know if the two ever met or corresponded. I have found no record of this in the studies of Burnham's biographers, but they may not have regarded this as a matter of importance to be noted.

13. The Savannah plan was not published. At least some of the drawings submitted to the city are among the Nolen Papers in Olin Library, Cornell University, Ithaca, New York. The scope of his Roanoke plan is summarized in Nolen's letter of transmittal to his client, the Roanoke Civic Betterment Club: "I have pleasure in sending you today . . . my Report on the Remodeling of Roanoke; two General Plans to the scale of 800' to the inch; two diagrams illustrating proposed Groupings of Public Buildings; a plan of Public Reservations and Thoroughfares to the scale of one mile to the inch, and a sheet of sections illustrating my recommendations as to the character of Main Thoroughfares. Together these form a complete presentation of my views and suggestions for the consideration of your Club."

14. Nolen's other early planning reports included a public building study for Milwaukee, Wisconsin, in collaboration with Frederick Law Olmsted, Jr., in 1909, and plans for Glen Ridge and Montclair, New Jersey, in 1909. For a complete list of Nolen's plans, other writings, and articles about him and his work, see J. L. Hancock (comp.), *John Nolen: A Bibliographical Record of Achievement* (Program in Urban and Regional Studies), Cornell University, Ithaca, N.Y., 1976. Most of the materials cited by Hancock, together with maps, drawings, etc., can be found among the Nolen Papers in Cornell's Olin Library. His life and work are covered in detail in Hancock's "John Nolen and the American City Planning Movement: A History of Culture Change and Community Response, 1900–1940," Ph.D. diss., University of Pennsylvania, 1964.

15. A. W. Brunner and J. M. Carrère, *Preliminary Report for a City Plan for Grand Rapids,* Grand Rapids, Mi., 1907.

16. Boston Society of Architects, *Report . . . by Its Committee on Municipal Improvement,* Boston, 1907.

17. "The Committee, when it first undertook the investigations . . . was animated by a theoretical belief in the value of civic centers, and by an ill-defined feeling that such institutions would tend towards the development of better citizenship. A more careful study of existing conditions, however, has

convinced us that these institutions are absolutely essential features in the wholesome development of a large city of today. The indiscriminate herding together of large masses of human beings ignorant of the simplest laws of sanitation, the evils of child labor, the corruption in political life, and above all, the weakening of the ties which bind together the home—these are dangers which strike at the very roots of society. To combat them the government must employ every resource in its power. Schools and libraries, playgrounds and public baths, by developing their minds, training their bodies and upbuilding the character of a people, furnish the foundation upon which a nation's welfare depends" (Civic League of Saint Louis, *A City Plan for Saint Louis,* St. Louis, 1907).

18. *Charities and the Commons* XIX (Feb. 1, 1908): 1514. For a useful summary of Marsh's many other activities as a writer, reformer, and houser, see Scott (note 5): 80–90. It should be noted that Nolen, a person of essentially working-class origins, was not unaware of the housing problem. In his plan of 1909 for the well-to-do commuting suburb of Montclair, New Jersey, he included a short section entitled "Better Housing for People of Small Means." In it he observed that "there is . . . a considerable population of Italians and negroes, attracted by the opportunities that are offered for work. It is pleasant to think of these people employed in the country; but when one sees their homes, they appear little better off than in the slums of a great city. This condition is a standing reproach." His solutions lacked the bite of his analysis, for while he advocated the creation of "model tenements for . . . [the] . . . working population," he specifically rejected the use of public action in favor of private initiative, stating that "it would not be difficult to obtain funds for such a purpose, and, as experience has demonstrated, the enterprise can be placed on a good business basis" (J. Nolen, *Montclair: The Preservation of Its Natural Beauty and Its Improvement as a Residence Town,* Montclair, N.J., 1909). The strong differences in opinion as to priorities in urban planning that divided architect-planners from those chiefly concerned with housing and working-class problems continued for many years. It was explored briefly by Peter Marcuse (note 5). Scott (note 5) also dealt with this issue in the early chapters of his splendid book on the background of modern American planning. The neglect of housing as a major focus in city planning before the 1929 Depression is reflected in a long and thorough survey of the status of American planning prepared by Theodora and Henry Hubbard of Harvard University and published in 1929. Based on extensive questionnaires, a field study conducted by Howard Menhinick, who visited 120 cities, and examination and analysis of hundreds of planning reports and other publications, this valuable compilation of material on the subject not only lacks a chapter on housing but contains only scattered and brief references to the topic. It is clear that through the decade of the 1920s housing and planning were regarded by professionals as almost wholly separate fields, a condition that has still to be fully rectified. See T. K. Hubbard and H. V. Hubbard, *Our Cities To-Day and To-Morrow: A Survey of Planning and Zoning Progress in the United States,* Cambridge, Ma., 1929.

19. Cass Gilbert suggested the general outlines of the plan in December 1903. In 1906 a special commission, which included Gilbert as one of its members, submitted a more detailed proposal. It is illustrated in Robinson, "Ambitions of Three Cities" (note 11); and W. Wheelock, "Re-Setting Minnesota's Capitol," in Robinson (ed.), *The City Plan,* a special civic broadside appearing in *Charities and the Commons* XIX (Feb. 1, 1908): 1547. It is in this latter article that Gilbert's proposal of 1903 is mentioned. Gilbert was no stranger to grand planning. At the

request of Glenn Brown, secretary of the American Institute of Architects, Gilbert presented a plan for central Washington at the AIA convention of 1900. For a full description of this event and illustrations of the plans presented at that time, see J. W. Reps, *Monumental Washington,* Princeton, 1967: 84–92. Gilbert, after working for the firm of McKim, Mead and White, established his practice in St. Paul, where, in 1900, he won the competition for the design of the Minnesota Capitol. He was later elected President of the American Institute of Architects.

20. J. F. Harder, "The City's Plan," *Municipal Affairs* II (Mar. 1898): 24–45.

21. Robinson, "The Street Plan of a City's Business District" (note 11): 247. Burnham's (or Charles Moore's) words in the *Plan of Chicago* echo this concept: "The electrification of the railways within the city . . . will serve to change radically for the better the dirt conditions in . . . [slum neighborhoods]; but the slum conditions will remain. The remedy is the same as has been resorted to the world over: . . . the cutting of broad thoroughfares through the unwholesome district" (Burnham and Bennett [note 3]).

22. Robinson, "Improvement in City Life: III. Aesthetic Progress"(note 6): 772.

23. Burnham's only previous European trip took place in 1896, when he visited the French and Italian Rivieras, Malta, Egypt, Lebanon, Palestine, Turkey, and Greece (see Moore [note 1], I: 117–28; and Hines [note 1]: 135–37).

24. The background of this project, how it proceeded, the reaction to it, and its consequences—all rather more complex than what is summarized here—is fully explored in my *Monumental Washington* (note 19). Other studies of Washington's development containing material on the Senate Park Commission and its work can be found in these more recent publications: M. Cable, *The Avenue of the Presidents,* Boston, 1969; F. Gutheim and W. E. Washburn, *The Federal City: Plans and Realities,* Washington, D.C., 1976; and National Capital Planning Commission, *Worthy of the Nation: The History of Planning for the National Capital,* Washington, D.C., 1977.

25. Cannon's words, as recalled by Root, are quoted in P. C. Jessup, *Elihu Root,* New York, 1938, I: 279–80.

26. Burnham expressed his admiration for Paris and his view that it served as the great exemplar for planners and urban designers in a letter to a younger friend ready to set off for Europe: "In Paris note the use of accents on the centers of vistas, especially the columns, the arches and corner buildings. Note the ease and perfection of the circulatory street system. It would be a good thing to keep a Paris map on your table, get your points of compass firmly fixed in your head as you study it, and never come in or go out without glancing at the map to direct or correct you. Remember, the city as a whole, as one grand design, is the major study and try to get the key and see how everything works out and is related. . . . I find it important to look down upon Paris. You get a very fine far-off view from St. Germain, another of vast importance from St. Cloud and the greatest from the Eiffel Tower. Spend a lot of time up there, map in hand; every minute of it will pay. After thus studying Paris you will not be able at first to recall it except as a confused mass. But later on when problems great and small come up in your own work, details will suddenly jump up in memory and be of great help to you." This passage is identified as a letter from Burnham of unspecified date in W. E. Parsons, "Burnham as a Pioneer in City Planning," *Architectural Record* XXXVIII (July 1915): 17. It may well have been sent to Parsons himself.

27. Moore (note 1), II: 1, 43–44.

28. E. R. Smith, "Paris, Topographical Transformation Under Napoleon III," *Architectural Record* XXII (July 1907): 121–

215

33; (Sept. 1907): 227–38; (Oct. 1907): 369–85; and (Nov. 1907): 490–506.

29. Letters to Huntington Wilson dated February 5 and October 7, 1907, as quoted in Hines (note 1): 323. Hénard's fascinating career is the subject of P. M. Wolf, *Eugène Hénard and the Beginning of Urbanism in Paris, 1900–1914,* New York, 1968. Between 1903 and 1906 Hénard published in eight "fascicules" his *Etudes sur les transformations de Paris.* A paper prepared by him describing his general development plan for Paris was read at the annual meeting of the American Institute of Architects in 1905. At the London Conference in 1910 Hénard delivered a paper at the same session addressed by Burnham. Burnham may have met Hénard in Paris on one of his several visits, possibly as early as 1901 when the French designer was already well known and respected. Hénard's place in the modern planning movement is reviewed in F. Choay, *The Modern City: Planning in the 19th Century,* New York, 1969. Among his other contributions was the invention of the traffic circle, or at least the notion that at such places all vehicular traffic should take a circular, counter-clockwise direction. At an early date he also developed the concept of multi-level streets; some of Burnham's ideas for Michigan Avenue may have been stimulated by Hénard's profusely illustrated studies.

30. G. Kriehn, "The City Beautiful," *Municipal Affairs* III (1889): 594. A useful study would be an examination of the influence of Parisian planning on the American scene. Admiration for what Haussmann had accomplished was widespread. As early as 1869 the Chicago *Times* referred to him in an article complaining about the irregularities of street widths in Chicago and called for the adoption of a long-range plan so that "all streets, and public buildings and improvements should conform to the idea that Chicago is not only a great city now, but that it will become a vastly greater one" (Chicago *Times,* July 10, 1869, as quoted in B. Pierce, *A History of Chicago,* New York, 1940, II: 318). In the 1908 special issue of *Charities and the Commons* (note 19), approving references to Paris and the work of Haussmann appear in several articles. Almost every planning report that appeared in the United States prior to World War I contained a reference to Paris, often with one or more illustrations as an example of outstanding planning. In the Chicago Plan Burnham made explicit his admiration for Haussmann, and his words also suggest that, perhaps unconsciously, he aspired to the same esteem he attributed to the planner of Paris: "Haussmann began a career which has established for all time his place among the city-builders of the world. As if by intuition he grasped the entire problem. Taking counsel neither of expediency nor of compromise, he ever sought the true and proper solution. . . . The world gives him credit for the highest success" (Burnham and Bennett [note 3]: 18).

31. Cleveland, Ohio, *The Group Plan of the Public Buildings of the City of Cleveland. Report Made to the Honorable Tom L. Johnson Mayor and to the Honorable Board of Public Service by Daniel H. Burnham, John M. Carrère, Arnold W. Brunner, Board of Supervision,* [Cleveland], 1903. The best account of the Cleveland project is in Hines (note 1): 158–73. For contemporary descriptions and appraisals of the project, see "The Grouping of Public Buildings at Cleveland," *Inland Architect and New Record* XLII (Sept. 1903): 13; H. Croly, "The United States Post Office, Custom House, and Court House, Cleveland, Ohio," *Architectural Record* XXIX (Mar. 1911): 196; and P. Abercrombie, "Cleveland, A Civic Center Project," *Town Planning Review* II (Apr. 1911): 131.

32. Burnham must have found the circumstances of his association with Cleveland both novel and appealing. Hines described how Johnson had endorsed the concept of a civic center after an 1895 contest for the design of such a complex held by the Cleveland Architectural Club. After his election in 1901 he supported the efforts of the Chamber of Commerce and the Cleveland chapter of the AIA to secure state legislation "that would allow the governor to appoint a commission of three experts, financed by the state, to advise Ohio cities on questions of urban planning. Though worded in general terms, the measure was proposed at the instigation of the citizens of Cleveland and was ultimately destined to apply primarily to that city. The legislature promptly passed the bill, and on June 20, 1902, Governor Nash announced the appointments recommended by Mayor Johnson" (Hines [note 1]: 160). Each of the three members received $5,000 a year while the project was in the planning stage and $2,000 for life as a permanent body. By an ordinance passed in 1902 the city expanded their authority to include "the supervision and control of the location of all public, municipal, and county buildings . . . within the limits of said city, and . . . [to] have control of the size, height, style, and general appearance of all such buildings for the purpose of securing in their location and erection the greatest degree of usefulness, safeness, and beauty"(cited in Hines [note 1]).

33. Burnham addressed a large meeting of civic leaders on his first visit to San Francisco in the spring of 1904. He outlined in general terms what might be accomplished in planning the city. The response was extremely favorable; while an editorial in the San Francisco *Chronicle* hinted at difficulties, it noted that Burnham's proposals were truly inspiring: "It is not the plans which present difficulties, but the execution. . . . As one looks at the beautiful eminences once so easily available for public purposes and adornment, there comes a deep feeling of regret that at the birth of San Francisco there was present no L'Enfant to lay down the lines of its growth" (cited in Hines [note 1]: 179). The perceptive editorial writer recognized, as Burnham seemingly did not, that Washington and San Francisco presented two quite different sets of problems for any planner with Baroque inclinations. The events leading to Burnham's acceptance of the San Francisco commission are summarized in Hines, ibid.: 174–80.

34. The Manila and Baguio reports were not published. Their text appears, apparently in full, in Moore [note 1], II: 179–202. For Burnham's work in the Philippines, see ibid., I: 230–45, consisting largely of extracts from Burnham's diary; Hines [note 1]: 197–216; and Parsons (note 26): 13–31. Parsons's work in refining the details of both plans as well as the buildings he designed is reviewed in A. N. Rebori, "The Work of William E. Parsons in the Philippine Islands," *Architectural Record* XLI (Apr. 1917): 305–24; and (May 1917): 423–34. Parsons also prepared plans for the cities of Cebu in 1912 and Zamboanga in 1916, both of which are illustrated in the second part of Rebori's article. Both made extensive use of radial boulevards.

35. Burnham and Bennett, *Report on a Plan for San Francisco,* San Francisco, 1905.

36. Croly, "The Promised City of San Francisco," *Architectural Record* XIX (June 1906): 425–36. The article was written before the earthquake and fire, but Croly added a postscript pointing out that the disaster, "deplorable as it was, offers San Franciscans a chance to improve the lay-out of the city at a much smaller expense than would formerly have been required, and it is to be hoped that certain steps in the direction of the realization of the scheme, which would have been postponed for years, can now be taken immediately" (p. 436).

37. Moore (note 1), II: 98–111, which includes the text of Burnham's address to the Merchants' Club of Chicago on April 13, 1897, describing his concept. See also Hines (note 1): 313–17.

38. Carl Condit described the ambitious scheme developed by Gookins in his *Chicago, 1910–29. Building, Planning, and Urban*

Technology, Chicago/London, 1973: 61–63.

39. A modern critic noted both the deficiences of Burnhamesque planning and how it led to a broader approach: "There was a lot of Baron Haussmann and precious little democracy in these vast geometries of befountained plazas and intersecting boulevards. Light, air, and foliage were concentrated around hypothetical water-gates and imaginary civic centers, never around housing or schools. Few of these schemes had any relation to the basic needs of the community." Yet, as he conceded, the plans of this era "played a vastly important role in introducing the concept of planned reconstruction into the popular mind. However pompous and autocratic the solutions, they were at least admissions that real problems did exist, and that local governments did have the power to exercise some sort of control over the urban environment. Moreover, as the movement matured, it involved many well-intentioned souls who were forced by the struggle itself to realize that the problem was much more than one of simple face-lifting. The movement was also to gain important accretions from the ranks of the social and welfare workers, who were increasingly aware of the relation between the physical environment and crime, delinquency and ill-health. Their insistence upon such factors had a salutary effect upon the movement as a whole, and playgrounds, schools, and clinics began to appear alongside ornamental drinking fountains and statues of Spanish War dead" (J. M. Fitch, *American Building: The Forces That Shape It,* Boston, 1948: 134–35). A contemporary of Burnham voiced more technical criticisms of Burnham's wholesale use of radial thoroughfares in a paper at the London Conference of 1910 in a session that Burnham chaired (see R. Unwin, "The City Development Plan," in Royal Institute of British Architects, *Transactions* (note 3): 247–65; and, in the same publication, H. V. Lanchester and Unwin, "Notes on the Exhibits": 734–44. According to Moore ([note 1], II: 139), Burnham chaired the session, although *Transactions* (p. 282) indicates the discussion following the papers was led by Justice Neville. In any event, Burnham doubtless heard or read Unwin's paper. One can only imagine the lively argument that might have taken place between these two distinguished planners.

40. In Cleveland Burnham agreed to accept his fees only because his less affluent colleagues on the commission persuaded him to do so (see Hines [note 1]: 162, 169–70).

Carol Herselle Krinsky

Chicago and New York: Plans and Parallels, 1889-1929

Visitors from the "Big Apple" know that in architecture and city planning, Chicago was often the top banana. Sometimes, though, observers of the fruit bowl noticed that the apple seemed to nudge the banana, perhaps moved by the worm of envy. These, after all, were the largest and most energetic cities in America during its most dynamic period of urban expansion. From their novel skyscrapers to their busy waterfronts, they set the pace for other American cities and impressed foreign observers with their activity and technological innovations. Although Chicago and New York often were seen as rivals, many aspects of planning and building in both cities led to comparable achievements, even if the means and the specific results differed.

Similar geographic disposition of the two cities led to similar planning and construction solutions. Both cities were situated on a large body of water, either an ocean or a lake. Both cities were also sited on a river that led to the hinterlands or could do so if the river were expanded by the creation of a canal. Both cities, therefore, became shipping centers, especially after the creation of the Erie Canal, which linked the two cities via Albany, Buffalo, and the Great Lakes. The agricultural and mineral products that were shipped from Chicago to New York for relay along the coast or to Europe (or within the United States by rail) helped to make the fortunes of both cities.

Laid out on a grid system with miles of straight streets crossed by miles of other straight streets, each city also had some diagonal streets. These were determined by well-drained ridges, valleys, or Indian tracks—Broadway in New York, and Clark, Ridge, and Vincennes in Chicago—but streets independent of the grid are exceptions. The grid plan was well suited to the real estate developer and the businessman, both of whom were essential to the growth of our cities. The real estate developer was almost guaranteed a rectilinear plot, which is easy to sell and on which it is easy to build rectilinear houses of rectilinear planks and bricks, while merchants were assured an expanse of street footage on which to establish shops and display merchandise. Chicago's grid is more interesting and more intelligently conceived than is New York's in that Chicago was plotted as a chain of sections forming neighborhoods separated by principal streets, such as Halsted and Ashland, Cermak and Roosevelt. Eventually, the public transit routes were established along these evenly spaced, wide streets. Manhattan has less regularly spaced main crosstown streets—14th, 23rd, 34th, 42nd, for instance.

The major business districts in each city—the Chicago Loop and the New York Wall Street area—were determined by the original settlements' needs for harbors and defense. Military installations commanding the approach to the commercial settlements helped to promote early commercial activity nearby. Concentration in the centers was confirmed later by the location of mass-transit facilities. Since a combination of railroad, real estate, and zoning factors eventually led to the creation of two business districts in Manhattan, one cannot push the parallels too far.

Neither city did a great deal to stop the growth of slum dwellings. New York at least began to enforce minimal standards of housing safety, air, light, and decency in 1879, but Chicago was preoccupied with rapidly rebuilding itself after the fire. Recognizing the need for public recreation space, both cities benefited from the activities of landscape architect Frederick Law Olmsted. New York's Central Park opened in 1893. Chicago bought park space on the north shoreline in 1864, establishing the Park District in 1869, an administrative mechanism empowered to create a park system. The Chicago parks were intelligently planned, and provisions were made for access to them by railroad. Although there was surface and elevated transit to Central Park, it was not until the years around World War I that subway service to the park was also available.

Both cities exhausted their local supplies of pure water, primarily because they, along with their neighbors, polluted the sources: the lake in Chicago and the rivers in New York. As a result, the city fathers had to resort to heroic measures to secure the water essential to their existing populations and future growth. Chicago did so near the turn of the present century by creating the Sanitary and Ship Canal, reversing the flow of the Chicago River. Manhattan brought its water from mountains upstate in 1842, subsequently building an additional water tunnel around the turn of the century.

Originally, the waterfronts in both cities were not used for public recreation but for shipping, and later, for railroad tracks and yards. Only recently has New York City drafted comprehensive proposals to provide public amenities along its waterfronts. Chicago's development of building technology—for example, the raft foundations John Wellborn Root used for the Montauk Building in the early 1880s—facilitated construction in both cities along the waterfronts, which had been enlarged by landfill.

Other parallel developments are evident in achievements in urban building. New York, with other Eastern cities, actually educated and trained many of the architects who created Chicago's first great skyscrapers. Rolled-iron structural support and metal-framed and curtain-wall structures were developed in New York. The elevator with safety stops, and building designs with stories grouped to suggest vertical extension, originated in the New York area. Furthermore, New York was long the home of the world's tallest buildings—Singer (1907), Woolworth (opened 1913), Empire State (opened 1931), and World Trade Center (1962 on). Nevertheless, it was to Chicago that many Eastern architects migrated. Chicago was the home of the first steel-framed building; it became famous for buildings that expressed aesthetically their underlying structure. In the late nineteenth century, New York was famous for its tall buildings, but Chicago was famous for its *beautiful* tall buildings.[1]

Of course, not all architects at that time specialized in skyscraper design. Many preferred to design public buildings—even some tall office buildings—in the "American Renaissance" mode. Buildings in this style exhibited plans with clear axes of movement, inspired by Roman

prototypes, as well as proportions and ornament related to Roman, Italian Renaissance, and contemporary French prototypes. The walls were often of limestone, traditionally a prestigious material.[2] Some of the chief designers of these buildings—including McKim, Mead & White, Carrère and Hastings, Cass Gilbert, and Richard Morris Hunt—were based in New York. Such buildings as the New York Public Library (Carrère and Hastings, 1898–1911), the Custom House (Cass Gilbert, 1901–07), and the Brooklyn Museum (McKim, Mead & White, 1897–1924) exemplify the style. But Chicago sponsored the Columbian Exposition of 1893, which gave widespread prestige to this style of design. At the fair, many of the buildings were combined to make a magical "White City," shining regally by day and glowing at night (thanks to the first comprehensive use of night-time lighting). Moreover, Daniel Burnham, who designed the fair, also designed several of New York's monumental buildings of the period, among them the Flatiron (1902) and Wanamaker (1903) buildings.

Of course, the "White City" was not a real city and it did not last very long. However, it inspired a good deal of civic construction, being itself a culmination of the energetic building activity that was taking place between the 1880s and the publication of the Chicago Plan in 1909. In those years, much of the urban infrastructure of both cities was created, especially the parts related to water and transportation. Major strides were made in civil engineering. Chicago built the Sanitary and Ship Canal (1890–1900), thus addressing problems of transportation, flood control, water pollution, sanitary disposal, and fresh water supply all at once. At about the same time, New York built its second water tunnel (1885–91, 1910). Chicago linked three elevated lines to form the Loop in 1897, and New York's elevated railways continued to provide extensive service. By 1900, planners were at work on the first subway, which opened in 1904. Chicago consolidated its position as one of the country's main railway centers. Between 1902 and 1910 in New York, the Pennsylvania Railroad dug a tunnel to bring the newly electrified trains from the mainland in New Jersey to Manhattan Island. At the same time, the New York Central and the New York, New Haven, and Hartford railroads combined to build Park Avenue as we now know it: The roof of a tunnel was ingeniously supported over their railroad tracks and yard. Chicago built more bridges to relieve the traffic problems created by inadequate bridges over the Chicago River, and New York added eighteen bridges of various sizes over its waterways between 1888 and 1909.

In the field of public administration, Chicago and New York followed comparable but not identical courses. In 1898 the present five boroughs of New York were united. Formerly, Brooklyn had been a separate city, the fourth largest in the nation. In the following year, Chicago annexed some of its inner suburbs.

New York led Chicago in regulating tenement house design. Unlike the prairie city's, Manhattan's boundaries were not infinitely expandable. While New York's manufacturers tended to cluster, Chicago's spread along the Chicago River and out to auxiliary foci such as the stockyards. New York's workers were crowded together near the industrial area in multistory tenements that were regulated and made tolerable as early as 1879. In 1901 the tenement house law was overhauled to provide for less coverage of the building lot, more light and air, better plumbing, and fire safety measures.[3] In requiring that apartment houses be of fireproof construction above a specified height, Chicago moved ahead of New York. Such regulation had the effect of limiting the number of buildings erected past the level at which fireproof construction was required. The lower buildings created less congestion, unless they were

Figure 1. Charles Platt Huntington, American (1874–1919). *Audubon Terrace,* New York City, 1908. Photo courtesy New York City Landmarks Preservation Commission.

Figure 2. John Mead Howells, American (1868–1959). *Panhellenic Tower,* New York City, 1928. Photo © Cervin Robinson, New York, 1979–80.

overcrowded by venal landlords or poor tenants who took in relatives and boarders.[4]

By setting up a Special Park Commission in 1899, which was meant to govern recreational parks, pools, parkways, and other facilities, Chicago became the leader in coordinated park planning. Parallels between the two cities are also close for coordinated industrial and commercial districts. In 1890 Irving Bush, an entrepreneur, began construction of the Bush Terminal District on two hundred acres of Brooklyn waterfront property. It was a complex of loft and warehouse buildings, a rail- and water-freight depot, and piers. At the same time, Chicago created the Central Manufacturing District for the coordinated manufacturing, warehousing, and shipping of Chicago's products.

Although both cities had a single main business area, buildings were erected in it with little sense of common action. A unified business zone was achieved in New York when the New York Central and the New York, New Haven, and Hartford railroads created the office buildings and hotels, apartments and clubs, post office, shops, and exhibition buildings around the rebuilt Grand Central Terminal and the newly created Park Avenue leading north from it. The buildings rest on foundations that were fitted between the tracks and that were cushioned against vibrations from the trains. The plan was the achievement of William Wilgus, a brilliant engineer. On Vanderbilt Avenue, which was cut into the city's grid to provide carriage access to the side of the terminal, there are more hotels, the Yale Club, and office buildings. Just to the west is the Madison Avenue men's shopping area, serving the wealthy businessmen who commuted by train to the new office buildings from the suburbs. The buildings near Grand Central Terminal were almost all square, with limestone on the lower stories and tan brick above. Dull as they were, apart from such exceptions as the Waldorf-Astoria Hotel, the general uniformity of their design gave the whole project visual unity. Below ground, a network of tunnels allowed many office workers and hotel guests to descend from their buildings into the terminal, which was also a subway station for three lines. (Perhaps some of the ideas for underground coordination were inspired by the railroad tunnels linking some of Chicago's buildings.) The brilliant multilevel design of the terminal building itself led passengers to trains, subways, shops, offices, hotels, and the street in all directions more efficiently than did its grandiose rivals, such as the Pennsylvania Station in New York or Union Station in Washington, D.C. The Grand Central zone was the model, apparently, for every later coordinated business development in the country, and perhaps in the world.[5]

Construction on the zone began in 1902, but was not finished by 1909, when the Chicago Plan was published. Nevertheless, it did have an impact on Chicago, since the plans for Grand Central, as well as more tentative plans for the Pennsylvania Station area, were known at the time. Perhaps the interest evinced by the Chicago Plan in building on railroad air rights and building multilayer structures had to do with the projects then rising—and tunneling underground—in New York.

New York witnessed the greatest activity in the planning of urban enclaves. New York's City Hall Park already had a post office, a courthouse, and the city hall itself. Between 1899 and 1911, architects John R. Thomas and Horgan & Slattery added the Surrogate's Court building on one side of the park. The citizens were represented at this center in another way: Across the park was "newspaper row," where the offices of several leading journals were housed within sight of the mayor. The Chicago Plan called for a spectacular civic center at the intersection of Halsted and Congress streets.

New York also developed a cultural enclave at the time that the Chicago Plan was put forward. In 1908, building commenced at 155th Street and Broadway on a complex of museums and learned societies known as Audubon Terrace (fig. 1). It included the American Numismatic Society, the American Geographical Society, the Hispanic Society of America, the Museum of the American Indian, and the American Academy of Arts and Letters. The style of these limestone palaces, of a sober and not very imaginative form of Classicism, was based on eighteenth-century French antecedents and was strongly inspired by the architecture of the Columbian Exposition. They are the sorts of buildings one sees in Washington, D.C., or in Chicago (for example, the City Hall, by Holabird & Roche, 1907–11). Generally speaking, however, New York's civic leaders did not cluster their cultural facilities as they did at Audubon Terrace or, more recently, at Lincoln Center. Neither did Chicago's, even though most of the city's principal cultural institutions are in the vicinity of Grant Park.

In both cities, the wealthy classes established great cultural institutions at about the same time. In Chicago, the Auditorium opened in 1889, the Public Library opened in 1897, and the Art Institute moved into its present home—a legacy of the Columbian Exposition—in 1897. In New York, the Metropolitan Opera House opened in 1883; the American Museum of Natural History was enlarged between 1892 and 1899; the Metropolitan Museum of Art expanded and received its present Fifth Avenue façade between 1895 and 1906; while the Public Library was built from 1898 to 1911. Outside Manhattan, the Bronx Botanical Gardens opened in 1895 and the Zoo in 1899. The Brooklyn Museum was designed in 1897, and the present Academy of Music building was completed in 1908.

Both cities had important educational enclaves by 1909. The University of Chicago campus was laid out in quadrangles of buildings by Henry Ives Cobb and others in a first great wave of construction from 1891 to 1910. During the same period in New York, McKim, Mead & White designed the new campus for Columbia University (1892), as well as the major buildings of New York University's Bronx campus (1894–1901). About ten blocks north of Columbia, City College's Gothic buildings were arranged in courtyards to the design of George B. Post (1903–07).

Both cities also had carefully planned residential pockets, some designed for the middle class and some for the working class. The Chicago suburb of Riverside (begun in 1879) antedates anything as good in New York, while Pullman (begun in 1880) was far more comprehensive than New York projects meant for factory workers. The Steinway district in Queens of about 1880 is an area of modest brick houses for the Steinway Piano Company employees; it remains a cohesive neighborhood. In Brooklyn, the Tower and Home buildings of 1879 were blocks of model tenements, erected by an important local philanthropist, Alfred Treadway White. By 1911, plans were announced for Forest Hills Gardens in Queens, which, like Riverside, was laid out with curved streets and studied landscaping. Built for the middle class, the houses are still sought after. They are made of concrete, testifying that New Yorkers, as well as Chicagoans, were interested in modern building technology. Constructed in the Flatbush section of Brooklyn from about 1885 to 1905, Prospect Park South is still a beautiful development of well-tended homes. The design and landscaping were all carefully supervised by a developer, Dean Alvord, who learned some of the lessons of Riverside.

New York businessmen generally preferred to construct their projects separately, sometimes even in rivalry, just as they built their cultural institutions in widely different locations.

Figure 3. Zoning rule diagrams for New York City.
(From F. Mujica, *The History of the Skyscraper,* New
York, 1930, pl. XXXVIII.)

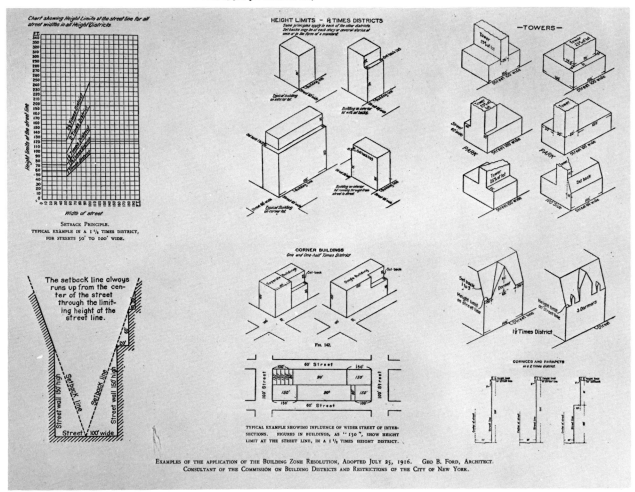

Figure 4. Zoning rule diagrams for Chicago. (From
Illinois Society of Architects, *Handbook for Architects and
Builders,* Chicago, 1923: 315.)

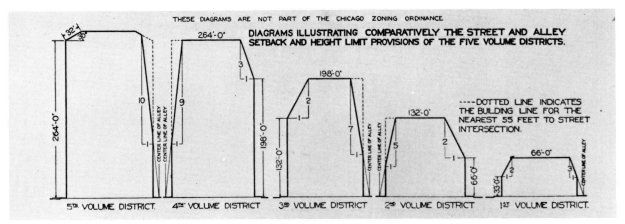

But the more enlightened businessmen of Chicago agreed to work together for the common good by planning. The most important city plan in the first decade of the twentieth century was the achievement of Chicago, not of New York.

The Chicago Plan of 1909 was forward-looking in many ways, even though it had little to say about housing the poor. Many of its elements were so important as to deserve special emphasis. The intelligent appendix, for instance, examined the legal basis for creating such a plan, reflecting the serious intent of its sponsor, the Commercial Club, and its designer, Daniel Burnham. They considered the regional implications of proposals for the city. In hiring Burnham, the Commercial Club chose the right man for the job, rather than someone whose chief qualification was friendship with the mayor. Enough money was spent to ensure publication of a handsome volume; it could impress certain sections of the public, while *Wacker's Manual,* a simplified form of the plan, was developed to explain it to the entire public.

Because the Chicago Plan had been produced for the Commercial Club, it was not tainted with socialism or utopianism; it was prescriptive but not particularly restrictive. Furthermore, the plan could be thought of as a practical one because it had a sufficient basis in existing ideas. By 1909, New York had a subway; it had the Grand Central and Pennsylvania Station proposals for air rights buildings; and it had had traffic segregated into pedestrian paths, carriage roads, and high speed roads, sometimes arranged in layers designed by Olmsted for Central Park.

New Yorkers familiar with the Chicago Plan certainly sympathized with hopes of building more cultural facilities, parks, and a formally planned civic center, consisting of harmoniously designed buildings. They founded Hunter College in 1913. Emile Perrot designed a formal collegiate Gothic campus for Fordham University, which was built from 1911 onward. The Municipal Building (by McKim, Mead & White), at one corner of City Hall Park, was finished in 1914. While it was going up, New York instituted a competition for a County Courthouse in 1912; Guy Lowell was the winner. This building, adjacent to the Municipal Building, became a keystone in New York's federal and judicial center at Foley Square, a block to the north of the City Hall Park civic-building group. Foley Square, developed from 1912 until the Depression and then again in the 1960s, is New York's closest response to the civic center project presented in the Chicago Plan. The buildings around Foley Square were designed in Classical style. A plan for the square proposed straightening an important street intersection. As in Chicago's projects, open space was included. Unfortunately, only a few buildings in the original design were completed, and the street and plans for open space never realized.

However appealing the Chicago Plan may have been to individual New Yorkers, there was no group ready to sponsor something similar. New York did not have the services of Daniel Burnham. But then, perhaps, such a comprehensive plan did not seem necessary in a city that already had its civic center, its parks, plazas, Coney Island; its universities and museums; its subways, trolleys, ferryboats, and elevated railways; its water tunnel; and its tenement house laws. Equally important, New York had experienced neither a fire nor the Columbian Exposition, both of which required enormous mutual effort for commonly perceived civic purposes. So New York continued to do things piecemeal for a while.

Progressive thinkers in government and civic life did not wholly neglect Chicago's suggestions. In 1910, New York established a Commission on the Congestion of Population. Concerned with streets and highways, it recommended restrictions on building height to reduce

some of the congestion. This had the potential of addressing several city-wide issues, such as controlling land exploitation and relating transit facilities to the development of various neighborhoods and areas.

Another problem in New York that planning would help to solve was that building developers were destroying one another. A builder who erected a twelve-story building on a block with four-story buildings created high value for his structure because of its visibility and the fact that the occupants of the eight upper floors enjoyed abundant light, circulation of air, and good working conditions. But the value of his building decreased dramatically the moment someone erected another twelve-story—or a twenty-story—building next door. The newcomer would reduce some of the breeze, the light, the views, and the prestige, as well as attract some of the builder's tenants. The prospect of successive builders causing rapid, drastic changes in property value while they added to the congestion of the city worried the city fathers as well as real estate and building industry executives. Besides, they were dealing not with structures of only twelve or twenty floors but with colossal edifices, the tallest buildings in the world. The worst offender was the Equitable Building, designed by Chicago's Ernest R. Graham. Erected between 1913 and 1915, this huge building had more office space than any previous building, even though it was not the tallest skyscraper in New York. It comprised 1,200,000 square feet and rose above the sidewalk about 540 feet. It cut off air and light from its neighbors, contributing as well to the egregious air pollution of narrow Thames Street, across Broadway. The city had as yet no way to stop the construction of similar buildings.

The Equitable Building so clearly violated common assumptions of equitable behavior in business and civic relations that it made more and more New Yorkers think about comprehensive planning. In 1913, the Board of Estimate and Apportionment, which had legislative and executive powers, set up a Committee on the City Plan, which had little effect because another committee, set up to study the heights of buildings, had so much effect. The Heights of Buildings Committee recommended that the whole city be zoned. A commission was appointed to do this work, and by 1916 New York City had the nation's first comprehensive zoning resolution. If the Chicago Plan was the great model plan in our country for at least two decades, then New York's zoning resolution was the great partial solution for urban ills. It was adopted with local variations in hundreds of communities all over the United States.

New York's zoning rules were of two kinds. One regulated the height of buildings, just as the commission had intended (fig. 3). On wide streets in a dense commercial zone, a building could rise to a height two-and-a-half times the width of the street but no higher. (On narrower streets, the allowable rise might be only one or one-and-a-half times the width of the street.) Any higher than this and the building would have to be set back from the front building line according to the following procedures: A line would be drawn from the middle of the street to the cornice at the allowed straight-up height, then projected back into the building lot. All additional stories would have to fit under this line, known as the sky-exposure plane. This zoning rule is responsible for the characteristic wedding-cake form of New York skyscrapers designed between 1916 and 1961. Only when the building had been set back over three quarters of the lot could the remaining quarter be covered by a tower rising straight up as high as the architect and client wished; this explains the towers of the Chrysler and Empire State buildings.

The other kind of zoning rule concerned buildings that would be allowed in a given neighborhood—factories, houses, etc. Department-store owners were particularly interested

in this rule, because they did not want to be surrounded by the factories in which their merchandise was made. The factories had been moving north, following the stores. But the store owners did not like the factory buildings, the immigrant workers, the delivery vans, and the hand-pushed trolleys. Joining other businessmen who had analogous problems, they promoted the city's segregation into various types of residential zones; commercial and manufacturing areas; and unrestricted zones to accommodate filthy factories, tanneries, slaughterhouses, and the like.[6]

While the zoning resolution was a powerful tool, it was not constructive and remedial, like the Chicago Plan. It could only prevent future abuses; existing tall buildings and factories could stay where they were. Nevertheless, zoning has been the primary, if limited, planning mechanism of most American communities, many of which lacked the larger vision that was evident in Chicago by 1909.

Chicago, on the other hand, appointed a City Planning Commission in response to the plan. Addressing itself to major projects, the commission tried to promote the civic center, glorious but impractically costly as it was. It proposed the major east-west boulevard leading to the civic center from the lake; it planned multilevel streets, including Wacker Drive, and a railroad terminal that had been another proposal in the Chicago Plan. The design of the lake-front parks, which were eventually built, and a green-belt forest preserve were also in its jurisdiction. The commissioners had a more comprehensive idea of what a city should be than did the zoning proponents of New York.

In the days before zoning, people could imitate Gothic castles and Renaissance palaces, adding façades in these styles to pre-existing banks and apartment houses. Or, if one already had a castle or palace available for conversion, one would only have to add to the standing building a dozen or so extra stories, a procedure that did not seem to strike most architects as odd. New York's zoning rules called for new types of building design which proved exciting to many architects. Buildings could no longer be designed as façades simply applied to boxes: Who had ever heard of a set-back Italian Renaissance palace? Instead, they had to be designed as three-dimensional forms of a completely new sort.[7] While it is true that the prize-winning 1922 design for the Chicago Tribune Tower was still Gothic, it is set back near the top as if its New York-based designers, John Mead Howells and Raymond Hood, were convinced that Gothic bell towers had anticipated New York's zoning rules hundreds of years before. Even more remarkable is the more famous design, the second-prize winner, by Eliel Saarinen of Finland, a building that follows the New York set-back rules. Either Saarinen was impressed by the rules, or he expected Chicago to adopt them. Perhaps he did not distinguish clearly between rules for Chicago and those for New York, thinking of this set-back skyscraper as a generally American, modern type of building. In any case, both designs for Chicago's premier building of the time could have met the New York zoning requirements.

Slightly later, New York's new skyscraper forms and modern styles attracted the attention of Chicago architects. The source for the black and gold of Chicago's Carbide and Carbon Building of 1929, by the Burnham brothers, was Raymond Hood's black and gold 1924 American Radiator Building in New York. On the other hand, John Mead Howells exported to New York a design that was a cross between the two prize-winning Tribune designs for his Panhellenic Tower of 1928 (fig. 2); it is a streamlined simplification of both of them.

Not only the architects but Chicago's city fathers must have been impressed by the

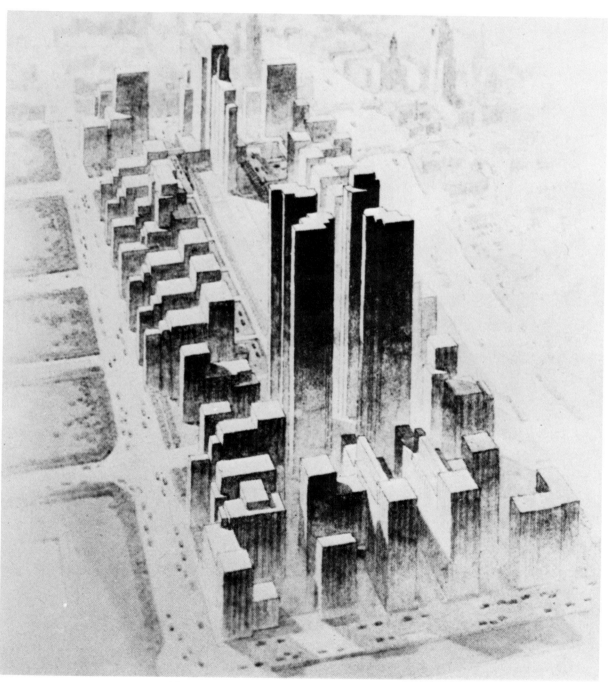

Figure 5. Ralph T. Walker, American (1889–1973). *Proposed Terminal Park Project,* Chicago, 1928. Photo courtesy Haines, Lundberg, and Waehler, New York.

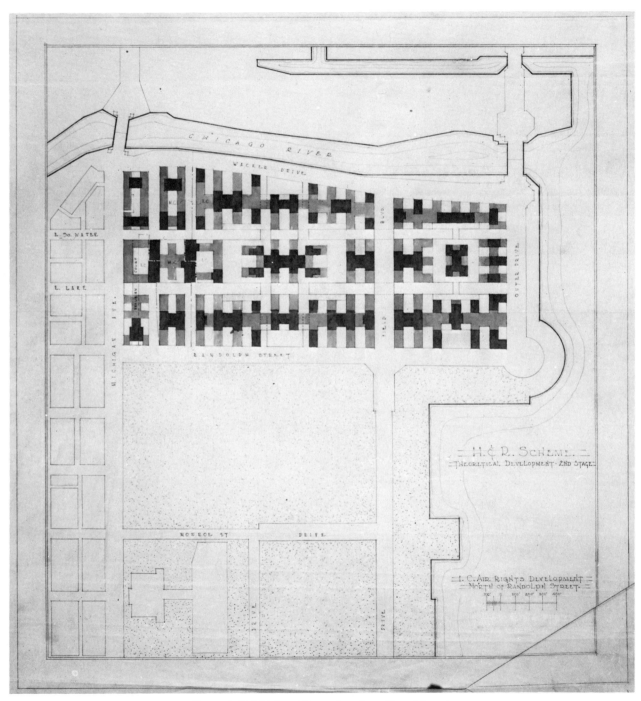

Figure 6. Holabird and Root, American. *Plan of densest
model of proposed development of Terminal Park Project,*
Chicago, 1928. Pencil and wash on paper; 64 x 50 cm.
The Art Institute of Chicago, The Burnham Library of
Architecture, Gift of Carol H. Krinsky, 1980.

usefulness of zoning, because they instituted it in 1923. They had, in fact, tried to do so earlier, in 1916, immediately after New York's rules became operative. In the measures that took effect in April 1923 (fig. 4), Chicago's government established areas where high-rise buildings were allowed, but let the buildings rise straight up to a maximum of 264 feet,[8] a more liberal allowance than buildings generally had in New York. The Chicago zoning rules designated residential and commercial streets—so many, in fact, of the latter that the commerce of Chicago has never grown to meet the permitted activity. Chicago's officials may not have felt the need to be as strict as New York's because Chicago had its City Planning Commission to take care of other urban building problems.

In 1923, New Yorkers finally published some plans that were more comprehensive than mere zoning. Returning to the subject of traffic congestion, a committee of architects and other professionals set forth some plans for building roads on superimposed levels which were proposed in New York every few years. (They had also appeared in the Chicago Plan, as well as in the work of French planners.) The artistic renderings accompanying the written proposals indicate depressed, grade-level, and elevated roadways, as well as basement, street-level, and elevated building entrances. Pedestrians were meant to walk at the elevated level, where shops and other points of interest were to be located. Such plans were never realized. To name only one obvious reason, they would have meant the relocation to an elevated level of all the facilities—restaurants, shops, etc.—on the ground-level floors of existing buildings. In Chicago, the multilevel Wacker Drive could be built because no major buildings directly adjacent to it remained.

While New York's futile road-planning efforts were under way, private citizens in New York assembled to do what private citizens of Chicago had done earlier: produce a truly comprehensive plan. In New York, the work was done by the Regional Plan Association,[9] comprised of authorities on transportation, recreation, and other major matters. Edward Bennett, who had participated in the Chicago Plan, was one of these experts. Their work, financed by the Russell Sage Foundation, was received favorably by enlightened businessmen. The studies were published in book form—well-illustrated volumes that appeared between 1927 and 1931. They were as influential in the planning of New York's bridges, parkways, tunnels, highways, parks, and in formulating ideas about civic beautification as was the Chicago Plan. Both plans were more than proposals for the city alone: They incorporated regional studies as well. Both were more concerned with profitable construction—roads, for instance—rather than housing for the poor.

The failure to plan properly for adequate housing has had appalling consequences for the urban poor to the present day. A very small-scale remedy adopted in both cities was the continuation of a nineteenth-century idea, that of limited profit, philanthropically supported housing. Sponsors in Chicago included Marshall Field, who built low-rise apartment houses for white tenants on Sedgwick Street. The sponsors in New York included John D. Rockefeller, Jr., who built the Paul Laurence Dunbar cooperative, low-rise apartments for black tenants in Harlem. Both projects were finished in 1928 and were built to the design of Andrew J. Thomas, a New York architect. The tenants were working-class people, the "deserving poor," a term used generally to refer to families of good moral reputation, headed by employed men. Since such people did not mistreat their dwellings, maintenance costs were low. Simple, repetitive, but thoughtful design kept the building costs down in the first place. In

theory, the sponsors could make a modest profit while doing good for good people. Not many philanthropic (or trade-union or cooperatively financed) housing projects were ever created, however, particularly with the rewards to be anticipated on investments during the 1920s. These rewards were far greater than the three to seven percent return on investment that housing could yield if all went well. Public housing was still a decade away. Slums continued to flourish in both cities.

Development of railroad properties promised far greater return. Throughout the 1920s, the Grand Central area took form. Hotels and a post office were built around Pennsylvania Station. Chicago's Union Station was finished on a site allocated to a railroad station in the Chicago Plan. The Daily News Building of 1929 (Holabird and Root) and the Merchandise Mart of 1936 (Graham, Anderson, Probst and White) were built on railroad air rights. A gigantic complex of office buildings over the tracks of the Illinois Central Railroad where the lake and the river meet was projected between 1928 and 1930. The suburban lines that used the rail yard there had recently been electrified (1926). An electrified rail line eliminates steam and smoke. When these are gone, electrified trains can be put into tunnels. This is exactly what happened, first in New York on Park Avenue and then in Chicago. The Illinois Central and Michigan Central sponsored studies by several architectural firms for their project, Terminal Park (figs. 5–7). They called on the Chicago architectural firm of Holabird and Root, as well as on two New York architects, Ralph T. Walker and Raymond Hood, both of whom were famous for their set-back skyscrapers. All the firms planned for densely packed high-rise buildings; some included a central open mall. In an extension of the Grand Central Terminal/Park Avenue idea, people were to enter the buildings from the mall or from underground entrances on the suburban-train-track level. The Chicago project had one attribute that the Grand Central zone lacked: a boat marina and public open space on the waterfront—features obviously hard to provide in the center of Manhattan. But the structures would have been bulkier, probably adding more new building to Chicago than even a booming economy could support. In any case, the project fell through in 1930, either because its financial success was uncertain or because the advancing Depression halted any such large-scale private planning.[10] (The present Illinois Center is comparable to Terminal Park in concept, even though it was conceived independently.)

At the same time, Holabird and Root, Ralph T. Walker, and Raymond Hood were at work on designs for the Century of Progress exhibition of 1933–34, which was financially successful. The business conditions associated with fairs are different from those connected with permanent office buildings. The fair and Terminal Park did have some elements in common. Accessible by railroad, they were enormous developments which required the coordination of financing, planning, construction, public relations, art, and mass activity on a huge scale. Planned for a variety of uses, they had to attract the public. Open spaces had to be incorporated between big buildings; pedestrian traffic had to be managed adroitly to increase visitors' contact with shops and other commercial premises, and to eliminate congestion which would deter people from staying, renting, and returning. The sources for both Terminal Park and the 1933–34 fair are at the Columbian Exposition in Chicago and Grand Central in New York.

Parallel projects were created in New York in this period, the most important of which was Rockefeller Center.[11] It was planned at the same time as Terminal Park and the Century of Progress exhibition, and its two leading architects, Raymond Hood and Harvey Wiley

Figure 7. Holabird and Root, American. *Densest model of proposed development of Terminal Park Project,* Chicago, 1928. Photo courtesy The Art Institute of Chicago, The Burnham Library of Architecture.

Corbett, also worked on the fair, while Hood, as we have seen, submitted proposals for Terminal Park. Rockefeller Center is a smaller version of Terminal Park and a far less congested one. Both projects shared the concept of tall buildings around a central open space; the buildings were distributed with overall balance but not mirror symmetry. Equipped with underground entrances and passages to rail facilities—railway lines in Chicago, subway lines in New York—they were conceived for mixed uses such as offices, recreation, and residence at Terminal Park, and offices, theatrical production, and shopping in New York.

Comparisons can be drawn between Rockefeller Center and the Century of Progress exhibition. Both had well-run promotion and public relations departments. Pedestrian traffic management was vital to the success of the fair and is just as important at Rockefeller Center, where about a quarter of a million people enter a three-block site every day. A particularly brilliant traffic-directing device was the creation of the artificial slope leading from Fifth Avenue toward the skating rink, which propels people toward the buildings and shops off the prestigious avenue. In addition, the sculpture, murals, fountains, trees, and colorful details that attracted people to the fair were used to lend gaiety and prestige to Rockefeller Center's large buildings. Another, smaller project, albeit minor, is London Terrace (Farrar and Watmough, 1930), a huge block of symmetrical high-rise apartment houses separated by a raised grassy mall. The project contains 1,670 apartments, as well as shops and sports facilities.

At this point, we reach a new period in urban development of both cities. Apart from the Century of Progress and Rockefeller Center, there was little new large-scale private building going on in either city or, for that matter, anywhere else during the Depression. In the subsequent war years, most development was undertaken for war-related purposes. Furthermore, most urban-scale projects and plans were either made or influenced by the federal government—highway construction, work relief projects, low-income housing, military bases, war plants, housing, and so on. Private initiative—the initiative that had promoted the Chicago Plan, the Regional Plan, the zoning rules, and the vast building projects of 1928–29—began to be rivaled by the various branches of government concerned with planning and building.

A date twenty years after the Chicago Plan's publication marks a good place to conclude this summary of parallels in the growth of New York and Chicago. There have been many parallel movements in both cities since 1929, of course. Nevertheless, a visitor from New York who comes to Chicago to compare building development in both cities has to realize that the "Second City" has sometimes been first, and not only in the age of the Chicago Plan. Chicago, after all, is now the home of the world's tallest building![12]

The author would like to thank Sarah Bradford Landau, John Zukowsky, and Guy Sterner for their help with references to projects and other literature, as well as William Holabird and staff members at Haines, Lundberg, and Waehler for information and pictures relating to the Terminal Park project.

1. See "The Chicago School Issue" of *Prairie School Review* IX, 1–2 (1972) for papers by W. Weisman, C. Condit, H. R. Hitchcock, and others on the contributions of architects in New York, the East Coast, and Chicago to the development of the skyscraper.

2. For an introduction to this subject, see R. G. Wilson *et al.*, *American Renaissance,* 1979, exh. cat., New York, Brooklyn Museum.

3. J. Ford, *Slums and Housing with Special Reference to New York City,* 2 vols., Cambridge, Ma., 1936, is the standard source of information on tenements, housing regulations, and housing for the poor.

4. See E. M. Bassett, *Citizens' Zone Plan Conference. Chicago. December 16 and 17, 1919. Report of Proceedings:* 54. It should be noted that Chicago's slum dwellings were often wooden buildings, one to three stories in height, closer to the slums of Brooklyn than to the taller masonry structures of Manhattan.

5. For more on Grand Central Terminal and vicinity, see D. Steck Waite and J. Marston Fitch, *Grand Central Terminal and Rockefeller Center,* Albany, 1974, with bibliography; and *Grand Central Terminal, City Within a City,* ed. by D. Nevins, New York, 1982.

6. A convenient source for the background of the zoning resolution and essential excerpts from it is F. Mujica, *The History of the Skyscraper,* New York, 1930, I: 37–40. For zoning and its place in city planning, see M. Scott, *American City Planning Since 1890,* Berkeley, 1969, esp. pp. 152–58 (for New York City zoning).

7. Zoning also regulated the rear parts of buildings by controlling the size of courts and yards. Articles on the architectural consequences of zoning include *Architectural Record* XLVIII (Sept. 1920): 193–217; *American Architect* CXXV (June 8, 1921): 603–08, 617–19; CXXIII (Jan. 3, 1923): 1–4; CXXV (June 18, 1924): 547–51; *Architectural Forum* XXXV (Oct. 1921): 119–24, 131–34; *Pencil Points* IV (1923): 15–18.

8. C. Bostrom, "History of Zoning in Chicago," in *Citizens' Zone Plan Conference . . . 1919* (note 4): 6–8. For Chicago's zoning rules, see the annual volumes of the *Handbook for Architects and Builders. Published under the Auspices of the Illinois Society of Architects,* esp. vol. XXVI (1923): 297–323.

9. Committee on the Regional Plan of New York and Its Environs, *Regional Survey of New York and Its Environs,* 8 vols., New York, 1927–29; *Regional Plan of New York and Its Environs,* 2 vols., New York, 1929–31. A Chicago Regional Plan Association was established in 1925. Its successor organization is now called the Northeastern Illinois Planning Commission.

10. Haines, Lundberg, and Waehler, successor firm to Ralph Walker's (then known as Voorhees, Gmelin, and Walker), has no documentary information on this project, although its existence was noted briefly in the firm's publication *Ralph T. Walker, Architect,* New York, 1957. The firm does have photographic material, however, which shows that Walker planned tall buildings around a central open space. Holabird and Root also retained no written material on their proposals, but William Holabird kindly sent the author the remaining plans and photographs—all but one of which are now in the Burnham Library of the Art Institute of Chicago. Their proposals for full development of the site incorporated no open space but rather included some low buildings between the tall ones. Mr. Holabird, who did not design this project, expressed his relief that so dense a project was never built. Raymond Hood's papers have been destroyed almost entirely, partly by accident. Photographs that must be of his model for the project are in the New York Historical Society. His model shows the marina. During the 1920s, Eliel Saarinen considered this site in his general proposals for lake-front development; see *American Architect* CXXIV (Dec. 5, 1923): 487–514. Holabird and Root made plans for the site in 1941, but these were abandoned in early 1942, no doubt because of the war.

11. See Waite and Fitch (note 5); and C. H. Krinsky, *Rockefeller Center,* New York, 1978.

12. The Sears Tower (Skidmore, Owings and Merrill; 1974). On New York City architecture in general, see Real Estate Record and Building Guide, *A History of Real Estate and Building in New York,* New York, 1914; Mujica (note 6); *New York City Guide* (Federal Writers Project. American Guide Series), ed. by L. Gody, New York, 1939; *King's Views of New York, 1896–1915 and Brooklyn, 1905,* comp. by M. King, new intro. by A. Santaniello, New York, 1974; Condit, *The Port of New York,* Chicago, 1980. On Chicago architecture, see Condit, *The Chicago School of Architecture. A History of Commercial and Public Building in the Chicago Area 1875–1925,* Chicago, 1964; H. M. Mayer and R. C. Wade, *Chicago, Growth of a Metropolis,* Chicago, 1969; and Condit, *Chicago, 1910–1929,* Chicago, 1973.

John Szarkowski

Photography and America

In this lecture I will attempt a few exploratory and tentative remarks on the overly ambitious subject of photography and America, and will try to relate something of my own current view of the American tradition in photography.

In 1893 the great American historian Frederick Jackson Turner, in a paper read to the American Historial Association, first announced the original and highly influential thesis that the character of American civilization had been profoundly influenced, over the period of a quarter millennium, by the existence of an open frontier.[1] Before Turner, it had been tacitly assumed that American civilization, if indeed it could be called a civilization and not simply a colonial culture, had been legislated somewhere on the Eastern Seaboard, in Boston or Philadelphia or Virginia, and then exported West by canoe or covered wagon with extreme difficulty and generally undistinguished results. The frontier, in other words, had been regarded as the embodiment of the Yin principle: something to be acted upon. On the contrary, said Turner, the frontier had been the most potent Yang principle in American history.

In the beginning, Turner's argument was based on the concept of the frontier as a westward-shifting reservoir of free land, which served as a vacuum for succeeding generations of malcontents, each of which would finally be reduced to forming a social compact of some sort, which in turn had to be fitted somehow into a national consensus. However, as he developed and refined his theory, Turner came to regard the frontier in a larger, metaphorical sense: not merely as a line on the map, but as a line of contention between the forces of social stability and those of creative anarchism. Beyond the frontier, the old laws and the old conventions lost much of their force. The first ones into the wilderness wanted not only free land but also a free hand. Beyond the frontier, freedom was perhaps less a principle than a habit. Independence was not an ideal but a daily requirement of survival. Freedom and independence together came to form a peculiarly American variety of *hubris,* which saw the specialist as a fraud and inherited wisdom as a variety of Old World witchcraft.

The more thoughtful people recognized a problem in this, but they were, of course, a small minority. Ralph Izzard wrote testily to Thomas Jefferson in 1785: "Our governments tend too much to democracy. A handcraftsman thinks an apprenticeship necessary to make him acquainted with his business. But our back countrymen think that a politician may be

born, just as well as a poet."[2] It is interesting that Izzard, although willing to support the conservative idea that a politician should be educated, shared the general American position that a poet was God's responsibility.

Turning now to photography—a phenomenon that was, incidentally, born during our country's Jacksonian revolution—I would like to suggest that as the frontier was an anarchistic force in the development of American civilization, so was photography an anarchistic force in the history of the visual arts; and, further, that this new picture-making method was in some respects the ideal pictorial system for a country based upon the principles of individual free-dom, political equality, cultural diversity, centrifugal movement, constant experimentation, extemporization, and quick results.

Every ambitious photographer is pulled between two contradictory ambitions. On one hand he wishes to lead photography into cultural and critical respectability by making it conform in some reasonable degree to the known canons of the traditional arts; on the other, he wants not to lead photography but to follow it down those paths suggested by the medium's own eccentric and original genius. The first motive concerns what art should do; the second what it might be able to do. The first inclines toward the claims of civilization and quality; the second, toward those of freedom and originality.

In nineteenth-century American photography, the forces of anarchy had altogether the best of it. One might point out that in the United States, unlike Europe, photography knew no royal societies, no licensing system, and no accredited courses of preparatory study. But it is likely that even in Europe these devices were less important and less influential than they might seem in retrospect. Perhaps more to the point is the fact that North America had no traditional subject matter. It had no ancient history that it knew of, no classical ruins, no romantic medieval monuments, and not even a proper aristocracy.

Consider the last of these issues first. I think it is suggestive that the standard early technique for photographic portraiture in the United States was the daguerreotype, while in Europe it was the calotype, or negative-positive system. With the calotype system, an almost infinite number of prints could be made from a single negative, whereas the daguerreotype produced one unique picture. The distinction corresponded perfectly to the social perspectives of the United States on the one hand and, for example, England on the other. In England almost everyone wanted a picture of Lord Tennyson, Dr. Livingstone, or the queen, so such pictures were published in sizable editions (see fig. 1). In the United States, by contrast, almost everybody wanted a picture of himself and his family (see fig. 2).

Even in the 1840s it took a great many photographers to make a daguerreotype of every family in the United States. But that was not a serious problem, since photographers could be, and were, created more or less overnight out of failed painters, chemists, tinkers, silversmiths, blacksmiths, and department-store clerks. Holgrave, the hero of Hawthorne's *House of the Seven Gables,* was, not insignificantly, a daguerreotypist. He had previously been:

> a country schoolmaster, salesman in a country store, and the political editor of a country newspaper. He had subsequently travelled as a peddler of cologne water and other essences. He had studied and practiced dentistry. Still more recently, he had been a public lecturer on mesmerism, for which science he had very remarkable endowments. His current phase as a daguerreotypist was of no more importance in his own view, nor likely to be more permanent, than any of the preceding ones.[3]

Figure 1. Julia Margaret Cameron, English (1815–1879). *Alfred Lord Tennyson,* 1865. Collodion; 10½ x 8¼ in. New York, The Museum of Modern Art, gift of Edward Steichen (120.52).

Figure 2. Unknown, American. *Couple with Daguerreotype,* c. 1850. Daguerreotype, one-quarter plate. New York, The Museum of Modern Art, gift of Virginia Cuthbert Elliott (87.74).

Figure 3. Timothy O'Sullivan, American (c. 1840–1882).
Slaughter Pen, Foot of Round Top, Gettysburg, 1863. Albu-
men; 6¾ x 9 in. New York, The Museum of Modern Art
(394.77).

Holgrave is a symbol in the novel of that frightening breed of native American who would have each generation repudiate tradition and begin again. It was Holgrave who said—almost a century before Le Corbusier—that each generation should tear down its father's house and build anew.

Photography reached voting age, and an advanced degree of technical competence, just in time to photograph the most tragic and traumatic episode in the history of the United States: the Civil War. The photographers who described that horror are still popularly known by the generic name of Mathew Brady. There were a score of them, and many had learned their trade before the war in one of Brady's several studios.

The American Civil War was the first war to be photographed in such exhaustive detail. It has been said that the primitive equipment and materials of that time prevented the photographers from achieving a narrative account of the war, but this is clearly nonsense, since ten billion photographs of subsequent wars, made with progressively sophisticated hardware, have been equally incapable of achieving a narrative account. I know of no war photograph that has managed even to explain who is winning and who is losing—surely the easiest part of the problem faced by Uccello or Velásquez in their battle paintings.

The most memorable photographs of any war seem to convey the sense that everyone lost, and that if there was a large design to the war, it was invisible to the participants. What photographs could describe clearly and eloquently was the chaos of war, the million pointlessly articulated, incoherent pieces of it.

The great novel of the American Civil War, *The Red Badge of Courage,* was written a generation after the war by Stephen Crane, who, of course, had not been in the war himself. But, as Ernest Hemingway noted, he had known the veterans and had, as a child, listened to their stories. And he had surely known what Hemingway called "the wonderful Brady photographs."[4]

The Red Badge of Courage is a profoundly photographic book, not in the surface character of its description but in the nature of its perspective. The hero of the story is a youth without a name. The larger political and philosophical meanings of the war are not mentioned. The strategic significance of the battle in which the youth fights is not explained to him, or to us. When the battle is over, it proves to be not the central battle at all but merely a diversionary skirmish. What the book describes is not the great war but the personal trial of one ignorant participant, seen from so close a perspective that large patterns are invisible:

> It seemed to the youth that he saw everything. Each blade of grass was bold and clear. He thought he was aware of every change in the thin, transparent vapor that floated idly in sheets. The brown or gray trunks of the trees showed each roughness of their surfaces. And the men of the regiment, with their slanting eyes and sweating faces, running madly or falling as if thrown headlong to queer, heaped-up corpses, all were comprehended. His mind took a mechanical but firm impression, so that afterwards everything was pictured and explained to him, save why he himself was there [see fig. 3].[5]

After the war, American photographers, including many of those who had photographed the war and who were perhaps no longer satisfied with studio portraiture, went west to photograph the new landscape opening beyond the Mississippi and Missouri. We know the names of a dozen or more of these photographers and they were all wonderful, in the same sense that all

fifteenth-century Italian painters were wonderful. The freshness of the problem and the scale of the opportunity presumably filtered out the fainthearted. Nevertheless, some of the western pioneer-photographers were better than others. I think the best of all was Timothy O'Sullivan.

We have noted that American photographers worked without the traditional subject matter that was available in Europe. This fact was of central importance in the issue of landscape. Imagine the grand tradition of landscape painting without shepherds, without kine and sheep composing themselves on the green hillsides, without roads lined with poplars, without the classical ruin, or the gazebo in the distance, without, in short, those clues of human habitation that changed the wild landscape from a threat to a place of poetic possibilities. American painters could go to Rome or to Germany to fill their sketchbooks with the traditional paraphernalia of the romantic landscape, then return to fit it in as best they could against the backdrop of the Hudson River. But the photographer could deal only with what was there. Often there was almost nothing there.

The traditional frontier photographer was also cursed, or blessed, as the case may be, with a fairly thoroughgoing ignorance of the traditions of painting. Thus, he was freed from the nagging, enervating suspicion that perhaps his work did not measure up to the best works of the ancients. I do not mean to suggest that ignorance is a good thing. Ignorance is not a good thing; it is nothing, *tabula rasa*. It is, however, easier to define a new problem on a blank slate.

It would seem that Timothy O'Sullivan approached photography as if no precedent existed. His boldness and originality are evident, for example, in the way he handled his skies. Like a woman's hair, skies were the crowning beauties of traditional landscape pictures. But, for the nineteenth-century photographer, they presented a very irksome technical problem. The plates of those days were sensitive only to blue light, and the sky itself was so rich in blue light that it would be rendered as a flat, blank white. Sophisticated photographers solved the problem by photographing skies on separate negatives and then combining the two by intricate, multiple printing techniques. This was a reasonably successful, although cumbersome, solution as long as the photographer remembered that the sun should light the clouds and the earth from the same direction. O'Sullivan, as far as we know, never printed in a sky. He solved the problems of skies in a more direct way, by eliminating them, or almost eliminating them, so that the subtle undulation of the horizon was made expressive by being compressed against the frame—by describing skies not as a space but as a graphic shape (see fig. 4).

Not too much attention should be paid to Timothy O'Sullivan, however, for he was an artist of exceptional native talent, and the discovery of photography's special formal potentials has not been exclusively the province of exceptional talents but equally of thousands of anonymous journeymen and amateurs, out of whose monstrous and largely shapeless output there have come those suggestions that more sophisticated photographers later made coherent and shapely. In this respect the history of photography might be more profitably compared with the history of literature than with that of painting, at least until this century. Next to language itself, it is difficult to think of a medium that has been used with such extemporaneous, undisciplined, centrifugal, mindless energy as has photography. And for the geographic and cultural reasons that I have suggested earlier, I think that this experiment was free to proceed in its purist laissez-faire form in the United States (see fig. 5).

By the end of the nineteenth century there were surely more photographs in the United States than there were bricks, creating something close to a visual equivalent of the old

Figure 4. Timothy O'Sullivan. *Wall in the Grand Canyon,*
Colorado River, 1871. Albumen; 10¾ x 8 in. New York,
The Museum of Modern Art, gift of Ansel Adams in
memory of Albert M. Bender (87.41.1–50).

Figure 5. Unknown, American. *Barbershop, Stillwater, Minn.*, 1893. Modern gelatin-silver print; 7½ x 9½ in. New York, The Museum of Modern Art (SC).

Figure 6. Timothy O'Sullivan. *Historic Spanish Record of the Conquest, South Side of Inscription Rock*, 1873. Albumen; 8⅜ x 10¹³⁄₁₆ in. The Art Institute of Chicago, Photography Gallery Restricted Funds (59.615/25).

statisticians' puzzle about the billion monkeys seated in front of the billion typewriters, or however it went. The question in that case, as you will remember, was: How long would it take the monkeys to reproduce, by accident, the complete works of Shakespeare? It has never seemed to me a very interesting question. We already have the complete works of Shakespeare. The interesting question is: How many original and valuable works would they produce first?

Anarchy is not allowed to continue indefinitely. Without an accepted social order for it to push against, it would presumably soon lose its flavor and its meaning. In the United States the figure who might be said to have rescued photography from the excesses of freedom was Alfred Stieglitz. He did his formative study as a photographer in Germany, where he learned to make very fine photographs, roughly in the spirit of nineteenth-century genre painting. It is also interesting that he lived in New York City for half a century and was, during a good period of that time, a neighbor of his contemporary, the great journalist Jacob Riis. But if they ever met or took interest in each other's work, there is no record of the fact.

Stieglitz was not only an artist of great original talent but also a quick study, capable of learning from his students. As a photographer, he had at least three or four careers, each seeming to belong to a new generation. In the beginning his work was brilliant. During most of the first half of the century it got better and better. It was perhaps limited only by the nature of his original ambition, which was that photography should be considered the equal of something else. Stieglitz's influence on American photography was, and remains, enormous. One can to this day identify the work of his more servile followers by a vaguely momentous solemnity of manner and a concentration on subject matter that suggests the eternal verities, rather than the specifics, of a particular time and place. Stieglitz gave away the game that had been played by nineteenth-century photographers, who claimed, and perhaps even believed, that photography was simply a matter of showing the truth. After Stieglitz, serious photographers could no longer be oblivious of the fact that when they photographed, they were committing a work of art (see fig. 7). Something precious was lost with this: the sense of photography as magic, something related to the fire of Prometheus. But if Stieglitz had not made the point, someone else less talented doubtless would have. The truth was bound to come out eventually.

I think it was Yeats who said, more or less, that we tumble out of one pickle into another. It was not even a full generation after Stieglitz had solved the problem of what the art of photography should mean when his solution began to come apart at the seams.

One of the charms of the history of photography is that it is so filled with diverting ironies. Consider this one: In 1937 the young Ansel Adams wrote to Alfred Stieglitz, then in his seventies, to tell him, among other things, of an album of nineteenth-century photographs he had given to Beaumont Newhall for inclusion in Newhall's great 1937 survey exhibition of the history of photography.[6] Remember that Stieglitz had spent his life in service to the visual arts. He had exhibited Matisse when Adams was six years old. He was enormously sophisticated in terms of an extremely broad range of artistic experiment. He had championed the most adventurous experiments of modern art in his time.

Adams, on the other hand, was a mountain man and a musician, whose contacts with the visual arts had been occasional, tentative, and cautious. So, Adams wrote Stieglitz to advise him about a marvelous new photographer he had discovered. The name of the photographer who made the pictures in the album, Timothy O'Sullivan, was unfamiliar to Adams, but he

told Stieglitz that the best of the pictures in the book were as fine as anything he had ever seen. He stressed that the album would be exhibited open to O'Sullivan's picture *Canyon de Chelle,* but he encouraged Stieglitz to make it his business to see the entire album, and specifically mentioned O'Sullivan's picture of *Inscription Rock* (fig. 6). He wrote: "There is something in that picture that out-surs the surrealists."[7] Although there is no record of Stieglitz's response, it is believed that he never found the energy to make the two-block pilgrimage along Fifty-third Street to the Museum of Modern Art to see the album.

It was Walker Evans's work that most clearly and strongly stated what was the matter with the fine-arts movement in photography, as seen in the photographs of Stieglitz's direct followers. Evans's work reclaimed for the use of sophisticated, introspective modernist photographers the clues provided by the nineteenth-century primitives. Despite its elegance, the fine-arts movement in photography produced work that was servile in its too solicitous regard for the known virtues of the traditional arts, and finally cautious in pursuing those qualities that were most distinctive to photography. The most basic of these is photography's uncompromising specificity. Photography is the best system of picture-making devised so far for describing the superficial aspect of things. I use the word "superficial" not in a pejorative but in a descriptive sense. Photographs describe the appearance of the surface of things. Their potential value as works of art depends on the assumption that there is sometimes a useful relationship between appearance and meaning.

The portrait identified as that of Bud Woods, from Walker Evans and James Agee's great collaborative work, *Let Us Now Praise Famous Men,* is well known (fig. 8). Perhaps less well known is the photograph of his identical twin, Ernest Woods (fig. 9), which was made by Evans on the same occasion. Bud was, of course, a better subject for a book of tragic implications and epic ambitions. Twenty minutes older than Ernest—tougher, meaner, more responsible—he was more thoroughly conscious of the necessity and the impossibility of preserving a family with forty acres of exhausted red clay and two spavined mules. Ernest was doubtless a faithful worker, if told what to do, but he was not the one to worry, plan, connive, fail. Consider his relatively carefree, unwrinkled, trusting, open-faced countenance, and the slavishness with which he wears his five-cent red bandana almost precisely as his older brother does.

The subtle yet absolutely crucial distinction between these brothers could not, I think, be satisfactorily rendered by any medium but photography, for the camera will clarify evidence that even the best of photographers will not have recognized until he sees it in the print itself. In a second, or in a thousandth part of a second, it will describe not only an astonishing number of specific facts but also their ephemeral relationship, their aspect: the ultimate subject of the picture. Or, let us assume that I have my facts wrong and that these photographs describe not two different men but one and the same man. What an astonishing circumstance that would be if the hard brother and the soft brother were in the real world the same, and the two discreet, separate subjects of these pictures, each equally factual and superficially correct, were created by nothing more than the lapse of a few seconds and change in the light.

The United States continues to be a hotbed of photographic activity, although there seems to be less and less functional necessity for specialists in the field. A thousand photographers of talent pursue their high ambitions, none willing to be called a follower. Presumably there is some hidden shape or structure to this experiment, some intellectually useful polarity that might help us understand the meaning of the continuous, cacophonous argument.

246

Figure 7. Alfred Stieglitz, American (1864–1946). *Georgia O'Keeffe,* 1920. Solarized palladiotype; 9¹³⁄₁₆ x 8⅞ in. The Art Institute of Chicago, The Alfred Stieglitz Collection (49.745).

Figure 8. Walker Evans, American (1903–1975). *Share-cropper, Hale County, Ala.*, 1936. Gelatin-silver; 9½ x 7⁹⁄₁₆ in. New York, The Museum of Modern Art, Stephen R. Currier Memorial Fund (63.71).

Figure 9. Walker Evans. *Sharecropper, Hale County, Ala.* (variant negative), 1936. Gelatin-silver; 9¾ x 7¾ in. New York, The Museum of Modern Art (63.71).

It seems to me that the argument is between those one might in crude terms call realists, who believe that there is some interesting correspondence between aspect and meaning and who are therefore concerned with the most precise distinctions of appearance; and, on the other hand, those one might call platonists, who make photographs that are to be seen as elegant metaphors for universal but invisible truths. Both positions are represented by artists of originality and high talent, but it seems to me that the work of the realist camp is most clearly at home in that tradition of American art that has most vigorously challenged the notion of art as a handmaiden of the platonic verities. The realists have opted, instead, for clear observations of fresh data, and produced work like that of Benjamin Franklin, Thoreau, Audubon, Whitman on his best days, Louis Sullivan when sober, Thomas Eakins all of the time, and, perhaps prototypically, Mark Twain.

The American critic Van Wyck Brooks determined that Mark Twain was finally a failure, brought down by the vulgarity of the crowd that he wished to please and by the fact that he worked unsupported by a clear sense of belonging to an ancient and nourishing artistic tradition.[8] Brooks's friend Sherwood Anderson, a frontiersman himself, admitted that not much of Twain's work was as fine as his genius promised, but he tried to explain to Brooks that Twain's achievement was all the more remarkable for the very reason that he was an aerialist working without the net of a cultivated tradition. Anderson also had an interesting idea to offer as to what might have helped. He said: "I can't help wishing Twain hadn't married such a good woman. There was such a universal inclination to tame the man—to save his soul, as it were. Left alone, I fancy Mark would have been willing to throw his soul overboard, and then—ye gods what a fellow he might have been, what poetry might have come from him."[9] That is the true, undiluted, double-the-stakes-and-hope-for-a-miracle voice of the American frontier, still clear in Anderson's voice in 1918 and not yet silenced.

What Van Wyck Brooks and Sherwood Anderson said about Mark Twain might, with some adjustment, also be said about Garry Winogrand (see fig. 10). Winogrand's work, like Twain's, possesses a childlike pleasure in tall stories, a juggler's taste for complication, a disdain for conventional standards of important subject matter, a pioneer disregard for neatness, and a high-spirited pleasure in the exhibition of extravagant skill.

Frederick Jackson Turner, with whom I started, was not a romantic. To the best of my knowledge, he never romanticized the meaning of the frontier mentality. He did not say that it was a good thing; he said it was a powerful thing. He understood that on the frontier, freedom often became license, that independence could be a kind name for ignorance. Nevertheless, the frontier mentality did allow the development of new artistic possibilities, some of which are visible today in what is most characteristic of modern American photography.

By definition, the meanings of such pictures are visible. That is not to say that these meanings would be accepted as evidence by a court of law. These photographs refer to specific, external facts relating to our experience and our knowledge, but the meanings of the pictures themselves are contained and discrete within the frame of the pictures.

Tod Papageorge, in his introduction to Winogrand's book *Public Relations,* says:

Winogrand seems as much that twentieth-century myth, the pure camera eye, as a person could be, but the truth is that he perceives the world as selectively as any artist does. What deceives us is the photographic language he has created to describe what it is that he finds interesting; for

Figure 10. Garry Winogrand, American (born 1928). *Los Angeles,* 1964. 9 x 13⅜ in. New York, The Museum of Modern Art, International Program Fund (576.73).

this language is not the personal, inflected speech of a man, but the mechanical utterance of a machine, a camera. As we study his photographs, however, we recognize that although in the conventional sense they may be impersonal, they are also consistently informed by what in a poem we would call a voice. This voice is, in turn, comic, harsh, ironic, delighted, and even cruel. But it is always active and distinct—always, in fact, a narrative voice.

We know from the other arts that there can be a direct correspondence between a powerful, dramatic literalism . . . and density of meaning. Balzac describes this attitude when he writes of Stendhal that there "are active souls who like rapidity, movement, sudden shocks, drama, who avoid discussion, who have little fondness for meditation and take pleasure in results." What is most remarkable about Balzac's comment, however, is its conclusion: "From such people comes what I should call the literature of ideas."[10]

I think that much of the photography I have discussed represents the effort to make the medium of photography responsive to the discovery of the visual equivalent of a literature of ideas. I do not mean the visual equivalent of novels or short stories or essays or editorials, but rather photographs that speak directly to the intelligence of our eyes. Photographs like these are concerned with photography's ability to know and to rationalize reaches of our life that are so subtle, so fugitive, so intuitively recognized that until now they have been indefinable and unshareable. Such pictures do not explain, any more than the great works of the ancient masters; they merely clarify. They do not instruct; they inform. If I may quote Yeats once more: "Only that which does not teach, which does not cry out, which does not condescend, which does not explain, is irresistible."

1. F. J. Turner, "The Significance of the Frontier in American History," *The Frontier in American History*, New York, 1920: 1–38.

2. Quoted in Turner, "Pioneer Ideals and the State University," *The Frontier in American History* (note 1): 274.

3. N. Hawthorne, *The House of the Seven Gables*, New York, 1961: 156–57.

4. Quoted by F. R. Gemme in his introduction to S. Crane, *Maggie and Other Stories*, New York, 1968: 5.

5. Crane, *The Red Badge of Courage*, New York, 1960: 149.

6. The exhibition "Photography 1839–1937" was accompanied by a catalogue of the same name; it was the first edition of Newhall's *The History of Photography*, New York, 1982 (5th ed.).

7. Adams to Stieglitz, March 21, 1937, quoted in N. Newhall, *Ansel Adams: The Eloquent Light*, San Francisco, 1963: 135.

8. ". . . he [Twain] is the symbol of the creative life in a country where, by the goodness of God, we have those three unspeakably precious things: freedom of speech, freedom of conscience, and the prudence never to practise either" (V. W. Brooks, *The Ordeal of Mark Twain*, New York, 1933: 324).

9. Anderson to Brooks, quoted in *The Shock of Recognition*, ed. by E. Wilson, London, 1956: 1263.

10. T. Papageorge, introduction to G. Winogrand, *Public Relations*, exh. cat., The Museum of Modern Art, New York, 1977: 16.

Wanda M. Corn

The Birth of
a National Icon:
Grant Wood's
American Gothic

Everyone knows the image: the stern Midwestern couple with a pitchfork, standing in front of a trim white farmhouse, their oval heads framing the little building's Gothic window (fig. 1). Though simple, plain, and nameless, the man and woman in *American Gothic* have become as familiar to Americans as the *Mona Lisa*. Their image, mercilessly caricatured and distorted, pervades our culture: Greeting-card companies use it to wish people well on their anniversaries; political cartoonists change the faces to lampoon the country's first family; and advertisers, substituting a toothbrush, calculator, or martini glass for the pitchfork, exploit the couple to sell us merchandise (fig. 2).

These parodies may tell us what some Americans think the painting is about, but they say little about what Grant Wood (1891–1942) intended when, in 1930, he painted this relatively small (thirty by twenty-five inches) picture. Did Wood want us to laugh at his deadly serious couple? Was he satirizing rural narrow-mindedness, as many critics and historians have claimed? If so, then what motivated this loyal son of Iowa to mock his countrymen? Who, in fact, are the man and woman in the painting and why do they look as though they could have just stepped out of the late nineteenth century? And, as modern American artists had shown no interest in Midwestern themes, how did Wood, midway through his career, come to paint *American Gothic* at all?

The literature on the painting is not extensive and offers little help in answering our questions.[1] It makes two principal claims about *American Gothic,* the first being that the painting's most important sources are European. Nearly every historian and critic credits the artist's visit to Munich in the fall of 1928 and his study of the Northern Renaissance masterpieces in the Alte Pinakothek as influences. There is no doubt that the artist's imagery and style changed around the time of this trip. For the previous fifteen years Wood had been painting loose, quasi-Impressionist landscapes (fig. 3). After Munich he inaugurated a new style, one characterized by static compositions, streamlined forms, crisp geometries, and repeating patterns. By Wood's own admission, the Flemish painters were an important stimulus. But historians and critics have tended to glamorize the tale, writing of Wood's Munich visit as if it were a kind of religious conversion experience or, as H. W. Janson once suggested, a

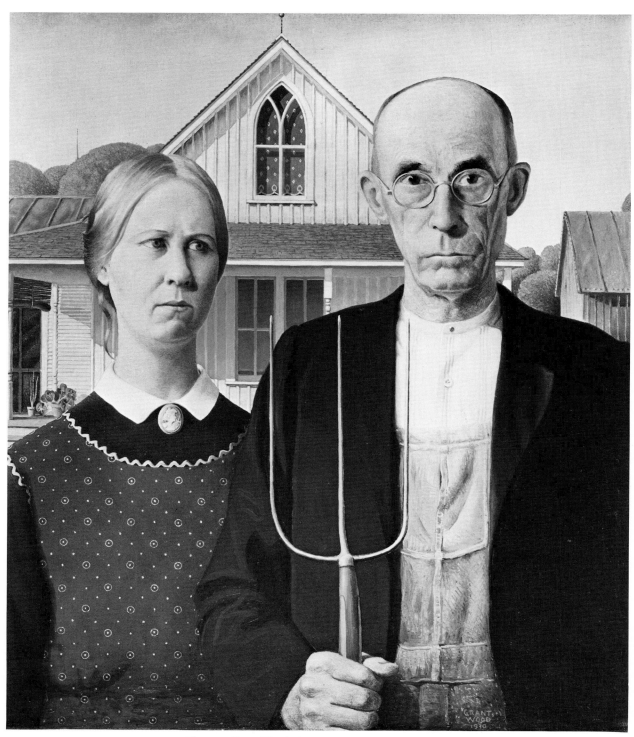

Figure 1. Grant Wood, American (1891–1942). *American Gothic,* 1930. Oil on composition board; 29⅞ x 24⅞ in. The Art Institute of Chicago, Friends of American Art Collection (30.934).

Vasari-like moment of inspiration. This mythologizing of Wood's career led Janson to offer his own playful parody of the artist's life:

> There once was a young Midwestern painter who, following the custom of his day, went to Paris in the early 1920s to learn about art. He tried as best he could to become a *bohemien* in the accepted manner, wearing a beret and painting Impressionist pictures, but he felt increasingly unhappy in this role. Then, one day, he went to Munich, where he saw the works of the Old Masters of Flanders and Germany, and he realized that these artists were great because they drew their inspiration from their immediate environment, from the things they were completely familiar with. He decided to do the same, so he returned home to Iowa, renewed his ties with his native soil, and out of this experience formed the style that made him famous overnight when he painted *American Gothic*.[2]

This tale, told in more reverent tones, persists in today's art history texts.

The second claim made about *American Gothic* is that the work is satirical, that Wood is ridiculing or mocking the complacency and conformity of Midwestern life. The interpretation seems to have originated in the early 1930s on the East Coast and has been conventional historical wisdom ever since. Reviewing the work in 1930 when shown at the Art Institute of Chicago, a critic for the Boston *Herald*, Walter Pritchard Eaton, found the couple "caricatured so slightly that it is doubly cruel, and though we know nothing of the artist and his history, we cannot help believing that as a youth he suffered tortures from these people."[3] Later, in the 1940s, Janson came to a similar conclusion: Wood intended *American Gothic* as a "satire on small town life," in the caustic spirit of Sinclair Lewis and H. L. Mencken.[4] In more recent times art historian Matthew Baigell considered the couple savage, exuding "a generalized, barely repressed animosity that borders on venom." The painting, Baigell argued, satirized "people who would live in a pretentious house with medieval ornamentation, as well as the narrow prejudices associated with life in the Bible Belt."[5] In his recent book-length study of the artist, James Dennis characterized Grant Wood as a "cosmopolitan satirist" and *American Gothic* as a "satiric interpretation of complacent narrow-mindedness."[6]

For the moment, let us set aside the characterization of *American Gothic* as neo-Flemish and satirical and ignore the many parodies of the image, and see the work afresh. By looking at Grant Wood's Midwestern background and his process of creation, we shall find that American sources—not European ones—best explain his famous painting. It will become clear that Iowa architecture, frontier photographs, and Midwestern literature and history are much more relevant to an understanding of Wood's painting than are the Flemish masters. Furthermore, a close study of American materials refutes the notion that Wood intended to satirize his couple-with-pitchfork.

The immediate genesis of the painting occurred while Wood was visiting friends in the tiny southern Iowa town of Eldon and came across a little Gothic Revival wooden farmhouse (fig. 4).[7] Not having a word to describe it—the term "Gothic Revival" was not yet current—Wood called it an "American Gothic" house to distinguish it from the French Gothic of European cathedrals.[8] Modest in its size, this house belonged in kind to the hundreds of cottage Gothic homes and farmhouses built throughout Iowa in the latter half of the nineteenth century when the state was being settled. What caught the artist's eye about this particular example was its simple and emphatic design—its prominent, oversized neo-Gothic window

and its vertical board-and-batten siding. The structure immediately suggested to him a long-faced and lean country couple, "American Gothic people to stand in front of a house of this type," as he put it.[9] He made a small oil study of the house, had a friend photograph the structure, and went back to Cedar Rapids, where he persuaded his sister, Nan, and his dentist, Dr. McKeeby, to become his models.

The couple, according to Wood, looked like the "kind of people I fancied should live in that house."[10] This is a fact missed by almost all of the painting's interpreters: The painting does not depict up-to-date 1930 Iowans, but rather shows people who could be of the same vintage as the 1881–82 house.[11] To make the couple look archaic, Wood turned to old photographs as sources. He dressed his two models as if they were "tintypes from my old family album," a collection that Wood greatly valued and that today is on display at the Davenport Municipal Art Gallery.[12] His thirty-year-old sister was transformed from a 1930s woman—see Wood's portrait of Nan of the same period (fig. 5)—into a plausible stand-in for one of his nineteenth-century relatives (fig. 6). On his instructions, Nan made an old-fashioned apron trimmed with rickrack taken from an old dress, and pulled her marcelled hair back tightly from her face. Wearing the apron with a brooch and a white-collared dress, she now resembled the photographs in Wood's family album. For Dr. McKeeby, the male model in *American Gothic,* Wood found an old-fashioned collarless shirt among his painting rags, to be worn with bibbed overalls and a dark jacket.[13]

Wood adapted not only the dress from late nineteenth-century photographs, but also the poses and demeanor: the stiff, upright torsos, the unblinking eyes, and the mute, stony faces characteristic of long-exposure studio portraits. In placing the man and woman squarely in front of their house, he borrowed another popular late nineteenth-century convention drawn from the itinerant photographers who posed couples and families in front of their homes (fig. 7). This practice, common in the rural Midwest through World War I, produced untold numbers of photographs, all recording the pride of home as much as a likeness of the inhabitants.

It is common in these photographs to see potted plants decorating the porches and lawns. Indoor plants moved to an outside porch during the spring and summer gave evidence of a woman's horticultural skills and were also a source of pride; in the Midwest it was hard to keep plants alive during the long and bitter winters. When Wood put potted plants on the porch of the house in *American Gothic,* just over the right shoulder of the woman, he was providing her with an appropriate attribute of homemaking and domesticity.

The man's attribute, of course, is the pitchfork. Wood's initial idea was to have the man hold a rake; this was the way he rendered the scene in a preliminary pencil study hastily sketched on the back of an envelope.[14] For reasons of design, he discarded the rake for the pitchfork to emphasize the verticality of the long faces and the slender Gothic window. But it was also because the artist wanted to use a tool clearly associated with farming, not gardening, and with late nineteenth-century farming at that. This offended one Iowa farmer's wife, who, viewing the picture in 1930, objected: "We at least have progressed beyond the three-tined pitchfork stage!"[15]

Whether rake or pitchfork, the idea of the man holding a tool came from old frontier photographs in which men and women, in keeping with an even older painting convention, held objects appropriate to their status and occupation. Men held shovels, rakes, or pitchforks, while women leaned on brooms or chairs. In photography, of course, the long-handled tool

Figure 2. Adaption of *American Gothic* (fig. 1) by Poster Pot, Sebastopol, California, 1972.

Figure 3. Grant Wood. *Yellow Doorway, St. Emilion,* 1926. Oil on composition board; 16 x 13 in. Cedar Rapids Museum of Art, Gift of Harriet Y. and John B. Turner II.

Figure 4. Busey and Herald, American, active late 19th century. House in *American Gothic,* Eldon, Iowa, in 1881–82. Photo courtesy Wanda M. Corn.

257

was more than an occupational emblem; it helped steady the holder during the long exposure necessitated by slow films and cameras. A classic photograph of this type, dating from the 1880s and showing the man holding a pitchfork and the woman leaning on a chair, is by the Nebraskan itinerant photographer Solomon D. Butcher (fig. 8). The architecture here is prairie sod rather than American Gothic, but the convention is precisely the one used by Grant Wood, right down to the pioneer woman's potted plants in tin cans on the table by the doorway.

Wood responded to all kinds of old visual sources besides photographs: furniture, china, glass, quilts, popular prints, maps, and atlases. Some of these things were handed down to him as family treasures; other items he bought. He valued objects in keeping with his own aesthetic of simple design and pattern—Victorian oval frames or braided rugs—as well as things that reflected Iowa history. Blue Willow china was important to him because it had been one of the precious luxuries pioneer families had brought with them from the East; he also gave prominent places in his home to the handmade wooden neo-Gothic clock and sewing box, and the piecrust table that his family had used on the farm.[16]

He borrowed omnivorously from these sources for all of his important paintings. In his portrait of *John B. Turner, Pioneer* (fig. 17) the background is easily identifiable as an 1869 map of Linn County, Iowa; the frame is oval, a shape Wood liked so much that he once made a coffee table out of a Victorian oval frame. *Fall Plowing* (fig. 9) and other landscapes hark back, in their bird's-eye views and quilted fields, to the primitive prints of farms and villages in nineteenth-century regional atlases (fig. 10). In 1930, the same year *American Gothic* was painted, Wood made a work that blended a complex range of historical sources. For the Stamats family of Cedar Rapids he painted a five-and-one-half-foot-long overmantel to go above a fireplace, reviving the late eighteenth- and early nineteenth-century taste for large painted landscapes as wall decorations (fig. 11). He took, he said, the elliptical shape of the painting from an old oval china platter; the stylized bulbous trees from his mother's Blue Willow china; and the floral border, as well as the composition of the family strolling in front of its house, from Victorian prints, particularly from ones by Currier and Ives (fig. 12).[17] To add a final touch of historicism, Wood painted the family in nineteenth-century costumes.

Wood's collecting habits and enthusiasm for antiques was part of a nationwide enthusiasm in the late 1910s and the 1920s for old American art and artifacts. This new pride in American things and in national history reflected the country's confidence as it emerged as a world power after World War I. Where Americans had been embarrassed before by their provincial history, now they began to treasure and research their past. Furniture and paintings that once seemed awkward and second-rate now became charming and quaint—on their way to becoming valuable antiques. Signposts of this antiquarian movement dot the decade: The first exhibitions of nineteenth-century American folk art occurred in 1924; the American Wing opened at the Metropolitan Museum in that same year; in 1926 the nation celebrated its 150th birthday; the restoration of Colonial Williamsburg began in 1927; and in 1929 Henry Ford dedicated the Henry Ford Museum and Greenfield Village in Dearborn, Michigan. It was in the 1920s, as Russell Lynes has observed in his book on American taste, that "wagon wheels became ceiling fixtures; cobbler's benches became coffee tables; black caldrons and kettles hung on irons in fireplaces."[18] "The last touch of absurdity" in the public's embrace of old artifacts, Lewis Mumford caustically observed, was a government bulletin that "suggested that every American house should have at least one 'early American' room."[19]

Figure 5. Grant Wood. *Portrait of Nan,* 1932–33. Oil on masonite board; 40 x 30 in. Phoenix, Estate of Senator William Benton.

Figure 6. Maria Littler Wood's carte-de-visite. Photograph; 3¼ x 2 in. (oval). Davenport Municipal Art Gallery, Grant Wood Collection.

The passion for Early Americana centered on Colonial- and Federal-period antiques and architecture. Neo-Colonial houses, appearing first on the East Coast during the eclectic revivalism of the late nineteenth century, now became popular throughout America, in Iowa and California as well as in New England. Wood painted the overmantel for Mr. and Mrs. Herbert Stamats for just such a house; in that overmantel, one can see the 1929 neo-Colonial structure with its Cedar Rapids family standing in front. But the fact that Wood painted the overmantel in a neo-Victorian style rather than a neo-Colonial one is significant, for it suggests that Wood's appreciation of the American past was much broader than that of the period's tastemakers. For most people in the 1920s the arts of Victorian America were ugly, unimaginative, and too reliant upon revival styles.[20] But Wood, self-taught as a connoisseur of Iowa artifacts, came to see that his Midwestern heritage was of the nineteenth century, not the eighteenth; Victorian, not Colonial. It was for this reason that Wood put a very plain neo-Gothic house behind his couple (fig. 4). As a close observer, he recognized that Gothic Revival architecture was one of the oldest building styles in the Midwest, and it provided the same distinctive flavor in his region that salt-box houses gave to New England.

Wood's sensitivity to house and furniture styles was partially a product of his acquaintance with the American Arts and Crafts movement, and partly because he had an obvious talent for building and working with his hands. For two summers in the early 1910s, he had studied in Minneapolis at the School of Design, Handicraft and Normal Art; he then tried for a few years to make his living as a jeweler and metalworker. In the 1920s he earned income by designing furniture and doing interior decorating for Cedar Rapids families. His first decorations, particularly those for his own studio apartment, emphasized simplicity and handcrafted materials and looked like designs straight out of the pages of Gustav Stickley's magazine, *The Craftsman*.[21] But, by the end of the 1920s, he had given up his arts-and-crafts look and was decorating in revival styles. For the Stamats and several other Cedar Rapids families, he helped build and decorate Colonial Revival homes. His most challenging commission, however, and the one that reflected most clearly his enthusiasm for Midwestern sources, was the 1932 Cedar Rapids home of Mr. and Mrs. Robert Armstrong. Having heard Wood praise the use of indigenous Iowa materials in a lecture on *American Gothic,* the Armstrongs commissioned the artist and Bruce McKay, a friend of Wood's and a building contractor, to build them a "native" Iowa house. Wood and McKay derived the proportions and details of the house—door frames, shutters, fireplaces, staircases, cupboards, ironware, and moldings—by measuring and researching two extant local stone buildings, an 1860 house and an 1855 tavern. In the closet areas of the Armstrongs' upstairs bedrooms, Wood called for white board-and-batten walls, like those of the house in *American Gothic*. When the house was finished, the artist and Mrs. Armstrong furnished it with antiques: pieces brought to Iowa by pioneer settlers and old country furniture made in the nearby Amana communal colonies founded by Germans in the nineteenth century. In 1939, *Arts and Decoration* described the house as an "exact replica of an 'old settler's' house."[22]

Although Wood seldom talked about his tastes, they fell into patterns. First, as we have already seen, he enjoyed certain pieces of Victoriana such as old photographs, Currier and Ives prints, and oval picture frames. His strong preference, however, was for objects that had a "folk" look to them, things that were handcrafted or homespun, simple in design, clean in line, or boldly patterned. He liked stenciled country furniture, punched tinware, braided rugs,

Figure 7. Solomon D. Butcher, American (1856–1927).
Mr. Story, 1909. Photograph. Lincoln, Nebraska State
Historical Society, Solomon D. Butcher Collection.

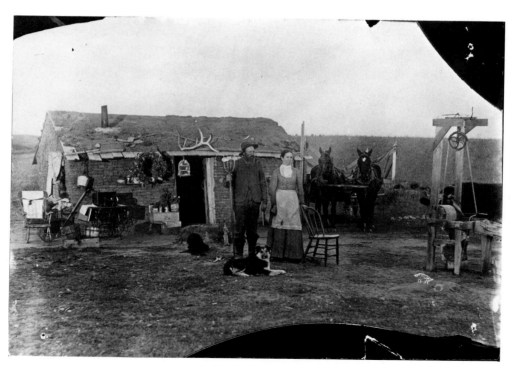

Figure 8. Solomon D. Butcher. *John Curry Sod House,* c.
1886. Photograph. Lincoln, Nebraska State Historical
Society, Solomon D. Butcher Collection.

Figure 9. Grant Wood. *Fall Plowing,* 1931. Oil on canvas;
30 x 40 in. East Moline, Il., John Deere Corporation.

Figure 10. Residence of J. W. Richardson. Lithograph.
(From A. T. Andreas, *Illustrated Historical Atlas of the State
of Iowa,* 1875; reprint, Iowa City, 1970: 265.)

quilts, and the look of white cupboards with black hand-wrought iron fixtures.[23] In this he was the Midwestern counterpart of those East Coast artists—Charles Sheeler or Hamilton Easter Field, for example—who in the 1910s and '20s collected American primitives, Pennsylvania Dutch illuminations, and country furniture.[24]

What distinguished Wood's taste from that of Eastern artists, however, was his intense interest in items that not only were well designed but also reflected the particulars of Midwestern history. Sheeler collected Shaker furniture and painted it because he liked its "modern" aesthetic, its functional lines, and its simple geometries. When Wood collected or painted regional artifacts, it was because of their historical significance as well as their aesthetic qualities. In *Fall Plowing* (fig. 9) he depicted one of the steel plows used by Midwestern pioneers to turn the tough prairie sod into farmland. Invented by John Deere around 1840, this kind of plow cut the heavy sod easily and self-scoured itself in the Midwest's moist, sticky soil. It replaced the unsuitable equipment pioneers had brought with them from the East. Grant Wood relished the crisp, abstract curves of the steel plow, but at the same time he celebrated its centrality in Iowa's history. In his painting the plow stands alone, without a man to guide it or a horse to pull it, like a sacred relic.[25] A similar conjunction of abstract design and historical association explains Wood's attraction to the farmhouse in *American Gothic*. Even as he greatly admired the formal and repeated verticals of its board-and-batten walls and the mullions of the windows, Wood believed that the structure, in its modest proportions, stark neatness, and unembellished lines, evoked the character of the Midwest. "I know now," Wood said in 1932, "that our cardboardy frame houses on Iowa farms have a distinct American quality and are very paintable. To me their hard edges are especially suggestive of the Middle West civilization."[26]

Wood's interest in clean lines and patterns reflects the modernism of the period. But how, one wonders, did he develop the notion that "hard edges" were distinctively Midwestern? Why was he even interested in Midwestern buildings, people, and landscapes at a time when every painter of importance considered the middle states an artistic wasteland? Did Wood develop his iconography of the Midwest only after seeing that early Flemish artists painted their own locales and the people in them, as so many commentators have said?

To this last question the answer is an emphatic no. It was American writers, not Old Master painters, who led Wood to discover and believe in the artistic worth of the Midwest as a subject.[27] When Grant Wood painted *American Gothic* in 1930, writers had been defining the uniqueness of Midwestern life for almost half a century. One of the first of these was Hamlin Garland. With *Main-Travelled Roads* (1891), *Prairie Folks* (1892), and *Boy Life on the Prairie* (1899), Garland gained international recognition for his depictions of pioneering and farm life in Iowa, Wisconsin, and the Dakotas, the region he called the "Middle Border."[28] These local-color stories featured vivid descriptions, thick dialects, and idiosyncratic characters and events. Many recounted prairie living as harsh and bleak, giving, Garland said, "a proper proportion of the sweat, flies, heat, dirt and drudgery" of farm life.[29] He was among the first to create a literary notion of the Midwesterner as rural, raw, and tough—as "hard-edged."

Even if they hated his harsh views—or the fact that he wrote about the prairie while living in Boston—every subsequent native artist of Garland's "Middle Border," whether painter or writer, would be indebted to him for recognizing the distinct regional character of the Midwest. Furthermore, Garland's success conveyed to future generations a clear message: The open land, farm culture, and small towns of the Midwest were not a wasteland but a rich

263

source of artistic material. It is hard to imagine Wood's career—and that of a score of writers—without Garland's example.

In imagery, however, Wood's work depends even more on the next generation of Midwestern writers, those of the 1920s, who rejected the highly descriptive prose of Garland and other local colorists to write more crisply and emphatically about what they viewed as archetypal of their region. The most famous of these was Sinclair Lewis, a Minnesotan, whose delineations of the Midwestern small town in *Main Street* (1920) and of its booster and materialist mentality in *Babbitt* (1922) became best-sellers. Wood greatly admired these books and publicly credited Lewis for the new "yearning after the arts in the corn-and-beef belt."[30]

Typically, Wood was not very precise regarding what he liked about Lewis's books other than that they were about the Midwest. But one quality surely impressed him: *Main Street* and *Babbitt* were about general character types, not about specific individuals. Carol Kennicott, for example, the central figure in *Main Street,* is a college-educated, idealistic crusader for culture and social reform. Lewis drew her portrait in such a general way that she, along with every other denizen of Gopher Prairie, Minnesota, could be recognized as a type found in small towns across the United States. In 1936–37, Wood paid tribute to Lewis by doing the illustrations for a special limited edition of *Main Street.*[31] The names Wood assigned to his nine drawings, all but two of which depict characters in the book, are not of individuals but of types: The Booster, The Sentimental Yearner, The Practical Idealist.

The man and woman in *American Gothic,* of course, also constitute types; they are definitely not individualized portraits. But it is an oft-made mistake to compare Wood's couple with the "solid citizen" types featured in Lewis's novels. Sinclair Lewis wrote about modern Americans who lived in town, traveled in trains and cars, listened to the radio, and went to the movies. While many of them were complacent, conformist, and narrow-minded—traits often attributed to the couple in *American Gothic*—they were not pitchfork-carrying, country types. Grant Wood's folks live in town—one can just catch sight of a church steeple rising over the trees to the left—but, it is clear from their dress, their home, and their demeanor that the orientation is rural and behind the times. Their values are Victorian ones, not the modern ones of a Carol Kennicott or a George Babbitt.

It was East Coast critics who first compared Wood's work with that of Sinclair Lewis. Local Iowans knew better; the literary parallels they drew were to contemporary Iowan writers, most particularly Jay Sigmund and Ruth Suckow. Wood, they said, was doing in paint what Sigmund and Suckow for some years had been doing in words, creating significant art out of regional materials. This comparison was apt, for Wood was a great admirer of both writers.[32] Jay Sigmund lived in Cedar Rapids and he and Wood had become close friends a few years before the creation of *American Gothic.* Making his living as an insurance salesman, Sigmund was also an accomplished outdoorsman, a historian of the Wapsipinicon River Valley, and a writer, publishing books of Iowa verse and prose: *Frescoes* in 1922 and *Land O'Maize Folk* in 1924. Sigmund's literary reputation was regional; Ruth Suckow's writing, on the other hand, won her a national following. Her short stories about Iowa were published in H. L. Mencken's *Smart Set* and *American Mercury,* and her novel *The Folks* appeared in 1934 and became a best-seller. Most influential on Wood were probably her first novel, *Country People* (1924), and her collection of short stories, *Iowa Interiors* (1926).[33]

As suggested by titles such as *Land O'Maize Folk* and *Country People,* Sigmund and

Figure 11. Grant Wood. *Overmantel Decoration,* 1930. Oil on upsom board; 41 x 63½ in. Cedar Rapids Museum of Art, Gift of Isabel R. Stamats in memory of Herbert S. Stamats.

Figure 12. Frances F. Palmer, American. *Life in the Country—Evening,* 1862. Lithograph for Currier & Ives.

Figure 14. Matilda Peet. Tintype; 3 ½ x 2 ⅛ in. Davenport Municipal Art Gallery, Grant Wood Collection.

Figure 13. Grant Wood. *Victorian Survival,* 1931. Oil on composition board; 32 ½ x 26 ¼ in. Dubuque, Carnegie-Stout Public Library.

Suckow wrote about country types, not Sinclair Lewis's *Main Street* types. The farmer, the villager, and the rural family are the protagonists in these Iowans' writings. The couple in *American Gothic* could have stepped out of their pages. The man might well have belonged to what Suckow termed the "retired farmer element" in the town, men who were "narrow, cautious, steady and thrifty, suspicious of 'culture' but faithful to the churches."[34] And the woman might have been one of Sigmund's "drab and angular" Midwestern spinsters whose moral propriety and excessive duty to family kept her at home caring for a widowed parent.[35] It may come as a surprise that Wood's intention from the outset was to paint an unmarried daughter and her father in *American Gothic,* not a man and wife. In seeking models for the painting, he wanted, he said, to ask an "old maid" to pose but was too embarrassed.[36] So his thirty-year-old married sister agreed to play spinster and to stand next to the sixty-two-year-old dentist playing the father. When the painting was completed and the couple interpreted as man and wife, Wood rarely went to the trouble of explaining otherwise, undoubtedly pleased that it could just as easily be read as a married couple. Indeed, thereafter, he himself occasionally referred to the couple as man and wife.[37]

In 1931, Wood again portrayed the Midwestern turn-of-the-century spinster (fig. 13). His inspiration this time came from a tintype of his Aunt Matilda (fig. 14). With its sepia tones and rounded corners, the painting looks like a large stereopticon photograph of a long-necked Victorian lady sitting next to an equally long-necked dial telephone. In the 1920s, dial phones had just replaced the older system, which depended upon a central operator to place calls.[38] The painting, therefore, shows the old confronting the new: The prim Victorian world of the woman meets the jangling world of the modern telephone. Appropriately, Wood titled the painting *Victorian Survival.*

The man and woman in *American Gothic* are, of course, also "Victorian survivals," more at home in the rural world Grant Wood had known as a child than in the modern Iowa of his adulthood. During the first years of his life, from 1891 to 1901, Wood had lived on a country farm, attended school in a one-room schoolhouse, walked behind the horse-drawn plow, and endured spinster aunts, one of whom, he remembered, pulled her hair back so tightly that he wondered "how she could close her eyes at night."[39] The most exciting event of each childhood year was threshing day, when the big machines and neighboring farmers arrived to help thresh the grain. The threshers' noontime meal was a feast, brimming the little farmhouse over with people, smells, and activity.[40]

Thirty years later, Grant Wood began to paint those scenes. Sitting in his Cedar Rapids studio with a telephone at his elbow and cars going by the window, he painted the spinster in *American Gothic* and *Victorian Survival;* the walking plow in *Fall Plowing;* the one-room schoolhouse on an unpaved road with its hand pump, woodshed, and outhouse in *Arbor Day* (fig. 15); and the noonday harvest meal in *Dinner for Threshers* (fig. 16). Like *American Gothic,* each of these scenes was on its way to becoming a relic when Wood painted it. By 1930, children rode on motor buses over paved roads to consolidated schools with modern plumbing, tractors plowed the fields, combines made threshing days obsolete, and spinster aunts no longer dominated the family stage as they had in Victorian America.

One wonders, then, about the spirit in which Wood painted. Did he work out of a deep sense of regret about contemporary life or, as his most recent biographer has suggested, out of a disposition to "withdraw from industrial-urban society"?[41] Neither formulation seems

adequate. The facts are that Grant Wood was content in the modern world and never complained of Cedar Rapids and Iowa City, the two cities in which he resided. He never attempted to farm or to live in the country. His friends were city people like himself. But, having experienced a bifurcated life, ten years on a farm followed by thirty in Cedar Rapids, Wood recognized that the insular, rural world into which he had been born was slowly disappearing, that in his own lifetime the telephone, tractor, automobile, radio, and cinema were bringing that era to an end. Here, too, he may have been sensitized by the dominant theme of Ruth Suckow's writing—the gulf between modern, 1920s lifestyles and the nineteenth-century patterns still followed by older rural and country people. Suckow, who always used regional materials to explore broad human issues, made of Midwestern generational conflict a vehicle with which to discuss the toll of social change on families. Over and over she wrote of the sadness and incomprehension that result from the horse-and-plow farmer confronting the lifestyles and values of his car-driving, city-dwelling children.[42]

Wood's response to this confrontation was different. Only once, in *Victorian Survival,* did he paint it head on. In Wood's other "ancestor" paintings, as we may term them, he sought to capture the uniqueness of his past and to memorialize his Midwestern heritage. Ignoring the technological changes occurring around him, Wood painted his "roots." He wanted to know where his culture had come from, not where it was going. In the same spirit that motivated Americans to collect and restore discarded American folk paintings, or to rehabilitate eighteenth-century colonial villages, Wood painted "bits of American folklore that are too good to lose."[43]

Indeed, the best way to think of this artist is as a kind of folklorist searching out indigenous legends. On two occasions he painted national folk tales. In *The Midnight Ride of Paul Revere* (1931; New York, The Metropolitan Museum of Art), Wood depicted the famous nocturnal gallop to warn New Englanders that the British were coming. Later in the decade, he painted *Parson Weems' Fable* (1939; Fort Worth, Amon Carter Museum), a large work retelling the famous tale of the young George Washington cutting down the cherry tree. What challenged Wood most, however, was regional folklore, particularly that of the common farmer, whose culture, Wood believed, formed the bedrock of Midwestern life.[44] Farm folklore had never become an integral part of America's national self-image. In the 1920s, indeed, many Americans often thought of the farmer as a "hayseed" or "hick," fortifying the belief that the nation's breadbasket had no history of any interest or consequence. Wood thought otherwise. In *American Gothic,* he honored those anonymous Midwestern men and women who tamed the prairie, built the towns, and created America's "fertile crescent"—and who, in the process, became insular, set in their ways, and fiercely devoted to home and land. In *Fall Plowing,* Wood celebrated the farmer's harvests, while in *Arbor Day* and *Dinner for Threshers* he transformed annual rituals of rural life into quaint and colorful folk tales.

In all of Wood's historical paintings, whether of national or regional themes, the legendary qualities are never bombastic or heroic. Unlike other American regionalists who painted rural life, Wood rarely aggrandized his figures through exaggerated scale, classical idealization, or Old Master grandiloquence.[45] His paintings tend to be small, his figures closer to puppets or dolls than gods and goddesses. Indeed, there is a levity about Wood's work that rescues it from sentimental heroism or strident patriotism. Paul Revere appears to ride a child's hobbyhorse through a storybook landscape constructed of papier mâché and building blocks. In *Dinner for Threshers,* a panel modeled after a religious triptych, the participants look like

Figure 15. Grant Wood. *Arbor Day*, 1932. Oil on masonite panel; 25 x 30 in. Beverly Hills, Ca., King Vidor Collection.

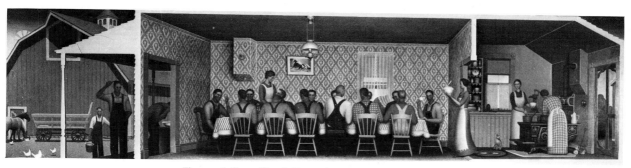

Figure 16. Grant Wood. *Dinner for Threshers*, 1934. Oil on masonite panel; 19½ x 26¼ in. The Fine Arts Museums of San Francisco, Gift of Mr. and Mrs. John D. Rockefeller III.

Figure 17. Grant Wood. *Portrait of John B. Turner—Pioneer,* 1928–30. Oil on canvas; 30¼ x 25½ in. Cedar Rapids Museum of Art, Gift of Harriet Y. and John B. Turner II.

clothespin dolls in a Victorian dollhouse, not like saints. And the man and woman standing in front of their "cardboardy frame house" in *American Gothic* are so flat and self-contained they could be children's cutouts.

Sometimes these whimsical, storybook qualities shade into humor, a fact that has confused Wood's critics and led many to think Wood was ridiculing or making fun of his subjects. This is not the case; Wood's use of humor was gentle and good-natured, not mocking or contemptuous. It was a device he used to convey charm and quaintness and to give his works the lighthearted quality of storybook legends. And most important, he found that humor helped create convincing character types. In *American Gothic* we cannot help but smile at the ways Wood emphasized the "hard-edged" Midwestern character of his rural couple. He expressed the man's maleness and rigid personality in the cold, steely tines of the pitchfork, then playfully mimicked these qualities in the limp seams of his overalls and in the delicate tracery of the Gothic window. To suggest the spinster's unfulfilled womanhood, Wood flattened her bosom and then decorated her apron with a circle and dot motif, a form he might well have thought of as a kind of miniature breast hieroglyph. And to underline the controlled and predictable nature of the couple's life, Wood allowed a single strand of wayward hair to escape from the woman's bun and snake mischievously down her neck. It is the only unruly element in an otherwise immaculate conception.

Though he was quiet, slow of speech, and somewhat shy, Grant Wood was one of the finer wits of Cedar Rapids. But, until *American Gothic,* his humor surfaced only in conversation, at parties, or in making gag pieces for friends and for his studio apartment.[46] His art was of a different order, serious and reserved. One can argue, in fact, that only when Wood harnessed his gentle wit and made it an integral part of his art did he arrive at a personal and mature style. When he had struggled in 1928 and 1929 in *John B. Turner, Pioneer,* and *Woman with Plants* to create images of the pioneer (figs. 17, 18), the results were heavy-handed, the types not clearly drawn. For these works Wood chose Iowa settlers as models, people whose faces, he thought, recorded the pioneer experience. Wood painted John B. Turner as a successful Cedar Rapids businessman, but, to indicate his personal history, the artist posed him against an 1869 map of the area in Iowa where Turner had settled in the 1880s as a young man.[47] The model for the second work, Hattie Weaver Wood, was the artist's seventy-one-year-old mother, who had been born in Iowa during its early settlement, later taught school in a prairie town, and farmed with her husband until his early death in 1901.[48]

Of the two portraits, that of Mrs. Wood, with her deeply lined face, faraway gaze, and stiff pose, came closer to conveying the legendary qualities the artist was after. Experimenting with ideas that would become central to *American Gothic,* Wood dressed his mother as a country woman and had her hold a pioneer woman's attribute, the hardy sansevieria plant popular on the frontier. At either side of her he placed other house plants, a begonia and a geranium. Though she then lived with the artist in Cedar Rapids, he depicted her expressionless and still against an emblematic background of farmland, barn, and windmill. In its tightly focused realism and stylized line, *Woman with Plants* reflects the artist's study of the Northern Renaissance masters the previous year. It is the most "Flemish" painting Wood ever did. He simulated the translucent qualities of a Flemish work by patiently building up the painted surface with oil glazes. From Flemish portraits he borrowed the close-up, half-figural composition, the body filling the lower frame, the sitter's hand pushed close to the picture plane.

Woman with Plants, however, like *John B. Turner, Pioneer* before it, was still an individual-ized portrait. It did not come close to the streamlined generic types which the artist finally achieved in *American Gothic.* After this breakthrough, Wood never again traveled abroad in search of the old and picturesque or to study the Old Masters. In Midwestern farmlore he had finally discovered his own subject matter. In old American architecture, prints, photographs, and artifacts he had found his sources. And in humor he had found a device to make his paintings lighthearted and accessible, as easy to assimilate as a storybook fable. In the tradition of regionalist writers such as Sinclair Lewis, Wood created a character type both lovable and laughable, one with virtues as well as foibles. "These people had bad points," Wood said of his famous couple, "and I did not paint them under, but to me they were basically good and solid people. I had no intention of holding them up to ridicule."[49]

Wood was also grappling in *American Gothic* with one of the basic tenets of modern painting: the belief that form and content should be one. The imagery and style of his early work had been diffuse and eclectic—trees, barns, cathedrals, old shoes, back alleys—painted sometimes with the thick brush of a van Gogh, at others with the gentle touch of an Impressionist. But, as he came to conceive of himself as a painter of Midwestern history and legend, of "cardboardy frame houses," *American Gothic* couples, and quilted farmlands, Wood realized he had to create a style consonant with his subject matter. He was groping toward such a synthesis in *John B. Turner, Pioneer* and *Woman with Plants,* but found it only in *American Gothic.* There he used every formal element of the composition to say something about the Midwest and the couple's character. The static composition and immaculate forms expressed the couple's rigid routines and unchanging lives. The repeated verticals and sharp angles emphasized the couple's country hardness, while the blunt palette of white and black, brown and green, echoed their simplicity. To make the couple look entombed, as if relics from another age, the artist bathed the scene in a dry white light, crisply embalming every little detail of the pair and their home. Even the profusion of patterns in *American Gothic*—the dots, circles, stripes, and ovals—Wood saw as a Midwestern component of his new style. Decorative patterns abounded in his region, Wood believed, in wire fences, ginghams, rickrack, patchwork quilts, lacy curtains, and cornfields.[50]

In its style, imagery, and sources, then, *American Gothic* grew out of Wood's Midwestern experience and earned him the title of "regionalist" painter. To the artist's considerable surprise, the painting won immediate fame, a fame that continues unabated fifty years later. It is not hard to understand why. In the best tradition of regionalist art, Wood began with local materials but ultimately transcended time and place. *American Gothic* has proved to be a collective self-portrait of Americans in general, not just of rural Victorian survivals. Proof of the point is that even the visually untutored recognize the image of Mr. and Ms. American. So, too, the admen and cartoonists, who find *American Gothic* an infinitely variable mirror in which to portray Americans. In parody, Wood's simple, plain, and nameless couple can be rich or poor, urban or rural, young or old, radical or red-neck. The image can be used to comment upon puritanism, the family, the work ethic, individualism, home ownership, and the common man.[51] Rich in associations running deep in myth and experience, *American Gothic* has become a national icon.

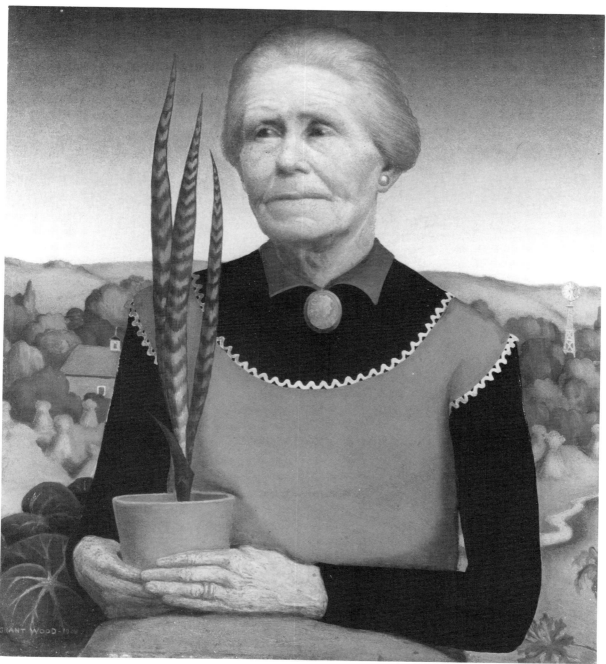

Figure 18. Grant Wood. *Woman with Plant,* 1929. Oil on
upsom board; 20½ x 17⅞ in. Cedar Rapids Museum of
Art, Art Association Purchase.

1. This article was originally written for *Art, the Ape of Nature, Studies in Honor of H. W. Janson*, ed. by M. Barasch and L. F. Sandler, New York, 1981: 749–69. Janson wrote the first art historical essay on Grant Wood in 1943. He followed this with three more articles on Wood and Regionalism. That my essay asks different kinds of questions from those posed by Janson and comes to very different conclusions should not obscure the intended tribute: I could think about Grant Wood at a time when he was *persona non grata* in many artistic circles because one of my teachers had done so earlier. For Janson's essays, see "The International Aspects of Regionalism," *College Art Journal* II (May 1943): 110–15; "Review of *Artist in Iowa; A Life of Grant Wood*, by Darrell Garwood," *Magazine of Art* XXXVIII (Nov. 1945): 280–82; "Benton and Wood, Champions of Regionalism," *Magazine of Art* XXXIX (May 1946): 184–86, 198–200; "The Case of the Naked Chicken," *College Art Journal* XV (Winter 1955): 124–27.

American Gothic is treated at some length in D. Garwood, *Artist in Iowa; A Life of Grant Wood*, New York, 1944; M. Baigell, "Grant Wood Revisited," *Art Journal* XXVI (Winter 1966–67): 116–22; Baigell, *The American Scene*, New York, 1974: 109–12; J. M. Dennis, *Grant Wood*, New York, 1975.

2. Janson, "The International Aspects of Regionalism" (note 1): 111. Grant Wood first talked about the impact of the Flemish painters on him to Irma Koen ("The Art of Grant Wood," *Christian Science Monitor* [Mar. 26, 1932]).

3. Boston *Herald*, November 14, 1930. For this review and many others, see Nan Wood Graham, *Scrapbooks*, Archives of American Art, No. 1216/279–88. *American Gothic* was first exhibited in the 1930 Annual Exhibition of American Painting and Sculpture at the Art Institute of Chicago, where it won the Norman Wait Harris Bronze Medal and a $300 prize. It has been in the permanent collection of the Art Institute ever since.

4. Janson, "Benton and Wood, Champions of Regionalism" (note 1): 199.

5. Baigell, *The American Scene* (note 1): 110. Baigell basically reiterated the interpretation of *American Gothic* given by Grant Wood's unauthorized biographer, Darrell Garwood (*Artist in Iowa* [note 1]: 119–20).

6. Dennis (note 1): 120.

7. Wood told in various lectures and interviews of discovering the Eldon house. See newspaper clippings quoting Wood in N. Wood Graham, *Scrapbooks* (note 3).

8. Kenneth Clark's pioneering study *The Gothic Revival: An Essay in the History of Taste* first appeared in 1928, but it was not until after World War II that historical appreciation flourished for Victorian architecture and decorative arts.

9. Letter to the editor from Grant Wood, printed in "The Sunday Register's Open Forum," Des Moines *Sunday Register*, December 21, 1930.

10. "Iowans Get Mad," *Art Digest* V (Jan. 1, 1931): 9.

11. See C. Loth and J. T. Sadler, Jr., *The Only Proper Style: Gothic Architecture in America*, Boston, 1975: 104, where the 1881–82 date is given for the Eldon house and attributed to Messrs. Busey and Herald, local carpenters.

12. This comes from a newspaper account of a lecture Wood gave in Los Angeles, reported in an unidentified, undated newspaper in the Cedar Rapids Public Library Clipping File on Grant Wood.

13. Interview with Nan Wood Graham, October 14, 1977. See also N. Wood Graham, "American Gothic," *Canadian Review of Music and Art* III (Feb.–Mar. 1941): 12. Mrs. Graham on several occasions has kindly answered my questions about *American Gothic* and about her brother's life and work. I am deeply indebted and grateful to her for her interest in my work.

14. Reproduced in Dennis (note 1): 86.

15. Letter from Mrs. Ray R. March of Washta, printed in "The Sunday Register's Open Forum," Des Moines *Sunday Register*, December 14, 1930.

16. Wood's home furnishings, photographs, and books are preserved in the Grant Wood Collection of the Davenport Municipal Art Gallery.

17. Reported to the author by Mrs. Herbert Stamats in a telephone interview, August 19, 1976.

18. R. Lynes, *The Tastemakers*, New York, 1955: 239.

19. L. Mumford, *American Taste*, 1929, excerpted in *The Culture of the Twenties*, ed. by L. Baritz, New York, 1970: 402.

20. See, for example, the perfunctory treatment of Victorian furniture in W. A. Dyer, *Handbook of Furniture Styles*, New York, 1918; and in W. L. Kimerly, *How to Know Period Styles in Furniture*, Grand Rapids, Mi., 1928.

21. For Wood's early training and for illustrations of the furniture he designed, see Dennis (note 1): 19–37, 160–61. A photograph of the artist's studio apartment is on page 28.

22. See the text and illustrations in M. Darbyshire, "An Early Iowa Stone House," *Arts and Decoration* XLIV (Mar. 1939): 12–15. Much of my information about the Armstrong house comes from a visit to the house and an interview with Mrs. Robert Armstrong on August 11, 1976.

23. My deductions about Wood's taste are based on a study of his own furnishings, visits to the houses he decorated, and interviews with people who knew him.

24. See W. Corn, "The Return of the Native: The Development of Interest in American Primitive Painting," unpubl. M.A. thesis, Institute of Fine Arts, New York University, 1965.

25. There is a display of the steel plow and its role in opening up the prairie at the John Deere and Company headquarters, Moline, Il.

26. Quoted in Koen (note 2).

27. I share here the viewpoint of Matthew Baigell, who argued in "Grant Wood Revisited" (note 1) that Wood's work "has stronger literary than artistic antecedents." We cite, however, different antecedents and come to different conclusions.

28. Two useful sources for Midwestern regional literature are B. T. Spencer, "Regionalism in American Literature," in *Regionalism in America*, ed. by M. Jensen, Madison, Wi., 1951; and C. A. Andrews, *A Literary History of Iowa*, Iowa City, 1972.

29. H. Garland, *A Son of the Middle Border*, New York, 1917: 416.

30. In the Paris edition of the Chicago *Tribune*, sometime in July 1926; N. Wood Graham, *Scrapbooks* (note 3), No. 1216/271.

31. The Limited Editions Club edition of S. Lewis, *Main Street*, New York, 1937. All nine of Wood's *Main Street* illustrations are reproduced in Dennis (note 1): 123–27.

32. See newspaper clippings in N. Wood Graham, *Scrapbooks* (note 3), No. 1216/278, 283, 308. Hazel Brown, in *Grant Wood and Marvin Cone* (Ames, Ia., 1972: 66), recalled that Wood and friends would sit around and discuss "Frank Lloyd Wright, Ruth Suckow, and Jay Sigmund."

33. J. G. Sigmund, *Frescoes*, Boston, 1922; and *Land O'Maize Folk*, New York, 1924. R. Suckow, *Country People*, New York, 1924; *Iowa Interiors*, New York, 1926; and *The Folks*, New York, 1934.

34. Suckow, "Iowa," *American Mercury* 9 (Sept. 1926): 45.

35. The phrase "drab and angular" was used by Sigmund to describe a spinster in his short story "First Premium" in *Wapsipinicon Tales*, Cedar Rapids, Ia., 1927. See also Sigmund's poems "The Serpent" (*Frescoes* [note 33]: 40–42) and "Hill Spinster's Sunday" (*Jay G. Sigmund*, ed. by P. Engle, Muscatine, Ia., 1939). Suckow described how a very promising young girl ends

her life as a lonely spinster in "Best of the Lot," *Smart Set* 59 (Nov. 1922): 5–36.

36. The first public statement claiming that Wood's couple were father and daughter appeared in a letter to the editor by Nan Wood Graham. See "The Sunday Register's Open Forum," Des Moines *Sunday Register,* December 21, 1930. Mrs. Graham gave a fuller account of Wood's original ideas for the painting in "American Gothic" (note 13).

37. See, for example, "An Iowa Secret," *Art Digest* VIII (Oct. 1, 1933): 6.

38. See J. Brooks, *Telephone: The First Hundred Years,* New York, 1975: 168.

39. P. Rinard, "Return from Bohemia: A Painter's Story," Archives of American Art, No. D24/161–295, 78. Although this biography is always attributed to Grant Wood, it was Rinard's M.A. thesis for the Department of English, University of Iowa, August 1939. Rinard was an extremely close friend and associate of Wood's and wrote the thesis in close consultation with the artist.

40. Ibid.: 45–46, 76f.

41. Dennis (note 1): 213. In his recent study, Dennis argued that Wood's attitude toward contemporary life was shaped by the Southern Agrarians, who advocated "a local rural life as the alternative to industrial urbanization" (ibid.: 150). I am not convinced by this argument. We have no evidence that Wood knew the writings of the Southern Agrarians. The first collection of these writings, *I'll Take My Stand* (New York, 1930), appeared in the same year *American Gothic* was painted. Furthermore, Wood would have had no reason to be sympathetic to writers interested only in the cultural health and economic salvation of the South. The Midwestern regional writers of the 1920s Wood did know and read. Two good guides to these writers' work are Andrews (note 28) and M. M. Reigelman, *The Midland: A Venture in Literary Regionalism,* Iowa City, 1975.

42. See, for example, Suckow's novel *Country People* and her short stories "Four Generations" and "A Rural Community" in *Iowa Interiors.*

43. Grant Wood, quoted in *The New York Times,* January 3, 1940. Wood was speaking here about his painting *Parson Weems' Fable.* Denying any intent to debunk, Wood claimed to be preserving "colorful bits of our national heritage." Dennis discounted this statement, arguing that the artist was a debunker and a satirist (note 1: 109–29). Dennis is more on target, I think, in his discussion of Wood as a mythologizer, as a maker of fantasy and make-believe (pp. 87–107).

44. Wood's view that the farmer is "central and dominant" in the Midwest is best expressed in his 1935 essay "The Revolt Against the City," republished in Dennis (note 1): 229–35.

45. The major exceptions to this statement are the federally funded murals Wood designed in 1934 for the library of Iowa State University in Ames. In other murals, such as those done for the dining room of the Montrose Hotel in Cedar Rapids, Wood could be just as playful and lighthearted as in his easel paintings.

46. Wood's sense of humor was such a vital part of his personality that everyone who knew him has commented on it. Numerous stories of his pranks and jokes can be found in Garwood (note 1) and Brown (note 32). See also Rinard's essay in *Catalogue of a Loan Exhibition of Drawings and Paintings by Grant Wood,* The Lakeside Press Galleries, Chicago, 1935. The Cedar Rapids Art Center owns many pieces that Wood made for fun— a "mourner's bench" for high school students who were being disciplined; flower pots decorated with flowers made of gears, bottlecaps, and wire; and a door to his studio with a movable indicator telling whether the artist was in, asleep, taking a bath, etc.

47. For information about the Turner family, I interviewed John B. Turner II in July and August 1976. His father, David Turner, was Wood's chief patron during the artist's early career; his grandfather was the model in *John B. Turner, Pioneer.* Wood dated this painting twice: "1928" in the lower left under the oval frame, and "1930" at the edge of the frame in the lower right. Although historians have considered this work to be post-Munich, I suspect this is wrong. Based on the early date and the style of the piece, Wood probably began the portrait sometime in 1928 and dated it before leaving that fall for Munich, where he stayed until Christmas. In 1930 he made revisions to the painting, and dated it anew when he added the oval frame, a shape in keeping with the neo-Victorian features of *American Gothic.*

48. Mrs. Wood's early biography appears in Rinard (note 39): Chapter 1.

49. Quoted in D. Dougherty, "The Right and Wrong of America," Cedar Rapids *Gazette,* September 5, 1942.

50. See Koen (note 2) and quotations from Grant Wood's lectures and interviews in the clippings in N. Wood Graham, *Scrapbooks* (note 3).

51. There are several major collectors of *American Gothic* caricatures. I am grateful to Nan Wood Graham, Edwin Green, and Price E. Slate for having made their large collections available to me. My own collection, begun only in the early 1970s, already numbers well over a hundred items.

Benjamin H. D. Buchloh

Michael Asher and the Conclusion of Modernist Sculpture

Concrete material reality and social meaning should always be the primary criteria of specification. Before all else, we see in ideological objects various connections between meaning and its material body. This connection may be more or less deep and organic. For instance, the meaning of art is completely inseparable from all the details of its material body. The work of art is meaningful in its entirety. The very constructing of the body-sign has a primary importance in this instance. Technically auxiliary and therefore replaceable elements are held to a minimum. The individual reality of the object, with all the uniqueness of its features, acquires artistic meaning here.[1]

Sculpture traditionally differed from painting through its seemingly unquestionable three-dimensionality, its physical and physiological corporeality. Sculpture was defined almost as literal embodiment of the artist's subjective plastic concerns, determined by the objective aesthetic and practical conditions of the sculptural discourse at hand to implement and concretize these concerns, and the spectator's (often the patron's) willingness and ability to recognize his existential being-in-the-world in the sculptural embodiment and representation. Or, as Rosalind Krauss recently stated in an appropriate academic definition: "The logic of sculpture, it would seem, is inseparable from the logic of the monument. By virtue of this logic a sculpture is a commemorative representation. It sits in a particular place and speaks in a symbolical tongue about the meaning and the use of that place."[2]

As we will be dealing in the following with some historical aspects of contemporary sculptural works in general, and with two works that were executed by Michael Asher in 1979 for two museums in Chicago in particular, it seems appropriate to consider these works in sculptural terms, as they do in fact "[sit] in a particular place and [speak] in a symbolical tongue about the meaning and the use of that place." To achieve, however, an adequate reading of the complexity of the works in question, and the material and procedural transformations that have taken place in the evolution of contemporary sculpture, and to come to an understanding of the consequences and repercussions following from these works, it is necessary to recapitulate briefly some of the crucial changes that define sculpture in the history of modernism.

Looking at the concrete material reality of modernist sculpture (that is, its materials and its procedures of production) as well as looking at its rapidly changing history of appreciation and

← See figs. 1 and 2.

reception, one could almost come to the conclusion that sculpture, due to its plastic and concrete "nature" more than any other art practice, seems to lend itself to a particularly obdurate discourse of aesthetic ideology: how to maintain and continue atavistic production modes (modeling, carving, casting, cutting, welding) and apply them convincingly to semi-precious or so-called "natural" materials (bronze, marble, wood) under the conditions of a highly industrialized society. Only twenty years ago (if not more recently) the works of Alberto Giacometti and Henry Moore could still pass as the epitome of the sculptural, where in fact their archaic iconography and plastic appearance revealed hardly more (but also no less) than the author's (and the public's) ossified insistence on maintaining a discourse that had lost its historic authenticity and credibility in the first decade of this century.

Even a practicing academic sculptor and sculpture-historian, William Tucker, seemed to acknowledge the specific dilemma of his own discipline, however, without coming to an adequate understanding of the historical conditions that determine the dilemma of that category, when commenting on Rodin as follows:

> Thus, Rodin's mature sculpture follows the effective emergence of modern painting, moreover, in comparison with the directness, simplicity, and objectivity of the new painting. The statement in sculpture seems tentative, half-formed and weighed down by a burden of romantic and dramatic subject matter of moral and public "function" which the Impressionists had been able to jettison from the first. The reasons for the late arrival and confused intentions of the new sculpture lie partly in the physical character of sculpture and painting, partly in the relative development in Europe since the Renaissance, partly in the specific conditions of patronage and public taste which were obtained in 19th century France. Sculpture became an art in which the taste and ambition of the public patron became the determining factor, and virtuosity and craftsmanship the criteria of artistic achievement.[3]

A more rigorously analytical reading of the history of modernist sculpture would have to acknowledge that most of its seemingly eternal paradigms, which had been valid to some extent in late nineteenth-century sculpture (i.e., the representation of individual, anthropomorphic, wholistic bodies in space, made of inert but lasting, if not eternal, matter and imbued with illusionary moments of spurious life), had been definitely abolished by 1913. Tatlin's corner-counter relief and his subsequent *Monument for the Third International* and Duchamp's "ready-mades," both springing off the height of Synthetic Cubism, constitute since then the extremes of an axis on which sculpture has been resting ever since (knowingly or not): the dialectics of sculpture between functioning as a model for the aesthetic production of reality (e.g., architecture and design) or serving as a model investigating and contemplating the reality of aesthetic production (the ready-made, the allegory). Or, more precisely: architecture on the one hand and epistemological model on the other are the two poles toward which relevant sculpture since then has tended to develop, each implying the eventual dissolution of its own discourse as sculpture. This ambiguous transition of the discipline had been sensed as early as 1903 by the conservative poet Rilke in his Rodin study, but of course his sense was conveyed in a tone of deploration and lament as the withering artistic category was indicative of vanishing privileges and esoteric experiences, which he perceived as being incorporated in the wholistic, autonomous art object:

> Sculpture was a separate thing, as was the easel picture, but it did not require a wall like the

picture. It did not even need a roof. It was an object that could exist for itself alone, and it was well to give it entirely the character of a complete thing about which one could walk, and which one could look at from all sides. And yet it had to distinguish itself somehow from other things, the ordinary things which everyone could touch.[4]

The threshold between symbolic space and actual space, the ambiguous shift between functional object and aesthetic object, demonstrates the lines between which Michael Asher's works operate with increasingly analytical precision, deconstructing our notions of the sculptural as though they would want to prove that sculpture as a category has lost its material and historical legitimacy.

I

Sculptural materiality before or beyond its iconic, formal, or procedural definitions has to be considered as a symbolic system that is highly overdetermined. For example, we cannot help but suspect that the "nobility" of bronze and marble in the late nineteenth-century work of Rodin was at least in part a result of his dependence on the class of bourgeois fin-de-siècle nouveaux riches which supported him and that these materials fulfilled this audience's desire for "nobilization" of the material world as much as they fulfilled Rodin's "aesthetic" needs. If the real interests of a society at a given historical moment are based, for example, on the speculation with real estate, heavy industry, and the founding of canons, then the aesthetic sculptural representation that would best and necessarily function as the "disinterested" and "purposeless as such" might well turn out to be luscious white marble and bronze. Therefore, symbolic determinations of sculptural materials do not only result from the author's professional idiosyncrasies—whether his individual psychosexual organization tends more toward modeling soft and palpable masses (like clay) or whether he feels like cutting stone or carving wood—but they also result from the audience's expectations. Another point to consider is whether the specific material and the procedures of its production do attract and allow for a projective identification and seem in fact to embody the viewer's physical being in the world. Quite obviously, then, this being in the world in the material terms of three-dimensional representation of voluminous masses and bodies would refract and reflect in various manners the means and procedures of production of this material world itself, inasmuch as they condition author and audience of sculpture alike.

In contradistinction to Rodin, to give another example, the truly radical modernity of Medardo Rosso's sculptures resisted this incorporation into bronze in most of his works and the sculptural production process itself was arrested and fragmented at the level of the wax and plaster model: materials that by their very nature quite explicitly reject any heroic or sublime connotations. Rosso often said that he wanted the materials of his sculptures to pass unnoticed because they were meant to blend with the unity of the world that surrounded them. The actual fragmentation of the sculptural procedure—whether deliberate or circumstantial—corresponds as a plastic and historical fact to Rosso's fragmentation of the sculptural representations themselves. His reluctance or incapacity to fulfill all the requirements of the traditional sculptural production process, from modeling to casting, indicates an essential critical shift of attitude. It reveals the increasing doubts about the ability of a practice of artisan-oriented sculpture to come to terms with its historic reality: The completion of various steps and

sequences of production activities, pretending to be conceived and executed by one individual, had become obsolete. Along with the fragmentation of the sculptural procedures appeared the phenomenon of a heterogeneous materiality: Prefabricated elements, alien to the craft of nineteenth-century sculpture, were introduced or intruded into the conventionally unitary sculptural body. *Little Dancer of Fourteen* (1881), the only sculpture by Edgar Degas that was publicly exhibited during his lifetime and cast in bronze posthumously, produced this modernist scandal for the first time. When it was exhibited at the Exposition des Indépendents in 1881, Joris Huysmans hailed it as follows:

> At once refined and barbaric with her industrious costume.and her colored flesh which palpitates furrowed by the work of the muscles, this statue is the only truly modern attempt I know in sculpture.[5]

Both phenomena—the fragmentation of representation and of the production process and the juxtaposition of heterogeneous materials—emerge as the dominant phenomena of modernist sculpture. At first they appeared accidentally, as in the case of Degas, but in Cubism and Futurism the combination of mechanically produced anonymous objects and fragments with individually produced aesthetic signs became a quintessential production procedure, resulting ultimately, it would seem, in the final takeover of the aesthetic construct by the mechanically produced object in Duchamp's ready-mades. These phenomena receive a meticulous description and precise historical analysis in Georg Lukacs's attempt to define the conditions of reification in 1928:

> Rationalization in the sense of being able to predict with every greater precision all the results to be achieved is only to be acquired by the exact breakdown of every complex into its elements and by the study of the special laws governing production. Accordingly, it must declare war on the organic manufacture of whole products based on the traditional amalgam of empirical experiences of work. . . . The finished article ceases to be the object of the work process. . . . This destroys the organic necessity with which interrelated special operations are unified in the end product. Neither objectively nor in his relation to his work does man appear as the authentic master of the process: on the contrary, he is a mechanical part incorporated into a mechanical system. He finds it already preexistent and self-sufficient; it functions independently of him and he has to conform to its laws whether he likes it or not. As labour is progressively rationalized and mechanized, his lack of will is reinforced by the way in which his activity becomes less and less active and more and more contemplative. The contemplative stance adopted toward a process mechanically conforming to fixed laws and enacted independently of man's consciousness and impervious to human intervention, i.e., a perfectly closed system, must likewise transform the basic categories of man's immediate attitude to the world: It reduces space and time to a common denominator and degrades time to the dimension of space.[6]

The intrusion of those alien materials in Degas's sculpture established a very precarious balance between the subjective aesthetic creation and the factors of given objective reality along the lines pointed out by Lukacs. Ever since, and most definitely since Duchamp's "ready-mades," these historical conditions have been forced to their most logical and radical extreme. Duchamp's work features most prominently that contemplative character of spatialized time in

Figure 1. The Art Institute of Chicago, Michigan Avenue Entrance, in 1979, showing the 1917 bronze replica of Jean Antoine Houdon's *George Washington* (1788). Photo courtesy Rusty Culp.

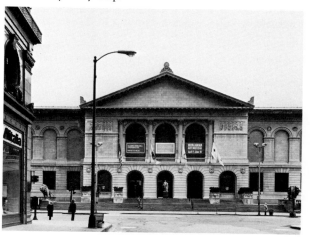

Figure 2. The Art Institute of Chicago, Michigan Avenue Entrance after the removal of *George Washington*. Photo courtesy Suzanne Plunkett.

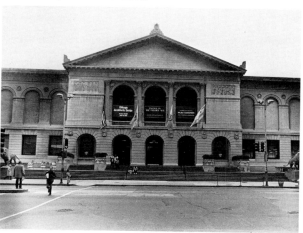

Figure 3. Michael Asher, American (born 1943). *73rd American Exhibition,* The Art Institute of Chicago (June 9–August 5, 1979), Gallery 219. Photo courtesy Rusty Culp.

the object that Lukacs talks about. Quite amazingly, a totally opposite reading of Duchamp as the artist who continues and accomplishes the nineteenth-century tradition of the dandy, the artist who refuses participation in the collective production process and inverts his role as procreator into that of the divine blasé, the flaneur who simply walks around the world and designates found objects as art—this reading converges precisely with the above observation, as the arrest of temporal flux and passive contemplation are the modes in which the melancholic perceives the world and the increasing estrangement from it.

Inevitably, at this point, Walter Benjamin's observation on the interaction between allegory and commodity has to be quoted: "The devaluation of the world of objects by the allegory is exceeded within the world of objects itself by the commodity."[7] From the first decade of the twentieth century on, the precarious ambiguity between the apparent autonomy of sculptural constructs and the socially determined conditions of material production, between aesthetic object and symbolic space on the one hand and real object and actual space on the other, has determined the practice of sculpture.

Not always, however, does aesthetic production evolve logically according to its own inherent historical necessities and in response to the change of the conditions of material production. Quite to the contrary, it seems that one of the essential features of aesthetic production—at least in twentieth-century art history—is the constant reiteration of the same problems and contradictions according to the law of compulsive repetition.[8] As the contradictions which are objectively anchored in the organization of the means of production obviously cannot be resolved aesthetically, every generational or period stratum within the continuity of an obsolete form of production assumes increasingly mythical and ideological qualities and functions as opposed to the truly aesthetic.

The history of post-World War II sculpture is particularly rich with these myths, and only one of the most spectacular ones should be briefly discussed as an example and historic link: that in which the issues of Constructivism's and Dada's attitudes toward the mass-produced object seem to coalesce, as, for example, in the work of David Smith, John Chamberlain, and Anthony Caro. If anything, the welding of metal and junk sculpture in their work seems to resolve in a most comforting manner that blatant contradiction between individual aesthetic production and collective social production, that between construction and found object. In fact, however, this contradiction is also mythified by the work's seeming synthesis of the heroic gesture of construction and creation and the melancholic gesture of denial and negation. In the same way, these artists, as public figures and biographical myths, combine the image of the proletarian producer, taming the elements and extracting wealth from the furnace, with that of the melancholic stroller in the junkyards of capitalist technology—an image that has persisted right into the present in figures like Carl Andre and Richard Serra. The necessarily fetishistic character of this work had been adequately diagnosed in the 1920s by the Russian productivist artist and theoretician Boris Arvatov, who wrote in *Kunst und Producktion:*

> While the totality of capitalist technology is based on the highest and latest achievements and represents a technique of mass production (industry, radio, transport, newspaper, scientific laboratory), bourgeois art in principle has remained on the level of individual crafts and therefore has been isolated increasingly from the collective social practice of mankind, has entered the realm of pure aesthetics. The lonely master—that is the only type in capitalist society, the type

of specialist of "pure art"—who can work outside of an immediately utilitarian practice, because it is based on machine technology. From here originates the total illusion of art's purposelessness and autonomy, from here art's bourgeois fetishistic nature.[9]

As for the mythology and meaning of materials and production procedures, scrap-metal/assemblage sculpture and the welding technique concretize the historic dilemma between obsolescent means of aesthetic production and their romanticization (i.e., fetishization) on the one hand and the advanced means of social production on the other, as well as they embody the attempt to solve this historical dilemma. The failure of that attempt, inasmuch as it becomes evident in the work itself, is then the work's historic and aesthetic authenticity. Julio Gonzalez, who had been trained as a stonecutter, learned welding in the French Renault car factories during World War I and integrated his enforced experience from alienated labor in social production into his individual aesthetic production. Or, from a different point of view, one could argue that he adapted his aesthetic procedures to the experience of collective production procedures. This "modernization" of the sculptural discourse was instantly successful because it seemed to respond to and fulfill the needs of a disposition within artist and public at the moment to achieve at least a symbolic reconciliation of the increasingly apparent contradictions. Picasso adopted this technique in the early 1920s, and a new sculptural category and production technique was born. When David Smith "discovered" Gonzalez's and Picasso's work through the mediation of the art magazine *Cahiers d'Art* and imported the technique to North America, a further crucial step in the mythification of that simple sculptural procedure, which had originated from Cubism's necessity to assemble planes in various spatial positions and directions, had taken place. Smith, more than Gonzalez, propounded the image of the proletarian producer, linking it with the mythical Hephaistos/Vulcan figure. On frequent occasions he pointed to the immensely important experiences of factory labor that shaped and determined his work, in particular his experience as a welder in a World War II tank factory. He referred to his welded sculptures as constructions of the same historical order as locomotives. To what degree this self-image of the welding-mask-weaving proletarian/producer and twentieth-century Vulcan possessed mythical attraction for David Smith is hinted at by the fact that his widow has revealed that most of Smith's claim for severe and enduring experiences as a factory welder, in fact, were exaggerated.[10]

The next step of aesthetic removal and mythification occurred when this modernized sculptural production procedure was "rediscovered" and "reimported" to Europe by Anthony Caro in 1960 upon his first visit to North America and his encounter with David Smith. His radically superficial overnight shift (as in the radical superficiality of changes in the discourse of fashion) from his figurative bronze casting to nonrepresentational welded assemblage sculptures made of scrap metal, and his subsequent step to investigate the decorative potential of gaudily painted arrangements of metalwork samples, accomplished historically the aesthetic falsification and "cultural" inversion of everything that constructivist ideas had originally intended and achieved within their limited political possibilities.

It took artists of the minimal and post-minimal generation like Carl Andre and Richard Serra in the mid- and late 1960s to literally "decompose" these mythified construction techniques, materials, and production procedures. The aesthetic shock and subsequent relief that their work might have caused originally resulted precisely from the deconstruction of sculp-

ture, the perseverance of singularized, particular elements, clarification of the constituent forces within the sculptural construct, and the transparence of the production procedures evident in their work. It is symptomatic in this context that Serra referred to the technique of welding as "stitching" during the 1960s and that he readopted that very same technique when his work in the 1970s returned to the mythification of the constructivist legacy to allow for a pretense to public monumental sculpture.

Ever since the first decade of this century, radical sculpture has increased the fragmentation of the sculptural production process itself, as well as it has intensified the reflection on the constituent factors determining this process. Internally, the material elements assembling the sculptural phenomenon have become increasingly isolated, singularized, and specific; and the procedures of its fabrication as well as the physical laws and forces allowing or generating its appearance in space have become more and more the center of the sculptural investigation. Externally, an analysis of the perceptual relations that connect the sculptural object with the perpetual acts of the subject is incorporated into the very conception and formation of the sculpture. Necessarily resulting from this is an increased and systematic reflection of the interdependence and interrelationships of the sculpture and its surrounding spatial/architectural container.

II

The emergence in sculpture of the 1960s of minimal and post-minimal aesthetics, which form the historical context out of which Michael Asher's work developed, constitutes a major period of modernist sculptural history. Despite numerous and reiterated affirmations by American critics and historians that minimal and post-minimal works are not to be seen in the historical context of modernist sculpture pointed out above, the contrary holds true: too frequent are the references by the artists themselves, implicitly and explicitly, given in works and statements, that acknowledge the rediscovery of plastic principles and theoretical positions which had been articulated in Duchamp's work on the one hand, and in that of the Constructivists on the other (for example, Andre on Rodchenko, Judd on Duchamp and Malevich, Flavin on Tatlin, and Morris on Duchamp). This was precisely the part of the modernist tradition that had been ignored and rejected by the normative aesthetics of Greenberg's formalist "new criticism," which, even though debated and questioned, provided another essential element of the critical foundation against which the new sculptural work could be defined. In addition to this new positivist approach and the discovery of Merleau-Ponty's recently (1965) translated *Phenomenology of Perception,* we see a laconic pragmatism resulting from what Moira Roth has called appropriately *The Aesthetics of Indifference,* from a sceptical investigation into the epistemology of painterly and sculptural signs, and from artists' discovery of logical positivism and semiology. It comes, too, from an ideology of anti-expression (questioning subjective meaning or existential meaning in general), that seemed to have dominated the preceding decade. Stella's famous statement "What you see is what you see" is a lapidary condensation of all these elements.

The formalist concept of "self-referentiality" is the more theoretical prescription by which art until around 1965 had to abide. What in fact amounted to a pictorial or sculptural analogy to the semiological understanding of the sign, its state of being constituted by two different elements—signifier and signified—that were arbitrarily connected, as Saussure had claimed in

1913 in his "Cours de linguistique générale," and the self-reflexivity resulting from that analogy in artistic production, again in principle, if not in explicit theoretical reflections, had been achieved by both Duchamp and Malevich in 1913. One of the first minimal works to expand the notion of self-referentiality to a considerable degree was Robert Morris's *Mirrored Cubes* (1964–65). It found its parallel on the West Coast in the early mirrored cubes of Larry Bell. Both refer explicitly to an unexecuted project by Duchamp, defined in the *Green Box*,[11] suggesting the placement of mirrored cubes on the floor of a room.

Asher went to New York for a year in 1963–64. He became very interested in Flavin's and Judd's work, and constructed tapered wedge pieces in 1966 that follow a similar logic. They were installed flush against the wall and painted over with a color identical to the wall that supported them. As in Morris's early work and Bell's mirrored cubes, the most prominent characteristic of the work is its analytical approach to the actual nature of the plastic phenomenon in its triadic context: to be aesthetical/spatial sign by itself; to be relating to a larger comprehensive spatial, i.e., architectural phenomenon, which may or may not purport its own and different order of signs; and to be embedded, constituted, and activated only through the individual act of perception that the spectator introduces into the interdependence of those two systems. The sign itself, at least in Morris's early work and in Michael Asher's wedge pieces, is clearly determined by an attitude of negating its own importance. Significance other than that of distinction and demarcation between the two dimensions of individual subjective perception and objective spatial condition is denied. Dan Graham, later to become a close friend of Asher's, underwent a similar development in his work, leading gradually out of formalist and minimal aesthetics. He described his conception of an aesthetic structure as follows: "There is a 'shell' placed between the external 'empty' material of place and the interior, empty material of language: systems of information exist halfway between material and concept without being either one."[12]

The formalist notion of self-referentiality was replaced by an increasingly complex system of analysis that would make the work operative rather than self-reflexive. The idea of situational aesthetics implied that a work would function analytically within all the parameters of its historical determination, not only in its linguistic or formal framework. This transformation had already occurred in the development of the original formalist methodology toward materialist semiology and productivist theory.[13]

Three concepts were of crucial importance for this transgression: the notion of specificity, the notion of place, and that of presence. Donald Judd defined his understanding of specificity in regard to sculptural materials still with a clear innuendo toward positivist pragmatism by almost literally transferring a key term of Russian formalist criticism to sculpture. We read in his 1965 essay "Specific Objects": "Materials vary greatly and are simply materials— formica, aluminum, cold-rolled steel, plexiglass, red and common brass and so forth. They are specific. Also they are usually aggressive."[14] Shortly afterwards, Michael Asher and a whole generation of artists embarked on proving that materials are not simply materials but that they are procedurally and contextually determined. As Beveridge and Burn argued against Judd:

Aren't you saying you want the association to be restricted or localized to the object or its immediate (i.e., architectural) environment? Along with an autonomous form of art, you

Figure 4. The Museum of Contemporary Art, Chicago, façade before installation by Michael Asher (see figure 5). Photo courtesy Tom van Eynde.

Figure 5. Michael Asher. The Museum of Contemporary Art, Chicago (June 8–August 12, 1979), view of façade during exhibition. Photo courtesy Tom van Eynde.

wanted a more autonomous art object, what you would call more objective. Traditionally, art objects are associated with other art and art history by way of their materials and by being a conventional type of art object. Such associations would, I suppose, in your words, be specific. But this was the last thing you wanted. The autonomy you developed for your objects had to function in respect to your presupposition of an art (historical) context and hence you still needed a means of associating the object with that context. Since the object itself denied any associations, the physical situation became a more important vehicle. That is to say, the object had to be circumstantially associated with its art context.[15]

The second concept—place—was mainly developed by Carl Andre and Dan Flavin.[16] Andre defined sculpture as place (as opposed to object or anthropomorphic representation). Other than pointing to the spatial specificity of the sculptural work (as opposed to the material specificity that Judd talked about), Andre's definition also originally implied (as did Flavin's practice) a subversive assault on the commodity status of artworks (given that they were moveable objects, contextless, offering themselves to every kind of transaction). Sculpture as place was supposed to integrate into its actual formation the spatial conditions into which it inscribed itself as constituent elements. Dan Graham again observed and described this with lucidity:

> I liked that as a side effect of Flavin's fluorescents the gallery walls became a canvas. The lights dramatized the people (like spotlights) in a gallery, throwing the content of the exhibition out to the people in the process of perceiving; the gallery interior cube itself became the real framework.[17]

Quite independently, the French artist Daniel Buren wrote in 1970 an extraordinarily perspicacious critique of Duchamp's "ready-made" concept which reveals, if read along with Dan Graham's description of Flavin's work, the unreflected and problematic points of the minimalist concept of place, its unconscious indebtedness to Duchamp. He referred to precisely those points that Michael Asher's work was to focus on:

> The Museum/Gallery for lack of being taken into consideration is the framework, the habit . . . the inescapable "support" on which art history is painted. Wishing to eliminate the tableau/support, on the pretext that what is painted can only be illusion, Duchamp introduces into a new framework/tableau a real object, which at the same time becomes artificial, motiveless, i.e., artistic.[18]

The almost literal congruence of the two statements points to the objective nature of these artistic concerns of the post-minimal generation.

Temporal specificity is defined in the third term—presence—which is closely interrelated with its spatial and material counterparts. Again the term implies not only that the sculptural installation is determined by the specific temporal circumstances into which it is introduced, but also that it obtains within these circumstances a specific, temporally limited function and is disposable after its usage in time. Again Graham had pointed this out in looking at Flavin's work when it was shown in Chicago in 1967:

> The components of a particular exhibition upon its termination are replaced in another situation—perhaps put to a non-art use as a part of a different whole in a different future.[19]

Figure 6. Michael Asher. The Museum of Contemporary Art, Chicago (June 8–August 12, 1979), showing aluminum panels from the museum's exterior installed in the Bergman Gallery. Photo courtesy Tom van Eynde.

Asher later started using the term "situational aesthetics," in which both spatial and temporal specificity are combined.

By 1968 it had become fairly clear that the generation of minimal artists had either abandoned the original implications of these aesthetic strategies in increasingly adapting their work again to the offers and needs of the art market—or that these aesthetic strategies in themselves had to be radically modified to maintain their status as a functional tool in the aesthetic inquiry of the historical conditions determining works of art. Michael Asher's first major one-man exhibition, in 1969 at the San Francisco Art Institute, applied the minimal principles of self-referentiality and specificity in spatial and temporal terms with a vigorous directness and analytic immediacy that revealed the unreflected formalist heritage in Minimalism as much as it determined a new understanding of sculptural materiality.

He divided the allocated exhibition space at the San Francisco Art Institute into two halves by constructing a wall of the given exhibition panels that normally served as additional support surfaces in exhibition spaces for the installation of paintings, etc. One half of the room contained an entry/exit door and was fairly dark, because of the wall construction, while light flooded into the other half of the room through windows and a skylight. The bright half of the room was accessible only by a passage left open between the constructed and given walls. Asher described this work as follows: "The presentation at San Francisco was clearly dictated by every element which was available and it suggested a way of working for the future: using just elements which already existed without a great modification to the space."[20]

The very same year, in Europe, a hitherto almost totally unknown artist, Marcel Broodthaers, embarked on, as it seemed at the time, a fairly eccentric adventure: he had printed a well-designed letterhead that announced in conservative typography the foundation of a new museum in Brussels: "Musée d'Art Moderne (Section XIXème siècle), Département des Aigles." He appointed himself director of this museum. The guests, among them Daniel Buren, were invited for an official opening. The official opening speech was delivered by a "real" museum director of a "real" museum in a room (Broodthaers's former "studio") filled with empty wooden picture crates that museums use for the transport of works of art, a number of art picture postcards installed on the walls, and installation equipment. Broodthaers quite clearly had developed an awareness of the Duchamp dilemma; his seemingly eccentric activity turned out to be the beginning of a systematic analysis of the myth of the museum, its transforming capacities in the process of acculturation. As early as 1966 he pointed to the various hidden frames that determine the art object: "Every object is a victim of its nature: even in a transparent painting the color still hides the canvas and the molding hides the frame."[21]

As much as these two works on first observation seem to be incompatible and opposed—which is ultimately explained by the fact that they originate from opposite sources—as much do they reveal upon close analysis their actual historic connection, despite the major morphological and stylistic differences that had developed between European and American art since the 1940s.

To the same degree that Asher's work overcomes the neo-positivist formalism that had marked the work of the preceding generation and that had (however vulgarized and falsified) its origins partly in Constructivism—to the same degree does Broodthaers's work surmount the trap of Duchamp's "ready-made" concept that had kept almost all object-oriented art in its

spell. Both positions—the constructive and the allegorical—seem to coalesce and henceforth determine the historically relevant work in contemporary art production.

It is crucial to comprehend the two installations of Michael Asher at the Art Institute of Chicago (see figs. 1–3) and at the Museum of Contemporary Art in Chicago (see figs. 4–5) in the historical perspective of sculpture (as opposed to a conceptual definition or gesture or to align, which would be even a graver misunderstanding, this work with a neo-Dada-environment tradition, as has been done). Only then do these works reveal all their ramifications. As usual, a detailed and accurate formal analysis of the sculptural phenomena yields access to the works' more general historical repercussions. Asher's sculptural installations seem only to be constituted, however, by conceptual gestures, directions, decisions, and by "found" or "given" objects and materials or, more correctly, conditions and circumstances of a particular situation in a museum/exhibition context. The material of a sculptural production process in both cases is totally negated, to a degree that surpasses even the most radical conceptual definition of a sculptural process as in, for example, Lawrence Weiner's statement from 1968: "A field cratered by structured, simultaneous TNT explosions."[22]

The works inscribed themselves functionally into their own historical spatial context. The museum and they became the dialectical counterpart of their actual historical time, the exhibition period. It becomes apparent that their functional presence and the precision of their function were highly dependent on their actual negation of their own material presence as sculpture.

What, then, are the materials of Asher's installations? Should they actually be called "sculptural" at all, or should they be considered as an application of an academic discipline— the criticism of ideology—within the field of the visual arts? Is the necessity to look at the work in sculptural terms inherent in our own system of description and classification in the traditional historical categories? We can see, however, once looking at the work in the terms of that category, to what extent it inscribes itself into the tradition of the sculptural discourse as much as it integrates itself into the actual historical, i.e., institutional, practice that propounds that discourse.

Jack Burnham, in the context of Haacke's works, which deal equally with the museum and its institutional practices, has described some of the necessities for this:

> . . . he sees the museum and gallery context as an absolutely necessary element for the meaning and functioning of his works. . . . The questions had to be asked in the galleries and the gallery public had to be confronted with its self-portrait in that same environment. The walls of the museum or gallery are as much a part of his work as the items displayed on them. These works also need the "impregnation" of the gallery to set them in opposition to other contemporary art.[23]

The situation in the case of Asher's work, however, is more complex: as a sculptural phenomenon these works talk in their own language about sculpture to sculpture—thus redefining the terminology and commenting, as we have seen, on the present situation of the discourse. Simultaneously and paradoxically, the material terms in which Asher's work manifests itself concretely are as alien to the tradition of the sculptural discourse as they are essential to the actual constitution of the work. As we observed in the case of Degas's and Duchamp's sculptural works that shifted the paradigms of sculpture, it is precisely the degree of negation of the discipline that allows for the work's historical authenticity. Or, put differently, the almost total

alienation from its conventions generates the work's identity, which in one act of double negation reveals and negates both the historical determination of itself as discourse and the conditions of historic and material reality which determine that discourse.

Asher's work at the Art Institute linked and juxtaposed three different situations of display with three different experiences of visual rupture. The first was the withdrawal of a monumental sculptural representation from the display system of the Art Institute's façade, the Allerton Building on Michigan Avenue. The sculpture, a bronze cast from Jean Antoine Houdon's marble representation of George Washington from 1788, which had been installed at the main entrance in 1925, functioned as a focal sign conveying a message of national heritage with the authority of the eighteenth-century aesthetic object against the backdrop of a late nineteenth-century neo-Renaissance building. Asher proposed that as his contribution to the 73rd American Exhibition, the sculpture should be removed from its pedestal and should be placed in its original historical context in an eighteenth-century period room (Gallery 219) containing European paintings, furniture, and decorative arts of the eighteenth century. The sculpture was placed in the center of the gallery on a wooden base, identical in height and color to the other wooden bases in the gallery; the marble pedestal was put into storage. In this second situation of display, a reconstruction of an eighteenth-century interior, the contextualized work of sculpture caused a different rupture: Even though its bright green-blue patina almost matched the turquoise of the painted walls and some of the silk covers of the eighteenth-century furniture, it made it all the more obvious that this work had been put to a different usage in the past and had therefore acquired material features which conflicted with its definition as an object of high art in a well-guarded museum interior. Its usage as a monument made itself felt in a way that Proust once described as "the looks that objects ever have received seem to remain with them as veils."

A Plexiglas box inside the gallery contained information sheets which defined the work as Michael Asher's contribution to the 73rd American Exhibition and directed the viewer to this exhibition in the Morton Wing of the museum. Downstairs, at the entrance of the 73rd American Exhibition, another box containing information sheets (see Appendix A) also gave a description of the work but directed the viewer upstairs to Gallery 219. Therefore, the visitor, who had been circulating in the survey of contemporary work that the 73rd American Exhibition provided, experienced the third rupture when confronting the contextualized sculpture in Gallery 219 between the two exhibition settings and their installation.

This passage through history juxtaposed suddenly a stylistically homogeneous system of conceptual and painterly artwork with the shock of an equally homogenized aesthetic code of the eighteenth century. This confrontation of a visual code of contemporaneity with that of history suddenly historicized the semblance of actuality and dynamic immediacy that contemporary works generate in the viewer's experience and directed their perspective toward the actuality of the historical dimensions in their present experience. Inasmuch as we experience visual rupture as a sensory deprivation, as a negation of expectations, the three experiences of deconstruction that we made while observing Asher's installation at the Art Institute reveal the complex synthesis of motivation that constitutes aesthetic expectation and reception in the contemporary context and comment, therefore, simultaneously on those motivations in production.

Before these will be analyzed we will describe the second work, which was, as it happened, installed simultaneously as a one-man exhibition of Michael Asher at the Museum of

Contemporary Art. Gesturally, the two works were clearly similar: the dismantling of a given architectural display system, elements of a façade. The Art Institute had appropriated for its façade an eighteenth-century work of sculpture (or more precisely a twentieth-century bronze replica), and the architects of the new Museum of Contemporary Art had appropriated the stylistic idiom (or what they had perceived it to be) of minimal sculpture as a linguistic model from which they copied their modular system of architectural decoration. In the first case the appropriation of the monumental sculpture served to convey a message of national authority intertwined with historic credibility and cultural dignity (ironically, the work representing the "Father of the Country" was sculpted by a Frenchman). In the second case the appropriation of the serial modular elements of minimal sculpture was intended to convey the cultural message of a technocratic notion of progress (whether this notion was imbedded already in the idiom of minimal sculpture is disputable). As his work for the Museum of Contemporary Art, Asher stipulated (see Appendix B) that during the exhibition the two horizontal rows of aluminum panels that were in line with the Bergman Gallery windows should be removed from the façade and placed on the interior wall of the gallery. The ten panels from the east side of the building and eight panels from the west were to be arrayed inside in the same formation and sequence, but in an actual position which was not identical to the exterior placements. In the interior installation these eighteen panels were placed sequentially as a planar relief. On the east side ten panels extended twenty-two feet along the wall; the part beginning on the west side (eight panels) extended for twenty-four feet, nine inches toward the center of the wall. This left thirty feet of unused wall space in between in which Sol Lewitt—whose work was exhibited simultaneously in a retrospective show at the Museum of Contemporary Art— executed a black wall drawing. The entire work, both its exterior elements (the withdrawn parts) and its interior elements (the displayed parts), could be viewed from the street.

Once the panels were placed on the walls within the interior they became subject to the perpetual conditions that permit and determine the reading of material entities as symbolic/aesthetic entities. Again, the juxtaposition of the exterior elements (the remaining cladding) and their semifunctional architectural usage and the interior elements (their disfunctionalized painterly display) resulted in a double negation of both architectural and aesthetic (painterly sculpture) discourse. Again, as in the work at the Art Institute, there was a third element of deconstruction: the Museum of Contemporary Art had agreed—five months prior to the first actual installation—to buy the work for its permanent collection. Therefore, a paradoxical situation occurred: once the exhibition was finished and the cladding was reinstalled in its proper place as architectural decoration, the work seemed to cease to exist while, in fact, it was put in storage on the museum's façade, accessible to the public's view at all times, as distinct from work which is normally in storage and inaccessible. Being bound into the specific situation of the architecture, moreover, the work would cease to exist as part of the collection—thus prescribed by the contract between the artist and the museum—as soon as the architecture of the museum would be altered (at that point plans for an expansion were already being discussed).

Conditions of collective reification change gradually (or, under the particular circumstances of crisis, rapidly and drastically). Their aesthetic representations appear accordingly: No longer can any object, whether individually crafted or mass-produced, reflect appropriately the degree of abstraction on which collective reification is operating and institutionalized.

Art production itself has become an activity that shares the conditions of cultural industry. On the one hand, embellishing the corporate image to the public, and, on the other, depending on an elaborate state support system, like cultural civil services, it helps to channel any attempt at critical negation into a hermetically sealed ideology of culture.

During periods of history in which the governing powers want to convey a sense of conclusion (more precisely that history as process and change has been concluded), this experience of subtle oppression and stagnation is extrapolated in monumental public structures. Amnesia, the loss of memory which is at the origin of the destruction of historical dialectics, tends to incorporate itself in false public commemorative representations. Their stability and weight seem to balance off the insecurity that individuals and society at large experience once they have been totally deprived of actively participating in the decision-making process of history. At this point in time sculptors seem to be tempted to offer their services for monumental public commissions which embody those latent tendencies; they fill the gaps of historic identity with gigantic monuments. The recent increase in public commissions for monumental sculpture confirms this hypothesis, and the critics rhapsodize already in a new ideology of post-modernist populism:

> The root of the difficulty would seem to lie back at the turn of the century with the disappearance of the monument. Avant-garde art in general, with its oppressive neutrality of content, has a long history of being perceived by the public at large as irrelevant. Its abstractness, however, is not the problem as much as its failure to conduct a public dialogue. Belief or conviction on the part of the artist, while perhaps the most important single ingredient of a great work of art, is not, as far as the public is concerned, a substitute for symbolic content. . . . The artists who succeed there . . . will be those who are willing to come to terms with the notion of public commitment, who realize that such a stance, far from compromising their work, can infuse it with non-esthetic content which has absented itself from modernist art.[24]

In his two installations in Chicago Michael Asher did not adapt to these historic tendencies but incorporated these tendencies manifestly into his work to make them transparent. The specificity of Asher's installations in regard to all the elements that enter the conception, production, and reception of a sculptural construct results in a model of historicity. This analytical model dismantles the new historism of Post-Modernism where regressions into a mythical language cover the problematic conditions of the present.

Appendix A
Handout prepared by Michael Asher for Art Institute installation

Michael Asher
73rd American Exhibition
The Art Institute of Chicago
June 9–August 5, 1979

The sculpture of *George Washington,* cast in 1917, is a replica of the marble sculpture of 1788 by Jean Antoine Houdon. In 1925 it was installed in front of the Michigan Avenue entrance of the Art Institute.

As my work for the *73rd American Exhibition* (June 9–August 5, 1979), I have moved the sculpture of *George Washington* into the galleries. The sculpture is on the second floor in Gallery 219. For directions please ask one of the guards.

In this work I am interested in the way the sculpture functions when it is viewed in its eighteenth-century context instead of in its prior relationship to the façade of the building, where it has

been for fifty-four years. Once inside Gallery 219, the sculpture can be seen in connection with the ideas of other European works of the same period. By locating the sculpture within its own time frame in Gallery 219, I am placing it within the framework of a contemporary exhibition, through my participation in that exhibition.

Appendix B
Handout prepared by Michael Asher for Museum of Contemporary Art installation

Michael Asher
Museum of Contemporary Art, Chicago
June 8 through August 12, 1979

The newly remodeled building of the Museum of Contemporary Art, designed by the architectural firm of Booth, Nagel and Hartray, was completed in March 1979. The façade of the

museum is planned on a five-and-one-half-foot-square grid pattern and is constructed with glass and aluminum. Two rows of aluminum panels, which are attached to and cover an underlying brick structure, line up horizontally with the two rows of glass windows of the Bergman Gallery. The glassed-in Bergman Gallery functions as a showcase so that art is visible from the street.

In this work, I have removed from the façade the two horizontal rows of aluminum panels that are in line with the

Bergman Gallery and have placed them on the interior wall of the gallery. The ten panels from the east side of the building and the eight from the west are arranged inside so that they correspond exactly to their previous positions outside. After August 12, 1979, the aluminum panels will be reinstalled on the exterior of the building.

This work belongs to the museum's permanent collection. It is intended to be repeated each year for approximately two months, or the length of a temporary exhibition.

1. M. M. Bakhtin and P. N. Medvedev, *The Formal Method in Literary Scholarship* (1928), Baltimore, 1978: 12.

2. R. Krauss, "Sculpture in the Expanded Field," *October* 8 (1979): 33 ff.

3. William Tucker, *Early Modern Sculpture,* New York/London, 1974: 13.

4. Quoted in Tucker (note 3): 9.

5. J. Huysmans, "L'Exposition des Indépendents en 1881," *L'Art moderne,* Paris, 1908: 250–55, quoted in C. W. Millard, *The Sculpture of Edgar Degas,* Princeton, 1976: 124.

6. G. Lukacs, "Reification and the Consciousness of the Proletariat," *History and Class Consciousness,* Cambridge, 1971: 88 f.

7. W. Benjamin, "Zentralpark," *Gesammelte Schriften* I, 2 (1974): 655.

8. On the level of sculptural production, materials, and procedures on which we have tried to focus here, it seems only a matter of time now that the return of bronze casting in sculpture will be celebrated as an innovative and courageous return to the essence and roots of sculpture. As an aesthetic equivalent to ruthless and outright political reaction, casted bronze sculpture offers the stubborn solidity and semblance of perpetuity with which contemporaries can identify. It is noteworthy that even five years ago such a shift would have been almost inconceivable—which again proves to what extent those aspects of aesthetic production carry meaning. Also, it is certainly no accident that Michael Asher's installation at the Art Institute of Chicago integrates a bronze cast into his work, thus quite elliptically pointing to the imminent sculptural reactions without directly participating in them.

9. B. Arvatov, *Kunst und Produktion* (1925), Munich, 1972: 11.

10. Information on this issue is conflicting. In Cleve Gray's *David Smith by David Smith* (New York, 1968: 174) is the following:

> Smith often made a point of his poverty during the thirties and forties and his consequent need to work. In his statement for Elaine de Kooning's article "David Smith makes a sculpture" in *Art News* No. 50 (Sept. '51), page 37, he wrote: "All of my life the work day has been any part of the twenty-four hours on oil tankers, driving hacks and the shifts in factories." His first wife, Dorothy Dehner, has said that Smith exaggerated this aspect of his life greatly and that due to a small income of hers at this time Smith's obligation to work at odd jobs was almost non-existent.

Rosalind Krauss related the following in *Terminal Iron Works* (Cambridge, 1971: 60, n.16):

> In the three years in Schenectady during which he worked eight hours a day in the factory as a welder on M 7 tanks and locomotives, Smith identified himself increasingly with his fellow workers. Not only was he fiercely proud of his status within the factory unit and a "first class armor plate welder" (see Archive IV/280), but his sculptural output dropped off radically at this time, as he became absorbed in his work in the

munitions plant. From 1942 to 1944 he made almost no metal sculpture, beginning instead to learn stonecutting and carving, and in the entire span of those three years, he produced only fifteen pieces.

11. Duchamp's own notes in the *Green Box* read as follows: "Flat container in glass—holding all sorts of liquids. Colored pieces of wood, of iron, chemical reactions. Shake the container and look through it. Parts to look at crossed eyed, like a piece of silvered glass, in which are reflected the objects in a room." See *The Bride Stripped Bare . . . (The Green Box),* London/New York, 1960, n.p.

12. D. Graham, "Other Observations," *For Publication,* Otis Art Institute, Los Angeles, 1976, n.p.

13. See, for example, Bakhtin/Medvedev (note 1) and the radical change in the thinking and writing of Ossip Brik, who shifted from a pure formalist position to one of a committed productivist in *Into Production* (1923). More recently, however, it seems that critics, historians, and artists have become reluctant to acknowledge the historical and aesthetic consequences that their own work generates.

It is symptomatic that artists and critic/historians alike react when confronted with such a radical paradigmatical shift in sculptural production. For example, Rosalind Krauss, whose book *Passages* can be rightfully considered as the most complex and advanced reading of modernist and post-modernist sculpture to date, literally excludes all of those sculptural activities that question the materials and production procedures of traditional modernist sculpture and that conceive "sculptural" phenomena (i.e., perceptual and actual subject/object interactions) within a historically defined and conditioned time/space coordinate system. Krauss does not once mention the work of Asher, Robert Barry, Dan Graham, or Lawrence Weiner—artists who have all substantially redefined the idea of the "sculptural" in their work. This omission of the essential innovations within the very same aesthetic discipline to which a particular study is dedicated ironically enough had its precedent in a publication that ten years earlier was also considered the most advanced critical study of modernist sculpture—Jack Burnham's *Beyond Modern Sculpture*. Published at a time when crucial steps in the definition of minimal sculpture had been taken, this book does not mention Andre once and only randomly deals with the sculpture of the minimalists.

It seems that critic/historians in situations of radical shifts displace their critical attention to highly derivative, secondary, or tertiary forms of academicized artistic production—however conspicuously obsolete—that at least reaffirm the perpetual validity of aesthetic categories and corresponding critical apparati. See, for example, the attention paid by critics to this kind of sculpture by Alice Aycock, George Trakas, Dennis Oppenheim, etc.

Once critics have devoted their work to a particular kind of aesthetic production, they cannot easily acknowledge paradigmatical shifts in historically determined production procedures. Secondary work not only seems to save and justify in retro-

historians' commitment to one particular aspect of the aesthetic discourse (at the price of excluding others) but also seemingly justifies the perpetuation of that perspective and the ongoing application of its obsolete methodological tools. Obviously, this mechanism functions mutually for both artists and critics. Artists in such situations tend to make apodictic statements that shift the category of sculpture from the historical to the ontological level. See, for example, a recent statement by Serra in *October* (10 [1979]: 73) claiming the universal and eternal validity of sculptural notions:

> I have always thought that the basic assumption of film could never be sculptural in any way and to bog the analogy between what is assumed to be sculptural in sculpture and what is assumed to be sculptural in film is not really to understand the potential of what sculpture is and always has been.

14. D. Judd, "Specific Objects" (1965), in *Complete Writings,* New York/Halifax, 1975: 123.

15. K. Beveridge and I. Burn, "Donald Judd," *Fox* 2 (1975): 130.

16. The notion of "place" in sculpture was originally coined by Barnett Newman in regard to his sculptural work *Here I* (1951). It can be assumed that both Andre and Flavin, fervent admirers of Newman's work, derived their concept of place in sculpture from him. For Newman's discussion of his understanding of sculptural place, see H. Rosenberg, *Barnett Newman,* New York, 1978: 63.

17. D. Graham, letter to the author, July 22, 1979.

18. D. Buren, "Standpoints," *Five Texts,* London/New York, 1973: 38.

19. D. Graham, *Pink and Yellow: Dan Flavin,* exh. cat., Museum of Contemporary Art, Chicago, 1967, n.p.

20. M. Asher, unpublished notes.

21. M. Broodthaers, *Moules, Oeufs, Frites, Charbons,* Antwerp, 1966.

22. L. Weiner, *Statements,* New York, 1968, n.p.

23. J. Burnham, *Hans Haacke, Framing and Being Framed,* Halifax/New York, 1977: 137.

24. N. Foote, "Monument, Sculpture, Earthwork," *Artforum* 18 (Oct. 1979): 37.

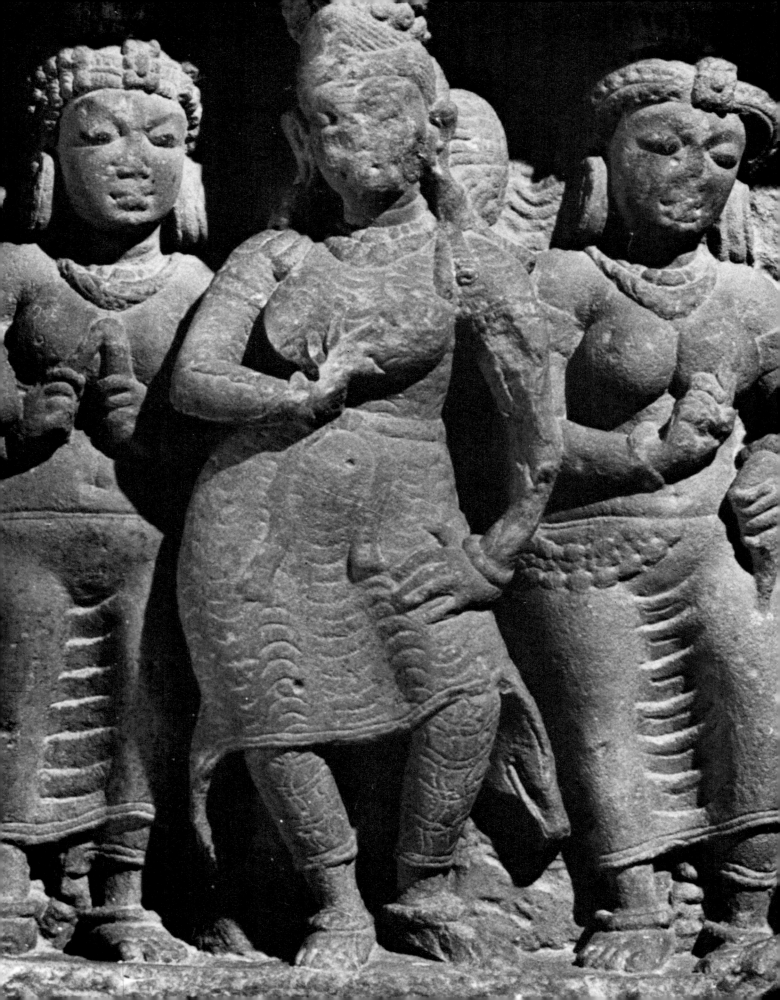

Pratapaditya Pal

The Divine Image
and Poetic Imagery
in Gupta India

The study of Indian art, particularly of the ancient period, is generally concerned with icono-graphic exegesis or with stylistic analysis. The explanation lies partly in the fact that most surviving ancient Indian art is religious. Whereas the majority of historians of Indian art have delved into the religious literature to explain the iconography and principles embodied in the image, very few scholars have discussed the vast body of available secular literature that, in fact, is particularly relevant to appreciating the aesthetic norms underlying a work of art.[1] Notwithstanding the fact that the Indian artist was called upon to create an image according to certain religious precepts, he was also a creative artist. And like the Indian poet, he too was interested in expressing ideas and feelings, moods and metaphors; he was especially eager to experience the flavor, or *rasa,* that was the very essence of his creation.

Although the themes of Sanskrit literature (A.D. 300–600) are often drawn from mythol-ogy,[2] as are those of the visual arts, there is a considerable amount of court poetry that is essentially secular. It has been said that poetry is the clearest mirror of an age, and the Gupta period is extraordinarily rich in this particular literary form. Thus, familiarity with Gupta poetry can enhance considerably our appreciation of Gupta art, which created the aesthetic norms that remained valid for generations of artists in India and a large part of Asia.

The statement that the Gupta period constituted a golden age in Indian history is an exaggeration; nevertheless, the period was one of high intellectual and cultural achievement.[3] It is also commonly said that the age of the Guptas was one of extraordinary spirituality. This too, I believe, is a myth. But it is an understandable reaction when we look at such spiritually moving sculptures as the Sarnath *Buddha* (fig. 1). It is very easy to conclude that such images could be created only by a tremendous upsurge of religious devotion. In fact, the Gupta period was not any more or less spiritual than any other age. By the same token, I do not think Gothic Europe was particularly spiritual, yet the period produced some of the greatest works of Christian art.

Bhartrihari, the most cynical Sanskrit poet living in the Gupta age, wrote as follows:

> Should I sojourn in austerity
> On the sacred riverbank,
> Or should I, in worldly fashion,
> Court women of high grace?

Or drink at streams of scripture
The nectar of rich verse?
In life as transient as a flashing glance,
I can choose no single course.[4]

I think this expresses a universal dilemma faced in every age—that between the spiritual and the material.

In the fifth-century burlesque *Pādatāḍitakam,* by Syāmalika, the stage manager declares: "Away with ministers and saints stealthy as a cat or a crane! Let loafers [*dindika*], jesters and rakes [*vīṭa*] remain; may the assemblies of sharpers [*dhūrta*] ever thirst for drinks! Hermits do not attain heaven by their loud wails; if one is destined to attain heaven, then laughter and mirth will not be an impediment! Therefore, let intelligent men forsake their sour looks and laugh wholeheartedly."[5] This is hardly a picture of a particularly spiritual age. Indeed, the authors of the *purāṇas,* many of which were compiled during the Gupta period, constantly lament the lack of devotion and spirituality and long for the appearance of the apocalyptic Kalki, avatar of Vishnu.

Gupta art was of fundamental significance for the history of much of Asian sculpture, occupying a role similar to that of Greek art in the development of European art. The period between 350 and 550 is considered the time of Southeast Asia's "Second Indianization." Throughout Southeast Asia, artists were affected by the artistic creations of Gupta India. It is essential to note that the general subject of this body of work is the cult figure—images of gods and goddesses and their realm. One finds in the period's literature a similar evocation of this mythological world. Since this was the age when Hinduism was systematized, it was also the period when cult images became standardized and refined. Such objects as the Sarnath *Buddha* inspired sculptors as far away as China. The svelte form, sensuous and abstract modeling, strong contrapposto, and slow, flowing movement of these sculptures are significant aspects of the Gupta aesthetic adapted by other East Asiatic cultures.

To understand another side of the Gupta character, one must look to the period's gold coins (fig. 3), which are extremely significant in that they are the only surviving examples of secular art of the time. No other period in Indian history, in fact, has left such a vast quantity of gold coins. They reflect a very prosperous economy: Gold coins in themselves are an indication of wealth, and these are pure gold. On the obverse of the coins are depictions of the various Gupta monarchs. In their stance, the kings resemble the gods portrayed in the sculptures. Thus, there was really no distinction between religious and secular art in the Gupta age: The same artistic norms were used to depict both humans and deities. This is clearly evident if we compare the images of Lakshmi, the goddess of fortune, on the reverse, and the queen of Chandragupta I on the obverse of one of the coins.

Written evidence left by the Chinese and others reaffirms the remarkable prosperity of the Gupta age. The kings ruled the country very well, with only modest taxation. In view of this fact, contemporary visitors were amazed at how such an empire could flourish. However, graft, or "tea-money," seems to have been a way of life then as it is now. Once again Syāmalika's work is particularly enlightening. When the rake asks his friend whether he has won his case pending in the court, the latter replies: "The situation in the court is that the judge Vishṇudāsa sits and meditates; his brother Kaṅka accuses me of bribery and he has just punished me with a beating. On the other hand Vishṇudāsa scolds me and dozes in the court.

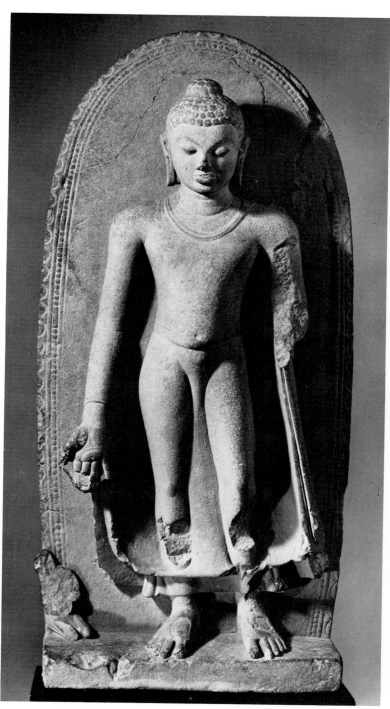

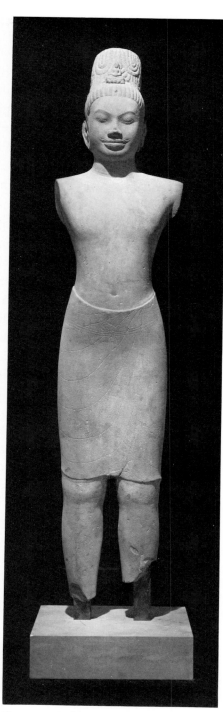

Figure 1. *Buddha Sākyamuni,* Uttar Pradesh, Sarnath, c. 475. Buff sandstone; h. 34⅛ in. New York, Asia House, Mr. and Mrs. John D. Rockefeller 3rd Collection. Photo courtesy Otto E. Nelson, New York.

Figure 2. *Avalokiteśvara,* Cambodia, seventh/ eighth centuries. Philadelphia Museum of Art.

There the officers, the record keeper and clerks all demand money. Even the pious who have been asking for money for some time now have just caught me."[6]

The reason for the period's affluence was trade. Indeed, trade brought the wealth that the Gupta emperors enjoyed and upon which Gupta society flourished. It was probably the most urbane society India had ever seen or would see again until the arrival of the Mughals in the sixteenth century. Expanded commerce and agriculture were made possible by the efforts of the Emperor Samudragupta to push back the forest tribes and clear the land. The wealth of the merchants as well as of the religious establishments led to a tremendous upsurge in artistic patronage. From the paintings of the time, as for instance in the Buddhist cave temples at Ajanta, we gain a vivid picture of the general bustle of the harbor and city life.

The same relationship between economic development and artistic growth has, of course, existed in other places and in other periods in history. In India can be mentioned the earlier Kushana/Satavahana age (first century B.C. to third century A.D.). In Indonesia, the building of the great monuments in central Java during the Sailendra period (eighth–ninth centuries) coincides with increasing maritime enterprise. The merchants of Venice contributed to the encouragement of the arts in that great city-state during the sixteenth century, while the rise of capitalism and overseas trade were behind the rapid upsurge of new subject matter and styles in seventeenth-century Dutch painting.

Unfortunately, the ancient Indian palaces have not survived, nor have any utilitarian objects, which, in royal households, were probably made of silver and gold. Because these were regarded merely as without any religious significance, they were recycled. Few luxury items have survived. Nevertheless, we know that the Gupta court must have been as luxurious and sumptuous as that in contemporary Sassanian Persia. A remarkable silver bowl now in the Cleveland Museum of Art (fig. 4) provides us with only a glimpse of the superb artistry of the Indian metalsmith. And where can we go to identify such scenes or capture the flavor of such themes? Certainly not to religious literature, but rather to the secular literature of the period. In a contemporary text a festival is described as follows:

> How splendid is that eventide festival held with the rising of the moon! . . . It seems that the moon has risen to listen to the prattle of women assembled at a drinking party and its light is reflected in the tips of their earrings. . . . At one place, someone is in the company of his beloved and singing sweetly, at another, the *vīṇā* is being strummed, and at yet another place wine is being drunk at a party.[7]

The richness and vitality of the urban life of Gupta India is vividly described in contemporary literature. For example, in *Chaturbhāṇī,* an early fifth-century text, the capital city, Ujjaini, is described in ecstatic terms as a place of lively, cosmopolitan activity. We are told of the sound of pleasure boats, of banter over the trade of goods brought from across the four oceans, and of Vedic recitation; somewhere there is a learned discussion of drama and poetry, elsewhere the gossip of rakes. People from all over the world—Scythians, Greeks, and so on—converge on the city and create joy everywhere. The author goes on to describe the courtesans' quarters. These women played a very important role in the life of ancient India, particularly Gupta India. The literature contains innumerable references to foreign dancers and courtesans. In a relief from the Daśāvatāra temple at Deogarh, *Dancer with Musicians* (fig. 5), the dancer in the middle is a foreigner—which is evident from her Scythian costume.

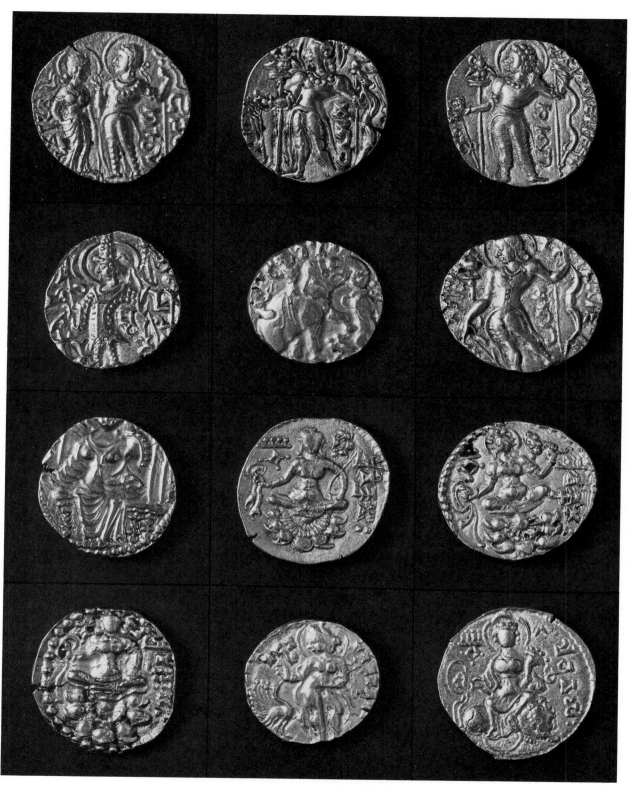

Figure 3. Coins showing Gupta emperors, North India, fourth–sixth centuries (top six coins are obverse; bottom six coins are reverse). Gold; average diam. ¾ in. Los Angeles County Museum of Art, Gift of Justin Dart and Anna Bing Arnold.

Figure 4. *Dish with a Scene of Revelry*, northwestern India, fifth century. Silver with trace of gilt; diam. 7⅞ in. Cleveland Museum of Art, Purchase from the J. H. Wade Fund.

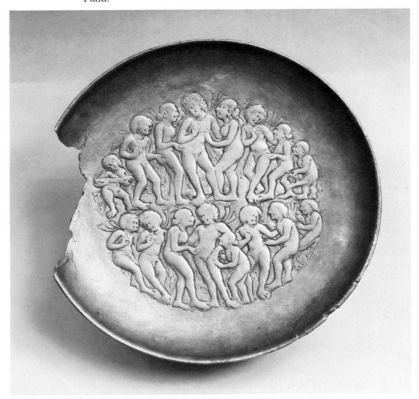

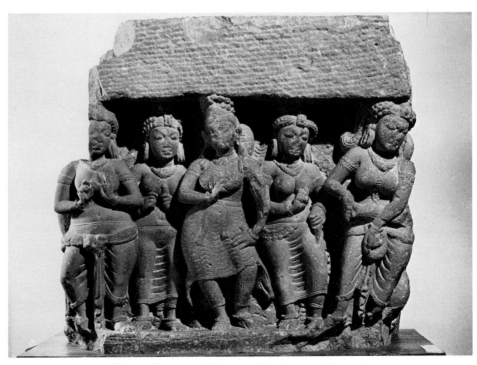

Figure 5. *Dancer with Musicians*, Uttar Pradesh, Deogarh, c. 500. Red sandstone; h. 22¼ in. New Delhi, National Museum.

The paintings of the period help us reconstruct the styles of Gupta buildings. This visual information can be supplemented by such contemporary descriptions as the following, of the city of Daśapura:

> Here the houses have waving flags . . . are full of tender women . . . are very white [and] extremely lofty, resembling the peaks of white clouds lit up with forked lightning. And other long buildings, on the roofs of the houses with arbors in them, are beautiful, being like the lofty summits of [the mountain] Kailāśa; being vocal with songs [like those] of the Gandharvas; having pictured representations arranged [in them]; [and] being adorned with groves of waving plantain trees.[8]

Although such descriptions are somewhat hyperbolic and the surviving structural temples are of modest scale, secular literature as well as accounts left by such visiting Chinese Buddhist pilgrims as Fa-hsien (c. 400) provide us with ample information about contemporary architecture. Whitewashed, lofty buildings, built mostly of brick and timber, with wide terraces and balconies and well-laid-out gardens, were quite common in the cities. Mansions of the wealthy often contained picture galleries, while the pillars and brackets were decorated with caryatids. In his *Raghuvaṃśá,* Kālidāsa left a very poignant description of the deserted palace at Ayodhya, from which we quote the two following verses, which are remarkable not only for their vividness but also for their demonstration of the poet's aesthetic sensibility:

> Wall-painted elephants in lotus-brooks,
> Receiving each a lily from his mate,
> Are torn and gashed, as if by cruel hooks,
> By claws of lions, showing furious hate.
> I see my pillared caryatids
> Neglected, weathered, stained by passing time
> Wearing in place of garments that should please,
> The skins of sloughing cobras, foul with slime.[9]

How such murals with elephants sporting in lotus pools looked may be gleaned from the painted ceilings of some of the Buddhist caves at Ajanta.

Textual evidence also makes it clear that many of the picture galleries in palaces contained murals of historical events and family portraits. The gold coins of the Guptas are today the only surviving examples of portraiture of the period and they depict more than simple busts, as was usually done on coins. Rather, we encounter the emperors engaged in a wide variety of activities, including playing musical instruments, performing sacrifices, and hunting. Despite their diminutive scale, the representations are both perceptive and lively and the various monarchs do have different visages. Nevertheless, the portrayals are idealized and reflect the same artistic norms that were employed to represent the gods, as mentioned above.

We now turn to the aesthetic ideals that inspired the artists of the period to create the images that were to serve as models both in India and elsewhere. To demonstrate the ideal form that the Gupta sculptors created and how it differs from Western tradition, I remind you of the Greek ideal. Lord Clark has noted that "the Greeks had no doubt that the god Apollo was like a perfectly beautiful man. He was beautiful because his body conformed to certain laws of proportion and so partook of the divine beauty of mathematicsThis body, tense as a drawn bow, is in its totality like some Euclidian diagram of energy."[10] Gupta art was also

based on precise mathematical calculations. One did not carve a divine image without adhering to canons of proportions. And yet we all agree that there is a fundamental difference between the Indian approach to form and that which prevailed in the Greco-Roman world. After all, the human body, no matter how perfect, is subject to deformity, disease, and decay, but the gods are eternally youthful and not constrained by physical or terrestrial limitations. Indian artists felt that by simply imitating the form of the most perfect athlete, they would not be able to express divine essence.

Here again, the dry descriptions of iconographical texts cannot help us to appreciate the extraordinary sensuous and graceful forms of Gupta sculptures. We must ask with the most eminent poet of the Gupta age, Kālidāsa:

> Who was the Creator at her making?
> Who was the Creator at her making?
> How could the Old Ascetic, with interest turned
> from beauty of the senses,
> Numb from repetition of the Veda,
> Construct this figure that delights the heart?[11]

The theologian may have conceptualized the image, but it was the artist who imagined and visualized the form.

Let us examine the well-known sculpture from Besnagar depicting the river goddess Gaṅgā (fig. 6). As she stands with her hips thrust, exposing her ample breasts, we know at once that few women in real life could be so beautiful. She is all flesh and no bones; she is palpably sensuous and yet somewhat remote. Her limbs are serpentine, her smooth and velvety thighs remind us of the shape of a banana trunk, her eyes imitate the shapes of the leaves above her head. If we were to read about her in an iconographical text, we would learn the meaning of her posture and her attributes. But to appreciate her elegant form as conceived by an unknown master of the Gupta period, we must turn to her description in the Indian epic *Mahābhārata,* when she appeared before King Sāṃtanu:

> And there he saw one day a beautiful woman who fairly blazed with loveliness, like Srī the lotus goddess come to earth. Her body was flawless, her teeth impeccable, and celestial ornaments adorned her. She was alone wearing a sheer skirt; and she shone like the calyx of a lotus. When he saw her, he shivered, astounded by the perfection of her shape; and this overlord of men could not cease drinking her with his eyes.[12]

The ideal human body in Sanskrit literature is almost invariably described or eulogized in terms of natural forms. Indians believed that in nature there is a constancy of form that is not present in the human body. The rich metaphors the Indian poet drew from nature became the artist's models, so to speak, in creating his ideal form: Fingers looked like bean pods, the thighs of women like the trunk of the banana tree or of an elephant, a man's shoulders like the temple of the bull's head. Frequently in these figures there are three lines around the neck, because its shape was likened to the conch shell's, with its three lines. The shape of a nose was to be curved and strong like a parrot's beak or delicate like the sesame flower. A woman's face resembled the moon; her eyes, lotuses. Not only do these similes relate to basic shapes, but they also express dominant qualities. Thus, the face shares the moon's soft radiance, and the eyes open as gently as lotus buds. In fact, in ancient Sanskrit literature, one of the most

Figure 6. *The River Goddess Gaṇgā,* Madhya Pradesh, Besnagar, c. 500. Beige sandstone; h. 29 in. Boston, Museum of Fine Arts, Charles Amos Cummings Bequest Fund.

Figure 7. *The Goddess Destroying Mahishāsura,* Madhya Pradesh, sixth century. Red sandstone; h. 30⅞ in. Chicago, Mr. and Mrs. James Alsdorf Collection.

Figure 8. *Mother and Child,* Rajasthan, c. 500. Gray schist; h. 30 in. Los Angeles County Museum of Art, Nasli and Alice Heeramaneck Collection.

eloquent ways to express one's appreciation of a woman's walk was: "Oh lady with the large buttocks, your gait is like that of an elephant." The Indian clearly admired the graceful way in which an elephant, and a woman, carry themselves. It might be said that while the exactitude of geometry provided the infrastructure or core, a sense of the flesh was created out of nature's abundance. Indian artists distilled and transformed the essence of nature into the limbs of the human body to create the ideal form "in very vibrant stone."

Another important concept that profoundly influenced the ideal form of Indian sculpture was that of yoga. This may be best demonstrated by the image of the Sarnath *Buddha*. Indians believe that a perfect yogi has both a disciplined body and a calm and controlled mind. In other words, he is the embodiment of both physical and mental harmony. Writers describe the ideal yogi in meditation as one who holds the body, head, and neck both erect and still, while looking fixedly at the tip of his nose without glancing around. Serene, fearless, firm, and resolved, he sits in harmony with himself and the universe. As the Bhagavadgītā (6, 19) says: "As a lamp in a wordless place flickereth not, to such is likened the yogi of subdued thought who practices union with the self." Furthermore, the body of an ideal yogi is not the muscle-bound physique of a body-builder but is smooth, flexible, and yet firm. So too are the bodies of the Indian gods, as we can see in the form of the Sarnath *Buddha* and in that of the serene and elegant Bodhisattva (fig. 2).

Like the poets, Indian artists were not primarily concerned with psychological and physical reality. Even though the dynamic Hindu goddess Durgā is engaged in deadly combat with the buffalo demon, she is cool and composed (fig. 7). Nevertheless, even if the themes are mythological and religious, they do express human feelings and emotions, although with subtlety and suggestiveness. It will not be possible to define at length here the humanistic tradition underlying Gupta art, but one or two objects can suggest its importance.

One of the most beautiful sculptures from this period portrays a divine mother and child (fig. 8). No early European Madonna possesses the naturalism of this representation. Despite its hieratic character, this image of the infant Kumāra, the Hindu god of war, held by his mother, Pārvatī, is warm and informal. The playful child attempts to pull the flowers from his mother's wreath, while she turns her head away indulgently. Here, Kumāra is certainly not the divine general described in religious texts, nor is Pārvatī (as Durgā) the conqueror of the buffalo demon. Rather, they appear here as they are described in Sanskrit poems, where they are lovingly portrayed as a rambunctious child who occasionally gets into mischief and as a permissive mother who is always forgiving. This, indeed, is the lithic counterpart of Kālidāsa's Pārvatī and Kumāra, whose infancy "[is] not very different from human infancy, for he learns to walk, gets dirty in the courtyard, laughs a good deal, pulls the scanty hair of an old servant, and learns to count."[13] As for the mother, we would agree with Kālidāsa that:

> The vision of the infant made her seem
> A flower unfolding in mysterious bliss.[14]

Another theme that has been represented with endless variation by Indian sculptors is that of lovers, both human and divine. After all, love is the very essence of Sanskrit poetry and, just as nature provides metaphors for the human situation, love between man and woman is the constant refrain in the description of nature. As Ryder has stated, "No other poet in any land has sung of happy love between man and woman as Kālidāsa sang."[15] This statement is

Figure 9. *Amorous Couple,* Uttar Pradesh, fifth/sixth century. Terracotta; h. 15¼ in. Cleveland Museum of Art, Purchase from the J. H. Wade Fund.

equally applicable to Indian sculptors. Even in their coins the Gupta monarchs emphasized the importance of conjugal harmony when Chandragupta I was portrayed with his Licchavi queen, gazing at each other as a devoted couple (fig. 3). And in a beautiful terracotta (fig. 9), the happy love between a couple is expressed with grace and subtlety, as the man's left elbow rests gently on the woman's shoulder and her right hand is placed delicately on his thigh. The *rasa* underlying this expression of a tender relationship is the same as that experienced when reading Kālidāsa's beautiful description of Siva and Pārvatī after their marriage. The male may well be Siva, describing a spectacular sunset to his bride as they sit in the majestic Himalayas. The delicacy and refinement of such terracottas clearly reflect a sensibility similar to that of the poets of the age.

It should be evident from this discussion that not only were the visual arts and poetic literature in Gupta India intimately related, but that a knowledge of the latter is essential for an appreciation of the former. Moreover, notwithstanding the predominance of religious themes, Gupta art, like the contemporary poetry, is a clear mirror of the age—sensuous, full of life, humane.

1. C. Sivaramamurti is almost alone in writing extensively about art and secular literature; see his *Sources of History Illumined by Literature,* New Delhi, 1979.

2. Sanskrit, the classical language of India, served the same purpose as did Latin in the Middle Ages, in that it was a unifying force among people speaking diverse dialects.

3. The Brahmanical, or Hindu, religions, such as Vaishnava, Saiva, Sākta, Saura, and Gānapatya, each named after its main deity—Vishnu, Siva, Sakti, Sūrya, and Gānapati, respectively—were codified. Furthermore, the major religious literature of Hinduism was also assembled during this period. The other major religions of the time were Buddhism and Jainism. The two best-known schools of Gupta art are those that developed at the major Buddhist centers at Sarnath and Ajanta. But Buddhism was not pre-eminent; most Gupta emperors were Hindu.

4. B. S. Miller, *Bhartrihari: Poems,* New York, 1967: 125.

5. M. Chandra, *The World of Courtesans,* Delhi, 1973: 153.

6. Ibid.: 159.

7. Ibid.: 162.

8. J. F. Fleet, *Inscriptions of the Early Gupta Kings and Their Successors,* Varanasi, 1970: 85.

9. Kālidāsa, *Shakuntala and Other Writings,* New York, 1933: 173.

10. K. Clark, *The Nude,* Harmondsworth, 1960: 26, 167.

11. D. H. H. Ingalls, *An Anthology of Sanskrit Court Poetry,* Cambridge, Ma., 1965: 177.

12. *The Mahābhārata,* ed. and trans. by J. A. Van Buitenen, Chicago, 1973, I: 219.

13. Kālidāsa (note 9): 173.

14. Ibid.: 172.

15. Ibid.: xviii.

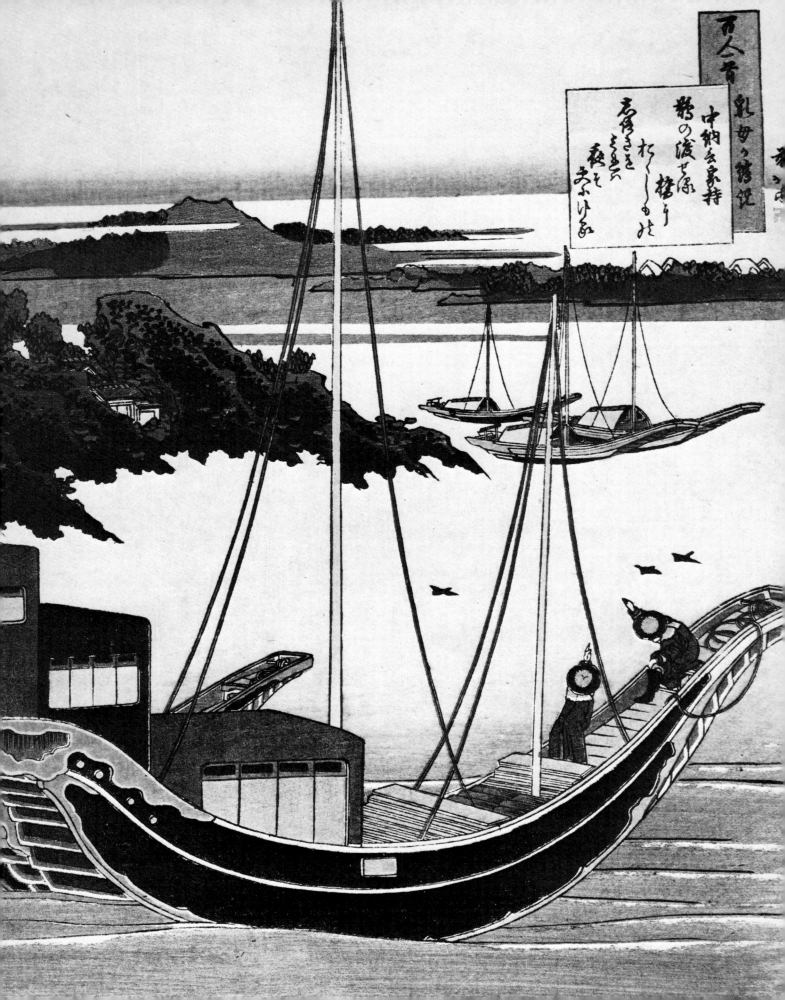

Roger Keyes

Hokusai's Illustrations for the *100 Poems*

Pictures, it is often said, are an old man's art. Katsushika Hokusai, one of the greatest Japanese artists of the Edo period (1612–1867), began his career as a professional artist in 1779. He was enormously productive as a painter, print designer, and book illustrator throughout most of his long life, and yet it was only when he reached his seventies that he began designing the *36 Views of Mt. Fuji* and the other extraordinary sets of brilliant color wood-block prints for which he is chiefly known. The last and most ambitious of these was *Hyakunin isshu uba ga etoki (100 Poems as Seen by an Old Nurse)*. Publication of the set commenced during the spring of 1835 and seems to have been interrupted in early or mid-1836, after twenty-eight prints had been engraved and twenty-seven published. Hokusai continued working on the set through the summer of 1838; sixty-two more of his designs survive as drawings, facsimiles, or wood-block prints. This paper will consider the dating and sequence of the published prints, the attribution of the unpublished drawings, the relation between the poems and the images, and the importance of the set.

Like most of the color wood-block prints Hokusai designed during the 1830s, the illustrations for the *100 Poems* were printed on horizontal sheets of good-quality paper in the standard *ōban,* or large-size format, measuring approximately ten by fifteen inches when untrimmed. The pictures lack printed borders, and the design and colors continue to the edges of the sheet. In the upper right-hand corner of each print is a colored vertical cartouche with the series title. The first four words, *Hyakunin isshu (100 Poems),* are written in Chinese characters. The subtitle is written below this either in Japanese syllables or in a combination of Chinese characters and Japanese script. The cartouche is overlapped by a square upon which is written the text of the illustrated verse and the name of its author. The cartouche is in the shape of a *tanzaku,* or poem slip, and the square, which has a decorative background pattern of colored clouds, represents a *shikishi,* or poem card.

All but one of the illustrations are signed Zen Hokusai Manji. Hokusai changed his name many times in the course of his career. During his apprenticeship he used the name Shunrō; for a brief period in the mid-1790s he signed his pictures Sōri or Hokusai Sōri; he used the name Hokusai by itself through 1813. At the end of that year he gave the name Hokusai to a pupil

and adopted the name Taito, which he used until 1820, when he commemorated entering his second cycle of sixty years by assuming the name Iitsu ("one again"). In the spring of 1834, as he entered his seventy-fifth year, he changed his name for the last time, to Manji ("ten thousand"), using the Buddhist emblem of the reverse swastika for this signature, which appears on most impressions of the *100 Poems* prints. The exceptions are the one unsigned print in the series (Group IV, no. 39; see below) and late impressions of the first ten prints in the series. On these, the character Manji was printed in red, as though it had been added to the original drawing as a hand-stamped seal. This red block, which also contained the mark of censorship and the name of the publisher, was often lost, misplaced, or omitted, so that late impressions of the first ten published prints in the series often appear to be signed simply Zen Hokusai ("formerly Hokusai").

Somewhere on the lower half of most impressions of the published prints are two red printed seals: the round mark of censorship, which contains a stylized form of the character *kiwame* ("examined"), and a square mark that bears the formal name of one of two different publishers, whose names, although written with different characters, are coincidentally pronounced alike: *Eijudō.* Five prints bear the mark of Nishimuraya Yohachi, the publisher of the *36 Views of Mt. Fuji* and most of Hokusai's other important sets of landscape prints. This seal is written with characters meaning "hall of eternal life." The other published prints bear the mark of Iseya Sanjirō, a relatively minor book and print publisher, whose mark does not, to my knowledge, appear on any other important set of prints. This mark is composed of characters meaning "hall of flourishing trees." On five of the prints published by Iseya Sanjirō, Hokusai's name Manji is printed in red. On all the others it is engraved on the key block, like the rest of the signature, and printed in black. The first contemporary mention of the *100 Poems* set is contained in a catalogue advertisement of books and prints published by Nishimuraya Yohachi at the back of a novel by Shinsui entitled *Azami no hana koi no ōgurama (Thistles and the Great Cart of Love),* with illustrations by Utagawa Sadahide, which was published in the spring of 1835. After a list of the Hokusai sets published by Nishimuraya—*36 Views of Mt. Fuji, Waterfalls, Famous Bridges,* and *Small Birds*—the *100 Poems* set is announced as *daishimpan* ("a great new publication"). The only other approximately contemporary mention of the set that has come to light is another advertisement in an undated example of a little book of Hokusai's comb designs republished by Iseya around this time.

The advertisement for Nishimuraya's publications at the end of the novel also states that all three volumes of Hokusai's masterpiece of book illustration, *Fugaku hyakkei (100 Views of Mt. Fuji),* had been completed. This was untrue. In fact, only the first two volumes of the celebrated book, those dated spring 1834 and spring 1835, with embossed pink covers, were published by Nishimuraya. The key blocks for the third volume were engraved in Edo, presumably in the Nishimuraya workshop, but the production was interrupted, and the color blocks seem to have been cut by engravers from another firm, Eirakuya in the city of Nagoya, which eventually published the book. In the spring of 1835, publication rights for the *100 Poems* set passed from Nishimuraya to Iseya Sanjirō, after the appearance of only the first five pictures in the series. This abrupt transfer, as well as the sudden interruption in the publication of *100 Views of Mt. Fuji,* suggests that the well-established and apparently prosperous firm Nishimuraya suddenly and unexpectedly closed in the spring of 1835.[1] Iseya probably hired the same engravers and printers who had been employed by Nishimuraya to produce the first

five prints in the set, because there is no perceptible difference in the craftsmanship of the prints issued by either publisher.

The closing of the great publishing firm Nishimuraya was only a symptom of the economic disorder that began to engulf the entire Japanese nation during this period. From 1833 to 1836 there were droughts, crop failures, and famine throughout the countryside, and by the middle of 1836, the city of Edo was in the midst of a severe recession. Poor people starved in the streets; Hokusai made ends meet by pasting old sketches in scrapbooks and selling them to book dealers, and by painting "rice pictures." He announced that anyone could bring him a sheet of paper or silk with a few dots or lines in it and, for one measure of rice, he would turn them into a picture. In one day he is said to have earned several pecks of rice by this method. The threat of death and the specter of famine brought many urban arts to a standstill; the publication of prints was one of them. By mid-1836, publication of Hiroshige's great *Kisokaido* set was curtailed, and was not begun again until two or three years later. Hokusai's *100 Poems* was stopped at the same time, and publication was never resumed, although the artist continued to produce finished drawings that were meant for publication.

To recapitulate, Nishimuraya published the first five of Hokusai's illustrations for the *100 Poems* in the spring of 1835. Early impressions of these prints have the character Manji printed in red, as do five of the twenty-three prints published by Iseya Sanjirō. It was common in the mid-nineteenth century for large series of prints to be issued in small sets rather than individually. Given this practice, it is reasonable to imagine that the first five prints of *100 Poems* were published as a group, as were the second five, and the remaining eighteen in three or four additional groups before the series was finally interrupted.

In compiling a census of *100 Poems* prints in public and private collections with Mr. Peter Morse, I observed that some examples of the first five prints in the series, those published by Nishimuraya in the spring of 1835, were very late impressions—printed from blocks that were considerably worn. This indicated that the prints were popular in their time, and that large numbers were issued before the print market collapsed around the middle of 1836. Late impressions were a little less common among subjects in the second group of five prints. In general, there seemed to be a correlation between the relative rarity of a print and the presence or absence of any late impressions: The rarest prints were those published closest to the curtailment of publication. Prints have been assigned to the last three groups on this basis, as well as by differences in the choice of written characters in the subtitles. The division presented here, however, is not presented as a final solution and should be revised after further comparison and research. The arabic numerals before each entry indicate the traditional position of the poem in the set. The number is followed by the name of the poet and a brief identifying description of the print.

I. Nishimuraya Yohachi. Manji in red (sometimes lacking on late impressions).
 Circa spring 1835.
 1. Tenchi Tennō. Peasants in autumn field.
 2. Jitō Tennō. Women carrying cloth away from river.
 3. Kakinomoto Hitomaro. Peasants net fishing at night by smoking fire.
 6. Chūnagon Yakamochi, Chinese boats moored by cliff.
 9. Ono no Komachi. Peasant household by cherry tree.

II. Iseya Sanjirō. Manji in red (sometimes lacking on late impressions). Circa mid-1835.

 4. Yamabe no Akahito. Travelers on path by ocean view of Mt. Fuji.

 5. Sarumarudayū. Women returning to village with baskets of leaves.

 7. Abe no Nakamaro. Poet on hilltop surrounded by Chinese friends.

 11. Sangi no Takamura. Abalone divers.

 17. Ariwara no Narihira. Peasants crossing a bridge over a stream.

III. Iseya Sanjirō. Manji in black. Circa late 1835.

 12. Sōjō Henjō. Dancers on a high platform.

 18. Fujiwara no Shigeyuki Ason. Ship sailing to the left.

 20. Motoyoshi Shinnō. Ox and women with parasols by bay.

 24. Kanke. Ceremonial ox cart.

 37. Bunya no Asayasu. Boat in lotus pond.

 52. Fujiwara no Michinobu Ason. Palanquin bearers running down slope.

 71. Dainagon Tsunenobu. Peasants by well and open field.

IV. Iseya Sanjirō. Manji in black. Circa spring 1836.

 28. Minamoto no Muneyuki Ason. Hunters by fire in snow.

 32. Harumichi no Tsuraki. Peasants sawing wood by stream.

 36. Kiyowara no Fukayabu. Pleasure boats on Sumida River.

 39. Sangi no Hitoshi. Poet on dyke in rice fields. (Always unsigned.)

 50. Fujiwara no Yoshitaka. Steam rising from bath. (Two states known, with and without space cut in color block at left for publisher's set.)

 68. Sanjōin. Court ceremony with full moon.

V. Iseya Sanjirō. Manji in black. Circa early or mid-1836.

 19. Ise. Workmen tiling roof.

 26. Teishin kō. Courtier visiting temple.

 30. Mibu no Tadamine. Courtier leaving cottage at dawn. (Key-block proof only.)

 49. Dainagon Yoshinobu Ason. Palace workmen resting by gate.

 97. Gonchūnagon Sadaie (or Teika). Workman stacking wood by salt kiln.

The *Hyakunin isshu (100 Poems),* an anthology of classical thirty-one-syllable verse by one hundred different poets, is said to have been compiled from a collection of poems written on square cards by Fujiwara no Teika (also pronounced Sadaie) (1162–1241) to decorate the walls of his villa near Mt. Ogura, on the western outskirts of Kyoto. Teika was also the editor of the *Shinkokinshū,* a celebrated imperial anthology of thirty-one-syllable verse. Both works, with their elegaic tone and emphasis on themes of love, autumn, melancholy, and longing, express the poetic taste of the thirteenth century.

Many anthologies of one hundred verses were compiled during the medieval period, but the Ogura collection was chosen for use as a card game. As time passed, this game became more and more popular; by the Edo period it was the best known and best loved of anthologies. The game of poem cards was played at the New Year. A collection of one hundred cards was placed on the floor and the players sat around them in a circle. The first half of the poem was written on one side of the card, the second half on the back. The cards were placed face down. The leader of the game slowly began to chant the opening lines of one of the verses. The first player to recognize the verse and seize the card with the closing couplet gained

Figure 1. Katsushika Hokusai, Japanese (1760–1849).
Peasants Net Fishing at Night, illustration of a poem by
Kakinomoto Hitomaro, c. 1835. Colored wood-block
print; 25.7 x 37.6 cm. The Art Institute of Chicago,
Clarence Buckingham Collection (28.1089). The follow-
ing figures all illustrate prints or drawings for prints that
are or were intended to be part of Hokusai's *100 Poems*
(c. 1835–38).

a point. The player with the most cards, or points, at the end of the game was the winner. During the Edo period, books were published to help the players learn the verses. These books, which were usually directed toward women and children, often used the poems for purposes of education and moral instruction. Such anthologies included *Hyakunin isshu hitoyo banashi (100 Poems: a Story for One Night)*, which was written by Ozaki Masayoshi, illustrated by Oishi Matora, and published in 1833, shortly before Hokusai's prints began to appear. The standard format was to portray the poet seated in formal robes, with his or her name written alongside in bold calligraphy. The text of the poem was then given, followed by a commentary which usually began with the phrase *kokoro wa* ("the heart of the poem is . . ."). The commentary might be followed by a small illustration suggesting the season, mood, feeling, or "the heart" of the verse. Both Hokusai and his audience were familiar with these anthologies, and his pictures also served as expressions of the poems' "heart."

Japanese poems are intentionally ambiguous and lend themselves to a variety of interpretations. A Confucian scholar interested in moral instruction would naturally read different meanings into a verse than a warrior, a merchant, or a modern poet. Rather than call his set simply *Hokusai's 100 Poems* (on the model of the *Hokusai Manga* [*Hokusai's Sketchbook*] and other picture books with the artist's name in the title), Hokusai chose to call it *100 Poems as Seen by an Old Nurse*. In keeping with the spirit of the poems themselves, this title is somewhat unclear. Furthermore, it is made less clear (or more suggestive) by Hokusai's deliberate inconsistency in the choice of characters he used to write out the phrase *uba ga etoki*.

The word *uba* can mean any one of four things in Japanese: an old woman, a grandmother, a foster parent or guardian, or a wet nurse. In the spoken language, there is no way of telling which is meant except by context, but there are three different written forms that distinguish the meanings. On over half of the prints and drawings in the set, Hokusai used phonetic syllables to spell out *uba*, but on six he used the characters for "milk" and "mother," which literally mean "wet nurse" and, by extension, imply a person who raises a child in place of the parents—in other words, a foster parent or guardian, something like the old English use of the word "nurse." English writers, therefore, translated the title of the series as *100 Poems Illustrated by the Nurse*[2] or *100 Poems Explained by the Nurse*.[3] But two of the published prints and many of the drawings use the character that means "old woman," and it was this character that appeared in the advertisement for the set in the spring of 1835. So Hokusai either started out with the idea of a guardian and moved toward the idea of an old woman, or had in his mind a combined image of an old female guardian or nurse.

As if this were not enough, Hokusai wrote the word *etoki* in three different ways. *Etoki* means an explanation of a picture, or an explanation through pictures. Hokusai took advantage of both meanings when, on most of the prints and drawings, he wrote the word in phonetic syllables. During the medieval period, popular religious instruction was often conveyed in the form of a commentary on a religious painting, and a certain class of nuns arose, called *etoki bikuni*, who traveled throughout the countryside to teach religion to the common people by telling stories about religious paintings. Hokusai must have been aware of this quasi-religious association, because on six of the published prints and many of the drawings for the set he substituted the character *en (yukari)*, meaning "relationship" or "fate," for the character *e*, meaning "picture," making a new word, *entoki*, which means "expounding relationships" or "explaining fate." There is another, more facetious meaning of *etoki*, which Hokusai certainly

intended at the beginning of the set. *Toku* signifies "solving puzzles and riddles," and several of the early pictures in the set, as we shall see, were based on visual puns or contained visual puzzles to be unraveled.

The artist's general intention, however, seems to have been to visualize the *100 Poems* from the point of view of a wise, detached, down-to-earth old woman who is alternately playful, serious, somber, and who understands the heart of feeling that lies beneath the changing, impermanent forms of the world. With the old woman as his persona and guide in the choice of images for the set, Hokusai seems to have set himself the task of creating visual equivalents of the moods evoked in the verse.

There is a tradition of equivalence among the arts in certain cultures. In India, for example, poets wrote verse and artists painted pictures in sets called *Ragamalas,* in which they sought to convey the emotional qualities of musical modes. Chinese painters tried to evoke the mood of verses in their pictures, while Japanese poets often illustrated their own verse. Hokusai himself had matched images to verse in hundreds of *surimono,* or privately commissioned wood-block prints. But no Japanese artist before Hokusai had ever systematically tried to express in pictures the full range and subtlety of human feeling that are two of the glories of Japanese classical verse.

To encompass this range, Hokusai needed three things: suitable images, suitable forms, and suitable colors. For the images, he turned to the old woman with her lifetime of imagination and experience, who, unlike a soldier, courtier, artist, or poet, with their single points of view, was equally capable of imagining peasants, distant China, or the ancient court. For the forms, he used his own broad repertory. For the color, he went beyond his previous experience and with his printers sought deeper and more intense, saturated pigments, often printing one over another to make them more vivid. The pictures have a greater brilliance and intensity of color than his earlier prints or the work of his contemporaries. Although the set was never completed, the effects of color he created for it served as a model for the brilliantly colored prints that were designed by Hiroshige and artists of the Utagawa school in the next decade.

Color was so important to the *100 Poems* prints and the range of color was so new that it is difficult to imagine the artist leaving the printers with no direct supervision. Indeed, the success of the color in the *100 Poems* prints is all the more remarkable when one realizes that Hokusai was absent from Edo during the period when the prints were being published and did not, therefore, have direct contact with either the printers or the engravers.

Among the few personal documents of Hokusai's career is a series of letters from various places on the Miura Peninsula to Kobayashi Shimbei and a few other Edo book publishers between the end of 1834 and the beginning of 1836, precisely the period when the *100 Poems* was being designed and published. The first two letters, dated the twenty-third of the tenth month and the nineteenth of the eleventh month of 1834, say that affairs were settled with the artist's grandson, and that drawings were under way for a book of pictures of warriors from the Chinese novel *Suikoden* and a book on T'ang poetry for Hanabusa, the publisher. The manuscript would be ready soon, and the artist would appreciate payment. In the next letter, dated the second month of 1835, the artist wrote that he was traveling and that "the old man's brush increased in strength each day." In the fourth letter, written in the middle of the same month, he asked that the book of warriors and another book on the life of the Buddha be engraved by Egawa Tomekichi. As soon as he finished the book of warriors, he intended to begin a medium-sized book of single figures called the *New 100 Poets.* On the thirteenth of the

fourth month of 1835, he wrote that two gold *ryō* and twenty silver *kan* remained of the three gold *ryō* and twenty-two silver *kan* he had borrowed from the publisher Yamafuji at Bakurochō in Edo. On the fourth of the fifth month, he wrote that he was suffering from abdominal pains. On the twenty-ninth of the same month, he acknowledged receipt of one gold *ryō* and forty-two silver *kan* in payment for pages one through eight of the book of warriors. In the eighth letter, written during the summer, he gave lengthy advice to printers, discussed the first two hundred impressions of an edition, enclosed the last three-and-one-half pages of the book on T'ang poetry, and asked Kobayashi to deduct the one *kan* and five *bu* he had borrowed from his fee of forty-two *kan*. In what seems to be the last letter, dated the seventeenth of the first month of 1836, he wrote that he would be out of supplies by the middle of the next month and would come up to Edo. Enclosing a volume of the book on T'ang poetry, he gave advice on carving for the engraver Sugita and noted the discomforts of traveling. He signed these letters with various names: Old Man Manji, Old Manji Mad about Painting, Miuraya Hachiemon, Jinzaburō the Landowner—an Old Man from Out-in-the-Country-Somewhere, Old Manji the Traveler in Uraga, and Old Man Manji Masterless Samurai of India. He also referred to himself on one occasion as Hachiemon the Farmer.

Various reasons have been proposed for Hokusai's departure from Edo: a criminal offense by one of his children, conflict with public authorities over his pictures, debt, the profligacy of his grandson. The only certainty is that he traveled to Ushijima, a rural town near Uraga on the Miura Peninsula in Sagami Province some distance south of Edo, and lived for some time in its vicinity. A descendant of the Kurada family told Hokusai's biographer in the 1890s that he had stayed in their house "because it was his home originally," suggesting that he, or his family at least, had originally come from there. He also added that Hokusai had left behind thirty or forty paintings "which had been sold only recently."[4]

Hokusai was born into the Kawakami family but was adopted when he was around four or five by a mirror-maker named Nakajima Ise. It is generally accepted that Hokusai was born in the rural Katsushika district just east of Edo, but it is possible that he was sent to the countryside before his adoption. If that were true, then he may have returned to Ushijima to rediscover his rural heritage; and the idea of the *100 Poems,* with its abundance of such themes and imagery, may have occurred to him there. It is even possible that a memory of a rural foster mother or wet nurse of his own prompted the choice of the set's subtitle. In any case, his experience living in the countryside gave him opportunities for observation which are recorded in the prints and drawings for the set.

The remarks of the Kurada family member and Hokusai's letters prove that the artist did live in or near Uraga for over a year while the *100 Poems* prints were being published. It is unlikely that all of the letters he wrote at this time are extant, and, since he sent book manuscripts with letters to his book publishers, he may have enclosed drawings for prints in letters to the publishers Nishimuraya and Iseya, as well. The Miura Peninsula is close to Edo, and, given that a book published in the spring of 1836, when Hokusai was still in Uraga, mentions that he lived near Mannen Bridge in Edo, there is also a possibility that he kept a residence in the city and traveled back and forth to Uraga during this period.

One of the earliest prints that Hokusai designed for the *100 Poems* (fig. 1) is the picture of peasants dragging a net upstream. It illustrates the poem by Kakinomoto Hitomaro, which is number 3 in the anthology. The poem reads: *Ashibiki no yamadora no o no shidari o no naganagashi*

Figure 2. Hokusai. *Poet on Hilltop,* illustration of a poem
by Abe no Nakamaro, c. 1835. Colored wood-block
print; 24.9 x 36.3 cm. The Art Institute of Chicago,
Clarence Buckingham Collection (28.1091).

yo o hitori kamo nemu ("The copper pheasant drags its feet along the mountain trails; in bed alone the night drags on like the pheasant's long and drooping tail"). The poet compares the long, sleepless night without his lover to the long, drooping tail of the slow-moving bird. Hokusai placed the poet in the window of a thatched cottage at the foot of the hill in the distance, reserving the foreground for a smouldering fire and a group of fishermen. At first glance, Hokusai seems simply to have composed a picture of net fishing in the countryside which can be enjoyed quite simply for its vivid colors, interesting shapes, and brisk drawing. And yet, the composition is based on a series of ingenious visual puns. The burning twigs in the lower right corner of the print are positioned in such a way as to suggest the shape of a copper pheasant, while the billowing smoke represents its long, long tail. *Nagashi,* the word for "long" in the poem, is also an abbreviation for *nagashiami,* a flow-net of fine mesh that was held across streams to catch fish, especially when they were spawning. *Ashibiki,* a poetic epithet for mountains, is made up of the words "leg" and "pull." Hokusai has translated the phrase into the image of the fishermen who strain with their legs to pull the long flow-net up the stream. *Shidari,* the archaic word for "drooping," also means the drops of water splashing the net. In Japanese, as well as in Western, verse, lovers burn or smoulder with passion. Although the word does not appear in the poem, the fire is burning, and *kogu,* the word for "burn," also means "row," a word linked with fishermen, an accidental association that must have pleased the artist and his audience.

Thus, the word play and visual puns give the picture an intellectual dimension it would have lacked without the poem as a point of reference. Hitomaro's clever verse is matched by Hokusai's equally clever imagery. But the poem also evokes a mood of unrequited physical passion; the poet speaks of the interminable night going on and on as he lies awake, obsessed by thoughts of his lover, who has not come. In some way that is perhaps easier to see than it is to verbalize, Hokusai managed to convey this sense of restless longing. Night is suggested only by the black at the top of the sky and the black shadows on the lake. The hills themselves are bright green, the fishermen are wide awake, and the orange smoke and the rust-brown color of the hilltop seem imbued with the intensity of the poet's desire.

Although it is printed in similar colors and also represents a night scene, the picture of Abe no Nakamaro conveys an entirely different mood (fig. 2). Nakamaro (698–770) was a Japanese nobleman who sailed to China as a young student and entered the service of the emperor Hsuan Tsung. Thirty-five years later an embassy from Japan prevailed on him to return to the land of his birth. The night before his departure, his Chinese friends gathered to pay him homage and say farewell. As the moon rose over the sea, Nakamaro was moved to compose a poem asking if this could be the same moon that rose over the hills in his own native land. Setting sail the next day, the ship was blown off course by a typhoon; the poet was shipwrecked, cast ashore in Vietnam, and seized by the rebellious natives. Eventually he returned to China, re-entered service with the reigning emperor, and remained there until his death without once returning to his homeland. There are no visual puns in this picture. The poet, wearing Japanese robes, is standing, aloof, on the hilltop, surrounded by well-wishers who bow to him in reverence. The moon is reflected on the broad expanse of water. The picture is calm and still, except for the strangely flapping banners at the left, which are meant, perhaps, to suggest the storm that would overtake the boat and prevent the poet's homecoming, adding another degree of pathos to the scene.

Figure 3. Hokusai. *Chinese Boats Moored by Cliff,* illustration of a poem by Chūnagon Yakamochi, c. 1835. Colored wood-block print; 25.3 x 37.4 cm. The Art Institute of Chicago, Clarence Buckingham Collection (25.3397).

Figure 4. Hokusai. *Women Carrying Cloth,* illustration of a
poem by Jitō Tennō, c. 1835. Colored wood-block print;
25.5 x 36.8 cm. The Art Institute of Chicago, Clarence
Buckingham Collection (39.2132).

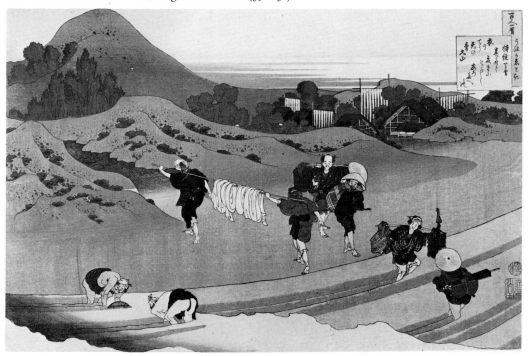

Figure 5. Hokusai. *Women Carrying Cloth,* preparatory
drawing for the published print, c. 1835. Ink and brush
on paper; 27.2 x 38.7 cm. Toronto, Royal Ontario Mu-
seum, Sir Edmund Walker Estate (926.18.598).

Hokusai's illustration for the poem by Chūnagon Yakamochi, number 6 in the anthology, shows an entirely different type of picture, color, and source of inspiration (fig. 3). The poem reads: *Kasasagi no wataseru hashi ni okushimo no shiroki o mireba yo zo fukenikeru* ("I see the white of fallen frost upon the bridge the magpies built to cross, and daylight breaks"). The Magpie Bridge was the name of a staircase leading to one of the chambers in the Imperial Palace. This name and the sense of the poem come from a Chinese legend that the Herdsman and Weaver stars can meet only once a year by crossing the River of Heaven, as the Japanese call the Milky Way, on a bridge made by the interwoven wings of magpies. The poet, who loves someone in the palace, has patiently waited through a long winter night. Despondent as day breaks, he remembers that the lovers cross the Magpie Bridge once a year and his hope returns. The boats in the foreground of Hokusai's picture are Chinese, and the rocky promontory are drawn in a Chinese style. The cabins of the boats might suggest a staircase, and the figures on the boat might represent the poet greeting the pink sunrise and looking out at the surface of the water, which is white like frost. The three birds could be magpies, and perhaps it is not too fanciful to see the shape of the promontory extending out above the water as the wing of some enormous other-worldly bird. Jūzō Suzuki may also be correct in his supposition that Hokusai designed the picture with a Chinese couplet in mind: "Bright moon and few stars, ravens and magpies flying south."[5] This couplet is part of a verse composed by the Chinese general Ts'ao Ts'ao the night before he fought the armies of the Kingdom of Wu by the Red Cliffs on the Yangtse River. In this case, the literary associations are less certain, but the deep-blue, red-brown, and pink colors, combined with the strange boats and the rough, rocky crags, convey a far different mood of love and longing than do the rich greens and yellows of the picture of net fishing.

In later prints, the artist continued to use visual tricks when they suited the subjects. "Where is the moon?" asks the poet Kiyowara no Fukayabu, and Hokusai showed a blank gray sky. The darkest part of the picture is the river, where black is printed over the deep-blue water, and the moon is a porcelain plate a man is rinsing beside his boat. "The autumn wind blows," ends the poem by Dainagon Tsunenobu. But *fuku*, "blow," can also mean "wipe," "thatch," and "spout." There is no sign in the picture of an autumn wind blowing, but a man is shown wiping his feet beside a spouting well beneath a thatched roof. In the illustration for the poem by Fujiwara no Yoshitaka, the languor and satisfaction of fulfillment in love are suggested by the billows of steam rising from a bathhouse, and the relaxed, contented poses of people resting after their bath.

As mentioned at the beginning of this article, Hokusai, despite the interruption of the publication of the set, continued designing pictures for another two years. Although Iseya Sanjirō began publishing actor prints again in 1838, publication of the *100 Poems* was never resumed. However, most of Hokusai's designs have survived in one form or another: fifty-one as drawings, four as modern wood-block prints based on drawings the whereabouts of which are unknown, seven as lithographic facsimiles of drawings (whereabouts also unknown). It is uncertain whether Hokusai illustrated all one hundred verses, but these sixty-two images, together with the single keyblock proof and twenty-seven published prints, make ninety known designs for the set.

All the unpublished drawings once belonged to a Japanese collector named Gyōzan. He placed a seal reading "Gyōzan Shujin" (Master Gyōzan) on the back of each sheet. Nothing is

Figure 6. Hokusai. *Women Carrying Cloth; The Lucky Gods Ebisu and Daikoku,* two preparatory drawings for unpublished book illustrations, c. 1835. Ink and brush with tint; each 17.8 x 11.9 cm. Tokyo, Shozaburo Watanabe Collection.

known about Gyōzan. Judging from his name, he could have been a pupil of Kawanabe Gyōsai, an important painter who admired Hokusai and who owned some of his drawings and prints. Sometime around the last quarter of the nineteenth century, the drawings were acquired by an English collector, Ernest Hart. They were not included in the sale of his collection in 1898, but seem to have passed to the dealer Michael Tomkinson, who planned to publish them all in facsimile, and had many of them reproduced in the Gillotype, or *gillotage,* process—a method of reproduction invented by the nineteenth-century French lithographer Firmin Gillot in which a lithographic image (in this case, a redrawn version of the original drawing) was transferred onto an intaglio plate. In 1907, before this project was completed, the majority of the drawings were purchased by Charles Freer; they are today in the Freer Gallery of Art in Washington, D.C., along with a large and possibly complete collection of the Gillotypes. The other drawings were dispersed at auction, principally at Sotheby's in London, particularly in the Tomkinson, Samuels, and Dankwertz sales. Most of these are in the British and Victoria and Albert museums in London, the Museum of Fine Arts in Boston, and the Metropolitan Museum in New York. Four drawings were purchased by the Japanese collector and publisher Sakai Kōkodō and were published as color woodblock prints around 1920. These four drawings are presently lost, and we cannot establish whether any of the seven drawings known only from Gillotypes still survive. Only two of the drawings, formerly in the Harari Collection in London, are known to be still in private hands.

None of the early collectors expressed any doubt that the drawings for the unpublished prints were by Hokusai himself. Nevertheless, the weakness of the Harari drawings and the recent discovery that a class of professional draftsmen called *hanshita eshi,* or block copyists, earned their livelihood by making the finished drawings from which wood-block prints were engraved, have led Jack Hillier to suggest that the drawings may all have been made by a copyist and not by Hokusai himself.[6] His main arguments are that Hokusai would not draw badly, nor would he have bothered to draw in such painstaking detail when there were professionals to assume that onerous task. There is some evidence that would seem to support this view. The red-wash additions on several of the drawings are clumsy and uncharacteristic, and in one of his last letters from Uraga, Hokusai asked his publisher Kobayashi to "get permission from Egawa [the engraver], and go to the block copyist."

However, Hokusai often drew with painstaking and meticulous detail in his paintings; he had ample time to produce drawings (unlike some of his more prolific contemporaries); and he was so exacting about the quality of his published work that it is difficult to imagine that he would countenance a copyist. Copyists were important in Osaka, where most print designers were amateur artists and poor draftsmen. Their services were also required in the studios of Edo artists like Hiroshige, Kuniyoshi, and Kunisada, all of whom designed over ten thousand prints. By contrast, during the 1830s, Hokusai produced relatively few single-sheet prints: Between 1830 and 1834 he designed approximately 150 color prints, and between 1835 and 1838 he worked on only one project—the *100 Poems* set. After 1836, with Iseya inactive and Hokusai barely able to make ends meet, it is even more unlikely that he would have employed a copyist.

There is no question, though, that the quality of the *100 Poems* drawings varies greatly. This reflects the fact that they were done over a period of several years and that Hokusai's own life and vision of art also changed during this period. Some of the pictures are vigorously drawn;

others combine bold figure drawing with dull, repetitive detail; others seem stale and flaccid. There seems to be a gradual transition between these types of drawings, as though the artist gradually began to lose interest in the set and grew by degrees more perfunctory and absent-minded in his draftsmanship. To my eye, however, even the worst drawings exhibit mannerisms in their brushwork that are characteristic of Hokusai, and appear with more vigor and effect in the better drawings of the series and in other Hokusai drawings that are generally accepted.

If we conclude that Hokusai normally drew his own final versions of drawings for the wood-block engravers, then perhaps he was referring, in the passage cited above, to the calligrapher who was employed to make a fair copy of the text for the engraver. Indeed, in a second letter to Kobayashi, he requested that Matsumoto Moriyoshi write out the fair copy (hikkō) of his preface, "since I am an unlettered old man, and everyone would laugh if I wrote the preface out myself." The weak red-wash work on the 100 Poems drawings, mentioned earlier, is probably a later addition; the red underdrawing, on the other hand, is vigorous and characteristic of Hokusai.

No preparatory sketches are presently known for any of the 100 Poems drawings, but a rough drawing in the Royal Ontario Museum (fig. 5) seems to be a sketch for one of the published prints (fig. 4). A more detailed drawing (fig. 6) is from an album of highly finished drawings for an unpublished illustrated book, now in the Watanabe Collection in Tokyo. The drawings were probably done in 1834 or 1835, and many of them were redrawn and published in two sets of landscape prints: Chie no umi and Shōkei kiran, a series of fan prints. Most Japanese scholars seem to consider that these meticulous drawings were also done by Hokusai, rather than by a copyist.[7]

In the unpublished drawings, Hokusai continued along the path he had marked out for himself in the twenty-eight prints. Some of the pictures are brilliantly composed; others seem rather conventional and dull without their published colors. Among the most interesting are two pictures whose symbolism seems to broaden into allegory and take on deep personal meaning for the artist—something quite unusual in Hokusai's career and in the general history of Japanese art. The poem by Lord Kentoku, number 45 in the anthology, speaks of unrequited love: "Since no one will speak a pitying word, I shall die, and my death will be a fitting end to my folly." Hokusai shows four women spinning thread by a lotus pond and a woman weaving inside a window (fig. 7). The weaver calls to mind the Weaver Star, who is pitilessly separated from her lover, the Herdsman, for all but one day of the year. The Weaver is the star Vega in the constellation of the Lyre ("zither" or koto-za, in Japanese), which is composed of five stars arranged in the position of the women in Hokusai's picture, Vega being the brightest. The drum on which the threads are being spun is inscribed with two Buddhist phrases: sangai yui isshin ("All the phenomena in the universe arise from the workings of the mind") and shinge mubeppo ("Nothing exists separate from the mind or heart"). In this context the eight bands between the threads suggest the Buddhist Eightfold Path, and the picture itself is an allegory of creativity and the nature of art. "The mind," according to the Flower Garland Sutra, the first sermon the Buddha preached after his enlightenment, "like a skillful painter, creates the aggregates. In all the universe there is nothing that does not arise from consciousness."

Two years after the publication of the set was interrupted, Hokusai drew a more personal allegory of human life as an illustration for a poem by Jūnii Ietaka, number 98 in the anthology (fig. 8). The poem mentions the Shinto summer ceremony of purification called misogi, which

326

Figure 7. Hokusai. *Five Women Spinning and Weaving; the Constellation Lyre,* preparatory drawing for an unpublished print illustrating a poem by Lord Kentoku, c. 1837/38. Ink and brush; 25.3 x 37.2 cm. Washington, D.C., Freer Gallery of Art, Smithsonian Institution.

Figure 8. Hokusai. *Purification Ceremony at a Shrine; Allegory of the Artist's Life,* 1838, drawing for an unpublished print illustrating a poem by Jūnii Ietaka. Ink and brush; 25.3 x 37.2 cm. Washington, D.C., Freer Gallery of Art, Smithsonian Institution.

Hokusai took as the subject of his design. A young couple approach the gate of a shrine at night, and a little boy perched on the man's shoulders holds a lantern. Inside the precincts of the shrine, a priest holds a ceremonial wand over a man who kneels in front of a curtain to pray. Walking away from the shrine is a bent old man with a walking stick and a lantern. At the middle of the picture is a banner with an inscription indicating mid-summer in the ninth year, with cyclical signs indicating the ninth year of the Tempo period, or 1838. The rest of the inscription says that the calligraphy was executed by Mitsui Shinna at the age of eighty-one. In fact, the famous Edo calligrapher was this age in the ninth year of the Anei period, that is, 1780, the year in which Hokusai's first illustrated book was published. The lantern the woman carries bears the characters *Ise san,* an abbreviation of the name of the publisher, Iseya Sanjiro, whom the artist may still have expected to resume publication of the set. But Ise was also the name of the young Hokusai's adopted father. The picture seems to be an allegory of his life: approaching the shrine as a child, praying in his early manhood to the hidden god, and walking away in old age, his work accomplished. (The face and pose of the old man are nearly identical to those in Hokusai's famous self-portrait in the Musée Guimet, Paris.)

Perhaps these last two prints brought Hokusai an insight that released him from his ceaseless compulsion to create. At any rate, for the last decade of his life he designed practically no book illustrations or wood block prints, and the few genuine paintings he did in this period convey a sense of great serenity and power.

1. This is corroborated by the research of Mr. Jūzō Suzuki, a leading Japanese *ukiyo-e* scholar, who informed me in private conversation that he has not found any books published by Nishimuraya after this date.

2. B. Stewart, *Subjects Portrayed in Japanese Colour-Prints,* London, 1922: 125.

3. L. Binyon and J. J. O'Brien Sexton, *Japanese Colour Prints,* London, 1923: 172.

4. Iijima Kyōshin, *Katsushika hokusai den,* I, Tokyo, 1893: 61b.

5. From *Sangoku shi engi (The Romance of Three Kingdoms),* a novel dating from the early Ming dynasty (1368–1644).

6. J. Hillier, *Hokusai Drawings,* London, 1966.

7. Suzuki Jūzō, "Chie no umi o megutte," in *Ehon to ukiyoe,* Tokyo, 1979: 331–54.

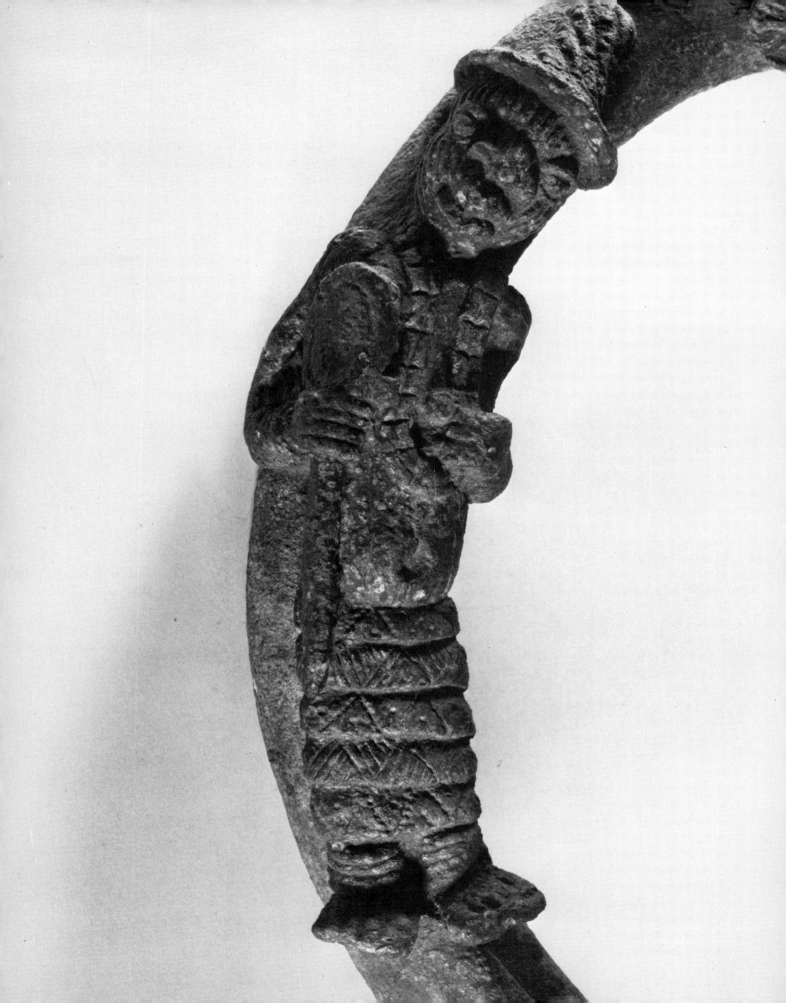

Susan Mullin Vogel

Rapacious Birds and Severed Heads: Early Bronze Rings from Nigeria

Beautiful, wreathlike rings depicting a ghastly subject—vultures devouring severed heads and bound, decapitated bodies—were discovered on altars in Benin in 1897. The meaning and use of these Benin rings was still a mystery in the mid-1970s, when smaller rings, eight to twelve inches in diameter with a fine, green archeological patina, came to light. They had the same arresting motifs, treated in a different style. These rings, which are the subject of this study, were said to have been found in uncontrolled excavations in Ife and to be Yoruba in origin.

Three groups of rings can now be distinguished. Those in a Benin middle-period style (mid-sixteenth to late seventeenth centuries) are the most uniform in iconography and the most numerous; there may be about twenty of them.[1] A second group, which might be called "Lower Niger" or provincial Benin in style, consists of only six rings, which are extremely heterogeneous in iconography and style. The recently discovered Yoruba rings are the only ones that regularly have an archeological patina. These have a very complex and consistent iconography but are executed in several different styles. Ten rings are known in this group.[2]

The Benin rings (figs. 30–33) have a commanding figure on the center front who carries a staff of the "peeled wand" type in his right hand and in his left, a flaring object closely resembling a bronze club found in Benin encrusted with blood and believed to be an executioner's weapon.[3] This central figure wears crossed baldrics on his chest and a pointed cap or coiffure that sometimes has an explicitly rendered braid coming down the front, ending on his forehead. He is flanked by two smaller and less elaborately garbed figures, the one on his right holding a severed human head (often upside down), the one on his left holding a sword. Between these figures and the commanding figure two vessels are usually depicted. They may be simple discs or detailed, with one shown as flat-topped and the other containing two celts, cutting edge up. On the sides of the rings usually are two bound and decapitated figures, two severed heads, and four birds pecking at these human remains. Most Benin rings also have two figures of drummers behind the vultures and bodies. At the center back, all the Benin rings have a pair of small figures wearing crossed baldrics and pointed caps like those of the central figure; they hold what appear to be calabashes whose long necks point away from their bodies.

← See fig. 17.

Figure 1. Yoruba. *Ring 1*. The Metropolitan Museum of Art, Rogers Fund, 1976. Except for figure 36, the medium of each object illustrated here is bronze. Figures 1 through 10 date from before 1700. Their dimensions are listed in the Appendix.

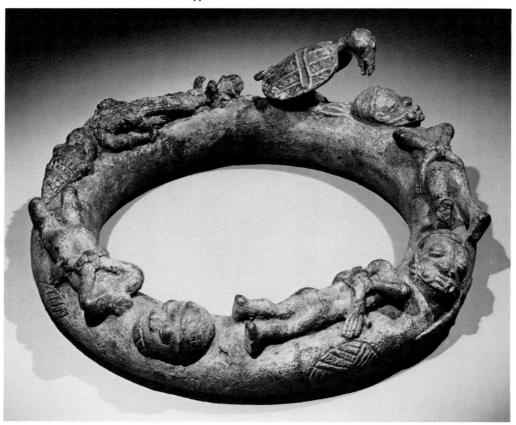

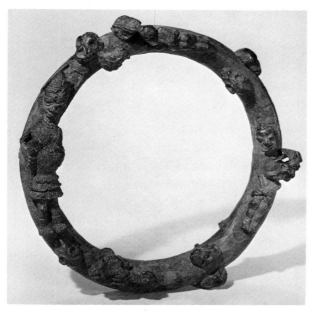

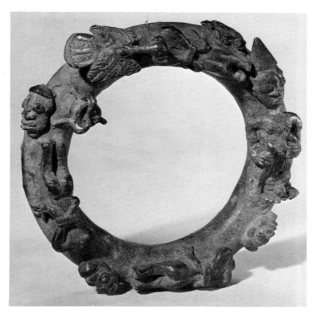

Figure 2. Yoruba. *Ring 2*. New York, Merton D. Simpson Collection. Photo courtesy The Art Institute of Chicago.

Figure 3. Yoruba. *Ring 3*. New York, Merton D. Simpson Collection. Photo courtesy The Art Institute of Chicago.

Frequently lying between these figures is another head or face that may not be severed. Several of these have vertical facial striations like those found on classical Ife sculptures. On the outer surfaces of the Benin rings usually are knives or swords in relief on either side of the commanding figure and elsewhere, and schematically rendered leaves incised into the bronze. Many of these rings appear to have an iron armature inside; none seems to be a hollow cast around a clay core.

Although the interpretation of the Benin rings is not the subject of this paper, several points are important for a consideration of the archeological rings that concern us here. The commanding central figure on these rings does not seem to be the *oba,* or king. The fairly rigid consistency of the rings' iconography suggests that they were made for a very precise ritual purpose, in contrast to the Benin bronze plaques, for example. The homogeneity of their style suggests that these rings were made over a relatively short period. One in the Cleveland Museum of Art has been dated by William Fagg to the late eighteenth century, although he tends to associate them as a group with the middle period of Benin's art history.[4]

The function of the Benin rings remains in question. It was once proposed that they were stands for hiddle-period heads, because they were thought to resemble the flanges at the base of late-period heads.[5] This idea has been discounted because the shape and size of the rings would not have permitted their use in this way. Although often referred to as neck rings,[6] they would have been extremely awkward to wear; furthermore, the careful and extensive depiction of regalia in Benin art does not appear to include any examples of such rings being worn. A ring in a provincial-Benin style in the Metropolitan Museum of Art, New York (fig. 29) arrived labeled with Vice Admiral Sir George le Clerc Egerton's calling card and this notation: "NO. 4 Found with several similar rings upon the Altar. Observe the headless man's arms lashed together above and below the elbows. The ring is much worn with being handled." This precious scrap of information suggests that, like much of Benin sculpture, these bronze rings were altar furnishings.

The second group of bronze rings (figs. 25–29; "Lower Niger" or provincial Benin in origin), six in number, vary considerably in style and iconography. Characteristic of this group is the general absence of full figures, which are found on only two rings. One (formerly Ratton Collection) presents an ill-defined but recognizable parallel to the Benin figure groups in a commanding figure (turned sideways) wearing a braid to one side, attendants, and drummers; another (fig. 27) has a single full figure kneeling and holding one of the long-necked calabashes seen at the back of Benin rings. He does not seem to be the commanding figure, a role that appears to be assumed by a standing head centered on the ring and flanked on either side by three pots. The four other rings lack figures altogether, though all have a head that seems to be commanding because it is not gagged. In three cases this head is crowned with a coiffure that includes a braid at the center front or on the side. It may be significant that in style and coiffure two of these (figs. 26, 28) bear quite a close resemblance to the enigmatic figure found in Benin but believed to be an Ife work.[7] Like the Benin rings, all these provincial ones include medicine pots (shown as shallow rings, often in threes) associated with the commanding head (by proximity or by being placed opposite) or distributed at intervals around the ring. The bodies of the bound, decapitated figures are often rendered in a very rudimentary way, with no volume or detail. While these rings have no motifs on the outer or inner surfaces, a variety of elements are included on the upper surface (a monkey's skull, a

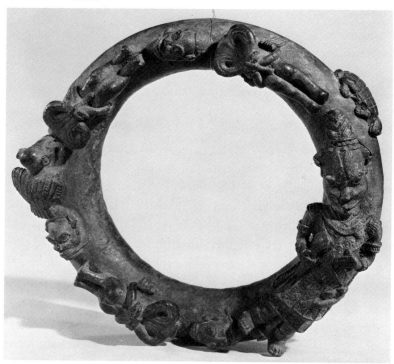

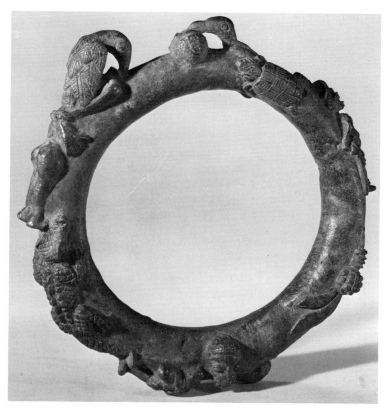

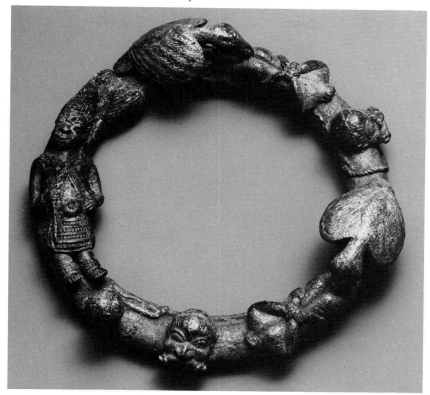

Figure 6. Yoruba. *Ring 6*. Geneva, Barbier-Muller Museum. Photo courtesy P. A. Ferrazzini.

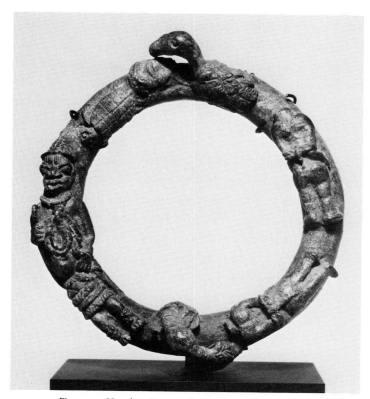

Figure 7. Yoruba. *Ring 7*. Amsterdam, Lode van Rijn Collection. Photo courtesy Sotheby, London.

chicken's head, crescent moons, and knives). None of these appears on more than one ring. The techniques of manufacture of these provincial rings are also varied; two (figs. 26, 28) are very thin casts around a still-present clay core, a technique seen on old Yoruba Ogboni bronzes;[8] others (figs. 27, 29) seem to be quite solid.

The rings in the third, Yoruba group have a green archeological patina—unlike almost all the rings in the other two groups. All ten (figs. 1–10; see also Appendix, where each ring is catalogued) of these archeological rings show a crowned figure in full regalia carrying a staff in the right hand. Though this commanding figure is clearly alive and meant to be seen as standing, the body is always parallel to the surface of the ring. This feature also distinguishes the Yoruba group from all the other rings. Most of the crowned figures wear crossed baldrics on the chest, necklaces, bracelets, and anklets, as well as a tiered skirt wrapper, usually knotted at the hip. Most rings in this group have either a turtle or shells in relief; all but two have a pair of pins joined by a rope in relief. Like the others, these rings show prone, decapitated figures whose elbows are bound, and severed heads, usually gagged with a rope or stick. All have at least one vulture devouring the dead. A limited number of other motifs appear on the rings (see Appendix), all apparently meaningful and all carefully placed in relation to the crowned figure—usually opposite or next to him.

What can be discovered about the meaning of this iconography? The beautiful rings, with their horrific birds and severed heads, are an inviting subject for study because the elements so carefully placed on them look like a ritual inventory, a sort of code that could be interpreted with the aid of other, more familiar art objects and with information about Yoruba history and beliefs. The extensive literature on the Yoruba has, in fact, yielded some indication of the possible meaning and function of the rings, but an examination of the closely related art objects has led to almost every major problem bronze in Nigerian art history. This is frustrating but provocative. Perhaps all these objects of unknown origin have some common unknown link. But let us first examine the iconography of the rings. On the simplest level, the rings appear to depict dramatic and unforgettable sights from the real world, occasions when there were many sacrifices and when vultures were bold and conspicuous in the town. As noted above, the severed heads on the rings wear gags, as sacrificial victims customarily did to be prevented from cursing their executioners, for such a curse could prove fatal.

Human sacrifice is a difficult subject on which to find unbiased information. Early visitors to Africa—missionaries or representatives of the colonial powers—had every reason to make their constituents in Europe believe that the Africans whom they encountered were benighted savages, badly in need of conversion or policing. They tended to exaggerate the prevalence of human sacrifice. When more unbiased observers finally arrived on the scene, human sacrifice had long been forbidden by the colonial rulers and eyewitness reports were impossible to obtain. Human sacrifice seems always to have been regarded as extremely awesome and was reserved for major ritual occasions. Its victims were usually prisoners of war, criminals, slaves, or foreigners, almost never members of what one would regard as one's own group. The rare human sacrifices in Yoruba country were made during the periodic festivals for certain powerful cults and gods and in rites connected with kingship, specifically when a king died and his successor was crowned. Since the rings depict multiple sacrifices (there are from two to four bodies on each), they can be taken to refer to a particularly momentous occasion.

The prisoners on the rings and the vultures with them are rendered with detailed and

336

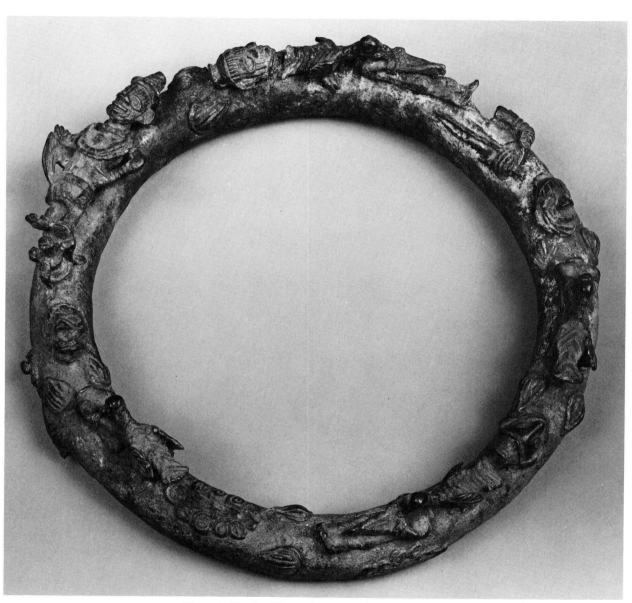

Figure 8. Yoruba. *Ring 8.* Geneva, Barbier–Muller Museum. Photo courtesy The Art Institute of Chicago.

Figure 9. Yoruba. *Ring 9*. Paris, Max Izikovitz Collection. Photo courtesy Studio Contact.

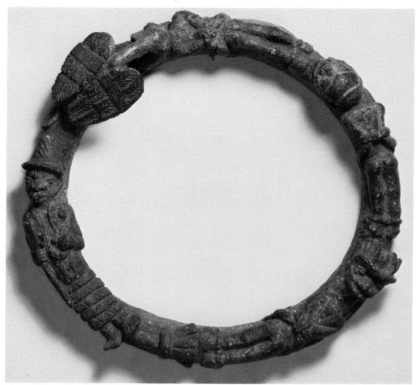

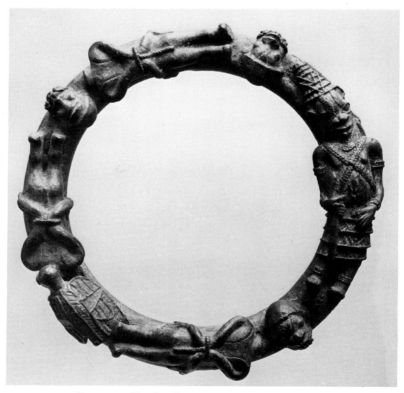

Figure 10. Yoruba. *Ring 10*. Paris, private collection. Photo courtesy Raymond de Seyne.

unusually close observation of nature. The artists depicted wounds on some of the bodies and treated the ropes that bind them with scrupulous naturalism. The vultures' disgusting behavior and characteristic poses are realistically portrayed. They grasp the victims with their claws and plunge their long beaks into the soft parts of the flesh.

But these images are also symbols of the invisible world, not depictions of a mythical world. Certain objects and creatures of the visible world were apparently selected for their metaphoric values. Yoruba beliefs about vultures suggest that the birds here refer to the gods' acceptance of the sacrifice and to "the mothers," the powerful elder women of Yorubaland. An Ifa verse says:

> Salagere, come and eat sacrifice.
> Vulture, come and eat sacrifice
> So that sacrifice may be acceptable to the gods.
> Etie, come and eat sacrifice
> So that sacrifice may be taken away by the gods.
> Vulture, nicknamed Etie, offspring of Ilode.
> One does not always realize that without Vulture,
> One cannot perform a sacrifice.
> Without Akala,
> One cannot perform any propitiation.[9]

Vulture is the messenger of the gods. It is he who carries the acceptable sacrifices away; his failure to do so is a signal of something drastically wrong. In fact, E. Bolaji Idowu has reported that "the greater the avidity with which the carrion birds disposed of the body [in human sacrifice], the better omen it was believed to be . . ."[10] Henry Drewal underscored the fact that vultures carrying away sacrifices specifically indicate acceptance by "the mothers," who, he pointed out, are also known as "the owners of birds."[11]

"The mothers," elderly women with special hidden powers, must be treated with respect and their powers referred to euphemistically, often through the use of bird imagery. A poem praising "the mothers" says:

> My mother Osoronga, arrogant dove that eats in the town
> Famous bird that eats in a cleared farm
> Who kills an animal without sharing with anyone
> One who makes noise (famous one) in the midnight
> Who eats from the head to the arm, who eats from the liver to the heart.[12]

All Yoruba cults, including those that are predominantly male, have at least one high-ranking female official. In the case of the powerful Ogboni society, the representative of the king is always a woman. When the society prepares for the burial of a king and the installation of his successor, Ogboni members must collect money from all households of the town and distribute it to "the mothers." This is considered essential but extremely dangerous work. The covert but crucial participation of "the mothers" was necessary for many rituals, including those for the burial and coronation of kings.[13]

Thus, the birds on the bronze rings have three dimensions. On one level, they are real vultures of the sort that can be seen in African towns and they recall an actual event. On a

second level, they allude to the correct performance of ritual and the acceptance of sacrifice by the gods. And, on a third level, they refer to "the mothers," without whom the ritual cannot be completed.

One of the rings in the group has a large crocodile on it, in addition to two vultures (fig. 5). Along the lagoons, the crocodile is a messenger for the sea gods, taking away sacrifices, including human ones.[14] The crocodile on this ring, then, may be equivalent to the vultures in meaning—appearing, like them, as an emblem of the accepted sacrifice. Alternatively, the crocodile on this ring may be equivalent to the crowned figure, since they are placed directly opposite one another. Though crocodiles are relatively rare in Yoruba art, they are common in Benin, where they symbolize royal power. The fact that this crocodile shows traces of a blackish sacrificial substance that on other rings appears only on the crowned figure further supports this connection.

As noted above, a single pair of slender pins joined by a cord appears in relief (fig. 11) on all but two of the bronze rings (rings 5, 7). These seem to be *edan* Ogboni, bronze and iron emblematic staffs of the Ogboni society of elders (fig. 34). That these might be depictions of garrotes or of rod-gags like those seen in the mouths of some of the severed heads cannot be considered since not only have the prisoners on the rings been beheaded, but garrotes were not used on traditional sacrificial victims, who were usually beheaded alive with a sword. The rod-gags, so carefully rendered on the rings (fig. 1), consist of a single rod (possibly a bone)[15] passing through the mouth and tied around the back of the head with a cord looped over a knob at each end. If pairs of pins were used as gags, two rods would have to appear in the prisoner's mouth.

The argument in favor of *edan* Ogboni is reinforced by a number of other Ogboni references on the rings. The Ogboni is a society of important elderly men and women devoted to the worship of the earth as a spirit. In the traditional Yoruba political system, it also constituted a leading civil authority and served to counterbalance the power of the king. It judged serious offenses and performed a yearly divination to ascertain whether the spirit Earth still supported the king's rule.[16] In this way the Ogboni could approve the king's political decisions or reject his rule. In extreme cases it could order the king to kill himself. The Ogboni also played an essential role in the installation and mortuary rites of kings.[17]

Today, the most common form of the *edan* Ogboni is a pair of bronze figures mounted on iron rods and joined at the head by a chain (fig. 34). These staffs are made for each new member and are used for oath taking, healing, identification, protection, and for magic communication when the *edan* are thought to travel disguised as birds. According to oral traditions, the original form of the *edan* staff was a plain pair of rods joined at the top.[18] The staffs depicted on the rings are plain and unfigured, like those shown in the hands of figures on some *edan*.[19] They are clearly joined not by a chain but by a cord, which is often given some prominence by being spread across the surface of the ring (figs. 2, 6). Denis Williams has suggested that the use of cords may predate that of chains,[20] which would corroborate an early date for the rings. The placement of *edan* on the rings is consistent and associates them with the crowned figure. All appear either alongside the crowned figure or directly opposite him. In every case, the *edan* are placed on the side of the ring and never on the top surface, where most of the other motifs are located. The reason for this is not clear; it may have been simply a design issue of relegating to the sides small, low relief objects. Another widely recognized

340

Figure 11. Detail of figure 4, showing crowned figure and *edan* Ogboni. Photo courtesy The Metropolitan Museum of Art.

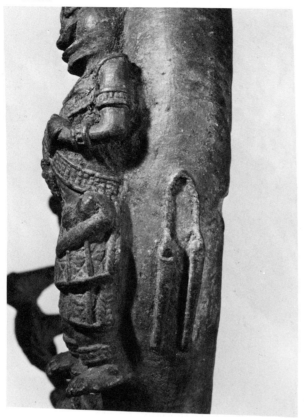

Figure 12. Detail of figure 5, showing left hand holding leaves. Photo courtesy The Metropolitan Museum of Art.

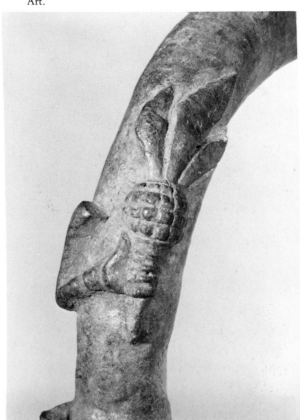

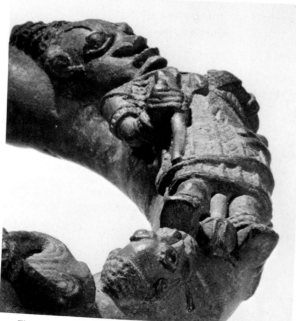

Figure 13. Detail of figure 4, showing crowned figure with pod between legs. Photo courtesy The Metropolitan Museum of Art.

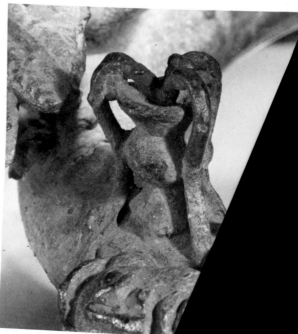

Figure 14. Detail of figure 3, courtesy The Metropolitan Mus

Figure 15. Detail of figure 8, showing vessel and pair of
joined horns. Photo courtesy Barbier-Muller Museum.

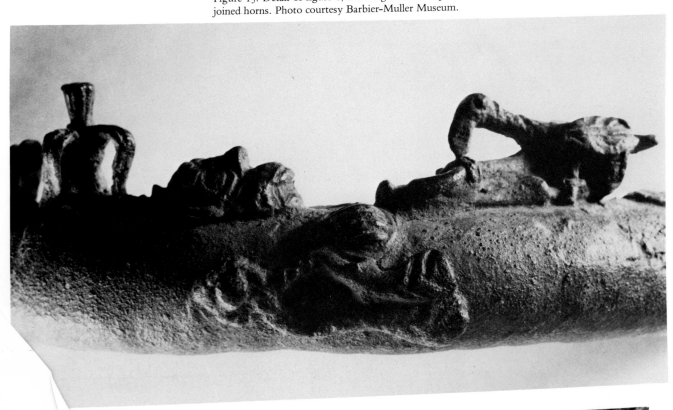

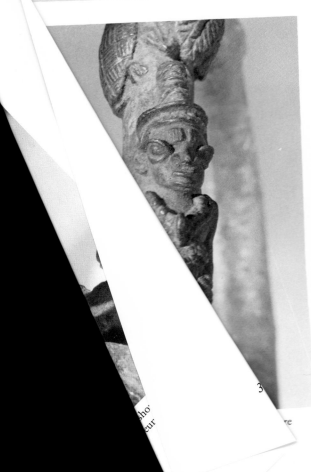

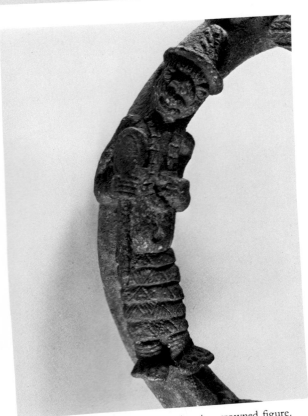

Figure 17. Detail of figure 9, showing crowned figure.
Photo courtesy Studio Contact.

symbol of the Ogboni society is a particular forehead mark in the form of a pair of opposed crescents (figs. 34–35). This distinctive mark is worn by the crowned figure on three of the rings (rings 3–4, 10).

As Robert Thompson so succinctly put it,[21] Ogboni symbolism is concerned with "three-ness, lefthandedness, and the wrong side of the cloth."[22] The empty left hand which rests on the chest or stomach of several of the crowned figures on the rings is enlarged and given remarkable prominence, particularly on ring 3, one of the two rings whose crowned figures have Ogboni forehead marks. On another of the rings (ring 5), a left hand bears three leaves (fig. 12). However, on ring 8, which is aberrant in many respects, a right hand holds a leaf (fig. 18; see also below). "Threeness" is even more central to Ogboni symbolism. An impor-tant Ogboni mystery is expressed in the saying "two Ogboni, it becomes three," a reference to two parts of the *edan* and to the omnipresence of the earth—among other meanings. Four, in contrast, is a number associated with order, completion, and harmony. Four is the number of Ifa, god of divination—a system that brings gods and men into harmony. Probably because the Ogboni regularly consults Ifa for divinations, the rings are replete with number symbolism based on three, on pairs, and on four. One ring (ring 8) has four bound, decapitated prisoners and four vultures. Four rings (rings 2, 5–7) have two prisoners and two birds (equaling four), and five (rings 1, 3–4, 9–10) have three prisoners and one bird (again equaling four). All those with three bodies also have pods emerging from below the skirt of the crowned figure—either a single pod sectioned in three or three separate pods (fig. 13).[23] Three of these rings feature crowned figures with opposed crescent forehead marks typical of the Ogboni. The "threeness" on one of these rings is tempered by the presence of four quartered circles engraved on the side (fig. 1).

Two rings have a small pot on a stand depicted upright on the surface and associated by placement with the crowned figure. On ring 3 it is located opposite him, and on ring 8 beneath his feet (figs. 14–15). While the exact meaning of this vessel is not clear, it too may be a reference to the Ogboni. Thompson remarked that the Ogboni is "correlated with the function of the three stones under the cooking vessel of the woman at the outdoor hearth."[24] The most clearly rendered vessel resembles a type that was used for offerings of palm wine in Ife shrines, according to Ekpo Eyo.[25] The most striking feature of the vessels on the rings is what appears to be a flexible, three-part element rising from the mouth of each vessel and descending to the "ground" or surface of the ring. The identification of these three bands or braces remains unclear, but their "threeness" is consistent with the rest of the iconography of the rings.

The crowned figures on almost half the rings have two blocks of straight-line forehead scarification of a type seen elsewhere in Yoruba and "Lower Niger" art.[26] The numbers of bands in these tiny blocks have been carefully calculated and produced. Ring 2 has four and four, but a different number of bands over each eye is more common. Rings 5 and 7 have three and four (fig. 16), and ring 1 has five and four (the meaning of which is unclear).

Four of the rings depict a tortoise above the head of the crowned figure (rings 3–5, 7).[27] There is never more than one tortoise on a ring, and its position always associates it with the head of the crowned figure. The Yoruba consider the tortoise the most subtle animal,[28] for it is credited with having tricked Death out of his club. A song that describes various aspects of Ogun, god of iron and war, mentions the tortoise as the appropriate sacrifice to the artisans'

shrine to this deity.[29] The placement of the tortoise on the rings may be a reference to the subtlety and intelligence of the crowned figure.

The crowned figure on every ring is clearly depicted as alive and in command. In several cases, his eyes are open and alert, unlike the closed, lifeless eyes of the severed heads. That he is meant to be standing up is shown by the way his garments and beads hang, by the staff in his hand, and by the fact that it would be incongruous for a formally dressed person to be depicted lying down. Fagg has speculated that this might represent a dead king lying in state,[30] but the literature emphasizes the secrecy of royal funerals. The bodies of deceased kings were never displayed, even to their palace intimates—indeed, the very death itself was kept secret.

The "living" figure on each ring wears either a conical crown or a crown of the type Thompson has called "stem on cone," usually with a relief "V" on the front.[31] Yoruba myth describes the origin of these crowns and lists the kings who are entitled to wear them. According to legend, Oduduwa was sent from heaven by the creator, Olodumare ("owner of the sky"), to establish land upon the primeval waters. He later became the first ruler of Ife, the sacred Yoruba city where land first appeared. Oduduwa became the ancestor of other royal dynasties when he sent princes from Ife to found the various Yoruba kingdoms. The number of these original kingdoms varies in different accounts, but the six whose claim is clearest are Oyo, Ijebu Ode, Ketu, Ondo, Ijesha, and the second dynasty at Benin.[32] The primacy of Ife as a religious center is recognized to this day by the Yoruba, who refer to it as "the navel of the earth." Ife also maintains its ancient importance as the source of political legitimacy for many Yoruba kingdoms and Benin. The dispersal of the house of Oduduwa is believed to be the expression, in mythic form, of a historical event that has been placed between 1200 and 1400 (see also below).[33]

Though the crowned figures on the rings are small—they average five inches in height—their regalia is depicted in detail (figs. 16–17). All wear skirts that seem to be tiered and patterned, with straight hems. The skirts are usually knotted at the left hip, but sometimes at both hips. All wear multiple-strand anklets and wristlets, usually crossed baldrics of beads on their chests, with a long necklace and/or a shorter one. The beads never hide the deep navel. In the right hand, these figures all carry a staff, usually disc-topped. Though it is consistent, this regalia is not sufficiently distinctive to be identifiable with any specific one in Nigerian art. Interestingly, the closest parallels are to be found on a group of three bronze aegis plaques of indeterminate style discovered in the walls of the palace at Benin but related to Ife and to the enigmatic Jebba and Tada bronzes.[34] These plaques are a great puzzle in Nigerian art history; two of them have been dated by thermoluminescence to the late sixteenth century.[35] Elements of the regalia their figures share appear in Benin (most notably, the crossed baldrics), in the Tada bronzes (the disc-topped staff), and in Ife (the long necklace and knotted skirt). Similar regalia is also worn by figures on bronze *edan* Ogboni and on bronze bracelets often called "Lower Niger" but likely to be Ogboni bracelets from the Ijebu Yoruba.[36] These parallels raise the possibility that the regalia in question on the bronze rings is that of the Ogboni—the figure is an Ogboni official and not the king. Though the regalia clearly relates to a tradition of Nigerian royal dress going back to Ife, the similarities are indicative only of contact with other courts. I am inclined to believe that the regalia depicted on the bronze rings is particular to their several points of origin, hence the small variations.

The bronze aegis plaques just mentioned have another connection with the Yoruba bronze

344

Figure 18. Detail of figure 8, showing right hand with leaf. Photo courtesy Barbier-Muller Museum.

Figure 18. Detail of figure 8, showing right hand with leaf. Photo courtesy Barbier-Muller Museum.

Figure 19. Detail of figure 2, showing small figure carrying stool. Photo courtesy The Metropolitan Museum of Art.

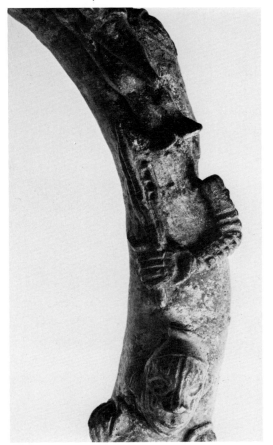

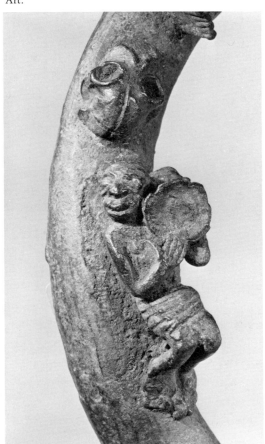

Figure 20. Detail of figure 2, showing small figure carrying stool. Photo courtesy The Metropolitan Museum of Art.

Figure 21. Detail of figure 2, showing stool. Photo courtesy The Art Institute of Chicago.

Figure 22. Detail of figure 2, showing face of crowned figure with scars from corners of mouth to ears. Photo courtesy The Art Institute of Chicago.

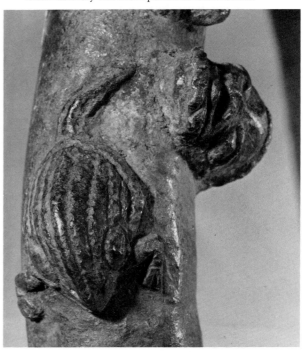

Figure 23. Detail of figure 5, showing shelled creature. Photo courtesy The Metropolitan Museum of Art.

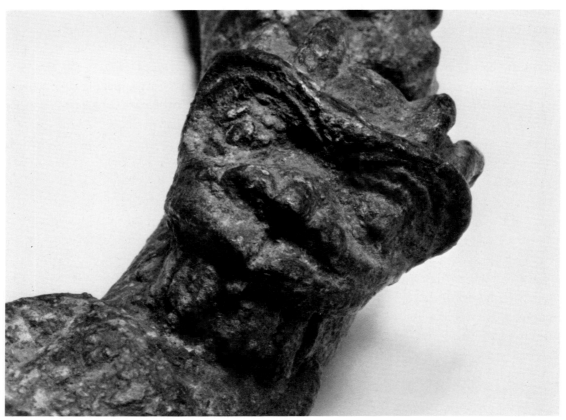

Figure 24. Detail of figure 9, showing monstrous head.
Photo courtesy Studio Contact.

rings. As mentioned above, two of the rings have hands holding long leaves. On ring 5 (fig. 12), a left hand holds three long leaves emerging from a kind of scored ball.[37] On ring 8 (fig. 18), a right hand holds a long, slender, wavering leaf marked with rows of dots. Leaves rarely appear in African art, but they occur in Benin art held by hands depicted on *ikegobo,* altars for the cult of the hand. The long leaves on the rings, however, look quite different from the round, three-leaved branch seen on Benin objects. Rather, they seem much more closely related to terracotta hands holding leaves excavated at Ife and Owo that were probably once part of full figures. A left hand with drooping leaves was excavated at the classical Ife site of Oke Eso.[38] The Ife and Owo leaves are consistently shown as long, slender, paired on a stem, and hanging across the back of the left hand in which they are almost invariably held.[39] The central figures on two of the aegis plaques mentioned above hold similar drooping leaves in the same fashion in their left hands (this part of the third plaque is missing). Eyo has identified the Owo examples as *akoko* leaves, which are used especially in installation ceremonies of chiefs and kings. When a Yoruba king is installed, he is given *akoko* leaves to indicate the authority with which he is being invested.[40]

Though features on the rings seem to point to connections with various Nigerian artistic traditions, the links with classical Ife are the most numerous and most specific. Rings of all three groups—those in Benin-court and provincial-Benin styles, as well as the Yoruba group—have faces on them with the all-over vertical facial scarification that is distinctive of Ife. In many, including four of the provincial-Benin group (figs. 26–29) and two of the Yoruba group (figs. 8–9), the commanding figure bears these scars. Gagged heads are depicted with some frequency in the art of Ife, though they are rarely seen elsewhere. Philip Dark has pointed out their absence in most Benin art, saying that "the portrayal of decapitated heads [*sic*] seems to be a recent trait, probably dating from the eighteenth century on."[41] A prominent feature of the commanding figure on almost all the archeological rings is his fleshy belly with its deep navel. This characteristic treatment of the body in Ife art appears also on the three aegis plaques discussed above. It is seldom found in Benin or Yoruba art.

Curiously, the objects most closely related to the bronze rings are not bronzes but a series of ritual clay pots excavated in Ife (fig. 36). Four such pots and fragments of two others are known. They are globular in shape, with relief decoration around the shoulder—which includes bound, decapitated bodies and other motifs found on the rings. The subject of the pots, like that of the bronze rings, seems to be a sort of inventory of ritual objects. All of the known pots depict the victims of human sacrifice. Some, very like those on the rings, are prone and decapitated with elbows bound; others appear as gagged heads, skulls in shrines, or disembodied legs emerging from a large basket. There are no birds on the Ife pots. However, on the pots are *edan*-like pairs of pins joined by cords similar to those on the rings.[42] To the best of my knowledge, this motif appears nowhere else in the corpus of Ife or Benin art. On one of the bronze rings (ring 8), functioning as a companion to the *edan* staffs on the outer side of the ring alongside the crowned figure, is a pair of curved horns similarly attached by a looped cord (on the outer side of the ring below the crowned figure; fig. 15). Pairs of these horns appear on three of the ritual pots from Ife, also symmetrically opposed to the *edan* staffs. The horns, attached by a cord, may be the same as a pair worn around the neck of a figure of a man suffering from elephantiasis of the scrotum excavated at Osongongon Obamakin, a classical Ife site, from which ritual pots and heads depicting gagged prisoners have also been recovered.[43]

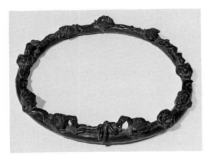

Figure 25. Provincial Benin. *Ring 11*. London, British Museum. Figures 25 through 29 are of unknown date.

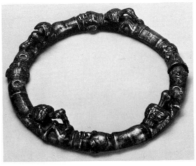

Figure 28. Provincial Benin. *Ring 14*. New York, The Metropolitan Museum of Art, Rogers Fund, 1980.

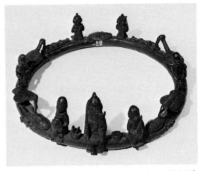

Figure 31. Benin. *Ring 17*. London, British Museum.

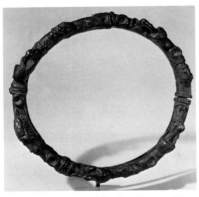

Figure 26. Provincial Benin. *Ring 12*. New York, Alvin Abrams Collection. Photo courtesy The Metropolitan Museum of Art.

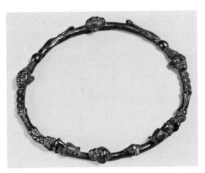

Figure 29. Provincial Benin. *Ring 15*. New York, The Metropolitan Museum of Art, Michael C. Rockefeller Memorial Collection, Nelson A. Rockefeller Bequest, 1979. Photo courtesy The Art Institute of Chicago.

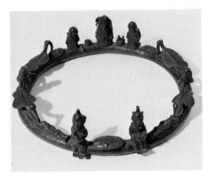

Figure 32. View of figure 31, showing ring from rear.

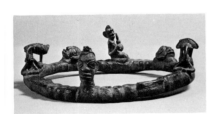

Figure 27. Provincial Benin. *Ring 13*. Dallas, Mr. and Mrs. James Ledbetter Collection. Photo courtesy Evan Maurer.

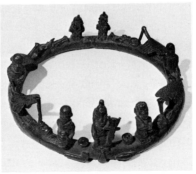

Figure 30. Benin. *Ring 16*. London, British Museum. Figures 30-33 are in the Benin middle-period style and date from the mid-sixteenth to the late seventeenth centuries.

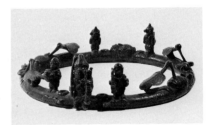

Figure 33. Benin. *Ring 18*. Dallas, Stanley Marcus Collection. Photo courtesy Bill J. Strehorn.

The more or less even disposition of these motifs around the pots recalls the circular disposition on the rings. One wonders if this circular arrangement of ritual objects might not be the origin of the ring form itself, a surface that, after all, is ill-suited for the display of irregularly shaped things. The treatment of the objects on the pots also recalls the rings. In both cases objects are depicted without regard to their relative scale. Moreover, they do not share a common space. Both art forms also present a shifting perspective in which the background—the surface of the pot or of the ring—is alternately perceived as a vertical or horizontal ground. "Standing" figures, shrines, baskets, an arm with leaves are shown as if upright against a vertical background; whereas birds, vessels, and prone, headless figures are depicted as if resting on a horizontal ground. This shifting perspective is a feature common to the ritual pots and the Yoruba rings; the Benin and provincial-Benin-style rings treat the surface as horizontal in a literal-minded and consistent way.

Ritual pots excavated at Ife have been found underneath the potshard pavements that are considered to be a marker for the "classical" period. Two ritual pots were excavated in situ at Obalara's Land, a site dated to 1340 ± 95.[44] The excavator speculated that the presence of *edan* Ogboni on these pots makes ". . . it seem possible therefore that these vessels were the products of a cult ancestral or related to the present Yoruba Ogboni cult. This is perhaps supported by the fact that the [ritual] vessel embedded in the center of pavement B seems to have been a vehicle for libations to the earth."[45] Ritual pot fragments have been excavated at the Ife-related site of Owo (Igbo Laja site, about 75 miles from Ife). Except for a tortoise and a hand that may be holding leaves, Owo pots do not seem to have the same motifs as the bronze rings.

A final feature which may be very significant occurs on only one of the Yoruba rings (ring 2). Beneath the feet of the crowned figure, a small figure carries a stool composed of two rings joining two discs which form the seat and base (figs. 19–21). This is a very unique shape for a stool, yet there are three bronze Nigerian stools almost exactly like it:[46] two long-known from Benin[47] and a third recently collected at Ijebu Ode and now in the University of Ife Museum.[48] This last bronze stool is said to have been used in mortuary rites for Ijebu kings, which again suggests connections between the bronze rings and the death of kings. Since motifs on this stool are related to the enigmatic Jebba and Tada bronzes, the stool has been attributed with them to Owo[49] and Benin,[50] as well as to Ijebu Ode, where it was documented.[51] The crowned figure on the bronze ring on which the small stool appears bears distinctive cheek scars in the shape of a double band, with crosshatching extending from the corners of the mouth to the ear (fig. 22). These are similar to cheek marks on the frontal faces at the base of the bronze stool from Ijebu Ode[52] and are related as well to marks seen on many Ogboni objects known to come from Ijebu Ode—i.e., bronzes (fig. 34) and wooden drums.[53] The frontal faces on the stool also have straight forehead marks like those found on the crowned figures on several rings (rings 1, 5, 7). On the stool and the rings, the two scarification blocks have unequal numbers of bars (proper right to left, they number: ring 1, 5/4; ring 5, 4/3; ring 7, 4/3; stool, 5/4).

Similar cheek marks occur on bronze bells photographed in Ijebu Ode[54] and others found in Ketu but cast at Ijebu Ode,[55] which are, in turn, related to bells of unknown origin found near the Forcados River in the Niger Delta. A bell from the Forcados find has in relief a bound, decapitated prisoner whose neck and anus are being pecked by vultures[56] like those on the bronze rings (ring 6). This figure, his legs spread and elbows bound, is particularly close to

one depicted on a ritual pot fragment excavated at Ife.[57] Long thought to be associated with Benin art, these bells may be related instead to Ijebu Ode and may reflect connections along the coast between Benin and the Lagos (Apapa) area, which was under Ife influence.

Finally, what can be concluded about these rings? Suggestions about the age, origin, and meaning of the bronze rings are all one gains from a study of the literature. Most clear is the iconography, which contains many elements related to kingship: the crowned figures, the hands holding leaves, the crocodile, and the bronze stool. More specifically, many elements are related to the mortuary and installation rites of kings that are performed by the Ogboni society: the human sacrifices, the *edan* Ogboni, the Ogboni forehead marks, the allusions to the number three and to the left hand.

There is a tradition in Benin and in other kingdoms founded by the house of Oduduwa that at the death of a king his successor must be confirmed by the *oni* of Ife, the descendant of Oduduwa. The heads of the *obas* of Benin were traditionally sent to Ife for burial and certain symbols sent back to Benin before a new *oba* could be installed. In Ilesha, the king's body was dismembered and parts buried in different places.[58] In the central Egbado area, similar rites were observed and the king's remains buried in various sacred sites in the town.[59] This was done in secret by the Ogboni and could have included sending part of the body to Ife, as was the Bini custom. From the Yoruba kingdoms of Oyo and Ekiti, swords are sent to Ife to be reconsecrated and returned for the establishment of a new king.[60]

Perhaps the bronze rings served such a purpose and were sent to Ife on the death of a king to signal the legitimate transfer of rule. They would have been a record that the proper sacrifices had been made and accepted, that all the rituals had been observed. The fact that the ten Yoruba rings all came to light over a very short period of time and that all have a fairly similar patina suggest that they were all found in a single place, perhaps a grove or burial place like the one where the heads of the *obas* of Benin were buried. According to hearsay at the time of their discovery, they were found in Ife burials under the heads of the deceased. I would suggest that the rings were made in various Yoruba kingdoms that looked to Ife to legitimize their rulers and that they were later sent to Ife, thus accounting for the diversity of styles found in a single place. It is interesting to note in this connection that the ring "found with several similar rings upon the altar" in Benin (fig. 29) is not a Benin-style object and is very unlikely to have been made there.

For an indication of where in the Ife orbit these archeological rings may have been made, there is only one documented object of related type and style.[61] It is a small (diam. 4⅛ in.) bronze ring, now in the Ife Museum, depicting bound, decapitated victims with vultures on their backs like those on the rings discussed here. It lacks the crowned figure and gagged heads. Unlike the Yoruba group of rings, this ring itself is made up of headless bodies treated fully in the round, revealing that two are male and two female. Spherical forms fill the intervals between them. This bronze was found at Ago Iwoye in Ijebu.

Though we now move further into the realm of speculation, there are other suggestive links between these objects and Ijebu. Like Benin, Ijebu (known as "Geebuu") was an early trading partner of the Portuguese. It was described as a brass-importing and ivory-exporting center by Duarte Pacheco Periera at the beginning of the sixteenth century: ". . . the trade which one can conduct here is the trade in slaves, who are sold for brass bracelets, at a rate of twelve to fifteen bracelets for a slave, and in elephants' tusks."[62] Despite this evidence, almost

no early Nigerian bronzes are now attributed to Ijebu, although many later "19th-century" bronze sculptures are known to have been made there.

Ijebu Ode is one of the Yoruba kingdoms whose original founding from Ife by a son of the house of Oduduwa is undisputed. Although it was a large kingdom with a homogeneous culture, the political structure was fragmented. Crowned *obas* ruled in several towns, including Ago Iwoye, where the small bronze ring in the Ife Museum was found. A. F. C. Ryder has pointed out that in Ife there is no tradition of bronze casting nor any traces of a now-vanished bronze-casting industry.[63] Unlike Ife and Owo, Ijebu, according to oral tradition, has continued as an important bronze-casting center for 500 years. The Ogboni society is of great antiquity and of great importance in the Ijebu area, where it is known as Oshugbo. Williams has suggested that the Ogboni may have originated at Ijebu Ode, while Fagg has pointed out that Ijebu is still the main stronghold of Ogboni/Oshugbo.[64] All of these things indicate a major bronze-casting center in Ijebu of long standing that was connected to Ife and produced works of art for the Ogboni society.

As noted above, the dispersal of the house of Oduduwa is taken to be the mythic expression of historic events that have been dated between 1200 and 1400.[65] The founding of the dynasty at Ijebu can thus be placed between those dates. The close links between Ijebu and Ife coincide with the period in which the great classical Ife bronzes were cast; these links continued until about 1500. The ritual pots at Obalara's Land that are so close to the bronze rings are dated about 1340. During the middle to late seventeenth century, Benin extended its authority along the coast, founded a politically subservient dynasty at Lagos, and brought Ijebu under its sway.[66] Perhaps the bronze rings were cast in the period when Ijebu owed unquestioned allegiance to Ife (i.e., before about 1700) and the idea for the casting of such rings was later transferred to Benin, where the practice continued. Outlying kingdoms and chiefdoms dominated by Benin may, in turn, have cast rings in their various provincial styles to legitimize and commemorate their transfer of rule and sent them to Benin for confirmation (where they were found at the end of the nineteenth century). Rings were also made in pure Benin style by the royal bronze casters perhaps for some analogous use. The connections between the Yoruba rings and classical Ife art argue for a relatively early date for those rings, while the lack of any rings in a Benin style earlier than the middle period can be taken to show that the Benin ones came later.

This march across the stony ground of Nigerian art history leads, like so many others, to provocative suggestions, hints, and hunches, but to few firm conclusions. When I began this research, I had expected to find connections between the Yoruba rings and later (eighteenth-century) Benin art. I was surprised at the direction in which the rings took me. Several of the major problem pieces of Nigerian art now seem to be related to one another[67] and to early bronze-casting—not from Benin or Owo, as had been supposed, but from Ife and Ijebu. (It should be noted that no bronzes have been uncovered in excavations at Owo and that there is no significant bronze-casting tradition there.) Perhaps as research and archeology progress, we will find that a number of different bronze styles were practiced in Ife and in the Ife orbit during the period that produced naturalistic sculptures. We know different styles of terracotta heads were used in Ife in a single period, because one of the ritual pots shows an altar with three heads in different styles, including a very naturalistic one.[68] Thermoluminescence has extended the range of dates for classical-style Ife sculpture up to the first half of the sixteenth

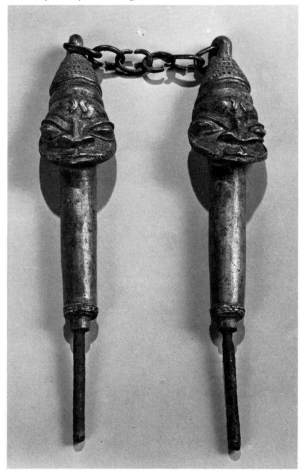

Figure 34. Ijebu Yoruba, 19th century? *Pair of edan Ogboni*. Chicago, Marilyn Houlberg Collection. Photo courtesy Marilyn Houlberg.

Figure 35. Yoruba, date unknown. *Ogboni Society Bracelet*. New York, Freddy Rolin Collection. Photo courtesy The Art Institute of Chicago.

Figure 36. Ife, 12th/15th century. Motifs on a ritual vessel from Koiwo Layout in the National Museum, Lagos. Drawing by Susan M. Vogel.

century, and the dates for the enigmatic Jebba and Tada pieces have been pushed back to become contemporary with classical Ife.[69] These two art styles now seem to have overlapped considerably in time, indicating that the Jebba and Tada bronzes could be provincial (Ijebu?) Ife works. Perhaps we will find that major bronze sculptures were created in Ijebu as early as the 14th through 17th centuries and that mediation between Ife and Benin occurred there and reached across the lagoons, embracing both Ketu and Forcados.

Appendix: A Catalogue of Ten Yoruba Bronze Rings[70]

Descriptions begin with the crowned figure and proceed above his head and on around the ring; within each description, motifs are numbered, and these numbers are used to relate one motif to another.

Ring 1

New York, The Metropolitan Museum of Art, purchase 1976, Rogers Fund

Diam. 7¼ in., largest dim. 7½ in., crowned figure 4¼ in.

Motifs: 1) Figure at right, wearing conical crown with chevron incisions on front, many-tiered skirt knotted at left hip, crossed baldrics with center bead. Has vertical forehead scars in two blocks of five on the right and four on the left, vertical scars on stomach, deep navel. Right hand holds disc-topped staff; left hand rests on beads. 2) Tripartite pod in conical casing emerging from skirt and lying between feet. Above crowned figure: 3) Bound, headless body. 4) Incised quartered circle, on outer surface, even with lower torso of no. 3. 5) Severed head with baleen-like teeth and no lower jaw. 6) Bound, headless body. 7) Circle, as above, on outer surface, even with lower torso of no. 6. 8) Severed head with rod gag. 9) Pair of pins (edan) connected by a band through large loops, on outer surface, even with no. 8 and directly opposite crowned figure. 10) Bound, headless body. 11) Circle, as above, on outer surface, even with hands of no. 10. 12) Severed head with rod gag. 13) Large vulture with band across wings leaning over but not touching forehead of no. 12. 13) Circle, as above, on outer surface, between pod and vulture.

Discussion: The motifs are uniform in size, evenly spaced around the ring, and confined to the upper surface, which is almost entirely covered by them. In style, the ring may be related to ring 10.

Ring 2

New York, Merton Simpson Collection

Diam. 8¾ in., largest dim. 9½ in., crowned figure 5 in.

Motifs: 1) Figure at left wearing conical crown with raised chevrons on front, three-tiered skirt, three-strand choker, and long necklace. Has forehead scars in two blocks of four on the right and four on the left, two long scars from corners of mouth to ears, deep navel. Right hand holds disc-topped staff; left hand rests on stomach. Above crowned figure: 2) Pair of pins (edan) joined by twisted cord, one on inner, one on outer surface, on either side of head of crowned figure. 3) Monkey (?) skull. 4) Severed head with rod gag. 5) Vulture pecking at neck of no. 6. 6) Bound, headless body. 7) Two opposed monkey (?) skulls, side by side. 8) Severed head, as above. 9) Vulture pecking at neck of no. 10. 10) Bound, headless body. 11) Two monkey (?) skulls, as above. 12) Very small figure, with knees drawn up, wearing short skirt wrapper knotted at left hip. Has vertical scars close together on stomach—could be female; plain hairdo. On left shoulder, carries stool composed of top and bottom discs joined by two rings at right angles to the discs. 13) Monkey (?) skull.

Discussion: This ring is a relatively rough cast. Its composition is open, with a somewhat uneven distribution of motifs. The outer surfaces have been used for some skulls and for birds. It was X-rayed by the Metropolitan Museum Research Laboratory and found to be solid metal (no armature, no core).

Ring 3

New York, Merton Simpson Collection

Diam. 7½ in., largest dim. 8 in., crowned figure 4¹³/₁₆ in.

Motifs: 1) Figure at right, wearing patterned, conical crown; long wrapper with basketweave pattern; crossed baldrics, armlets, wristlets, anklets. Has opposed crescent forehead marks. Right hand holds long staff with flattened, broad top; left hand (thumb prominent) held at waist. 2) Unsectioned pod, with dimple at tip, emerging from skirt and lying on feet. Next to crowned figure: 3) Pair of pins (edan) joined by thick band, on outer surface. Above crowned figure: 4) Tortoise with scored circles on shell, on outer surface. 5) Bound, headless body with patterned binding at elbows and three-fingered hands. 6) Vulture with herringbone pattern on wings pecking at neck of no. 5. 7) An upright, round vessel, opposite head of crowned figure, with everted rim, on foot or stand, with three tubular bands emerging from neck, touching sides of vessel, and ending on ring's surface. 8) Severed head with neck and plain, cap-like hair, on outer surface. 9) Bound, headless body, as above. 10) Severed head, as above. 11) Bound, headless body, as above. 12) Severed head, as above.

Discussion: This ring is relatively thick. All bodies are oriented in one direction, all heads in the other.

Ring 4

New York, Freddy Rolin Collection

Diam. 7 in., largest dim. 7 ¼ in., crowned figure 5⅜ in.

Motifs: 1) Figure at right, wearing conical crown with raised chevrons on front and short side lappets (?) (which could also be ears; see below); two-tiered, knee-length, patterned skirt, straight hem, with upper tier rising to left hip and large, unpatterned knot at left hip; crossed baldrics, necklace, armlets, wristlets, anklets. Has opposed crescent forehead marks, ears (?) treated as spirals high on head (or side lappets; see above), prominent breasts (could be female); navel indicated as a depressed ring. Right hand holds short, disc-topped staff; left hand rests on stomach. 2) Tripartite pod on stem emerging from skirt and lying between legs. Next to crowned figure: 3) Pair of pins (edan) joined by cord through loops, on outer surface. Above crowned figure: 4) Tortoise with scored shell, on outer surface. 5) Bound, headless body with parallel scarifications up back and down arms, rope dangling from knot, hands treated as bands. 6) Severed head with rope gag, punched hair texture. 7) Bound, headless body, as above. 8) Vulture with one leg, parallel and raised pattern on wings and tail, pecking at neck of no. 7. 9) Severed head, as above. 10) Bound, headless body, as above. 11) Severed head, as above.

Discussion: The ring is relatively thick and its casting very detailed. The composition is orderly—all figures lie squarely on the upper surface except for the tortoise and the edan Ogboni. The head of the crowned figure closely resembles faces on some Ogboni bracelets. A blackish substance on the tortoise and crowned figure was examined by the Metropolitan Museum's

Research Laboratory and found to contain minute vegetable fibers.

Ring 5
New York, private collection
Diam. 7⅞ in., largest dim. 9¼ in., crowned figure 3½ in.

Motifs: 1) Figure at right, wearing stem-on-cone crown with incised diaper pattern; short, three-tiered skirt wrapper knotted at left hip; necklace, crossed baldrics with an element at the intersection, wristlets, and anklets. Has punched hair texture and curved, tripartite Owo hairline visible under crown; vertical forehead scars in two blocks of four on the right and three on the left; vertical scars on stomach. Right hand holds long staff; left hand held at waist. Above crowned figure: 2) Tortoise with basketweave texture on shell. 3) Reclining vulture, with leaf-patterned feathers, pecking at open eyes of no. 4. 4) Severed, gagged head with punched hair texture and straight hairline. 5) Large vulture with leaf-patterned feathers standing on shoulders and pecking at neck of no. 6. 6) Large, bound, headless body with gashes in left leg and buttock. 7) Large, naturalistic crocodile overlapping feet of no. 6. 8) Small, bound, headless body. 9) Severed, gagged head with scored hair texture and straight hairline. 10) Shelled creature with tail and forelegs. 11) Left arm and hand (thumb extended) wearing wristlet and holding stem with three long, slender leaves springing from boldly scored ball.

Discussion: The composition of this ring is free, its casting fine and detailed. It may be from the same workshop as ring 7. The ring is unique in the location of almost all of its motifs on the outer surface and in the inclusion of a crocodile and a shelled creature (fig. 23). The latter may be related to other amphibious or shelled creatures in Yoruba art that cross animal categories, notably the crayfish on the Ijebu Ode stool in the Ife University Museum (see notes 50 and 51) and the frogs on one aegis plaque found in the walls at Benin. They also appear regularly on Benin aegis plaques and pendants.[71] The crocodile is opposite the crowned figure and is encrusted with a blackish substance. The ring was drilled by the Metropolitan Museum's Research Laboratory and found to be solid bronze (no armature, no core).

Ring 6
Geneva, Barbier-Muller Museum
Diam. 5¾ in.

Motifs: 1) Figure at left, wearing conical crown with three segmented horizontal registers below chevron-patterned top; short skirt with horizontal pattern knotted at both hips; necklace, crossed baldrics, wristlets, and anklets. Has prominent, fleshy stomach with deep navel. Right hand holds disc-topped staff; left hand (thumb prominent) rests on stomach. Above crowned figure: 2) Pair of shells. 3) Vulture with patterned wings pecking at anus of no. 4. 4) Bound, headless body. 5) Severed head with rod gag, big features, and notched eyebrows. 6) Pair of pins (edan), on inner and outer surfaces, joined by rope. 7) Vulture, as above, pecking at anus of no. 8. 8) Bound, headless body. 9) Severed head, as above, with hole in top of head. 10) Branching, trident-like staff (?) in low relief on inner surface. 11) Sphere with triple groove around the "equator" and textured bands that quarter the top half, standing on two-tiered ring.

Discussion: This ring exhibits a prevalence of full, rounded forms rendered in a relatively naturalistic style. The motifs are generally confined to the ring's upper surface. The even, closely spaced disposition of motifs and their large scale recall rings 1, 4, 6, 9, and 10. The sphere (which is definitely not a vessel) and branching staff are unique to this ring. The crowned figure exhibits an encrustation of a blackish substance.

Ring 7
Amsterdam, Lode Van Rijn Collection
Diam. 6¾ in., crowned figure approx. 5 in.

Motifs: 1) Figure at left, wearing brimmed, conical crown; short, many-tiered skirt knotted (?) at left hip; high necklace, crossed baldrics, two strands of beads that form loop hanging from front of baldrics, wristlets, and anklets. Has vertical forehead scars in two blocks of four on the right and three on the left; notched eyelids; round, fleshy stomach with vertical scarifications and deep navel. Right hand holds disc-topped staff; left hand clasps stomach. Above crowned figure: 2) Tortoise with basketweave texture on shell. 3) Severed head lying on its side with punched hair texture and curved, tripartite Owo hairline. 4) Vulture, its breast resting on surface, and with leaf-patterned feathers, pecking at eye of no. 3. 5) Bound, headless body. 6) Bound, headless body, foot-to-foot with no. 5. 7) Vulture, as above, on outer surface, pecking at eye of no. 8. 8) Severed head lying, as above, with punched-ring hair texture and large ear.

Discussion: This ring shares many stylistic features with ring 5, including the placement of the vultures on the outer surface—with their feathers and curious posture—the tortoise shell, and the face and regalia of the crowned figure. Ring 5 is larger, exhibits greater use of the outer rim, and presents more numerous motifs. Nevertheless, the rings seem so similar that I feel they must have come from a single workshop. The two rings are the only ones without Ogboni edan staffs. Along with ring 8, they are also unique in that the headless bodies are not all oriented in one direction. On ring 7 the severed heads apparently are not gagged.

Ring 8
Geneva, Barbier-Muller Museum
Diam. 10½ in., crowned figure approx. 3¾ in.

Motifs: 1) Small figure at left, wearing brimmed, conical crown; short skirt knotted at left hip; choker, wide and circular double strand of beads, wristlets, and anklets. Has straight hairline visible below crown, all-over vertical facial scars typical of Ife, vertical scarifications on stomach. Right hand holds ill-defined, curved object (staff or fly whisk?); left hand rests on hip. Above crowned figure: 2) Pair of pins (edan) joined by a band looped over knob and crossed, on outer surface. 3) Pair of shells—one on inner, one on outer surface. 4) Severed, gagged head with vertical facial scars like those of crowned figure. 5) Frond in relief, on outer surface, composed of four pairs of spirals on central stem with pair of spirals at end. 6) Vulture pecking at rope binding no. 7. 7) Bound, headless body. 8) Single shell, on outer surface, alongside no. 7. 9) Right arm and hand, thumb extended, wearing bracelets and holding long, slender leaf with central rib and row of dots. 10) Severed head, as above, but without gag. 11) Pair of shells, as above. 12) Bound, headless body. 13) Vulture, as above. 14) Pair of shells, as above. 15) Severed, gagged head without scarifications. 16) Vulture, as above. 17) Bound, headless body, as above. 18) Frond, on outer surface, alongside no. 17, similar to no. 5, but with five and four spirals on sides and none at end. 19) Pair of shells, as above. 20) Frond, on outer surface, with four pairs of spirals and single spiral at end. 21) Vulture, as above. 22) Bound, decapitated body. 23) Pair of shells, as above. 24) Pair of horns, on outer surface, alongside shells, joined by rope looped over knob and crossed. 25) Severed head with sunken eyes and lumps on forehead. 26) Upright, flaring vessel on stand, with truncated cone, point down, at top (neck of vessel or handle of lid?), and with three bands emerging from mouth and descending to ring's surface without touching vessel's body.

Discussion: This is the largest ring, with the most motifs. It is

354

a rough cast. The motifs are disposed unevenly around the ring. In proportion to the ring, the size of the crowned figure is unusually small. Unique to the ring is the inclusion of fronds and joined horns (fig. 15), the number of bodies (four), the five pairs of shells, and the single shell. The iconography is aberrant in several ways—in the inconsistency of numbers (shells, spirals), in the placement of the motifs (i.e., the fronds appear on both the upper and outer surfaces). But the placement of the Ogboni *edan* and the vessel adjacent to or opposite the crowned figure is consistent with that of other rings. Motifs on this ring also occur in identical form on ritual vessels from Ife: the joined horns and *edan* staffs both shown on a cord looped over a knob and crossed (fig. 36), and the frond with paired spirals.[72]

Ring 9
Paris, Max Izikovitz Collection
Diam. approx. 7¾ in., crowned figure approx. 4¼ in.

Motifs: 1) Figure at left, wearing brimmed, conical crown with diaper pattern; long, many-tiered skirt (unknotted); long, double-strand necklace, wristlets, and anklets. Has all-over vertical facial scarification typical of Ife; three vertical scarification marks on stomach, which is fleshy with a deep navel. Right hand holds disc-topped staff; left hand holds necklace (both thumbs prominent). Below feet of crowned figure: 2) Stem with band around it that terminates in three cones, each having a groove running its length. Above crowned figure: 3) Shell (raised, flat, and grooved), on outer surface. 4) Vulture with band across wings pecking at neck of no. 5. 5) Bound, headless body with ankles tied, feet extended laterally on ring. 6) Shell, as above, between no. 4 and no. 5. 7) Severed head with rope gag, punched hair texture. 8) Shell, as above (?). 9) Bound, headless body, as above. 10) Monstrous head, with pointed, animal-like ears, horns (?), prominent and ridged simian brow, large nose, fleshy upper lip, and protruding tongue or baleen-like teeth that hide lower lip. 11) Pair of pins (*edan*) joined by rope, on outer surface. 12) Bound, headless body, as above.

Discussion: The above description was taken from a photograph. This ring is important because of the Ife-type facial

scarifications of the crowned figure (which are seen also on ring 8) and the monstrous head (fig. 24). The furrowed brows and fleshy lips of this head recall those of several Ife sculptures that may represent prisoners.[73] Perhaps the closest parallel for this monstrous face is that of a figure on one of the aegis plaques found in the walls at Benin, which has a dwarfish body, deformed legs, and enlarged phallus, as well. This ring is also unique in having Ogboni *edan* that are neither alongside nor opposite the crowned figure; they are, however, oriented in the same direction he is. The three pairs of shells on this ring are spaced at regular intervals; the fourth position is occupied by the *edan* staffs.

Ring 10
Paris, private collection
Diam. approx. 8 in.

Motifs: 1) Figure at right, wearing conical crown with two raised V's on front and short side lappets (?) (which could also be ears; see below); four-tiered skirt; choker, crossed baldrics, wristlets, armlets, and anklets. Has opposed crescent forehead marks, curl-like ears (?), fleshy chest (breasts?) and stomach with deep navel; three vertical stomach marks. Right hand holds disc-topped staff; left hand rests on skirt. 2) Pod between feet. Next to crowned figure: 3) Pair of pins (*edan*), on outer surface alongside crowned figure. Above crowned figure: 4) Severed head with rod and rope gag, plain hair, and incised V or cuts on forehead. 5) Bound, headless body with single line of scarification up the back and down the arms. 6) Vulture pecking at neck of no. 7. 7) Bound, headless body, as above. 8) Severed head, as above, only with single horizontal cut across forehead. 9) Bound, headless body, as above. 10) Severed head, as above.

Discussion: The above description was taken from a photograph. This ring may be grouped with rings 1, 4, and 6, with which it shares an even use of the upper surface, full and rounded modeling of the bodies, and a limited number of motifs. The ears or lappets on either side of the crown resemble those on ring 4. The face of the crowned figure is similar in style to that on ring 4 as well as to that on an Ogboni bracelet (fig. 35).

Conversations with many scholars have been helpful during the long period during which I have been working on the bronze-ring puzzle. A number of friends and colleagues read and commented on a draft of this article. Though none of them are responsible for the conclusions drawn here, I am very grateful to Ekpo Eyo, William Fagg, Robert Thompson, Frank Willett, and especially to Margaret and Henry Drewal, who also gave me unpublished information on royal funerals. I would like to thank Pieter Meyers of the Metropolitan Museum of Art's Research Laboratory, who did analyses of some of the rings. I am also grateful to the owners of bronze rings, who furnished me with photographs and allowed me to study their objects. The late Douglas Fraser debated the Ijebu-Owo question with me as the ideas in this paper developed. To him—scholar, teacher, friend—this work is dedicated.

1. W. B. Fagg, in Christie's, London, sale cat., March 20, 1979: 37.

2. At the time this paper was written (1979–81), I knew of only the ten Yoruba rings discussed here and in the Appendix. An eleventh has since come to my attention (see note 70).

3. H. L. Roth, *Great Benin: Its Customs, Art, and Horrors*, Halifax, 1903, fig. 61.

4. Fagg (note 1).

5. G. P. Miles, "Ring and Bronze Head: a suggestion," *Ethnologica Cranmorensis* 1 (1937): 11.

6. See W. and B. Forman and P. Dark, *Benin Art*, London, 1960: 57.

7. F. Willett, *Ife in the History of West African Sculpture*, London, 1967, pl. 89.

8. E. Eyo and Willett, *Treasures of Ancient Nigeria*, New York, 1980, cat. no. 97.

9. W. Abimbola, *Ifa: An Exposition of Ifa Literary Corpus*, Ibadan, 1976: 211.

10. E. B. Idowu, *Olodumare, God in Yoruba Belief*, London, 1962: 119.

11. H. Drewal, personal communication to author, 1979.

12. Drewal, "Art and the Perception of Women in Yoruba Culture," *Cahiers d'études africaines* 68, 17 (1977): 550.

13. Ibid.

14. R. E. Dennett, *Nigerian Studies*, London, 1910: 111.

15. Roth (note 3): 80.

16. P. Morton-Williams, "The Yoruba Ogboni Cult in Oyo," *Africa* 30 (1960): 363.

17. Ibid.: 371.

18. D. Williams, "Art in Metal," *Sources of Yoruba History*, ed. by S. O. Biobaku, Oxford, 1973: 156.

19. T. Dobbelmann, *Der Ogboni-Geheimbund; Bronzen aus Sudwest-Nigeria*, Berg en Dal, 1976, cat. nos. 40, 58, 121–22.

20. Williams, *Icon and Image: A Study of Sacred and Secular Forms of African Classical Art,* New York, 1974: 78.

21. R. F. Thompson, *Black Gods and Kings: Yoruba Art at UCLA,* Los Angeles, 1971, chap. 6, p. 1.

22. An alternative interpretation convincingly put forward by Margaret Drewal is that "threeness" is associated in general with spirituality (as opposed to the everyday world) and that left-handedness is the medium of spiritual communication ("Symbolism in Yoruba Dance Sculpture," unpub. paper delivered at the African Studies Association Annual Meeting, Philadelphia, October 15, 1980).

23. Three pods of a similar sort often occur on Ogboni bracelets (fig. 35). Their meaning is not clear. Marie Thérèse Brincard has discussed them and has suggested that they may be gongs ("Les Bracelets Ogboni: Analyse iconographique et stylistique," unpub. thesis, Université de Paris, 1980: 55). They also may be related to the tripartite "vegetation" in the mouth of the antelope on the bronze stool in the University of Ife Museum (Williams [note 20]: 253–54). One ring (no. 3) has an unsectioned pod with a dimple at the tip. It is also possible that these are phalluses. For a crowned Obgoni figure wearing skirt with a phallus visible beneath, see *For Spirits and Kings: African Art from the Paul and Ruth Tishman Collection,* ed. by S. M. Vogel, New York, 1981: 104.

24. Thompson (note 21).

25. E. Eyo, "Igbo'Laja, Owo," *West African Journal of Archaeology* 6 (1976): 49.

26. See, for example, various Ogboni bracelets, the University of Ife's bronze stool, the medallion worn by the "Gara" image from Tada, two "Lower Niger" warriors (*African Arts* 10, 3 [1977], back cover; and Fagg, *Nigerian Images,* London, 1963, pl. 62), a standing nude female figure (ibid., pls. 36–37), and a bronze flask with three faces (ibid., pl. 60). The date and geographic origin of all these objects is disputed or unknown.

27. Rings that do not have a tortoise often include shells in a similar position (figs. 6,8), although these also occur in pairs at intervals all around the rings. Rings have either shells or tortoises or neither; no ring has both. The meaning of this is unclear.

28. Idowu (note 10): 188.

29. Ibid.: 89.

30. Fagg, personal communication to author, April 1979.

31. Thompson, "The Sign of the Divine King: Yoruba Bead-embroidered Crowns with Veil and Bird Decorations," in D. Fraser and H. Cole, *African Art and Leadership,* Madison, 1972: 230.

32. R. Smith, *Kingdoms of the Yoruba,* London, 1976: 116.

33. Ibid.: 123.

34. E. Meyerowitz, "Ancient Bronzes in the Royal Palace at Benin," *Burlington Magazine* 83 (1943): 248–53; and Willett (note 7), pls. 97–99.

35. Willett and S. J. Fleming, "A Catalogue of Important Nigerian Copper-Alloy Castings Dated by Thermoluminescence," *Archaeometry* 18, 2 (1976): 140–41.

36. Dobbelmann (note 19): 131.

37. This may be similar to a boldy scored ball held by a small hand in relief on a fragment of a ritual pot excavated at Owo (Eyo [note 25], pl. XVId).

38. O. Eluyemi, "New Terracotta Finds at Oke-Eso, Ife," *African Arts* 9, 1 (1975): 35. Interestingly, this site also yielded a terracotta fragment of a figure in naturalistic style wearing what is almost surely a ram's-head pendant like those seen on the aegis plaques (ibid.: 34). Like those, this one is shown complete with chains and crotals. A similar bronze ram's-head pendant was found with the aegis plaques in Benin (Meyerowitz [note 34], fig. B) and another at Apapa near Lagos (G. A. Wainwright,

"The Egyptian Origin of a Ram-Headed Breastplate from Lagos," *Man* 51 [1951], pls. Ia, Ic).

39. Eyo and Willett (note 8), cat. nos. 66, 70–71.

40. Ibid.: 125.

41. Forman and Dark (note 6): 57.

42. These were first identified as *edan* by Fagg and Willett ("Ancient Ife: An Ethnographical Summary," *Odu* 8 [1960]: 26).

43. Willett (note 7), pls. 40, 62.

44. P. Garlake, "Excavation at Obalara's Land: an interim report," *West African Journal of Archaeology* 4 (1974): 125.

45. Ibid.: 145.

46. A number of related wooden stools were also made at Benin. However, they have a somewhat different overall aspect, lacking the emphasis on open vertical loops joining seat and base, and having instead horizontal coils on either side of a square opening (Dark, *An Introduction to Benin Art and Technology,* Oxford, 1973, fig. 39).

47. F. von Luschan, *Die Altertumer von Benin* I, Berlin and Leipzig, 1919: 479.

48. Williams (note 20): 253–54.

49. Fraser, "Tsoede Bronzes and Owo Yoruba Art," *African Arts* 8, 3 (1975): 30–35; Fagg, in Christie's, London, sale cat., December 9, 1975: 18.

50. J. R. O. Ojo, "A Bronze Stool Collected at Ijebu Ode," *African Arts* 9, 1 (1975): 48.

51. Williams (note 20): 253–54. In the absence of any scientific or collection data—or even a consensus of scholarly opinion on the origin of the Jebba and Tada bronzes—I can see no reason to doubt the collection data available on the stool. Indeed, its stylistic and iconographic connections with other Ijebu bronzes, and its links with the Jebba and Tada group might logically lead instead to an Ijebu attribution for them. For the time being, an Ijebu identification for the stool seems more prudent than a speculative Owo or Benin attribution.

52. Fraser (note 49): 34.

53. Fagg (note 26), pls. 89–91.

54. P. A. Talbot, *The Peoples of Southern Nigeria* III, London, 1926, fig. 225.

55. Fagg, in Christie's, London, sale cat., October 24, 1978: 21.

56. Forman and Dark (note 6), pls. 90–91.

57. Willett (note 7), fig. 64.

58. Ibid.: 131.

59. Drewal (note 11).

60. Williams (note 18): 152.

61. Werner and Willett, "The Composition of Brasses from Ife and Benin," *Archaeometry* 17, 2 (1975), pl. 6.

62. Smith (note 32): 88.

63. A. F. C. Ryder, "A Reconsideration of the Ife-Benin Relationship," *Journal of African History* 6 (1965): 29.

64. Williams (note 20): 308; Fagg, *African Tribal Images,* Cleveland, 1968, cat. no. 304.

65. Smith (note 32): 114–15, 123.

66. Ibid.: 93.

67. Specifically, this group includes the Jebba and Tada bronzes, the Ijebu Ode stool in Ife, and the aegis plaques found in the walls at Benin.

68. Eyo and Willett (note 8), fig. 20.

69. The Wunmonije torso is dated 1515 ± 45 or 1535 ± 45 (Willett and Fleming [note 35]: 137). The "Gara" image from Tada is dated 1365 ± 55 (ibid.: 142); the classical Ife figure from Ita Yamoo is dated 1365 ± 70 (ibid.: 138).

70. The eleventh Yoruba ring, not included in the Appendix (see note 2) can be catalogued as follows: New York, private collection. Diam. 5$\frac{1}{16}$ in., largest dim. 5$\frac{1}{2}$ in., crowned figure

3 ¾ in. Motifs: 1) Crowned figure at left, in style and regalia virtually identical to crowned figures on rings 5 and 7. Above crowned figure: 2) Vulture, its breast resting on surface, and with leaf-patterned feathers, pecking at no. 3. 3) Back half of tortoise that has been cut in two. 4) Front half of tortoise, lying on its shell. 5) Bound, decapitated body. 6) Very small vulture, as above, on outer surface, pecking at eye of no. 7. 7) Severed head. 8) Snake, whose narrow, textured body extends along outer surface, ending near feet of crowned figure. 9) Stem with three leaves springing from boldly scored ball identical to that on ring 5, but without hand. Discussion: This ring is surely from the same artist or workshop that produced rings 5 and 7. It is the smallest ring of the group and the only one to have a snake, one body, and two birds. The presence of the tortoise that evidently has been sacrificed is unique but suggests that the tortoises on other rings also represent sacrificial animals.

71. Eyo, *Two Thousand Years Nigerian Art,* Lagos, 1977: 156, 132, respectively.

72. Willett, "A Contribution to the History of Musical Instruments Among the Yoruba," in *Essays for a Humanist: An Offering to Klaus Wachsman,* New York, 1977, pl. 8.

73. Willett (note 7), pls. 20, V; Eyo and Willett (note 8), cat. no. 58.

Contributors

JOHN BOARDMAN is the Lincoln Professor of Archaeology and Art at Oxford University.

BENJAMIN H. D. BUCHLOH teaches art history at the State University of New York at Old Westbury and is editor of the Nova Scotia Series.

WANDA M. CORN is Associate Professor of Art History at Stanford University.

LORENZ EITNER is Chairman of the Department of Art at Stanford University and Director of the Stanford Museum.

SYDNEY J. FREEDBERG is Professor of Fine Arts at Harvard University.

WENDY HEFFORD is Assistant Keeper, Department of Textiles, Victoria and Albert Museum.

ROGER KEYES is an art historian residing in Woodacre, California.

CAROL HERSELLE KRINSKY is Professor of Fine Arts at New York University.

PRATAPADITYA PAL is Curator of Indian and Southeast Asian Art and Curator-in-Charge of West Asian Art at the Los Angeles County Museum of Art.

JOHN W. REPS is Professor of City and Regional Planning at Cornell University.

KARL SCHEFOLD is Professor of Classical Archaeology and Director of the Archaeological Seminar at the University of Basel.

JOHN SHEARMAN is Professor of Art History and Chairman of the Department of Art and Archaeology at Princeton University.

JOHN SZARKOWSKI is Director of the Department of Photography at the Museum of Modern Art.

EVAN TURNER is Director of the Cleveland Museum of Art.

SUSAN MULLIN VOGEL is Senior Consultant for African Art at the Metropolitan Museum of Art, and Executive Director of the Center for African Art, New York.

ELLIS WATERHOUSE was Director of the National Gallery of Art, Edinburgh, and Barber Professor of Fine Arts and Director of the Barber Institute at the University of Birmingham; he currently resides in Oxford.

JEFFREY WEIDMAN is Head of The Clarence Ward Art Gallery Library at Oberlin College.

GILLIAN WILSON is Curator of Decorative Arts at the J. Paul Getty Museum.

358